SUPER BODIES

WORLD COMICS AND GRAPHIC NONFICTION SERIES

Frederick Luis Aldama, Christopher González, and Deborah Elizabeth Whaley, editors

The World Comics and Graphic Nonfiction series includes monographs and edited volumes that focus on the analysis and interpretation of comic books and graphic nonfiction from around the world. The books published in the series use analytical approaches from literature, art history, cultural studies, communication studies, media studies, and film studies, among other fields, to help define the comic book studies field at a time of great vitality and growth.

OTHER BOOKS IN THE SERIES

Peyton Brunet and Blair Davis, *Comic Book Women: Characters, Creators, and Culture in the Golden Age*
Mark Cotta Vaz, *Empire of the Superheroes: America's Comic Book Creators and the Making of a Billion-Dollar Industry*
Anna Peppard, ed., *Supersex: Sexuality, Fantasy, and the Superhero*
Allan W. Austin and Patrick L. Hamilton, *All New, All Different? A History of Race and the American Superhero*
Jorge Santos, *Graphic Memories of the Civil Rights Movement: Reframing History in Comics*
Benjamin Fraser, *The Art of Pere Joan: Space, Landscape, and Comics Form*
Jan Baetens, *The Film Photonovel: A Cultural History of Forgotten Adaptations*
Marc Singer, *Breaking the Frames: Populism and Prestige in Comics Studies*
Matt Yockey, ed., *Make Ours Marvel: Media Convergence and a Comics Universe*
Mark Heimermann and Brittany Tullis, eds., *Picturing Childhood: Youth in Transnational Comics*
David William Foster, *El Eternauta, Daytripper, and Beyond: Graphic Narrative in Argentina and Brazil*
Christopher Pizzino, *Arresting Development: Comics at the Boundaries of Literature*
Frederick Luis Aldama and Christopher González, eds., *Graphic Borders: Latino Comic Books Past, Present, and Future*

SUPER BODIES

COMIC BOOK ILLUSTRATION, ARTISTIC STYLES, AND NARRATIVE IMPACT

Jeffrey A. Brown

University of Texas Press *Austin*

Copyright © 2023 by the University of Texas Press
All rights reserved
Printed in the United States of America
First edition, 2023

Requests for permission to reproduce material from this work should be sent to:
 Permissions
 University of Texas Press
 P.O. Box 7819
 Austin, TX 78713-7819
 utpress.utexas.edu/rp-form

♾ The paper used in this book meets the minimum requirements of ANSI/NISO Z39.48-1992 (R1997) (Permanence of Paper).

Library of Congress Cataloging-in-Publication Data
Names: Brown, Jeffrey A., author.
Title: Super bodies : comic book illustration, artistic styles, and narrative impact / Jeffrey A. Brown.
Other titles: World comics and graphic nonfiction series.
Description: First edition. | Austin : University of Texas Press, 2023. | Series: World comics and graphic nonfiction series | Includes bibliographical references and index.
Identifiers: LCCN 2022034888 (print) | LCCN 2022034889 (ebook)
 ISBN 978-1-4773-2736-4 (hardcover)
 ISBN 978-1-4773-2737-1 (pdf)
 ISBN 978-1-4773-2738-8 (epub)
Subjects: LCSH: Comic books, strips, etc.—Illustrations—History and criticism. | Comic books, strips, etc.—Illustrations—Social aspects. | Comic books, strips, etc.—Illustrations—Themes, motives. | Superheroes—Comic books, strips, etc. | Superheroes—Social aspects.
Classification: LCC PN6714 .B763 2023 (print) | LCC PN6714 (ebook) | DDC 741.5/352—dc23/eng/20221004
LC record available at https://lccn.loc.gov/2022034888
LC ebook record available at https://lccn.loc.gov/2022034889

doi:10.7560/327364

For my wife Anastasia!

CONTENTS

1. How to Draw Superheroes 1
2. The Superhero and the Dessinateur 29
3. Idealism and Comic Book Heroes 61
4. Retro Art and Nostalgia 91
5. Realism in an Unrealistic Genre 117
6. Super Cute Manga, Kawaii, and Infantilization 141
7. Grotesque Bodies and Monstrous Heroes 169
8. Superhero Noir, More Than Just Black and White 191
9. Drawing Conclusions 215

 Works Cited 229

 Index 236

1 | HOW TO DRAW SUPERHEROES

What makes comics unique as a medium is the combination of words and illustrations to craft a comprehensive narrative. Words and images are, of course, used together in other forms (e.g., children's books, instruction manuals, political cartoons), but the synergy of word and image in comic books is crucial to the overall narrative in a manner that other formats never reach. The field of Comics Studies has grown exponentially over the last fifteen years with a wide range of scholarly approaches delving into nearly every aspect of comic book genres, political and social themes, historical developments, cross-media adaptations, and audience consumption. But the importance of comic book art is typically overlooked. As a discipline, Comics Studies remains primarily rooted in a literary model of analysis, seldom embracing the art itself as a crucial part of the form. I am not implying the art is never mentioned, nor that it is treated as inconsequential, but the subjective nature of describing and interpreting illustrations makes artistic styles difficult to address. Taking account of qualities like tone, mood, and emotional affect risks undercutting the importance of the art, or merely waxing poetic about the beauty of the illustrations. Still, the art is a definitive part of comics and is crucial to shaping the meaning and intent of any story. Pascal Lefevre goes so far as to argue: "Form is anything but a neutral container of content in the comics medium; form shapes content, form suggests interpretations and feelings. Without considering formal aspects (such as graphic style, *mise en scene*, page layout, plot composition), any discussion of the content or the themes of the work is, in fact, pointless" (2011, 71). Though I do not think approaches to comics scholarship that do not account for the artistic elements are "pointless," I do understand Lefevre's frustration with

the academic blind spot where comic book illustrations reside. To have a fuller understanding of the entire medium, the artwork needs greater consideration.

The literary studies traditions that still dominate comics scholarship have tilted the field in favor of authors over other kinds of creators. For example, of the twenty-six books in the series Conversations with Comics Artists from the University Press of Mississippi, only three are about creators who are primarily illustrators. Six books in this interview series feature writers, and the rest focus on individuals who both write and draw their own stories: such iconic creators as Charles Schulz, Will Eisner, Howard Chaykin, Milton Caniff, Alison Bechdel, Chris Ware, Art Spiegelman, and Robert Crumb. Tellingly, most of these writer/artists, who have also been subject matter for dozens of scholarly articles, fit a conventional definition as serious auteurs, or the conception of "complete authors." These creators all produce mostly literary, black-and-white, independent work, with a focus on autobiographical narratives. This bias regarding which creators are studied reinforces the idea that only a select few comic forms can be considered high art, and thus worthy of study. Conversely, relatively little attention has been given within Comics Studies to the importance of artists and different styles of illustration, especially within the medium's most popular genre: superheroes. Several excellent book-length studies of specific comics creators have shifted the narrow focus of critical comics studies. However, even in the few cases where popular mainstream (especially superhero) artists have been the primary subject, there is also a preference for writer-authors; for example, Charles Hatfield's thorough study of Jack Kirby (2012), Paul Young's analysis of Frank Miller's work on Daredevil (2016), Scott Bukatman's consideration of Mike Mignola's creation Hellboy (2016), and Brannon Costello's overview of Howard Chaykin's career (2017). Interestingly, all of these legendary comics creators (Kirby, Miller, Mignola, and Chaykin) started out in the industry as illustrators before becoming both author and artist. Yet all four of these studies focus primarily on the later work of the creators when they were billed as writer-artists.

Though the colloquial idea of "comic book art" implies simplistic four-color renderings of stiff characters slugging it out, modern superhero comics actually showcase a wide range of complex artistic styles. The immediately recognizable look of comic books is a significant part of the medium's appeal and a prominent factor in how comics can affect readers. Changes in art can influence the overall perception of a story or a given character, even with superheroes as famous and readily identifiable as Superman, Batman, Wonder Woman, Spider-Man, or Captain America. The comic book superhero has been one of the most formulaic popular genres for nearly a century. No other medium is as dominated by a single

genre as comic books are by superheroes. Ever since the introduction of Superman launched the genre in 1938, it has maintained several unique narrative conventions (secret identities, incredible powers, sidekicks, etc.) and distinct visual iconography (colorful costumes, visible sound effects, heroic poses, etc.). However, the genre has also managed to explore a wide range of narrative and visual variations, while still employing the basic superhero conventions. In fact, as Henry Jenkins observes, the centrality of the superhero has allowed the genre to incorporate a range of artistic styles: "The superhero genre becomes a site of aesthetic experimentation, absorbing energies from independent and even avant-garde practices" (2017, 71). The exploits of caped crusaders remain primarily adventure stories, but they also venture into the territory of other genres such as horror, science fiction, melodrama, romance, comedy, and police procedurals. In fact, because the superhero is such a familiar and easily recognizable figure, the character is flexible enough to withstand different genres, different mediums, different historical periods, and different writers. But it is the change in artists and artistic styles that can drastically and viscerally affect different interpretations within the genre. The following chapters detail how the artistic style in superhero comic books can alter the impression of a character and the intent of the story. In addition to historical shifts in figural standards and discussions of specific artists, particular attention will be focused on six distinctive modern styles of superhero illustration: Idealism, Realism, Cute, Retro, Grotesque, and Noir. Of course, this is not an exhaustive list, nor are these styles mutually exclusive, but each of these artistic strains utilize aesthetics to convey additional meanings to the characters and the stories, and to evoke a different affect with readers.

To be clear, the six major artistic styles addressed in this book are not meant as strict nor definitive categories. Using what is essentially a Structuralist approach, my goal is to demonstrate there are distinct and identifiable styles of comic book illustration that reflect trends much broader than just the unique look of each artist, and there are visual conventions that convey specific meanings to compliment or enhance the overall story. There are overlaps and intermixing of different styles with significant ideological links between categories like Retro and Noir, which I have distinguished from each other for the sake of analysis. Both Retro and Noir invoke past eras and embody a sense of nostalgia, but for very different cultural moods. Likewise, Idealism and Grotesque are visual opposites in how they depict the superhero, but each style is mutually defined by the other. I also want to clarify that these stylistic categories are necessarily subjective; what one reader may see as Cute another may see as Grotesque, or perhaps some illustrations rightly fit into both categories equally. Looking at the work of a single artist from a range of categorical perspectives may illuminate new and important differences. In Film Studies, for example, an

individual movie can be usefully considered within the context of different genre formulas. Thus, a film like *Star Wars* (1977) can be studied as science fiction, a western, a Samurai story, a coming-of-age fantasy, or even a family melodrama. Each analysis helps to explain the cultural phenomena of a landmark film. It is my hope that others working in Comics Studies will expand and critique these categories, challenge them and refine them, and otherwise bring to bear a range of other art-focused considerations.

In the 1970s, DC Comics frequently included diagrams of "How to Draw" some of their most popular characters. Top artists provided brief, step-by-step instructions and examples of how to sketch the faces and bodies of heroes like Superman, Batman, the Flash, and Green Arrow. These deceptively simple instructions gave hope to many young readers that they could learn how to draw their heroes and maybe even become professional comic book artists one day. The single-page tutorials demonstrated a three-step progression from initial blocking of proportions, to roughing in the underlying muscle structure, to the finished details and shading. In his "How to Draw Superman," legendary illustrator Curt Swan noted that it was relatively easy: "From a simple stick figure, build a mass of muscle ready to explode into action." Swan's modest claim belies the years of training and practice that go into becoming a professional illustrator. It also glosses over the development of each artist's individual style. But Swan's comment does emphasize two of the most important aspects of comic book art: an ideal body and an implication of motion. Similarly, Carmine Infantino's "How to Draw" Batman tutorial in the 1970s asked readers to "note the broad shoulders and chest, as well as the muscular (but not muscle-bound) build." The Caped Crusader needs to be conspicuously muscular, but not so much that he couldn't leap into action at any moment. Marvel confirmed the centrality of perfect bodies poised for adventure in their 1984 instructional book *How to Draw Comics the Marvel Way*, which has remained in print continuously for nearly forty years. "There might be something more important than figure drawing in comic book artwork, but we sure don't know what it is," claim the co-authors Stan Lee and John Buscema, "everything is based on how you draw the characters!" (42). Most significant is what Lee and Buscema refer to as the "heroically proportioned superhero," who must be "larger, with broader shoulders, more muscular arms and legs, a heavier chest, and an even more impressive stance" (46). Moreover, once you have drawn this heroically proportioned body, "you've got to be able to move it, to animate it, to put it into action!" (60). Dozens of modern "How to Draw a Superhero" guides are available in bookstores and online today, and they all reiterate the same basic premise: illustrating the heroic body and its incredible feats is the cornerstone of the genre.

The figure of the superhero is the most important and definitive part of

1.1 "How to Draw Superman" (circa 1976), Curt Swan, artist, DC Comics.

the genre. How the superhero looks and moves is crucial to the aesthetics of comic books. Discussing gender representation, Anna F. Peppard notes that "superhero comics center upon and make meaning out of the spectacle of the body, whether in exertion, pleasure, pain, or trauma" (2014, 565). Likewise, comics scholar and historian Charles Hatfield argues: "Superhero comic books have always been about the spectacle of bodies on the page" (2012, 217). These spectacular bodies serve as both the visual and the narrative focal point of the entire genre. The superhero literally embodies all the themes around which the genre spins out countless stories. These are incredible bodies that can fly, fire energy blasts from fingertips or lasers from eyes, deflect bullets, breathe underwater, run faster than the speed of light, turn to fire or ice, or anything else the creators can dream up. Or, more accurately, these are bodies drawn to *look* like they are capable of all these amazing things. It is the look of these illustrated bodies that constitutes the "spectacle" Peppard and Hatfield describe as the perennial key to the stories. The figure of the superhero is the focus of this study: how he or she is drawn, how those drawings change over time, across styles, and from artist to artist. Furthermore, a central concern of the following chapters will be unpacking how these sometimes radically different artistic styles, and bodies, influence the stories and affect the readers.

Even the most realistic comic art is not meant to be a lifelike representation of human bodies. The superhero genre is science fiction, extravagant and romantic fantasy, and the illustrations reflect the imaginative fancy of the comic book world. The superheroic figure is variable, body shapes reflecting different narrative tones. These characters are not meant

to be real; they are symbolic interpretations of ideals, hopes, desires, and even fears. In *The DC Comics Guide to Pencilling Comics* (2002), veteran artist Klaus Janson claims: "One of the advantages of comic book anatomy is that it allows a wider spectrum of anatomical interpretation than other media or areas of study. Comic artists have the freedom to draw the human body in a variety of styles. The basic proportions of the human body can be exaggerated and distorted in comic book art" (28). As Janson suggests, for comic book illustration the rules of anatomy are really just very loose guidelines. In the following chapters, the discussion of different styles will demonstrate how the superhero body is free to be much more than just a macho fantasy. Instead, in the hands of different artists, bodies can become round and infantile, lumpy and misshapen, dark and vulnerable, clean and graphic, or any number of other possibilities. In comic book art, superhero bodies are not direct transcriptions; they are always a stylized interpretation of physical forms meant to imply certain characteristics.

I am interested in the artistic representations of superheroes in comic books because they are undeniably the most dominant figures in the medium and because *how* they are rendered is so often glossed over or taken for granted as merely functional illustrations in service of a childish adventure story. The superhero has become the most visible character type in popular culture over the last twenty years thanks primarily to the blockbuster film franchises and hit television programs. As source material, superhero comics have become the anchor for an incredible array of multimedia expressions, including video games, phone apps, toys, novelizations, clothing, and home goods. The superhero's cultural ascendency more than eighty years after first being introduced is a testament to the figure's ability to embody our shared fantasies. The superhero helps us work through beliefs about justice, authority, gender, puberty, sexuality, ethnicity, nationalism, technology, and violence, among other seemingly endless possibilities. How the superhero looks in comic books can both directly and indirectly influence not just the story being told, but how we form opinions and values about some of these crucial concepts. Superheroes are symbols as much as they are characters; not meant to be taken as real people but as iconic "types" enhanced with miraculous powers. Likewise, the illustrations (even the most realistic ones) are not meant to represent actual people, but are designed to convey meanings about bodies and to create an atmosphere within a fictional milieu. Addressing the ridicule often heaped on superhero art, Richard Harrison argues that the critics miss the point because they "treat comic book art as if it is representational, as if the purpose of the artwork in a comic book is to draw characters as though they were human beings dressed up to play their super heroic or supervillainous roles. Comic art is, instead, a species of graphic art precisely because the drawings aren't drawings of how characters look

but of what the artists are telling the readers about them through their pictures" (2020, 351). Comic book art takes the superhero as its primary subject, but it also visually represents the superhero as a symbolic construct, suggesting different qualities based on how he or she is illustrated. These artistic meanings, as culturally determined *and* personally subjective as they are, then circulate in various market-driven ways throughout Western media.

Words and Pictures

Every medium has inherent properties that different fields of study must account for. Film Studies has developed a language for addressing both the formal properties of the medium (camera angles, lighting, special effects, etc.) as well as the narrative message of the film. Theater Studies must tackle the interplay between live performers and audiences, as well as staging and choreography. Musicology contends with different arrangements, pace and tone, recording technologies, and the performer's skill. Likewise, Comics Studies grapples with, among other things, the duality inherent in the medium's combination of printed words and drawn pictures. The balance between prose and pictures is crucial to the general conception of comics as well as to a critical working definition for the field of Comics Studies. In one of the first serious attempts to establish parameters for a field of Comics Studies, Coulton Waugh declared, "Comics are a form of cartooning. The special feature of this latter is that it jumps at the reader picture side first—you see the situation. In the strips, the writing is a side explanation which the mind picks up, often without being aware of the process" (1991, 14). Comics historian Robert C. Harvey insists on the combination of words and images as the medium's most important distinction. "Comics are a blend of word and picture," notes Harvey, "not a simple coupling of the verbal and the visual, but a blend, a true mixture" (1994, 9). Similarly, Matthew J. Smith and Randy Duncan argue: "As an art form, a comic book is a volume in which all aspects of the narrative are represented by pictorial and linguistic images encapsulated in a sequence of juxtaposed panels and pages" (2009, 5). The unique structural form of comics as a combination of words and images perceived in tandem to create a narrative means that critical analysis needs to address both sides of the medium.

The balance between words and pictures is debatable, but it is impossible to overlook how the illustrations dominate most conceptions of comic books. Just the mention of characters like Superman, Batman, or Spider-Man likely brings to mind a clear image of those heroes in most people's minds. Each of us may picture a different version of Superman,

Batman, or Spider-Man, but we are familiar with the general appearance of their strong bodies, colorful costumes, and dynamic poses. In fact, in his influential text *Understanding Comics*, cartoonist and critic Scott McCloud reasoned that the art is more essential to comics than the written word: "Comics are juxtaposed pictorial and other images in deliberate sequence, intended to convey information and/or to produce an aesthetic response in the viewer" (1993, 9). Certainly, any number of comic strips regularly convey their brief narrative, or tell their joke, through images alone. Comics like *Peanuts*, *The Far Side*, *Dilbert*, and *Garfield* often eschew dialogue or written narration in favor of a "silent" or "pantomimed" series of images. And, while superhero comic books rarely abandon their trademark purple prose entirely, some books may rely only on illustrations for long sequences. For example, during Matt Fraction and David Aja's award-winning run on the series *Hawkeye* (2012–2015), the title character lost his hearing and the book reflected his soundless perceptions by relying only on Aja's art to carry the narrative forward. Any scenes involving Clint Barton (aka Hawkeye) were presented without dialogue or written narration. American Sign Language diagrams are incorporated, but without any subtitles to translate what Clint or his brother are signing. *Hawkeye* #19, which has been dubbed "The Deaf Issue," generated a great deal of praise for its inclusion of hearing-impaired themes and a deaf hero. In reviewing deaf accessibility in comics, Naja Later noted: "The necessity of communicating inaudibility in a soundless medium makes *Hawkeye* #19 a deeply resonant experience of deaf subjectivity" (2019, 141). Through the artwork alone, Aja is able to effectively convey the story for multiple issues, and to create a mood or tone that reflects the aural displacement experienced by the hero.

At the other end of the spectrum, and more uncommon than the wordless superhero comic book, are the few occasions where the written word takes precedence over the artwork. The most obvious case of this literary approach to a comic book occurred with the story "The Clown at Midnight" in *Batman* #663 (2007) from celebrated writer Grant Morrison. Though the tale was accompanied by a few disconnected illustrations provided by John VanFleet, "The Clown at Midnight" is essentially a prose story. The overwhelmingly written nature of this issue raised debates about whether *Batman* #663 should even be considered a comic book at all. Roy T. Cook (2011) argues on philosophical grounds that Morrison's tale does count as a comic book because it is delivered within the context of a serialized, periodical format, in a uniform physical medium; that it is really just an extreme variation within a long-running format. In fact, Cook reasons, it is possible (though improbable) that an entirely imageless comic book could exist in the future. But, even in the text-heavy *Batman* #663, the art plays a significant role in enhancing the uncanny atmosphere of

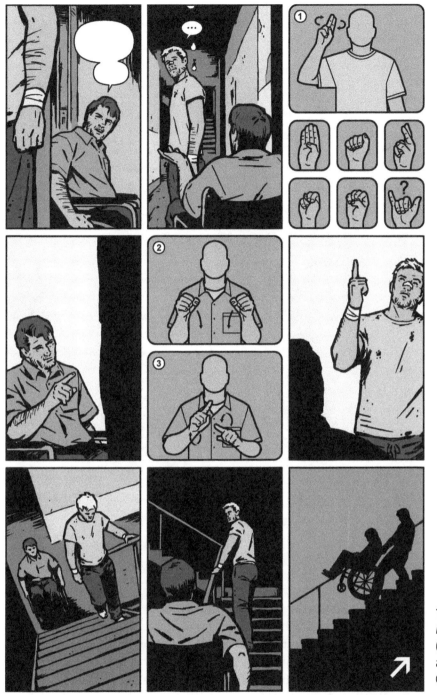

1.2 Page from *Hawkeye* #19 (2012), David Aja, artist, Marvel Comics.

the narrative. John VanFleet's paintings do appear on each page, mostly as close-ups of the Joker's maniacal face. The art does depict moments from the story, but only in bits and pieces. The images could tell the story on their own. However, the art still frames the narrative as a horrific tale rather than a typical superhero adventure. The Grotesque illustrations (a style addressed specifically in chapter 7) help establish a mood or feeling of

HOW TO DRAW SUPERHEROES | 9

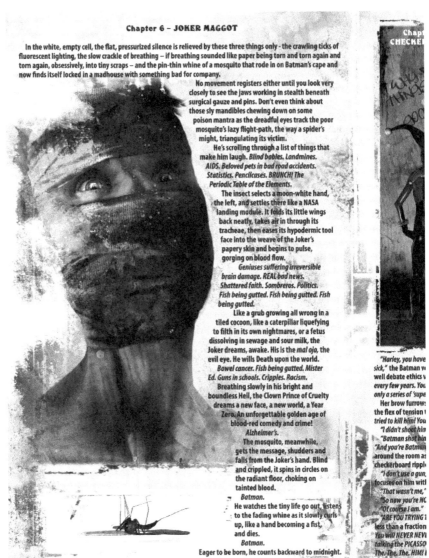

1.3 Page from *Batman* #663 (2007), John VanFleet, artist, DC Comics.

unease even before the first words are read. Even at its most minimal, the art in comic books is an essential element.

The chemistry of words and images in comic books, and any debates about which component is dominant, is important because it is the combination of the two that amounts to the medium's unique narrative expression and the powerful effect it can have on readers. Jan Baetens insightfully notes that "the discussion of words *and* images is a discussion of words *versus* images, for in Western culture, it is the differences rather than the analogies that have been stressed" (2020, 194, italics in original). Moreover, Baetens argues, the relationship has always been ideologically unequal, with words granted a higher status than images. By focusing on the art side of comics in this book I am not suggesting that the role of the writer is less significant than that of the illustrator. Of course, writers provide

far more than just the written word. They craft the story, direct the events, dictate the action, and create the characters' personalities. But, given the visual nature of the medium, the artwork is the chief mechanism by which the narrative is conveyed. Even when considering the written word on the comic page, the graphic presentation of those words usually carries additional narrative significance. Common devices like word balloons and thought bubbles indicate which information is available within the scene to other characters, and which is a privileged insight for the reader that may reveal valuable plot points or help to flesh out the character's personality. And when a character's overt narration is displaced into caption boxes, additional information is signified through the coloring, font, choice, and size of the words. In deconstructing the relationship between words and images in comics, Baetens describes this type of aural/visual combination as "the systemic visualization of speech" (2020, 200). For example, the noble Superman's words often appear in strong blue lettering, while the mentally unstable Deadpool's words might be expressed in a mélange of inconsistent fonts and sizes, and the observations of reporters like Lois Lane or Ben Urich tend to appear in an old typewriter font. Written words become a functional part of the art, just as the art is an expression of the written word. This is part of what Harvey is referring to when he calls comics "a blend, a true mixture" (1994, 9). Legendary comics writer and artist Will Eisner definitively declared, "TEXT READS AS IMAGE" in his manual *Comics and Sequential Art* (1985, 10). Eisner's point is that, unlike in other mediums, comics can display words as an artistic image that conveys more meaning than words alone can. Moreover, Eisner himself epitomized a technique where words could be displayed as three-dimensional elements in a scene—as titles that his hero the Spirit might lean against or leap from. In any case, it is worth noting that however "comics" is defined, visual elements are crucial to the overall narrative and the effect it can have on audiences.

It is not my goal here to rehash the debates over how to define comics; only to stress the significance of the art as an essential aspect that is relatively underappreciated. In fact, the desire to formalize a definition of comics is limiting in many respects, an attempt to set in stone a medium that is inherently flexible. Moreover, as Bart Beaty rightly points out, "the search for a universally acknowledged functionalist definition of comics has not been satisfied" (2012, 36). The breadth of what can count as comics is one of the problems with a comprehensive definition. Comic strips, single-panel comics, editorial cartoons, political caricatures, underground comix, and children's books are distinct enough in appearance and intent that a definition that can encapsulate them all is inevitably problematic. In a colloquial sense, comics are like Supreme Court justice Potter Stewart's famous 1964 admission regarding obscenities—that he may not be able

to define what it is, but "I know it when I see it." By limiting what type of comics I address in the following chapters, and the specific narrative genre presented within them, I hope to demonstrate the variety of artistic styles and their significance within a singular format, rather than addressing comic art in its broadest range of possible expressions. For the purposes of this book, my interest is restricted to the most popular and financially dominant form of comics, namely the mainstream superhero comic books produced in America primarily by the "Big Two" publishers, Marvel and DC Comics.

Efforts to conceptualize the unique properties of words and images as intertwined narrative elements in comic books are similar to developments in Film Studies (which also emerged from a tradition of literary analysis). Early silent films merely interjected written title cards between brief scenes of action, thus allowing the words to define the narrative by speaking directly to viewers. But with the development of sound technologies and a consistent Hollywood narrative style, the visuals became preeminent. Applying long-standing ideas about narrative theory to modern film provided a terminology that addressed ideas about narrative authority, veracity, and communication. Richard Maltby summarized the important distinction as being "between modes of narrative that *tell* their audiences what happens, and modes of narrative that *show* them what happens" (1995, 327, italics in original). As a visual medium, movies are devoted to *showing* their story and have developed a wide range of semiotic devices to layer or construct specific narrative meanings as part of a visual language. Thus, technical elements like camera angles, scene transitions, point-of-view shots, soundtracks, and lighting all become part of the narrative. While devices like text crawls to establish moments, subtitles, location and time banners, or voiceover narration still exist, audiences privilege the visual—what they can see for themselves—as the core of the story. In this regard, the *show* is granted greater weight than the *tell*. As Maltby argues, recognizing the significance of the visual format is crucial to establishing a lexicon that can address film as a distinct narrative form. Maltby concludes:

> This is not to suggest that a movie's images are any more "natural" or "objective" than words—far from it—but it is to argue that the conventions of cinematic narrative, and the way narrative information is conveyed in a movie, are radically different from those employed in verbal forms. If this seems to labor an obvious point, it is because the inheritance from literary criticism so often leads analysts of movies to make the metaphorical leap into treating a movie as a sort of linguistic event, as the narrator's speech even when there is none. (1995, 328)

Similarly, despite the fact that we read comic books (both "read" and "book" alluding to a literary-based tradition), comics are a primarily visual medium that emphasizes the show or the tell. DC Comics's creator's guide directly states: "Show, don't tell. Clearly show all the visual information so that the script does not *have* to include descriptive information. That way, the script, if any is needed, can concentrate on nonvisual information, additional detail, and subtext" (Potts 2013, 29). As Film Studies needed to account for the visual element of motion pictures, critical analysis of comics needs to account for the contribution of the artwork to the overall narrative. I think it is important to add as well that the consideration of comics' visual aspects should address both technical *and* aesthetic realms.

Interestingly, the technical visual aspects of comic book storytelling have been explored more meticulously than the aesthetic aspects. As a unique narrative form, comics have developed numerous medium-specific design techniques to present their stories. Technical conventions have evolved into a visual language that facilitates the readers' ability to understand the overall intent of the images. Technical aspects like panel-to-panel transitions, splash pages, overlapping layouts, and establishing shots have become crucial artistic components in the service of the narrative. "In comics, form and content are not separate but fundamentally complement one another," Martha Kuhlman argues in relation to structural conventions. "Visual patterns and design strategies literally make up the narrative" (2020, 172). In fact, the technical aspects of the artwork are more important for the flow of the story than the singular illustrations of characters are. *The DC Comics Guide to Creating Comics* informs aspiring artists that the industry's primary principle is: "Make all creative decisions in the service of the story" (Potts 2013, 24). In other words, every graphic element—from portraits to panel borders—is an inseparable part of the narrative. Editors repeatedly tell aspiring comic book artists at conventions that drawing a nice static picture of a superhero is relatively easy; to become professional artists, they need to demonstrate an ability to carry the action from one panel to the next with smooth transitions—to "tell" a story in pictures. These codified graphic techniques function as a complex semiotic system to present simple moment-to-moment transitions as well as abstract concepts like flashbacks, time-blending, hallucinations, unreliable narrators, and so on. The importance of comics' technical visual dimensions has also proved a necessary subject in establishing a shared understanding and a language of comics studies. To this end, a broad range of excellent work has studied technical visual devices such as *mise-en-scene* and framing (Lefevre 2012), panel sequencing and page composition (Kuhlman 2020), graphic typography (Baetens 2020), splash pages (Cortsen 2012), thought bubbles (Camden 2020), bridging panels (Poharec 2018), and the evolution of page layouts (Pederson and Cohn 2016).

Given the importance of the visual in comics, it is surprising that the ever-expanding field of Comics Studies has primarily focused on the literary side of the medium. Film Studies emerged from within English departments and adapted methods of classic literary analysis that led to an early focus on directors as auteurs as sole authors of the text, which could be read much as one would read a book. When Andrew Sarris adapted the French approach to cinema as "auteur theory" for American criticism, the concept retained a belief in a singular creative source. As Sarris surmised, the "premise of the *auteur* theory is the distinguishable personality of the director as a criterion of value" (1968, 31). Comics Studies has been primarily developed by researchers trained in literary research methods and thus typically has focused more on the "book" side of the medium than on the "comic" side, on the author as auteur. Katherine Roeder has argued, "the rich visual aspect of comic art has been neglected in favor of an approach that stresses narrative content" (2008, 5). Roeder does not mean to imply that the narrative and the visual aspects of comics can be easily separated, merely that the inherent literary approach has tended to downplay the significant contribution made by the art. Anna F. Peppard describes how a few select superhero writers have garnered the bulk of serious criticism because the literary is privileged over the visual: "The fact that Moore and Morrison are writers rather than artists furthermore reveals a longstanding tendency within comics studies to privilege words over images" (2019, 322). Despite how inseparable the narrative and the art are in comics, the writers are often credited as the main creator. "When approaching a comic, our first impulse may be to read for the content of the story *as* a story, and pass over its visual form," argues Martha Kuhlman, "yet to do so is to miss some of the most fascinating and rewarding aspects of comics" (2020, 172). As stories co-created by author and artist that are graphic (in every sense of the word) fantasies inspiring millions of readers and exerting a significant cultural influence, to undervalue the contribution of specific artistic styles is to miss half the text. Yes, the analysis of graphic structuring in comics as part of the narrative conveyance addresses the *technical* aspects of comic art, but the *aesthetic* qualities and how they contribute to the overall story have been relatively overlooked.

Scholarly approaches to the humanities are often grounded in the modernist assumption that the importance of a work of art is inextricably linked to a single creator, whether it be a writer, sculptor, poet, painter, composer, or director. The preeminence of an individual creator as the "author" of a work and its meanings is fundamental to literary studies but has also extended to other artforms through a persistent celebration of "auteurism." Most comic book studies adopt this single creator as auteur approach, which lends a sense of validity to serious considerations of one of the most trivialized forms of popular culture. "Auteurism has been the

key to the cultural legitimacy of comic books," argues Bart Beaty. "The scholarly study of comics, as it has developed in universities over the past quarter century, has tended to focus on those comics that best fit the literary scholarly traditions. Works with a single author, or to which a central authorship might be attributed in the case of collaborative works, have been strongly, indeed overwhelmingly, preferred" (2012, 5). In fact, auteur status is attributed to comic book writers (Alan Moore, Neil Gaiman, Robert Kirkman, Grant Morrison, Kurt Busiek, Gail Simone, and Warren Ellis); to creators who serve as both writer and artist (Will Eisner, Frank Miller, Howard Chaykin, John Byrne, and Mike Mignola); and those writers who often work in partnership with a specific illustrator (Stan Lee and Jack Kirby, Brian Michael Bendis and Alex Maleev, Ed Brubaker and Michael Lark, Jeph Loeb and Tim Sale). In every case, the writer is considered the auteur regardless of the collaborative nature of the medium and the significance of the illustrations in creating an overall tone for the story. To be clear, I am not arguing that illustrators should replace writers as auteurs. Rather, I believe Comics Studies needs to privilege the *dessinateur* alongside the auteur. The dessinateur (keeping the parity implied by the French terminology) is more than just an illustrator or cartoonist that brings the writer's vision to life. The *dessinateur* is also a source of narrative meaning, and in a more abstract sense, of tone and feeling.

In his analysis of the artist's unique contribution to the authorship of modern comics, Jared Gardner argues that the literary foundation of narrative theory creates an ellipse when it comes to studying "the *line*, arguably the most undertheorized element of comics scholarship and one that has no neat equivalent in any other narrative form" (2011, 53, italics in original). Gardner rightly points out that "very little attention has been spent addressing the one feature of comics that marks them as profoundly different—and perhaps even irreducibly so—from both novel and film: the trace of the hand, the graphic enunciation that is the drawn line" (2011, 54). But it is the contribution of the artist's hand—the drawn *line* on paper—that shapes much of the comic's meaning. Gardner refers to overlooking the hand-drawn line as the equivalent of a failed paraphrase; the inherent difficulty of trying to recount a story without the influence of the artwork's tone and style. Paraphrasing a comic book without the art is like trying to accurately recount *The Sun Also Rises* or *The Big Sleep* without the distinctive prose styling of Ernest Hemingway or Raymond Chandler. In the next chapter we will return to Gardner's idea of "the line of the artist, the handprint of the storyteller" (2011, 56) as crucial to elevating the status of artists. However, Gardner's emphasis on the influence of the illustrator to the overall meaning of the comic is an important recognition of the artist as more than a mere craftsman, but as a legitimate *dessinateur*.

Comic books are unique among visually based mediums. Film, televi-

sion, and theater play out a story in front of an audience with events plotted in a generally linear order that the viewer has to follow. At the opposite extreme, paintings, sculpture, photography, and even architecture are presented as static objects that the viewer can ponder and dwell upon. Comic books exist in a state between these two more common modes; a sequentially ordered story is given the illusion of movement through time and space with the aid of dynamic artwork that is, nevertheless, a stationary collage of images that readers can inspect and consume at their own pace. Moreover, the art in comics is designed to graphically convey meanings that are essential to the story, revealing plot devices, privileging the reader's point of view, and constructing a mood or tone for the narrative. "A graphic style creates the fictive world, giving a certain perspective on the diegesis," Pascal Lefevre notes in his study of sequencing in comic books and strips. "The artist not only depicts something, but expresses at the same time a visual interpretation of the world, with every drawing style implying an ontology of the representable or visualizable" (2011, 16). In broad strokes, the style of illustration can change the story. Cute, childlike superheroes evoke a playful innocence and sense of safe adventure; grotesque, misshapen superheroes stir up a sense of dread and horror. Moreover, the prominence of the artwork means that readers have to deal with the effects that the illustrations can arouse. Audience members may interpret the graphic intention consciously or subconsciously in any number of ways depending on their (sub)cultural and personal experiences, but the art can never be bracketed off from the whole of the story. "The viewer is obliged to share this figurative view of the maker," Lefevre continues, "since he or she cannot look at the object in the picture from any other point of view" (2011, 16). In filmic terms, the comics reader is *sutured* into the ideological perspective presented through the art.

One of the reasons that comic book art has been slow to receive its due in critical studies is the lingering stigma of not really being Art (with a capital "A"), worthy of serious consideration alongside the works of master painters. Comics, especially comic books, are still disregarded as a silly form of commercialized entertainment for children. They are disposable cultural ephemera, filled with simplistic drawings, and not worthy of serious consideration. In *Comics versus Art* (2012), Beaty points out that "specific historical and social processes have led to the devaluation of comics as a cultural form" (6). Though comic strips and several "serious" independent graphic novels are occasionally valued for their artistic merit, superhero art is still pilloried as lowbrow, mass-produced, silly entertainment. As Beaty notes, the lowly status of comics, even superhero comic books, has improved significantly in the twenty-first century (a situation that will be revisited in more detail in the next chapter). However, Beaty does

caution that "in an increasingly postmodern world in which the distinction between high and low culture is often assumed to have been eroded, outmoded biases continue to persist in the shaping of how we understand culture broadly" (2012, 7). The taint from decades of derision has yet to wear off completely, especially for art that seemingly features nothing more than muscle-bound men slugging it out while wearing their tighty-whities on the outside of their flamboyant costumes. But the fact that comic book art has been beneath serious consideration has allowed it to flourish into a uniquely varied aesthetic and narrative form.

Comic book art is commercially driven and has the potential to reveal more about cultural values and beliefs than more "serious" art, precisely because the goal of superhero art is to attract as many buyers as possible. The broadly derisive attitude toward comic book superhero artwork is best approached in the same manner that Carol Clover famously approached low-budget, trashy slasher films. Rather than dismissing slasher horror movies as artless and beneath serious consideration, Clover argued "that the qualities that locate the slasher film outside the usual aesthetic system . . . are the very qualities that make it such a transparent source for (sub) cultural attitudes toward sex and gender in particular" (1992, 22). Clover's point is that the lack of artistic merit means there is no misleading cover plot, no auteurist styles or themes, no metaphorical aspirations; just a "startlingly direct" presentation of what appeals to a particular audience. Superhero comics, and the artwork so crucial to the form, can be similarly transparent. Like the standard larger-than-life superhero adventure, the artwork is rarely subtle. Yes, as we will address throughout this book, superhero illustrations are often incredibly beautiful and nuanced works of art; but even when they are not, the art is still an important factor for understanding how cultural beliefs and attitudes are formed and perpetuated.

In addition to the perception of superhero illustrations as inherently lowbrow or immature art as an impediment to serious consideration, there is the dilemma of individual tastes and perceptions. Art, like beauty (or pornography), is in the eye of the beholder. How people perceive art, how they interpret and react to it, how they are affected by it, are all *predominantly* subjective responses. Not *entirely* subjective, because we do share cultural standards and have learned that some visual markers are supposed to be seen as beautiful and others as grotesque. It is this shared cultural knowledge about what different artistic styles are meant to convey that I will address in relation to the affective component of various aesthetic representations of superheroes. What I am not concerned about is a subjective interpretation about the artistic merits of some comic book art in contrast to others. Contrary to the opinions vehemently expressed by fans and/or

trolls on the Internet (or gallery critics), there is no value to declaring the work of one artist as good and another's as bad. One person's Rembrandt is another's de Kooning, and vice versa. Or in comic book terms, one fan's Alex Ross is another's Rob Liefeld, and vice versa. Moreover, declarations of artistic merit by fans, critics, trolls, curators, or peers are irrelevant in a commercial medium. As an industry, comics publishers care about sales as the ultimate arbitrator of what is "good art." The popularity of an artist's work, his style's ability to sell comics, is the industrial standard for successful art. Online forums may gripe about Greg Land as a fraud or a hack who obviously traces characters straight from magazine photographs, but publishers do not care so long as books featuring his art sell in large numbers. If a Greg Land title sells a million copies, then his art is "good." The highly competitive comic book market means that a book's art needs to attract an audience and an artist needs to have appeal in order to keep getting work. The standard of successful superhero art is determined by the market rather than by critics.

Full disclosure: I am not an art historian nor an art critic, and I am not concerned about the value of comic book art as Art (again, with a capital "A"). But I do think comic book illustration is as valuable and accomplished an artistic form as any other. I am an anthropologist, and my goal in this project is to uncover how the different artistic styles reveal cultural beliefs regarding the correlation between aesthetics and dominant perceptions. How, for example, illustrations of a perfectly proportioned and handsome Superman reinforce an unquestioned acceptance of moral virtue as linked to physical beauty. Or how some illustrations invoke a romanticized nostalgia for an idyllic American past, magically free from the messy realities of politics and racial inequalities. Superheroes are a complex semiotic system that expresses social and personal values. Moreover, the comic book is a cultural artifact whose discursive meanings are as varied as the aesthetic practices employed to convey and reflect specific effects. The art becomes a language both in itself and in support of the larger symbolic importance of the superhero.

Variety Show

Henry Jenkins's influential concept of "multiplicity" as an inherent feature of modern comics outlines how flexible the superhero can be. Narratively, the superhero comic book is capable of simultaneously sustaining a single character across multiple ongoing storylines, in different settings or at different stages of their career. As Jenkins notes, these variations of a core character are easily reconciled by readers familiar with the diverse world of comic book superheroes:

> Today, comics have entered a period where principles of multiplicity are felt at least as powerfully as those of continuity. Under this new system, readers may consume multiple versions of the same franchise, each with different conceptions of the character, different understandings of the relationships with the secondary figures, different moral perspectives, exploring different moments in their lives, and so forth. So that in some storylines, Aunt May knows Spiderman's secret identity while in others she doesn't; in some Peter Parker is still a teen and in others he is an adult science teacher; in some he is married to Mary Jane and in others they have broken up, and so forth. These different versions may be organized around their respective authors or demarked through other designations—Marvel's Ultimate or DC's All-Star lines. (Jenkins 2009, 20–21)

Though Jenkins's focus is primarily on narrative contexts and points out that the variations "may be organized around their respective authors," we can also consider different artistic styles as a component of multiplicity. In fact, the ever-changing appearance of superheroes from artist to artist can be understood as a fluid baseline for multiplicity.

Even within a stable storyline, artists often change from issue to issue. Thus, Spider-Man may remain a twenty-something married high school teacher, but his appearance might shift from a classically muscular build, to a rail-thin hero whose limbs defy biology when he swings into action, to looking like a figure from Japanese manga. This visual multiplicity is routine in comics and often goes unquestioned, but even a subtle aesthetic shift can contribute to a change in meanings and perspectives. A good deal of the artistic variations in comic book styles over the years can be attributed to staffing changes and each subsequent artist's individual style. But, even when it is unintentional, the change of a hero's appearance often invokes a change in their character. For example, R. J. Gregov argues that when John Romita Sr. replaced Steve Ditko as the illustrator of *Amazing Spider-Man* in 1966, the change in Spider-Man's appearance implied a different tone to his heroism. "Ditko's Spider-Man was lean with very little tone on his body. The face of Spider-Man's alter ego, Peter Parker, was unattractive and stiff," Gregov observes, but when "John Romita Sr. took over the book, Spider-Man filled out with muscles bulging under his costume. Peter Parker became a handsome young man with an attractive, round face" (2008, 471). As Gregov points out, both artists' work are official and classic portraits of Spider-Man, but they stress different attributes: "Ditko's Spider-Man emphasizes the ordinariness of the alter ego, Peter Parker, while Romita Sr.'s character focuses on the strong, heroic person that Spider-Man was" (2008, 471). Certainly, the modern comic book Spider-Man looks very different than either the Ditko or the Romita version.

The incredible range of artistic styles used in modern superhero comic books is apparent with even the most cursory glance at retail shelves stocked with new releases. The perfectly built Superman is posed heroically by artist Patrick Gleason on the cover of *Action Comics*, next to an Amanda Conner cover for *Harley Quinn* in a voluptuous (but cute) pinup pose, alongside a muted, shadowy, and noirish version of *Daredevil* illustrated by Alex Maleev, which is beside a realistic Caped Crusader on the cover of *Detective Comics* depicted by Francesco Mattina, as well as a number of cartoonish, manga-looking *X-Men* books featuring the art of Humberto Ramos or Chris Bachalo. The breadth of different styles is highlighted in several comic book series that feature short stories of a single character by different writers and artists. The enormously popular anthology series *Batman: Black and White* (1996, 2013–2014, 2020–ongoing) has featured "some of the finest talents in comics," according to the promotional material on the back cover of every issue. *Batman: Black and White* inspired other showcases for creators, including *Harley Quinn: Black + White + Red* (2020–ongoing), *Wolverine: Black, White & Blood* (2020–ongoing), *Wonder Woman: Black & Gold* (2021–ongoing), and *Superman: Red & Blue* (2021–ongoing). Each of these series showcases the artistic talents of creators by presenting the art as basically unadorned sketches, basic black ink drawings with only a little red or blue added for effect in the Harley Quinn, Wolverine, and Superman books. The juxtaposition of the different styles within a single book can emphasize how the look of a character can change the reader's impression. For example, in the anthology series *Sensation Comics Featuring Wonder Woman* (2014–2016), within the span of just a few pages the Amazon Princess may be drawn as young and cartoonish by Irene Koh, realistic but still hypersexualized by Jason Badower, or unconventionally dreary by Scott Hampton. A single iconic character can be transformed under the pen and brush of different artists into a figure with drastically divergent tones. Koh's Wonder Woman implies innocence and openness, a heroine perfect for younger readers and a fun adventure. Badower's Wonder Woman looks more mature and suggestively lifelike, a sexy fantasy figure come to life. And Hampton's Wonder Woman implies a grimmer character devoid of glamour, a figure suited for a darker and uglier storyline.

Anthology comics that feature some wildly divergent renderings of specific superheroes in different short stories side by side in a single issue suggest how the artistic styles can create a range of narrative affects. At times, comic books will utilize different artists and different artistic styles within a single story to reinforce a particular narrative theme, a shift in tone, or a change in character perspective. In "Purple Haze," which ran through *Alias* #22–28 (2003), Jessica Jones, an ex-superheroine turned hard-drinking and foul-mouthed private investigator, recounts how she had been abducted and controlled against her will by the villain Kilgrave,

also known as the Purple Man. As a "Mature Readers" series, *Alias* had a distinctly Noir tone (a style discussed in chapter 8) conveyed by Michael Gaydos's dark and gloomy illustrations, colored by Matt Hollingsworth, that depicted Jessica as an angry low-rent detective with a usually disheveled appearance. Dark shadows, muddy colors, and blunt character features reflected Jessica's view of the world as a dangerous place as well as her self-destructive nature and hard-boiled attitude. When Jessica tells her boyfriend Luke Cage about the abuse she suffered early in her career, the flashback scenes are rendered by a different artist, Mark Bagley, in his signature superhero style with bright colors and cartoony characters (a cross between the style of Idealism discussed in chapter 3 and the Retro style considered in chapter 4). Concerned with the working-class ambiance of the series, Terrence R. Wandtke describes contrasting illustrations in this issue as "an artistic style that departs from *Alias*'s bleak realism with images colorful, sleek, and in line with a style typical in 1990s superhero comics" (2018, 237). This shift in style reflects Jessica's young and naïve days as an innocent superhero, in contrast to the somber mood of her post-superhero life. Moreover, Bagley's more cartoonish style actually helps to emphasize just how vile Kilgrave's actions were as he controls the young Jessica and orders her to take off her clothes and commit violent crimes for him. The overall affect implies the dark potential that lies beneath even the most lighthearted depiction of superheroes.

The Importance of Style

What I suggest in the following chapters is a rough typography of different artistic styles used in modern superhero comics, how each style influences the tone of the story, the characterization of the heroes, and the intended affect the style evokes for readers. In particular, the discussion will center on how the different styles and different artists depict the focal point of the genre: the superhero's body. This body has gone through numerous changes since 1938 when Superman established an archetypal figure that all subsequent characters would be variations of. After discussing the evolution of the superheroic figure and the general derision commonly directed at comic book illustrations in the next chapter, I will shift the focus to six of the most dominant art styles, each with their own chapter. The bulk of this book concentrates on six distinct styles of superhero art—Idealism, Realism, Retro, Cute, Grotesque, and Noir. Other stylistic categories not addressed individually here might include the likes of caricature, abstraction, or impressionism. Moreover, while some of the illustration techniques used by comic book artists will be touched on for the ways they align with specific styles (e.g., bold lines for Cute, cross-hatching for Idealism), I

will not explicitly address distinctions that could be implied between techniques like watercolor or oil paintings, collage, pastels, photocopying, or airbrushing. Likewise, I will not focus on every stage of the comic art process. Certainly, inkers and colorists play a major role in bringing the original sketches to completion, and their work can help shape the look and feel of a drawing. I do not mean to discredit inkers and colorists, but I am focusing on the art in broad terms and thus will use the original penciller as the identified artist.

The next chapter, "The Superhero and the Dessinateur," outlines the development of superhero illustrations from the late 1930s through to the current era. It addresses industry-specific developments that affected the content and the appearance of comic books, including the institution of the self-censoring Comics Code as a result of a McCarthy-era moral panic about comics in the 1950s, the legal conflicts over creator's rights, and the rise of independent publishers in the 1990s. Of particular importance is the rise of identifiable comic book styles that developed out of earlier artforms and shaped the dominant look, and dominant perception, of superhero art. The stigmatization of comic book art as simplistic and formulaic has hindered the appreciation of the skills and accomplishments of individual artists and the incredible diversity of illustrations within the medium. It was the rise of organized comics fandom in the 1960s and 1970s that recognized and celebrated individual creators. This movement to valorize specific creators resulted in a greater promotion of some artists by publishers, and an increase in the artists' recognition and clout within the industry. This celebration of artists as the defining creative force behind many of the most popular comic books elevated the status of illustrators from journeyman draftsmen to legitimate *dessinateurs*. Even beyond the strict confines of comic book fandom, modern pencillers are now treated as established artists, with collectors fervently pursuing valuable original drawings, glossy coffee-table collections of their work, high-quality anthologies of the comics they have illustrated, and museum and gallery exhibitions of certain accomplished artists. This newfound glorification of the superhero artist as a *dessinateur*, as a creative source on par with the concept of an auteur, opens up the realm of comic book art styles for consideration as the most complex and dynamic part of the medium.

Chapter 3, "Idealism and Comic Book Heroes," moves into the specific categories of contemporary superhero illustration and considers the dominant and most stereotypical style used in comics. Idealism is the style that most critics assume represents the artwork in all superhero comic books. These are the handsome, muscle-bound men and the beautiful and busty women, all uniformly dressed in tights. Idealism personifies the gendered extremes of hegemonic masculinity and hypersexualized femininity. This style also reinforces a belief that morality and physical beauty are innately

intertwined. The bodies at the center of Idealism are the modern equivalent of the classic nudes found in fine art. Just as Da Vinci, Polykleitos, and Plato defined the human form according to a mathematical ideal, the superhero is defined by exaggerated measurements and symmetry. The ideological implications of Idealism as the dominant style of comic book illustration, and how these ideologies are manifest around the hero's body, are addressed in relation to specific visual conventions. For example, Idealism reveals a standardization of male and female bodies all cut from the same cloth, with the exact same muscles, curves, jawlines, hair, and so on. The identically perfect male heroes invoke a sense of machine-like hardbodies, a militaristic fantasy of interchangeable bodies, each personifying a piece of patriarchal authority. Conversely, the standardized ideal female bodies evoke the traditional misogynistic dream of a sexual harem or the assembly line goddess; an endlessly repeated succession of beautiful and available women. Other visual conventions aligned with Idealism, including a range of posing techniques (active, passive, fetishistic), are also addressed as artistic habits that continue to explicitly normalize gender ideals as aesthetic ideals.

"Retro Art and Nostalgia," the fourth chapter, considers the relatively recent trend of Retro illustrations as a style that suggests an idyllic and imaginary past era of superhero comics. With clean, bold lines, bright colors, streamlined bodies, and smiling faces, the Retro style typically invokes the aura of a midcentury modernist aesthetic. Retro comic book art is the height of postmodern nostalgia. The art is pure simulacrum, designed to convey an appearance of historicity, a "feel" or "mood" from a past moment in time, without really being of that earlier moment. Retro art is not meant to look like comic book art actually looked in the 1940s, 1950s, or 1960s; the modern version is much cleaner and cartoonishly exaggerated to evoke nostalgia, not memories. Tim Sale and Darwyn Cooke are two of the artists most often described as Retro, though their illustrations look very different from each other's. Sale's work, with writer Jeph Loeb, revisits the earliest years of major characters (Superman, Batman, Daredevil, Spider-Man, etc.), mixing a perception of the character's initial innocence with a feeling of melancholy. Sale's darker artwork reframes the hero's past as one of tragic loss. In contrast, Cooke's artwork is brighter and more optimistic, recapturing a sense of hope and fun that has diminished in modern comics. In particular, Cooke's work on *DC: The New Frontier* (2004) exemplifies Retro as a rewriting of the past by the ideals of today. The art deco style of Cooke's drawing brings together the entire midcentury DC Universe as clean-cut Joes and cute women in cocktail dresses. This is Kennedy's America, a smiling party before the nation lost its way. Cooke's superheroes (he also wrote *New Frontier*) unite to save America and to restore a belief in its ability to overcome any obstacles.

In chapter 5 the issue of realistic artwork is considered for how it grounds the fantastic elements of the superhero formula with a sense of real-life possibility. Ever since Alex Ross demonstrated in 1994 how powerful Realism in comics can be with his landmark illustrations for *Marvels* (written by Kurt Busiek), Realism has become an increasingly prominent style. Ross and the many Realist artists who followed him depict superheroes with an incredible skill that captures what these larger-than-life costumed characters might look like if real. These near photo-realistic illustrations are often valorized as "true" art because they are at the opposite end of the spectrum from the traditional cartoonish drawings found in most comic books. In addition to elevating the status of comic art, Realism can change the effect of superhero stories by depicting them as real people, and thus potentially with real problems and real vulnerabilities. Realism can add a tone of gravitas to the stories. At their most extensive, Realist comic books can resemble a type of photographic journalism; a documentation of reality rather than fiction, a real moment in time captured by the artist. Realism compounds some of the complicated themes that consistently run through comic books, such as the absurd physical perfection of male and female bodies. In Realism bodies may look more authentic, but that does not always mean more possible. Instead, realistic-looking bodies may still have impossibly larger arms and ripped abs, giving the impression that these physical extremes can commonly exist. The precarious balance between fantastical characters and realistic depictions can, at times, be a problem for readers' sense of identification. The superheroes may look too real, too much like an actual person, rather than a cartoonish concept of a superhero. Moreover, the real/not real status of the characters in this style can invoke a sense of unease, a recognition of the Uncanny Valley, that gap between humanity and the mere simulation of it.

The anachronistic Cute style of superheroes is discussed in the sixth chapter. In the late 1990s, Japanese manga emerged as a distinct aesthetic style exported to the West just as the American comic book industry was facing a huge decline in sales. Manga (and its close relative anime) were particularly popular with women and younger readers, two markets that American publishers were eager to cultivate. The heavily stylized black-and-white illustrations in manga were novel for the simpler lines, cartoonish exaggerations, and asexual-appearing figures. Manga became a major influence on a number of emerging artists working within mainstream superhero comics, including Humberto Ramos, Chris Bachalo, and Jonboy Meyers. Reflecting the influence of a manga style, the Japanese concept of *kawaii*, a sense of cuteness, youth, and vulnerability, infiltrated American superhero comics. Rather than just a cross-cultural adoption of different aesthetic norms, cuteness as a form of superhero illustration promotes an alternative affect that can be associated with the genre. Moreover,

the manga-influenced Cute style is taken to an extreme with *chibi*, illustrations that reimagine all the characters as stubby little toddlers. The infantilization of superheroes is anathema to the common assumption that the genre enacts a masculine fantasy of infallible strength. Instead, the cute toddler version of superheroes explicitly focuses on ideals of childish and playful interactions, and conveys a sense of vulnerability under the capes and masks. This cuter take on superheroes creates a very different affect among readers than most styles of comic book illustration do, invoking a sense of ownership, propriety, and a protective impulse.

Fundamentally different from the Cute style is the Grotesque style analyzed in chapter 7. Grotesque superheroes follow the larger tradition of the grotesque figure in both art and culture as a gruesome critique of aesthetic and moral standards. There is an important distinction between the comic book tradition of illustrating some characters as grotesque as a sign of their evil nature and the overall style of Grotesque art that depicts all characters as misshapen and twisted. Grotesque characters like the Penguin and the Red Skull appear as anomalies in other artistic styles; likewise some superficially grotesque heroes, such as The Thing and the Hulk, are marked as hideous in most comic books. Conversely, the Grotesque style of illustration renders everyone, heroes and villains alike, as deformed. Given the superhero genre's obsession with perfect and beautiful characters as physical (and moral) ideals, Grotesque illustrations mark a profound departure from the norm. As with broader cultural aesthetics and ideologies, the Grotesque superhero is defined in contrast to the Ideal superhero. The Ideal is clean, balanced, well-proportioned, and self-contained; the Grotesque is overwrought, asymmetrical, too exaggerated, and uncontained. When even the heroes are depicted as grotesques, the art blurs the line between important cultural boundaries, including between heroes and monsters, civilized and savage, normal and abnormal. Within a Grotesque style the typical superhero story becomes something else entirely: a potentially horrific and unsettling tale where the moral distinctions between good and evil become questionable.

The final chapter, "Superhero Noir," focuses on the illustration of superheroes directly inspired by the aesthetics and the ideology of hard-boiled detectives and classic Film Noir. The earliest superhero comic books were indebted to the pulp magazines that preceded them. The lurid content of the Pulps helped establish narrative formulas for comics, and the enticing art featured on the covers contributed to the look of comic book illustrations. Crime fiction in particular found its way into superhero comic books and has become associated with modern street-level investigative characters like Batman, Daredevil, The Question, Luke Cage, Jessica Jones, and Moon Knight. At its most superficial, Noir visual clichés (seedy offices, window blinds, chiaroscuro shadows, languid cigarette smoke, neon signs,

etc.) are merely invoked as a reference to classic Noir settings. But at its most affective, comic book artists expand the visual possibilities of Noir by maintaining the importance of an existential tone while adapting it to the world of current superheroes. This chapter focuses on the framing of Noir aesthetics as either retroactive tales that reimagine superheroes as essentially hard-boiled detectives in the 1930s and 1940s, or as modern-day tragic heroes fighting in the shadows of oppressive and corrupt cities. It is these super Neo Noirs that explore new techniques inspired by the themes of classic Noir (shadows, close-ups, extreme contrasts) to update the aesthetics but maintain the futile mood of the narrative. Ultimately, by combining the aura of Noir with superheroes, this art style suggests the impossibility of the hero's Sisyphean attempts to protect the innocent, uphold the law, and maintain the status quo.

In categorizing artistic styles, I do not mean to suggest that illustrators can only draw in one particular style. Many artists working in comics today can be very diverse; drawing cute superheroes in a title meant for young children, and depicting grim and grotesque heroes in a 'Mature Readers Only' series. But most comic book artists have a signature style, an individual look to their work that is associated with certain narrative themes and is easily recognized by fans. Though comic book art has been derided as simple, formulaic, immature, and indistinguishable by the general public, comic book readers are well aware of how distinctive each artist is. The top illustrators have become stars, able to sell a series on the strength of their artwork alone, or to increase the sales of an individual book simply by contributing a variant cover. It has become common practice in comic publishing to tout certain artists as an effective marketing strategy. Thus, there are commercial and financial incentives for artists to maintain a consistent look. And, in turn, the artist's identifiable illustrations become associated with a specific style of illustration. Of course, what exactly that style is may be subject to debate. One reader's Cute is another's Grotesque. But the very act of thinking of one style as qualitatively and aesthetically different from another can help Comics Studies begin to account for the artistic side of the medium.

Still, in every artistic medium there are certain artists whose work transcends the established rules and conventions. Often these artists will spearhead new styles and a new conceptual framework that challenges audiences to see the world in a different way. For example, Salvador Dali, Marcel Duchamp, Jackson Pollock, Mark Rothko, Cindy Sherman, and Louise Bourgeois all created new aesthetic styles that greatly changed our understanding of art. Some become so popular and influential that they are recognized as a style unto themselves, or the categories have to adapt to account for them. Some of the most interesting modern artists whose work appears in mainstream superhero comic books likewise resist easy

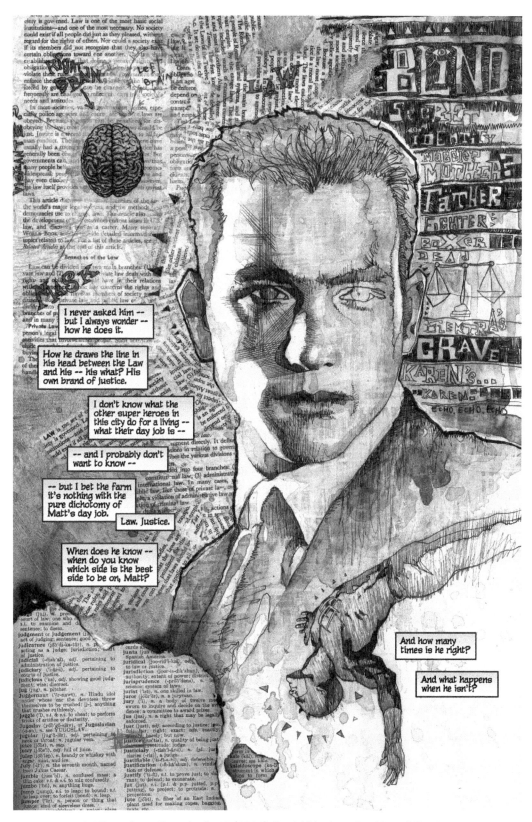

1.4 Page from *Daredevil* #17 (2001), David Mack, artist, Marvel Comics.

classification. The artwork of creators like Frank Miller, Bill Sienkiewicz, and J. H. Williams III have long pushed the boundaries of aesthetics and comic book conventions. Likewise, newcomers finding their way into mainstream comics from other fields, artists like Diego Latorre, Tula Lotay, and Frazer Irving, are redefining what comic books can look like. Some artists are, for all intents and purposes, uncategorizable. A prolific artist like David Mack, for example, defies easy categorization. Mack has illustrated independent and alternative comics as well as mainstream literary and superhero stories. Despite working within established genres, Mack's art is always unique. His use of collage and mixed media to craft even a superhero story is provocative, controversial, and pushes against decades of artistic convention (Figure 1.4). In his fascinating discussion of genre and aesthetic boundaries in comics, Henry Jenkins contrasts several artists' work on Marvel's series *Daredevil*, arguing: "The use of bold primary colors and a more realist style in Quesada's version pulls him closer to mainstream expectations, whereas Mack's more variegated hues and collage-like aesthetic stretches our sense of what a superhero comic looks like" (2017, 71). Where Joe Quesada draws in what I would classify as the style of Idealism, David Mack is something *else*. But that something is difficult to define—"variegated," "collage-like"—yes, but it is also something more than this. In a mainstream superhero book, Mack's work is jarring and unsettling, confusing and progressive. In his contrast of Quesada and Mack, Jenkins goes on to note, "The subject matter is more or less the same, but the mode of representation is radically different" (2017, 71). In fact, as Jenkins demonstrates (and as I hope this book documents), the subject matter is actually transformed by the different mode of representation.

2 | THE SUPERHERO AND THE DESSINATEUR

Since the late 1930s the superhero has been a protean symbol of the shifting American zeitgeist. In fact, the ability to adapt the superhero to different time periods and changing social and political norms is one of the main reasons the genre has proved so fruitful for historians and cultural critics. During World War II the superhero was an avatar of patriotism, with the likes of Captain America socking it to Adolf Hitler, while others promoted war bonds and ferreted out spies on the home front (Dittmer 2012). In the 1950s, superheroes embodied a conservative belief in cultural conformity, American exceptionalism, and an emerging sense of Cold War politics (Wright 2001). During the tumultuous civil rights era, superheroes began to explore themes of discrimination, and more ethnically diverse heroes were introduced (Fawaz 2016). And in the Reagan years, superheroes became hardcore vigilantes, reflecting the rhetoric of toughening up America coming from the White House (Coogan 2006). Moreover, the superhero has adapted to developments and challenges specific to the comic book publishing industry. Following the Joseph McCarthy-like campaign in the early 1950s in which comics were accused of turning readers into juvenile delinquents, superheroes became bland do-gooders following a very restrictive Comics Code of morality (Nyberg 1998). The shift to a system of direct distribution and the rise of fan culture in the late 1970s and early 1980s resulted in a revisionist wave of stories that reimagined the history of superheroes (Pustz 1999). And the current corporate convergences of the parent companies of both DC Comics and Marvel, coupled with the financial importance of movies, games, and merchandising, has repositioned the superhero as a central figure in a multimedia commercial market (Gilmore and Stork 2014). All of these, and

dozens of other significant cultural and industrial changes, are reflected in the genre's prominent themes, specific storylines, and character alterations. These changes have all been explored from a variety of theoretical approaches in a rapidly increasing corpus of Comics Studies scholarship. Intertwined with all the changes endured and reflected by the figure of the superhero are artistic changes to the look and tone of the characters.

While the following chapters will delve into a range of artistic styles utilized in modern comic books, the goal of this chapter is to provide a historical context that addresses both the industrial and the cultural factors unique to the world of superhero comic books that have diminished the artistic status of the illustrations. While this chapter deals with a number of historical conditions and artistic developments, it is not a history of comic books as a medium or superheroes as a genre. Several excellent histories of the industry have documented the origins and early years of the medium, often with a focus on individual creators and publishers as the driving force behind the comics. In addition to dozens of coffee-table books about the history of comics, there are a number of works that provide a perspective on the industry full of critical depth, historical details, and humanizing anecdotes. Works like Bradford W. Wright's *Comic Book Nation* (2001), Gerard Jones's *Men of Tomorrow* (2004), Sean Howe's *Marvel Comics: The Untold Story* (2013), Reed Tucker's *Slugfest* (2017), and Mark Cotta Vaz's *Empire of the Superheroes* (2021) all offer a rich portrait of the industry from its inception in the early twentieth century up through modern times. Though I do draw on these histories, I do not want to merely repeat them here. Instead, this chapter is concerned with the industrial and cultural conditions that have devalued mainstream comic book art and artists, and the inherent bias and tension between artistic merit and commerce, between individual illustrators and publishing conglomerates, and in relation to presumptions of artistic merit, narrative purpose, authorship, and quality. Moreover, this chapter will also broach the way that comic book fandom has elevated artists to *dessinateurs* in a manner that reproduces high cultural logic, and how the publishing industry and artistic institutions have embraced a modern recognition of illustrators as accomplished artists. The general derision of comic books and comic book art has steadily declined in the twenty-first century with the rise of Comics Studies, gallery and museum recognition of popular comics artists, and the broad increase in public interest in superheroes spurred by the dominance of Hollywood adaptations.

Applying Erving Goffman's (1963) social theory of personality attributes and demeaning stereotypes to marginalized forms of popular culture, Paul Lopes notes: "Comic books have been stigmatized since their introduction in the mid-1930s, and this stigma has affected comic books as well as artists, readers, and fans of comics" (2006, 388). Lopes is careful

to point out that stigmatization is different than "low status," but that the two do "overlap in terms of cultural forms and practitioners" (388). In differentiating them, Lopes argues, "stigma, unlike low status, makes an individual or cultural form *problematic*. While low status certainly has negative social effects, stigma leads to the discrediting of an individual or cultural form in a global sense" (388, italics in original). This distinction is important to keep in mind when considering the way comic book art has historically been devalued. While the lowly status of comic books in Western culture, particularly *superhero* comic books, has framed the merits of the medium as beneath appreciation, the stigmatization of the art form has meant that it has rarely even achieved serious consideration. In other words, superhero art and the superhero artist have been marked (a stigmata), or tainted, by both the genre and the medium, as lacking any inherent value or merit. This stigmatization has dominated the public perception of comic book art throughout most of its history. Like the comics themselves, the art has historically been derided as childish, simple, commercial, reproducible, and disposable. "The history of comics *as* art," notes David Ball, "might justifiably be regarded as a short and undistinguished one" (2020, 94). The cultural context that has resulted in superhero comic book art being relatively ignored and dismissed for nearly a century needs to be addressed before moving on to specific artistic modes currently used in comics, because all the different styles in modern books still circulate in a climate of disregard, and they challenge lingering perceptions of comic illustrations as not really *art*.

As a reminder, my focus throughout this book is the illustration of comic book figures as they appear within the superhero genre. No other medium is as thoroughly dominated by a single genre as the comic book is with superheroes. Television is not synonymous with situation comedies, movies are not all assumed to be horror, nor all music rap. Of course, comic books are not just for superheroes. But the undeniable association of the illustrated medium with a fantasy of muscle-bound men with impossible powers is a double whammy (in comic terms): both the stories and the art are presumed to be immature, and each is believed to be devalued in association with the other. The alignment of comic *books* with the dominant superhero genre differentiates them from the less-maligned comic *strip*. The popularity of newspaper comic strips resulted in the first comic book, *Famous Funnies*, published in 1933 as a magazine format reprinting of syndicated comic strips. But the shorter-form comic strip has generally been held in higher regard as an art form, often benefiting from a single author/artist, thus implying a purer form of artistic expression. On the one hand, the subject matter of early comic strips may have been humorous or fantastical, but there was an acknowledgment of the creativity inherent to strips like Richard Outcault's *Yellow Kid*, Winsor McCay's *Little Nemo in Slumberland*,

Frank King's *Gasoline Alley*, and George McManus's *Bringing Up Father*. Superheroes and comic books, on the other hand, have been regarded as a bastardization of the arts: not really literature, not really art, not really social commentary, nor morally redeeming. Given the sheer number of superheroes that populate the comic book world, it would be impossible to address all the variations of artistic status over the years. Instead, this chapter will address generalities, but will also attempt to narrow the discussion of different ways comic book art has been devalued by focusing primarily on the figure of Superman, the archetype for the entire genre.

To date, Bart Beaty's insightful book *Comics versus Art* (2012) is the most comprehensive analysis of the various cultural logics that have impoverished comic illustration and excluded it from serious consideration as an art form. Beaty's work addresses the status divide between traditional forms of "high" art and comics in general, including newspaper strips, caricature, alternative comix, Sunday funnies, and comic books of every genre. Beaty does deal critically with superhero comic books and artists, but his focus is on the broad hierarchical disparities rather than the specific denigration of superhero illustration. Beaty's work is crucial for any discussion of how comic art is perceived and interpreted and "the specific historical and social processes that have led to the devaluation of comics as a cultural form," and addresses "the recent rise to art world prominence of (certain kinds of) comics" (7, brackets in original). Ultimately, Beaty observes that, despite the shifting values attributed to commercial art forms, even "in an increasingly postmodern world in which the distinction between high and low culture is often assumed to have eroded, outmoded biases continue to persist in the shaping of how we understand culture broadly" (7). These "outmoded biases" are particularly acute when it comes to superhero comics. In particular, the artistic side of the superhero comic is persistently treated as without skill, value, or merit. The world of comic book illustration has changed a great deal over the last century, but the presumption that superhero art is nothing more than poorly drawn images of muscular men slugging it out remains.

Devaluing Comic Book Art and Artist

Taking superhero illustration seriously as an artform is thorny for a number of reasons. The difficulty of addressing the art without losing sight of the narrative or, conversely, letting the comic story dominate the art is a challenge. The two sides of comic books as a medium are essentially inseparable, but the art can be understood as a significant (perhaps the *most* significant) part of the superhero's influence. In and of itself, comic book art is not necessarily a complete story that can be studied as directly for its

narrative properties, in the way that a novel or a film can be. On the other hand, the sequential nature of comic book illustrations removes them from the typical dynamics of aesthetic analysis often used with more traditional two-dimensional artforms. As Andrei Molotiu argues in his analysis of original comic art, "traditional drawing experts have shied away from art that is often seen not as an end in itself but as a tool in the creative process, the end of which is the printed comic. Of course, the lowly status of 'popular' culture has also played a large role in this neglect" (2007, 24). The intertwined principles of comic book art as part of a medium-specific *narrative* device and the commercial aspects of the comics publishing *industry* as a provider of serial entertainment have equally contributed to the undervaluing of superhero art. Specifically, what I want to review here are five of the most critical assumptions that have served to devalue superhero illustration as an art form, all of which can be traced to the earliest years of the superhero as a popular media figure: 1) that all superheroes look the same; 2) that the illustration is always and only in support of the written word; 3) that the artwork, like the genre, is childish and immature; 4) that it is driven by commercialism rather than artistic expression; and 5) that the pressure to produce illustrations for strict deadlines limits the quality of the artwork.

In June 1938, National Allied Publications (which would later become DC Comics) released *Action Comics* #1 with a striking cover image of a muscular man in tights lifting a car over his head while several criminals flee in terror. This first appearance of Superman was an unqualified success, selling over one million copies a month by his third appearance (even though America was still struggling to emerge from the Great Depression). Famously created by two teenagers from Cleveland, writer Jerry Siegel and artist Joe Shuster, Superman established many of the narrative and visual conventions that still dominate the genre nearly one hundred years later. Superman is the definitive origin point for the genre and crystallized a number of themes developed in other media forms. Siegel, like many other early comic book writers, was heavily influenced by adventure stories from literature, radio, the pulps, comic strips, and movies. In particular, characters like Zorro, the Scarlet Pimpernel, the Shadow, Doc Savage, Buck Rogers, Dick Tracy, and the Phantom inspired features like the superhero's secret identity, his colorful costume, his exceptional abilities, and his defense of the less fortunate against the actions of bizarre villains.

All these narrative themes coalesced in the figure of Superman and established the superhero as a genre that catered to an overarching fantasy of empowerment for young, (primarily) male readers. As Richard Harrison has summarized, from its very inception, the core appeal of the genre is that "These are stories built around the idea that what we are in our ordinary lives isn't all that we are. Simply by existing, the superhero says, 'If

2.1 Superman from *Action Comics* #1 (1938), Joe Shuster, artist, DC Comics.

only you knew who I really was, you would see me as greater than you ever thought'" (2020, 344). First established by Superman, and then confirmed by nearly every caped crusader who followed him, the superhero presents a dream of ideal masculinity. The superhero is incredibly powerful, morally superior, handsome, can defeat all enemies, is admired by the masses, and is swooned over by beautiful women. Moreover, the narrative feint of the mild-mannered secret identity allows readers in on the ruse, allows them to imagine they too have a super-male persona lurking just below the surface. The heroic adventures played out through the story of the superhero consolidated all the desirable masculine traits of Tarzan, Flash Gordon, Hercules, Zorro, et al. into a solitary, formulaic figure. Starting with Superman, the superhero is a dream of hypermasculinity that still remains the core of the genre nearly a century later.

Just as Jerry Siegel's writing was shaped by the themes and the prose stylings of pulp adventures to craft a hypermasculine fantasy, Joe Shuster's artwork was inspired by a number of comic strip artists whose work was syndicated in national newspapers during the 1930s and provided a visual template for the illustration of ideal masculinity. Popular adventure strips like Milton Caniff's *Terry and the Pirates* and Alex Raymond's *Flash Gordon* depicted handsome square-jawed heroes with broad shoulders, as well as svelte girlfriends and/or slinky femme fatales, and caricatured or orientalized villains. The illustrations of artists like Caniff and Raymond provided a model for how heroic figures could be rendered in a two-dimensional medium reliant on crude mass printing presses and cheap paper. Their work also influenced the balance between a static image and the impression of action across panels that would become crucial to the success of Superman and all the caped heroes who would follow him. According to Gerard Jones's history of the medium's early years, Caniff and Raymond were extremely influential to the look of comic book superheroes. But Jones also singles out the legendary Harold (Hal) Foster as the most essential comic strip artist many young superhero illustrators would seek to emulate. "Joe Shuster was a member of a whole generation of young artists

shaped by the comics of the Thirties," Jones claims, "but there was one strip that he, and most of his peers, mentioned more than any other" (2004, 75). That strip was the serialized exploits of Edgar Rice Burroughs's famous character Tarzan as illustrated by Harold Foster. Foster was already a well-respected commercial artist in the advertising industry before turning to comic strips in 1929. Thanks to Foster's striking illustrations of the loin-clothed ape man, Tarzan became a huge success throughout the 1930s. Tarzan's muscular physique, depicted in near naked renderings, was an image of ideal masculinity put into action. Through Foster's inks, Tarzan seemed to effortlessly leap, swing, and fight in a way that defied physics but also appeared completely natural. According to Jones, "Harold Foster was a classical draftsman who understood that the real power of a story about an ape man lay not in its cliff-hangers or its jungle proscenia or its naturalistic beasts but in the beauty of the male human body" (75). Perhaps more than any other comic strip, Foster's work on Tarzan established a precedent for the muscular male body to become the focus of illustrations and the principal symbol of exceptional heroism.

2.2 *Flash Gordon* syndicated news strip (circa 1935), Alex Raymond, artist.

The debut of Superman in *Action Comics* #1 is routinely recognized by historians, critics, and fans for inaugurating the most common narrative elements of the genre. Richard Reynolds, for instance, claims that "much that would become central to the superhero genre is established in these 13 pages" (1992, 12). Likewise, Charles Hatfield argues the "landmark series fused the graphic energy of newspaper comic strips, the vigilante ethos of dime novel and pulp adventure heroes, and the pop futurism/utopianism of early pulp science fiction. Superman trumpeted a new formula" (2012, 112). But rarely has Joe Shuster's artwork for *Action Comics* #1 been acknowledged for establishing a standardized look for superhero comic books. The narrative conventions that came together with Superman were reinforced and brought to life by the distinctive illustrations provided by Shuster. His sparse, flat lines and blocky figures would become the model for superhero art throughout the Golden Era of comics, and would establish a muscular male ideal as a focal point that defines the genre and still dominates comic book illustration.

The explosion of superhero comic books that emerged immediately after Superman's unprecedented success were all illustrated by artists equally influenced by the adventure strips produced by Foster, Caniff, and Raymond. Hatfield notes that these adventure strip artists who influenced Joe Shuster, Bob Kane, Bill Everett, and others established a visual format that is still reflected in superhero illustrations today: "Caniff, Foster, Raymond, and later [Burne] Hogarth helped establish in comics an aesthetic of exoticism and pictorial lushness, at once enabled by and tensely counter-posed to a comparative realism." This aesthetic, Hatfield continued, "shaped and continues to shape the repertoire of comics, particularly mainstream comic books" (62). Moreover, all of the post-Superman comic books mimicked Shuster's consolidation of the adventure strip style into an economical and efficient form of illustration. Kane's Batman (1939), Carl Burgos's Human Torch (1939), Everett's Sub-Mariner (1939), Jack Kirby's Captain America (1940), C. C. Beck's Captain Marvel (1940), Mart Nodell's Green Lantern (1940), and dozens of other new superheroes were all depicted in a similar style of illustration. In short, all of the early superheroes were cut from the same artistic cloth. The cleanly blocked lines, simple faces, and muscular figures were quickly established as a visual convention that was equally important (if not more so) than narrative conventions like secret identities and eccentric villains.

Numerous characters that followed Superman hoped to replicate his success by copying both his story and his image. As Bradford W. Wright notes in his history of comics: "Superman had a strong residual impact on the industry, which expanded as new publishers entered the field and flooded the market with various imitations of him. Pulp magazine publishers and opportunistic entrepreneurs entered the comic book business looking for quick and easy profits with little financial outlay" (2001, 14). Within a few months of Superman's first appearance, rival publishers released their own take on the character. Victor Fox, an accountant for DC Comics who saw the profits generated by Superman, formed his own company and hired a young Will Eisner to create Wonder Man for *Wonder Comics* in May 1939. Wonder Man was almost identical to Superman in powers and appearance, except Wonder Man sported blond hair and a red costume. Similarly, *Prize Comics* introduced Power Nelson (aka Future Man), *Zip Comics* debuted Steel Sterling (dubbed the "Man of Steel"), and Fawcett Publishing released Master Man in *Master Comics*, all in 1940. Despite decent sales figures, Wonder Man, Power Nelson, Steel Sterling, and Master Man were all quickly forced out of the superhero business by DC Comics, which sued the publishers for plagiarism and copyright infringement. But Superman's primary rival during his early years was not as easily vanquished by corporate lawyers. *Whiz Comics*, also released by Fawcett Publications in 1940, written by Bill Parker and illustrated by

C. C. Beck, featured a boy named Billy Batson who is magically granted the ability to transform into the incredible Captain Marvel whenever he utters the phrase "Shazam." Captain Marvel was a very Superman-like hero whose popularity rivaled Superman, and even began to outsell National Periodical's (DC Comics) flagship character. National pursued litigation against Fawcett for Captain Marvel as well, but Fawcett was able to fight the accusation of copyright infringement until 1953, when the publisher either went bankrupt or settled out of court, depending on whose version of the story is being told.

According to court documents, much of the *National Comics Publications v. Fawcett Publications* copyright infringement case (or "Superman v. Captain Marvel," as fans dubbed it) focused on the visual similarities between the characters (see Helfand 1992). Superman's uniqueness as a costumed adventurer with superpowers was already dissipating by 1941 with the introduction of numerous other colorful superheroes. Many of these new heroes were published by National Allied Publications themselves (e.g., Batman, Flash, Green Lantern, Wonder Woman, Hawkman), thus weakening the company's argument for copyright exclusivity when it came to new superheroes. In other words, Superman's unique properties (the elements that initially reinforced the character's strong copyright) were shifting. Superman was now becoming an identifiable character "type" within a broader genre, rather than the only iteration of a specific figure. Thus, National Publications struggled to argue that any character in a bright body suit with remarkable powers and a secret identity was a direct threat to their production of Superman. Instead, National was forced into the difficult position of arguing that Captain Marvel looked so much like Superman that it was artistic plagiarism. Lawyers produced numerous examples of the characters in an effort to show that Superman and Captain Marvel were too similar in appearance (see Figure 2.3). According to legendary DC editor Jack Schiff, he had been tasked with "assembling a scrapbook that documented all the cases of plagiarism," and the most damaging evidence "was the testimony of two former Fawcett employees who had been ordered to copy *Superman*" (quoted in Duin and Richardson 1998, 279). Despite the evidence offered by National, there was an inherent difficulty in claiming artistic plagiarism because all superheroes looked alike. In fact, during the 1940s the relatively consistent style of superhero illustration across artists, characters, and publishers contributed to the presumption of a singular style of comic book art. This presumption is still shared by the general public today.

While the central purpose of this book is to explore the immense variety of artistic styles used in modern comic books and how those styles affect understandings of the superhero story, the singular style of superhero illustrations that existed at the birth of the genre has been intentionally

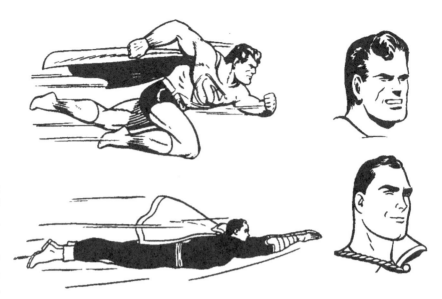

2.3 Court comparison of Joe Shuster's Superman and C. C. Beck's Captain Marvel, (1942).

and incidentally reproduced over the history of comics. The notion that "all superhero illustrations look the same" is a fundamental criticism of the medium and a major factor in the devaluing of comic art, and it is an accusation comics fans have railed against for decades. Still, though illustration styles have changed to reflect the aesthetics and the ideal body types of different eras, the industry has intentionally embraced signature "house styles" as a form of consistency and artistic branding. At DC Comics, for example, during the 1950s and 1960s superheroes were clean-cut, barrel-chested adventurers who were slowly granted more muscle definition than their 1940s counterparts. The similar illustration styles of legendary artists like Dick Sprang, Wayne Boring, Curt Swan, and Carmine Infantino provided a uniform depiction of heroic midcentury bodies. In the 1970s the heroes were illustrated as sleeker, leaner, more angular, and more defined through the signature styles of such artists as Neal Adams, Mike Grell, Jim Aparo, Dick Giordano, and Marshall Rogers. At its most extreme, various "house styles" have been officially sanctioned and regulated for both the comics and licensed products that utilized the characters. For instance, in the 1980s the *DC Comics Style Guide* provided to company artists and corporate licensees featured multiple character design sheets for every DC hero and supporting character, all illustrated by popular artist José Luis García-López. And in the 1990s and early 2000s the angularly art deco and vaguely nostalgic look created for *Batman: The Animated Series* by Bruce Timm became an identifiable DC brand across a number of animated television series and a broad range of DC comic books and merchandising. All of these signature or house styles reinforce the idea of superhero illustration as merely repetitive and formulaic. Not coincidentally, most

38 | SUPER BODIES

of these standardized types of illustration also emphasize the muscularity and exaggerations of an ideal body (an issue that will be addressed more directly in the following chapter).

The relatively two-dimensional artwork common to most early superhero comic books may seem quaint or simplistic by current standards, but it was an economical style born out of industrial necessity. As historian Robert C. Harvey notes: "Shuster's art, often called 'primitive,' was nonetheless entirely adequate to its task" (1996, 19). This might sound like faint praise, but the "task" of quickly grinding out illustrations on a tight weekly schedule meant that clarity was more important than details for Joe Shuster and his contemporaries. Bradford Wright summarized the production conditions of the 1940s comics industry as frantic and indigent:

> During these early years, the sheer novelty of comic books and costumed superheroes was sufficient to generate strong sales. Writers and artists had little motivation to get very sophisticated in their storytelling, and they had compelling reasons not to. They assumed, probably correctly, that a superhero's appeal to juvenile readers depended, most simply, on how interesting his costume and powers were. This market consideration, along with low pay, the absence of royalties, incessant deadlines, and an assembly line production process, meant that comic books became highly formulaic. Publishers valued comic book writers and artists more as producers than as creators. As one publisher reportedly liked to tell his staff, "Don't give me Rembrandt, give me production." (2001, 22)

In fact, the pressure to produce all of the interior art for four to eight Superman stories a month, plus multiple covers, forced Shuster to open his own small studio with a cadre of apprentice artists who would mimic his style. Shuster would remain the only artist credited in the books, but more often than not he was only drawing the faces; the assistants drew the rest. This studio model was adopted by several other early artists, including Bob Kane, Will Eisner, and Wally Wood. This practice established imitative artwork as an industry standard. Each assistant rushed to produce illustrations that looked like the signature artist's work, which already looked a lot like the work of others as an aesthetic for a new medium developed. The serial nature of the medium meant demanding deadlines for artists, which meant the art had to be relatively simple, interchangeable, and quick. Of artists in the early comic book years, Henry Jenkins argues: "Their renderings of the human figure become more intuitive than studied; such choices give the artwork immediacy and dynamism but also allow the artists to reproduce characters and settings more efficiently under industrial conditions" (2017, 78). What became recognized colloquially as a comic book

style (meaning bold, but formulaic and simplistic) was the result of industrial conditions more so than the skill of the artists or the capabilities of the medium.

The previous chapter touched on the presumption that the visual aspects of a comic book should always and exclusively serve the narrative. Instructional manuals for budding artists and critical studies of the medium both emphasize the importance of the artwork supporting the narrative. Recall the fundamental declaration from *The DC Comics Guide to Creating Comics*: "Make all creative decisions in the service of the story" (Potts 2013, 24). Likewise, in his groundbreaking analysis of various artistic contributions to Marvel's character Daredevil, Jenkins argues from a critical perspective: "The art serves the needs of the story" (2017, 68). Moreover, Jenkins elaborates, the "artwork must be legible; any narratively salient information must be presented in a way that can be easily deciphered by the most casual reader. There are no moments of confusion. As a second-order value, the artwork is also designed for immediacy and intensity—to shape our emotional response, so we keep flipping the pages and coming back for the next issue" (68). Though comics have been broadly defined as a combination of the written word and sequential illustrations, the art is presumed to be merely functional. Or, as Andrei Molotiu describes it, the purpose of comics art is primarily "a utilitarian and eminently consumable function: namely, to carry the plot forward and to get out of the way" (2007, 25). From this perspective on comics, as a narrative medium the story becomes the primary feature, and the art is reduced to a supporting role. This diminishment of the illustrations to being merely utilitarian, or only in service of the narrative, does a disservice to the importance of the artwork as *part* of the narrative. The artwork is inseparable from the overall effect of the comic, and certainly contributes to a reader's understanding of the story, as well as to less tangible factors like mood, visual perspective, and character appearances.

Historically, one consequence of the medium's primary goal of easy consumption has been to reduce artistic complexities. As we will see in the following chapters, this is no longer the case, since current art styles can range from very intentionally simplistic to incredibly detailed or confusingly abstract. But the enduring criticism of superhero illustration as two-dimensional is rooted in the visual shorthand that aided in immediate recognition of characters and events. "Traditionally comics are designed to be read quickly, which explains the preference for stereotypical elements that are easily recognized," Pascal Lefevre argues; thus "the main characters are usually dressed in a typical, familiar outfit, and are rendered with typified body and facial features: think of Superman and Batman in superhero comics, Mickey Mouse in animal comics, Tintin in classic bande dessinee, and Astro Boy in shonen manga" (2011, 16). These stereotypical

elements mean that the muscularity and square-jawed figure in colorful tights is immediately recognizable as a hero, but the narrative convenience of this symbolic image unintentionally promoted limitations on the art and contributed to gendered and racial stereotyping in the comics. Despite the greater range of artistic styles now viable in superhero comics, these normative visual stereotypes persist, as we will see in relation to both modern Idealism and Grotesque styles.

Though superhero comics have always had a significant portion of adults among their readership (from infantrymen in World War II to affluent collectors today), the genre has always been identified as a childish form of entertainment. During the Golden Age of comics, the illustrations were similar to those seen in newspaper strips and magazine advertisements (many of the comics artists worked in these other mediums in order to support their families), but the comic book images were identified as more childish by virtue of the relatively silly premise of "men in tights fighting crime." As Bradford Wright observes of the first superhero illustrations to influence public perceptions: "Shuster's crude artwork evinced a childlike exuberance, giving an added adolescent quality to the stories" (2001, 9). Certainly, children were the prime audience for superheroes from the 1940s to the 1980s, and continue to be a central focus today even as the industry has shifted to target older consumers. The association with children's entertainment seems to discredit or invalidate the medium and the artwork. In his discussion of stigmatization in popular culture, Paul Lopes notes that the "most interesting aspect of the stigma experienced in the world of comic books in North America was how the stigmatization of comic books as subliterate and a children's medium prevented this art form from evolving into more adult genres similar to those in the field of popular literature" (2006, 388). Dismissed as merely children's fare with no artistic merit or cultural value, superhero comics and illustration have been stuck in a tautological bind for most of their history. Perceived as only a children's medium, the adventures and images have catered to younger consumers, and because the adventures and images have catered to younger consumers, the perception of comics as exclusively a children's medium is continually reinforced.

The conception of comics as exclusively the domain of children was most famously institutionalized and enforced during the McCarthyesque moral panic of the 1950s. Spurred on by Fredric Wertham's sensationalistic bestseller *Seduction of the Innocent: The Influence of Comic Books on Today's Youth* (1954) and the US Senate's Kefauver Committee hearings into juvenile delinquency, the public feared that comics were destroying the moral fiber of America's youth. To avoid being run out of business, the major publishers developed the strict Comics Code Authority (CCA) as a self-censoring agency meant to assure parents and politicians that

comics would be nothing but clean, wholesome, and respectful fun for children. Though the most egregious pre-code comics were horror and crime titles, the superhero was accused of being too sexual, too violent, and potentially queer. Among other restrictions, the CCA forbade any depictions of graphic violence, illicit sexual relations, drug or alcohol use, disrespect for parents or law enforcement, or glorification of illegal behaviors. Essentially, as Paul Lopes notes, "The code eliminated adult content and reestablished comic books as a children's medium" (2009, 402). Thus, for most of the 1950s and 1960s, the likes of Batman and Superman were reduced to fighting silly aliens, gleefully trading puns with bad guys dashing across oversized household items, and dealing with mischievous imps from other dimensions. By the early 1970s both Marvel and DC had begun to push the boundaries of the CCA, but the entirety of the code was not abandoned until 1989. This institutionalized insistence on superhero comics as a medium only for children solidified a perception of comic book art as necessarily and exclusively childish. Though the code is long gone, and the styles of superhero artwork have greatly matured and diversified, the stigma of childishness remains ingrained.

Like much of popular culture, mainstream comic book illustration is also excluded from the realm of fine art because it is a profit-driven entertainment platform. In her discussion of comics as a commercial enterprise rather than a pure art form, Katherine Roeder observes that one of the most problematic qualities "is the taint of commercialism; comics are a reproducible, mass-cultural product, and the means of their production is bound up with the machinations of the commercial publishing industry" (2008, 5). The "taint of commercialism" that has contributed to the conception of comic book illustration as beneath appreciation as an art form (which is romantically imagined as beyond the baser realm of commerce) is a problematic premise. Yes, some of the most-acclaimed comic book artists working with superheroes today can make a great deal of money, but since its very inception the industry has been notorious for treating artists inequitably. Like the comic strip artists before them, early comic book creators would be credited for their contributions on a per-story basis. "This practice was simply a carryover from comic strips and in part happened because the first comic books were reprints of strips that of course carried bylines," points out Ian Gordon. "On the other hand comic book writers and artists were paid flat rates and signed over their copyrights, thereby relinquishing any control over their characters, including the opportunity to benefit from any subsequent republication or monetarization of the character in another fashion" (2017, 109). It is perhaps not coincidental that the most notorious example of comics creators as impoverished and exploited labor is intertwined with the birth of the superhero genre itself.

Young Jerry Siegel and Joe Shuster regrettably sold the rights to Superman to DC Comics for $130. Siegel and Shuster were initially retained as writer and artist for the early years of Superman, essentially paid a flat rate as freelance contractors. But, where Siegel and Shuster would struggle for decades as craftsmen in an industry that habitually paid them minimal rates, DC Comics would go on to earn billions in the publication and merchandising of Superman. In 1948, at the end of their ten-year contract working for DC Comics, Siegel and Shuster took legal action in an attempt to regain some of the rights to Superman. DC Comics won the lawsuit and removed Siegel and Shuster's names from the byline for Superman. Both creators struggled individually to continue in the comics industry without ever achieving any notable success. As Ian Gordon summarized, "by 1975 Siegel was poverty-stricken and working as a file clerk in Los Angeles. Shuster lived with his brother in an apartment in Queens, New York" (111). Moreover, Gordon continued, by the 1970s the names Siegel and Shuster "no longer stood for a writer and artist so much as for people wronged by a large corporation" (112). It was not until just prior to the release of 1978's *Superman* movie that DC Comics and their parent company Warner Brothers agreed to restore the "created by Jerry Siegel and Joe Shuster" byline to the comics and granted them both pensions and a medical plan. They acquiesced only due to the fear of bad publicity and potential boycotts of the film.

Siegel and Shuster are two of the most famous examples of creators taken advantage of by the industry, but they are not alone. Rather than a wildly profitable form of commercial art, which is regarded as a less artistic enterprise, comics illustrators have a long history of being exploited by corporations. In her discussion of the industry, Kathryn M. Frank argues that very little has changed since the sweatshop days of the 1940s: "Contracts, freelancing, and intellectual property have been problems the comics industry has failed to address substantively since Jerry Siegel and Joe Shuster signed away rights to Superman in 1938, despite increased reader awareness of creators' contributions (artists, inkers, and colorists have been receiving credits for decades) and fan skepticism toward franchising" (2017, 143). Indeed, one of the comics genre's most prolific and most celebrated artists, Jack Kirby, often found himself at odds with the publishers and undercompensated for his artistic contributions. Kirby was one of the central architects of the superhero genre, having co-created and drawn *Captain America* in 1940 and then working for nearly every comic book publisher after his return from World War II. Kirby is perhaps most famous for his 1960s work at Marvel as the co-creator (alongside writer and editor Stan Lee) and illustrator of such phenomenally successful characters as the Fantastic Four, Iron Man, the Hulk, Thor, and the X-Men. By 1970 Kirby

had grown so frustrated with the lack of credit and financial compensation he was given by Marvel that he moved to rival DC Comics and created his own line of "Fourth World" comics, including *New Gods*, *Mr. Miracle*, and *The Forever People*. By the end of the 1970s he was working freelance for a number of publishers, including a nominal return to Marvel. But, in the mid-1980s, Kirby "found himself singled out, as he saw it" and "punished for his indispensable contributions to the company. Marvel, in defiance of what had by then become standard industry practice, refused to return to Kirby his original artwork unless he signed a statement explicitly disavowing any creative credit for, or stake in, the Marvel characters for which he was famous" (Hatfield 2012, 78). Marvel flatly refused any substantial compensation for Kirby and essentially held more than thirteen thousand pages of his art hostage (originals that were worth a fortune in the emerging collector's market).

It was only after thousands of fans, the fan press, and several prominent modern comics creators rallied to express their support of Kirby that Marvel began to negotiate in good faith and agreed to return the bulk of Kirby's original work. Like with Siegel and Shuster, Kirby's mistreatment by a publishing house that he helped make a success reinforced the unequal business dynamics at play within the comics industry. Bart Beaty argues that Kirby's conflict with Marvel "recalled the entire history of comic book publishing organized as an exploitative system that treated creative talent as interchangeable, replaceable, and disposable, privileging the maintenance of corporate trademarks over the aesthetic demands of interesting storytelling" (2012, 90). Moreover, Beaty continued, "Marvel's actions highlighted for many the lack of respect that artists working in the comics form faced, even from within the industry itself" (90). The general lack of respect for comic book artists is only compounded when they are dismissed within the industry of which they are an essential part. Why should critics, scholars, reviewers, or even the public consider superhero illustration a legitimate artform when even comic book publishers don't?

Validating Comic Book Art and Artist

Though the stigma of superhero illustration as simple, infantile, formulaic, and commercialized tripe continues to haunt the perception of comic book art, the superhero artist has begun to be appreciated as a *dessinateur* thanks to the efforts of a very active fandom and structural changes in the marketing of comics. The devoted fandom associated with modern comic books shapes the market and publication trends in a way that guarantees the industry's survival and has reconfigured the relative cultural status of popular writers and artists. Indeed, if not for the efforts of dedicated fans,

Jerry Siegel and Joe Shuster may have never received any of the credit and financial compensation for Superman, nor would Jack Kirby have gotten any of his original artwork back from Marvel or been able to negotiate more appropriate residuals. Comic book fandom has passionately advocated for a more appreciative approach to comics creators as talented writers and artists. In regard to superhero illustrations as an artform, the fan communities are far ahead of academic Comics Studies, which are only slowly branching out from the comforts of literary and cultural analysis.

Though socially maligned until very recently, comic book fandom is a massive global subculture that includes more casual consumers, aficionados, and obsessive fanatics. Like most modern fandoms, comic book enthusiasts emerged as a recognizable social identity in the 1970s as several key fans began to organize conventions, open specialty stores, and publish fanzines. The groundwork for comics fandom was laid in the 1960s with the tentative release of fanzines by such notable enthusiasts as Dick and Pat Lupoff (*Xero*), Don Thompson and Maggie Curtis (*Comic Art*), and Jerry Bails and Roy Thomas (*Alter-Ego*) (see Pustz 1999 for a detailed history of organized comics fandom). By the 1970s, comics fandom was a thriving and active community. The emerging subculture of like-minded fans facilitated a passionate celebration of superhero characters, the medium of comic books, and an admiration of the individual creators behind the stories. Fans were able to share information and collections, identify previously unrecognized or uncredited artists, and elevate the status of influential illustrators.

In essence, the subculture of fandom established its own aesthetic standards and hierarchy of appreciation for the subject of comics in a manner that mirrored traditional approaches to the arts utilized in high culture. "The fan's ability to recognize and delineate 'authors' in production contexts in which less invested observers find only 'hacks' is a key component of fannish epistemology," argues Beaty. "By asserting the birth of the author in fields such as comics, fans invert dominant aesthetics hierarchies and problematize the standards of judgement that prevail in area[s] like the academy" (76). Fans reject the exclusivity of established standards of artistic merit safeguarded by critics and curators. Where others, even many working within the comics industry, may see disposable entertainment, trash for children or those with childish tastes, fans celebrate artistic skills and achievements. Prominent and/or innovative artists who had been discarded to the dustbin of comics history were identified, championed, and canonized. In addition to Shuster and Kirby, illustrators like Wally Wood, Dick Sprang, Steve Ditko, Joe Kubert, Will Eisner, Gil Kane, Lou Fine, Carmine Infantino, Neal Adams, and dozens more were celebrated and validated for their incredible talents and as architects for both the genre of superheroes and the medium of comics.

Elsewhere (Brown 2001), I have argued that the subculture of comic fans functions as a shadow cultural economy which parallels many of the same principles Pierre Bourdieu (1984) identifies as crucial to achieving "good taste" within elite social circles. In that earlier work I was interested in how fans create a social community around a shared passion for specific texts, and how some participants are granted a higher subcultural status based on their knowledge of comics. Here, more specifically focusing on the artwork, Bourdieu's observations about elite taste can also be seen as repeated within fandoms to distinguish between the relative worth and appreciation of different comic book illustrations and illustrators. Bourdieu argues that "good taste" often serves as a marker of "class" in relation to one's knowledge and appreciation of fine arts. A "social hierarchy of consumers" corresponds, according to Bourdieu, to "the socially recognized hierarchy of the arts, and within each of them, of genres, schools, or periods" (1984, 2). The value of an artform, and one's ability to be a discerning consumer of the arts, is premised on criteria such as knowledge of the work's authorship, its uniqueness, and the quality (expense, rarity) of the materials used to produce it, as well as the education, experience, and supposedly unbiased evaluation of the consumer. In other words, all of the traits associated with high art (expensive, unique, serious, individually authored, critically endorsed) are the exact opposite of how comic book art has been characterized (cheap, formulaic, juvenile, disposable, anonymous). But, within the shadow cultural economy of fandom, participants treat comic book art according to the same principles as elite culture treats "legitimate" art. Individual illustrators become *dessinateurs* because they are identified as the talented individuals behind an image, and the work is understood by dedicated enthusiasts and subcultural critics in relation to major trends and historical developments.

Perhaps the clearest example of comics fandom functioning according to the same principles and practices used in the world of highbrow art is the phenomenon of collecting. As a print format, the materiality of the comic book has always played an important role in the medium's appeal. Though digital comics have become an area of intense interest among publishers (a topic that will be taken up in the concluding chapter), the physical magazine is still the primary medium for superhero comics. Fans treat comic books as (sub)culturally and aesthetically valuable artifacts, collecting them, cataloguing them, enshrining them, carefully displaying them, having them fiscally appraised by professionals, and preserving them in environmentally safe conditions. For all intents and purposes, many fans assume a type of curatorial approach to comic books. The curatorial process in art galleries and museums evaluates and maintains artwork in ways very similar to what fans do with comics, discerning authorship, the conditions of creation, commercial value, historical/cultural importance, conservation,

and exhibition. The parallels between the highbrow treatment of traditional art and the fan community's approach to superhero illustrations is even more pronounced when it comes to the pursuit of original art. Collectors will spend thousands upon thousands of dollars to purchase original comic art by notable artists. Like one-of-a-kind masterpieces by acclaimed painters, an original page of comic art seems a direct connection to the illustrator. The original has lines drawn directly by the hands of the artist, a purer step in the creative process before inks and colors and text are overlaid; it is not a mass-produced copy or a numbered print, but a unique artwork. And, like with high art, the price for original comic art typically depends on the status of the illustrator, the historical importance of the image, and the "quality" of the work as deemed by expert evaluators. Thus, Frank Miller's depiction of Batman for the cover of *Dark Knight Returns* #2 was bought for $478,000 in 2013, as was John Romita Sr.'s cover art for *Amazing Spider-Man* #100 in 2018; a Neal Adams cover for *Batman* #251 fetched over $600,000 in 2019. A number of websites specialize in authenticating and selling original comic art, and established auction houses like Sotheby's regularly include comic art among their consignments.

Organized comics fandom brought an appreciation of previously maligned artists to the fore. Gradually, the influence (and economic importance) of fans led to a better treatment of artists within the comics industry. Much of this shift occurred because for many fans the artist became more important than favorite characters, writers, or publishers. The emergence of fledgling publisher Image Comics in 1992 gave evidence of this change in the value of artists. The comics industry was experiencing a massive boom in the first half of the 1990s, primarily due to the advent of direct distribution and the rise of comic book specialty stores since the mid-1980s. Several young artists working at Marvel (chief among them: Todd McFarlane, Jim Lee, and Rob Liefeld) were redefining the company's house style with an emphasis on anatomically detailed and exaggerated bodies rendered with sharp, jagged lines, an abundance of cross-hatching, and crowded panels. These artists developed a massive fan following, and the sales of their work skyrocketed. Marvel sought to capitalize on the popularity of these illustrators, offering greater incentives and the opportunity to headline new series. McFarlane was given his own *Spider-Man* title in 1990, and his first issue sold a record-setting 2.5 million copies. But this record was soon broken; in 1991 Liefeld released *X-Force* #1, which sold 3.7 million copies. Even more remarkably, *X-Force* was followed by a new *X-Men* #1 illustrated by Jim Lee that sold over 8 million copies, which still stands as the best-selling comic book ever. The phenomenal sales for *X-Men* #1 were also due to the issue being released with five separate variant covers, all illustrated by Lee, that could be put together to reveal a giant panoramic image. Recognizing that they were only being paid a small portion of the

overall profits their artwork was generating for Marvel, these illustrators (along with other popular artists Erik Larsen, Marc Silvestri, Whilce Portacio, and Jim Valentino) left Marvel to form Image Comics. Creating their own shared publishing imprint allowed these creators, and others who soon joined them, to maintain the ownership of any characters they created as well as any profits achieved by those properties. Suddenly, thanks to the economic power of fans and their valuation of certain artists, there was a whole new universe of superheroes ready to compete with those of the Big Two (Marvel and DC Comics) at the cash register.

Paul Lopes (2009), in his detailed history of industrial shifts within comic book publishing, characterizes the founders of Image Comics and many other like-minded comics creators who also ventured into areas of self-publishing as "rebels" rather than opportunists or ingrates (as some Marvel editors described them). Lopes argues that as figureheads for a new era of creativity, "rebels believed in the potential of comic books as a popular art form. Their pulp strategy of rebellion was not only a strike against the constraints of the Big Two and the dominance of the superhero genre, but also a rebellion against official culture's view of comic books as simply lowbrow, subliterate, adolescent fantasy" (114). Comic book writers and artists of the late twentieth century were interested in building on the respect the industry had accumulated following Frank Miller's dark deconstructionist take on Batman in *The Dark Knight Returns* (1985) and the revisionist *Watchmen* (1985–1986) by Alan Moore and Dave Gibbons, which had garnered critical and commercial acclaim and retooled the superhero for modern audiences. The importance of fan communities and their focus on following favorite illustrators, like the artists who left Marvel to form Image Comics, helped elevate the appreciation of superhero artwork. Lopes reasoned that "comic book culture provided the foundation for mainstream artists to claim legitimacy as artists" (115). Fandom's passion for certain artists made them valuable commercial properties as artists who could sell more books and demand a higher commission than less-recognized illustrators.

Concurrent with the rise of organized comic fandom celebrating the work of specific illustrators, a number of industrial changes from the mid-1970s to the mid-1980s altered the purpose and perception of superhero art. The shift from a predominantly newsstand system of distribution to a largely direct-market system of distribution and retailing changed how the business operated on the creative side as well. In a detailed analysis of the shifting dynamics in this time period, M. J. Clarke argues there was a crucial change in "the organization of comic-book artists which encouraged the emergence of innovative, collaborative studios; changes in the culture of publishing which altered the esteem held for comic-book artists and their work; changes in the technology and technique of comic-book

coloring which both necessitated and supported artistic experimentation; and changes in proposed audience groups which helped move content standards" (2014, 193). Indeed, direct distribution (which was initiated in 1973 by fan and convention organizer Phil Seuling) facilitated and increased comic fandom through the rise of specialty stores and regular access to new books. This fundamental shift in distribution and marketing benefited the artistic side of comic books in incidental ways. With publishers soliciting orders from retailers well in advance of a title's release, the typical production schedule was extended and illustrators were given more time to complete assignments, thus allowing far greater detail and an opportunity to explore innovative techniques. As publishers catered more and more to an older core audience, and to consumers prepared to spend more money on their books, unconventional styles were encouraged and unique artistic visions became a selling point. Furthermore, these changes demonstrated a market for better-quality books. Gradually, the cheap newsprint and staples were replaced with thicker paper, glossy printing, and higher-end color reproductions—all of which displayed the artwork in a better light than ever before.

Variant Covers, Special Edition Books, Galleries, and Dessinateurs

Since the early 2000s, superhero illustration has increasingly been treated as a legitimate form of art, both within the comic book publishing industry and in more rarified cultural circles. This is not to say that superhero illustrations have become uniformly accepted on par with traditional artforms like paintings and sculptures. But the general rise in popularity of superheroes (due in large part to the success of blockbuster movies), the availability of graphic novels in mainstream bookstores, the broad acceptance of fandoms which had previously been derided as "nerd" subcultures, and the growing acceptance of Comics Studies courses on university campuses have all elevated comics as a media form, and as the most visible component of that medium, the artwork often takes center stage. I want to briefly review three of the most prominent ways that superhero artwork has been highlighted and elevated beyond its narrative purpose: variant covers, prestige format books, and gallery exhibitions of original art.

During the comics boom of the early 1990s, fans and speculators alike were snapping up new books at an unprecedented rate, especially if the comic featured the death of a significant hero, or was a milestone number, or seemed "special" in any way. Publishers were eager to exploit this buying frenzy and rebooted long-standing characters so each series could start with a new first issue. Some books were released in sealed plastic bags so collectors had to buy two copies (one to open and read, one to keep sealed);

others featured foil covers, or hologram covers. Some covers had been shot through with a bullet; others supposedly had some of the artist's blood mixed in with the inks. It seemed like no promotion was too gimmicky when it came to increasing sales. One of the most successful tactics was to publish a single issue with several different cover images, encouraging consumers to buy the whole set. This practice of multiple covers inflated sales exponentially; the multiple covers ploy was exemplified by the five covers produced by Jim Lee in 1991 for his *X-Men* #1 (mentioned previously), which made it the best-selling comic of all time. By the late 1990s, however, the bubble had burst with comics speculators, and the blatant money-grab of multiple covers was rejected by most consumers.

In the 2010s the marketing tactic of "multiple covers" was rebranded as "variant covers," which has proved increasingly popular as a way to showcase some exceptional and innovative art. Multiple covers typically featured illustrations by the same artist or a single image printed in different colors. Variant covers, on the other hand, exhibit art from different artists, often in wildly different styles than what appears within the comic book. Variant covers have become standard in conjuncture with launching a new series, marking a special event (a wedding or a death), a landmark issue (500th, 1000th), cross-promotions (villains' month, powerful women month, etc.), or as a tie-in to external popular culture trends (hip-hop album covers, classic movie posters, Lego figures, etc.). Variant covers also demonstrate the incredibly wide range of styles that exist in modern superhero comic books. *Batman* #50 (2018) had 110 variant covers depicting the romance of Batman and Catwoman—from penciled sketches to oil paintings, and from children's cartoons to lifelike images suggestive of BDSM. In addition to providing a highly visible platform for different artists' skills, free from the constraints of a narrative, the diverse covers exemplify how changes in the style of illustration can imply a different tone to the characters. For example, Frank Miller's nine-issue *Dark Knight III: The Master Race* (2015–2017) featured over fifty variant covers with a range of top artists reimagining scenes from Miller's landmark original series *Batman: The Dark Knight Returns* (1985). Key moments are recontextualized through the covers. Batman's victory over a neo-punk gang leader becomes frightening in Gabriele Dell'Otto's realistic rendering. The same scene is more cartoonish and innocent in Darwyn Cooke's nostalgic style. In Bill Sienkiewicz's watercolor painting, the moment when Batman momentarily slouches in his saddle like an exhausted Don Quixote is full of pathos and melancholy, while J. Scott Campbell's traditional comic book Idealism presents the characters as simple superhero fun.

Covers have always been the most striking visual component of comic books. As a commercial product, the covers need to be eye-catching and enticing as well as an indicator of what readers can expect from the story.

In *DC Comics Variant Covers*, Daniel Wallace notes: "Fans had increasingly come to appreciate comic artwork as genuine art, with comic book covers as the medium's largest canvas" (2018, 6). Many of the modern variants treat the covers almost as a literal canvas, minimizing the series title, issue number, creator credits, and even barcodes so nothing distracts from the art. For example, the variant cover for *Superman: Endless Winter Special #1* (2020) by Rafael Grassetti depicts Superman in a more realistic style with title graphic removed, leaving the viewer to focus on the artistic quality of the illustration. "Variant covers have evolved into an artform all their own," points out John Rhett Thomas in *Marvel Comics: The Variant Covers*, "one that is really popular with not only publishers but fans and artists as well" (2021, 7). The popularity of variant covers means they are no longer reserved only for special issues. Publishers are happy because a variety of covers increases sales; fans are happy because of the exceptional artwork they can marvel at; artists are happy because variant covers provide a way to showcase their work in ideal conditions, free from narrative requirements or having to frame images to leave enough room for title graphics and corporate logos. As Thomas describes this artistic shift within the industry: "This freedom has led to some of comics' finest illustrators choosing to flex their talents primarily as cover artists, with variants making up a key part of their portfolio, in ways they couldn't fit if they were restricted to the monthly grind of an individual title" (7). Many of the most accomplished comics illustrators, those who are undeniably recognized as *dessinateurs*, now mostly do covers. The work of superstar artists (many of whom will be discussed in this book) is valued enough that they can earn more doing covers than illustrating entire stories on tight deadlines. Featuring artwork by the likes of Alex Ross, Adam Hughes, Amanda Conner, or Lee Bermejo is enough to increase sales. The prestige and the "blank canvas" format of variant covers has also allowed the industry to engage artists who have not worked in comics before but can bring a different approach to the characters, depicting them in ways they may not have been seen before. In addition to Rafael Grassetti, painters like Shannon Maer, Ian MacDonald, Cheol Lee, Gabriele Dell'Otto, Francesco Mattina, and Yasmine Putri have all produced "suitable for framing" covers which have helped expand the idea of what comic book art can be.

Since the 1980s the trade paperback (TPB) has been an increasingly important format for the comic book industry. Even more than original graphic novels (see Clarke 2014), TPBs that collect stand-alone storylines have become as popular as the original comic book issues, and standard practice for all Marvel and DC series. Comic writers (and many comic fans) have long wanted comic books to be taken seriously as literature, and the fact that these collected volumes are sold in mainstream bookstores has helped promote comics as a literary form. The materiality of the

2.4 *Superman: Endless Winter Special* #1 (2020), Rafael Grassetti, artist, DC Comics.

graphic novel format, whether in TPB or hardcover, lends a sense of gravitas and substance to illustrated superhero adventures that is absent from the flimsier single-issue comic format. The overall literary aspirations of American comic books have also been aided by the increased recognition of non-superhero graphic novels as literary accomplishments. When Art Spiegelman won a Pulitzer Prize for *Maus* in 1992, his graphic novel about the Holocaust where Jews are depicted as mice and Germans as cats, it opened the possibility for comics to be taken seriously as a distinct literary

form. More recently, works like Alison Bechdel's *Fun Home* (2006) won the Stonewall Book Award and the Lambda Literary Award, and *March* (2016) by John Lewis, Andrew Aydin, and Nate Powell won a National Book Award as well as numerous young adult literary awards. Both Marvel and DC have used hardcover book series that reproduce collections of their earliest comics as serious literary history artifacts. The *Marvel Masterworks* and the *DC Archives* book series frame the original exploits of their superheroes as akin to classic literature. As Daniel Stein points out, as early as 1989 advertisements for *Marvel Masterworks* "announced the acceptance of superhero comics as a form of literature whose history should be preserved in libraries alongside the classics" (2021, 261). Moreover, these high-end collections imply efforts "to elevate the medium were successful, and that the ephemerality of the serial artifact has been replaced by the stability and endurance of the printed book" (261–262). The physical qualities of book format reproductions transform the material from disposable newsprint periodicals suitable only for children to weighty tomes deserving of serious consideration and preservation.

The book-bound graphic novel format has contributed to a greater acceptance of superhero writers as real authors rather than subliterate hacks. The better print quality utilized for graphic novels serves to present the illustrator's work in its best light as well. In fact, the artwork is often used as a lure to attract new consumers, and to entice fans who may have already purchased the story in its initial run as a series of single comic book issues. Most TPBs in the current market include exclusive content from the contributing artists: reproductions of any variant covers that may have existed, as well as examples of first-draft artwork, character design sheets, and alternate concept sketches. For the most part, bound collections are organized around a single superhero title, or a crossover event where the story was told across a number of different series from the same publisher. These collected story arcs are published in a variety of formats to increase repeat sales: paperback, hardcover, anniversary editions, Absolute Editions, Ultimate Editions, Gallery Editions, Omnibus Editions, Noir Editions, and so on. In addition to the focus on characters and self-contained storylines, both Marvel and DC (as well as some of the smaller presses) have produced collections of both classic and contemporary comics organized around specific creators. For example, popular writer/artist John Byrne is celebrated in hardcover form in both *The Marvel Universe by John Byrne* (vol. 1, 2016; vol. 2, 2018) and *The DC Universe by John Byrne* (2017), as are Howard Chaykin, Frank Miller, and Mike Mignola. Likewise, legendary comic book artists such as Jack Kirby, Neale Adams, Walt Simonson, Steve Ditko, John Buscema, Norm Breyfogle, Marshall Rogers, and Jim Aparo have garnered multiple hardcover collections of the various superhero comics they have worked on. This shift to the artist as the focal point

(instead of the author or the character) consecrates the illustrator's status within comicdom as *dessinateurs*. Modern comic book illustrators most famous for their contributions to the superhero genre (Amanda Conner, Sara Pichelli, Jock, Ed McGuinness, Humberto Ramos, Joëlle Jones, Chris Bachalo, and dozens more) are also celebrated in Marvel's "Monograph" and DC's "Portfolio" series.

In addition to the relatively affordable paperback "Monograph" and "Portfolio" series, dozens of oversized hardcover art books devoted to the work of both classic and modern comic artists are widely available in the "fine art" section of most bookstores. These coffee-table-style art books are more expensive, aimed at collectors and older fans rather than casual comics readers. As Tomasz Zaglewski describes, these high-quality books focused on the work of individual artists are meant for artistic display rather than private reading: "oversize editions are clearly designed with the aim of being admired, in that they tend to concentrate on exhibitive ability (mostly by offering exclusive behind-the-scenes content, i.e., including reproductions of sketches and drawings by the original artist), being deluxe collective items intended to look impressive on the bookshelf rather than for cozy reading" (2020, para. 11). These costlier coffee-table books and the high-end collections of artists' portfolios function according to the same aesthetic and cultural principles as fine art appreciation. "Expensive, heavy, cumbersome, impossible to shelve next to 'normal' graphic novels," argues Jean-Paul Gabilliet, "these volumes cumulate all the characteristics of commodities designed to display their owners' standing rather than fulfill their alleged cultural function, i.e. enabling one to read a comics narrative" (2016, 19). The printing quality of these books and their implied exclusivity serve as evidence of the collector's expertise and as a physical embodiment of comics illustration as a recognized artform of the highest order.

At the opening of this chapter, I mentioned Bart Beaty's observation about the lingering stigma faced by comic art because even "in an increasingly postmodern world in which the distinction between high and low culture is often assumed to have eroded, outmoded biases continue to persist in the shaping of how we understand culture broadly" (2012, 7). Little has changed since Beaty noted this discrepancy as far as broad conceptions about the artistic value of comics are concerned. However, the overwhelming popularity of superheroes has inspired a number of museums and galleries to treat comic illustrations as a legitimate artform by displaying original work. Recent years have seen original comics art included in exhibitions organized around specific characters and/or publishers. The settings are as diverse and prestigious as the Library of Congress, the Norman Rockwell Museum, the Museum of Contemporary Art Chicago, the Henry Ford Museum, Champs-Elysees Galeries Lafayette, the Dunn

Museum, and the Smithsonian. Even more to the point regarding the cultural status of comic book artists and their superhero artwork, numerous exhibitions have centered on specific illustrators. Among the artists with solo exhibitions: Jack Kirby, Frank Miller, Jim Lee, Jim Steranko, and Darwyn Cooke. Of course, Superman, the original and still most recognizable costumed character, figures prominently in many of the exhibitions and promotions, such as the poster advertising "Heroes & Villains," a showing of Alex Ross's work at the Andy Warhol Museum. Exhibitions of comic book art, like the Frank Quitely installation "The Art of Comics," which debuted at the Kelvingrove Art Gallery of Glasgow in 2017 and also used Superman as a central marketing image, display original pages and sketches in the same format and with the same reverence afforded classic paintings. Each piece is accompanied by a curated panel with information and descriptions provided by an institutionally backed expert. Moreover, visitors are encouraged to take their time and contemplate the art in a pristine setting, otherwise bare walls adorned only with a few larger images provided by the artist to enhance the experience.

2.5 Superman/Vitruvian gallery installation (2017), Frank Quitely, artist.

In the context of a highbrow gallery, superhero illustration is validated as an artform partly because it is so removed from the normal consumption patterns. These are original works rather than the mass-produced copies that appear in comic books, pure pencil on paper before inkers and colorists have added more levels, divorced from the serial narrative and the dialogue. Discussing the effect of encountering original pages and how it elevates the form, Andrei Molotiu claims: "Coming face-to-face with original comic art generates a different experience. Looking at an original comic page, even if it is a so-called inside page (that is, neither a splash page nor a cover), the plot and what happens in it past the few panels before us are very far from our minds. What is intriguing, to begin with, is simply the beauty of the page itself, the quality of its draftsmanship" (2007, 25). Molotiu argues that we can appreciate the sheer beauty of the comics page

THE SUPERHERO AND THE DESSINATEUR | 55

displayed in a museum setting because it is set apart from the narrative; the art is no longer secondary to the story (one of the central critiques of comic book illustration often used to disqualify it as a legitimate artform). As Molotiu continues, this context forces us to see (not "read") the page differently:

> a strange development occurs when we confront the original, hand-drawn boards: rhetorical devices, narrative techniques, and so on are lessened in importance proportionally with the de-emphasis of our attention to story and plot. The material support of the narrative sequence no longer presents itself as a (ideally) transparent medium, and the rhetorical, meaning-producing level of the text is revealed as belonging only to the most superficial layer of a thick palimpsest of brush and pen strokes, touches of white-out, blue-penciled editorial interventions, traces of penciling, marginal instructions from writer to inker, and so on. Furthermore, as plot fades into the background, so does our immediate tendency to scan the page in the same direction and order as any written text (left to right, and top to bottom, in the Western tradition), which is replaced more with the perpendicular, centralized gaze of the viewer of paintings and drawings. (Molotiu 2007, 26)

As Molotiu describes the experience of original comic art encountered in the gallery, the change of context returns the art to its role as pure visual representation. No longer second fiddle to the work of the writer, no longer merely in service of the narrative, the sketches become legitimized art. Viewers contemplate the artistic achievement on its own merits, rather than the superhero adventure.

Original comic book art has become one of the most sought-after, and most expensive, collectibles among fans. Certainly the rarity of original pages contributes to their commercial value, but for many fans an original sketch is an important artifact because it is concrete evidence of the artist's authenticity. In Jean-Paul Gabilliet's historical overview of comics, he argues that the market for original art is indicative of an important juncture "between mass cultural production and artistic creation" (2020, 290). "Indeed," Gabilliet continues, the original work "privileges a type of object that was originally a unique creation and basis for mass (re)production, and is now seen as the tangible manifestation of individual expression. In the technical and economic process that leads to the sale of comic books, the original page is the only artifact, the only step, that maintains a sense of 'aura' in Walter Benjamin's sense of the term" (290). The reference to Walter Benjamin is an astute one, because he argued in the classic essay "The Work of Art in the Age of Mechanical Reproduction" (1936)

that historically art was synonymous with religious beliefs and ceremonies in a manner that granted the work a divine or spiritual "aura" which was evidence of the work's individuality and authenticity. This magical "aura" of unique expression was suggestive of the artist's soul imbued within the artwork. Thus, viewing original artwork is a way to connect with the soul of another, be it da Vinci or Ditko.

In similar terms, Jared Gardner's discussion of the artistic *line* as the most important and underappreciated narrative component in comics claims that illustrations "render the hand of the linemaker" visible, while other mass-mediated forms erase the signature line of the creator (2011, 54). "In fact," Gardner argues, "alone of all the narrative arts born at the end of the nineteenth century, the sequential comic has not effaced the line of the artist, the handprint of the stotyteller. This fact is central to what makes the comic form unique, and also what makes the line the mark of the individual upon the page, such a unique challenge for narrative theory" (56). The "challenge" Gardner is identifies for narrative theory is that the authorial (or more accurately the artistic) inscription remains visible. In other words, readers are aware that these lines, the drawings, were made by particular artists; thus the making of the comic is ever-present in the text itself. Comic book illustrations are never objective in the manner that other mediated narratives strive for; rather they are evidentially subjective—physical evidence of a creative subject who drew the lines. Gardner describes this artistic line as the elusive proof that Benjamin's theories searched for: "True storytelling, for Benjamin, requires a living connection to *work*, to the artisanship of making words" (55). While typewriters and computers may have effaced the line as a living connection to a writer, comic art retains that connection to the work of a living artist. The comic line is a link to the artist's aura.

Though Benjamin believed in a powerful "aura" that viewers experience with an original work of art, he did not dismiss mechanical reproductions as less important. Benjamin celebrated modern artistic forms for their ability to reach the masses and to alter the very idea of what artistic appreciation could be. In this sense, Benjamin described mass-produced art as less elitist, more democratic and participatory. A subset of the high-end hardcover coffee-table books extends the experience and appreciation of original comic art from the galleries to the collector's bookshelf in a manner that reflects Benjamin's faith in the value of mechanical reproductions. Marvel's partnership with IDW Publishing's *Artisan* editions and DC's *Unwrapped* series both present landmark superhero stories entirely through facsimile reproductions of the original penciled pages (see Zaglewski 2020). This technique explicitly promotes the artist as a *dessinateur*, and the central creative force behind the book. These editions are the only time the illustrator is granted top billing over the writer;

thus, for the first time, they become David Mazzucchelli's *Daredevil: Born Again* (rather than Frank Miller's), John Romita's *The Amazing Spider-Man* (rather than Stan Lee's), Andy Kubert's *Batman Unwrapped* (rather than Grant Morrison's), or Francis Manapul's *The Flash Unwrapped* (rather than Brian Buccellato's). Jean-Paul Gabilliet notes that despite these editions being facsimiles, they can function for comic book "connoisseurs" the same way the gallery-displayed originals do: as the purest evidence of the artist's presence and testimony to his or her artistic skills. "For them," Gabilliet argues, "the highest expression of commitment to the medium is to establish the closest possible proximity to a given comics narrative by perceiving it through its original artwork (or through the best photographs thereof), for example, through the artifacts produced and 'desired' by the artist(s) in the first place. For such readers, facsimile reproductions of original art constitute the most satisfactory vehicle to gain access to the traces, gestures, hesitations, changes of mind, and thousand occurrences making up the authors' daily lives" (2016, 23). Thus, a fan, or "connoisseur," experiences Jim Lee's *Justice League Unwrapped* as evidence of Lee's creative hand (rather than writer Geoff Johns's story) and can contemplate his unadorned pencils of Superman posed for action. The sketch in Figure 2.6 is evidence of the artist as creator; you can see where Lee thickened lines for effect, where he erased and redrew portions, where his cross-hatched shadows slip outside of borders.

The promotion of artists as *dessinateurs* offered through museum displays, coffee-table art books, and the additional rough drawings and initial character designs included in trade paperbacks all focus on the unadorned sketch as the prime example of artistic abilities. Following terminology put forth by Philippe Marion (1993), Jan Baetens refers to the drawn line in comic illustration as "graphiation," which is "the specific enunciative act uttered by the author or agent when he or she makes the drawings" (2001, 147). The line is evidence of the creator's presence; a bridge that links reader to artist via this physical mark. Furthermore, the less finished the drawing appears, the closer the viewer is to the original act of creation: "Graphiation is at its strongest in a drawing that is in the stage of a rough copy or sketch. The closer a drawing is to a sketch, the more the reader has the impression that he or she can discover something of the initial graphiation," which, Baetens makes clear, is a sense of "the vivid presence of the graphiateur" (147–148). The austere illustration is taken as the first and purest step in artistic expression, or as Jared Gardner argues, "We cannot help but imagine the flesh-and-blood artist putting pen to paper" (2011, 61). The illustrator's line, or graphiation, serves as proof of both artistic skill and personal veracity. In a sense, the line of the sketch is akin to the line of an individual's legal signature or a celebrity autograph. The mark on paper is evidence that the actual signator agrees to the terms of a contract, or verifies that

2.6 Superman pencils from *Justice League Unwrapped* (2017), Jim Lee, artist, DC Comics.

someone encountered an actual celebrity and interacted with them. This overlap between the artists' graphiation and someone's signature as evidence of their existence is made plain when artists are willing to provide small sketches or doodles for fans (along with their literal autograph) at book signings or "meet the artist" events at comics conventions.

The *Artisan* and *Unwrapped* books offer a glimpse into the creative origins of comic books in a manner rarely available to the consumer. Stripping away the inked lines and the colored panels situates the artist as the unabashed creator of the book. Though the images are merely facsimiles of original artwork, they do provide a different perspective to the role of artist and the balance between narrative and illustration. In revisiting his consideration of the power original comics art holds in galleries, Andrei Molotiu argued that these types of collections can generate a richer reading paradigm by challenging the subservient position of the artist: "Artist's Edition books, then, are neither simple simulacra of the original art they reproduce, nor are they just fancy graphic novels with a few bells and whistles: they present a third way of experiencing a comic" (2020, 59). Rather than a mere focus on the narrative, or an abstract encounter with out-of-context art, these books provide a third approach: understanding of the art as integral to the overall creation of the story, and as an anchor to the medium. In a similar manner, I hope to show in the following chapters how taking comic book art seriously in its many different modern styles can shift our understanding of the seemingly omnipresent superhero. The stories told in the superhero genre are incredibly popular and undeniably influence our understanding of core cultural concepts like heroism, morality, gender, violence, sexuality, and justice. But we also need to attend to how these narratives are visualized, how the art brings them to life, and how the images reflect and shape the reader/viewer's understandings.

3 | IDEALISM AND COMIC BOOK HEROES

It is impossible to overstate how excessively perfect male and female superhero bodies are in modern comic books. In most illustrations the super men and wonder women present an imaginary physical ideal that reflects their exceptional abilities and unflagging heroism. By far, the most common artistic style used in superhero comic books is a form of figural "Idealism." This dominant style leverages the body of the superhero and the superheroine as the focal point for the comic book, the story, and the overall fantasy of incredible powers. This is the style that critics assume when they decry the impossible depiction of male and female bodies in comic books. Idealism is so prevalent in superhero comics that it is an assumed norm against which other styles are regarded as variations. In many ways, Idealism is synonymous with the concept of superhero art. It is commonly accepted that the powerful bodies of the superhero represent an adolescent male fantasy of empowerment (that each mild-mannered Clark Kent reading the story can imagine himself as a Superman). Likewise, the obvious fetishism of the female form is designed to appeal to the voyeuristic desires of a predominantly heterosexual male readership. However, in addition to serving as clearly demarcated images of consummately gendered bodies, Idealism reinforces the long-standing assumption in Western culture that muscular bodies and perfect faces imply a moral superiority.

The previous chapter reviewed several of the ways superhero art, and superhero bodies, have changed over time, reflecting artistic developments as well as shifting cultural perceptions about what an ideal body looks like. It would be a mistake to conceptualize these changes as a type of evolution, constantly improving, naturally developing into a better form. The bodies admired in different historical periods are shaped by cultural

3.1 Batman and Catwoman promotional image (2020), Clay Mann, artist, DC Comics.

trends as diverse as fashion, economics, celebrities, fitness expectations, and health care. Moreover, while the contemporary superhero body is overwhelmingly associated with Idealism, and illustrated as almost a caricature of perfect figures, it also harkens back to classical perceptions of the body. The square-jawed men all have gigantic muscles and perfectly symmetrical builds, with ripped abs and bulging pecs that show every vein and muscle striation through the seemingly sprayed-on costumes. The

ideal hypermasculine figure is central to the style of artists like Jim Lee, Clay Mann, and Michael Turner, as well as David Finch, Andy Kubert, Ed Benes, John Byrne, Mark Brooks, Ed McGuinness, Greg Capullo, and dozens more. The strength and power of the superhero is signified by the exaggeratedly ideal body; they are, in a word, hypermasculine. Both Mann's Batman and Turner's Superman display clearly defined muscles, flexed and posed, ready to burst into action, handsome faces set in heroic determination. Furthermore, in both examples, the size and rock-solid physique of the male heroes is directly contrasted with the feminine ideal of the thin yet curvy Catwoman and Supergirl.

Superheroines, as the contrast from the Mann and Turner examples illustrates, are similarly powerful, but their idealism is reflected in their beauty and sexuality rather than muscularity. Women depicted in the style of Idealism have flowing hair, long eyelashes, and pouty lips. Their legs are long and toned (but not heavily muscled), tummies are flat, and breasts are disproportionately large and firm. As Esther De Dauw observes, the similarity of powers between male and female characters are not reflected through their bodies: "Most female characters do not look as physically powerful as male characters do, adding to the interpretation of female bodies as weaker and less resilient than male bodies. For instance, despite their great physical capabilities, Supergirl and Wonder Woman rarely have the sculpted musculature that male superheroes often have" (2021, 16). This difference in depiction represents a difference in cultural ideals for men and women. Numerous comics artists have been singled out by fans as masters of the ideal female form, including Adam Hughes, Amanda Conner, J. Scott Campbell, Terry Dodson, Greg Land, Stanley "Artgerm" Lau, Joseph Linsner, Greg Horn, and Frank Cho. Of course, these types of bodies are impossibly perfect, but to criticize them for being mere fantasy would be to miss the point and to misunderstand why Idealism is the dominant artistic style. These figures are part of the escapist fantasy offered by the superhero genre, and as such they model (literally embody) cultural beliefs about gender, physicality, and morality.

As a highly visible figure in contemporary media, it is natural that the illustrated superhero reflects social assumptions about ideal embodiments of masculinity and femininity. Cultural aspirations become the norm in comic books, where every character can be illustrated as perfect. The level of physical flawlessness in comics far exceeds even Hollywood's ability to present ideals through sex symbol actors and actresses or Madison Avenue's advertisements populated by supermodels. The expectation of ideal gender representations in comic books is explicit and intended. As Stan Lee and John Buscema instruct in *How to Draw Comics the Marvel Way* (1984): "Perhaps the most important single point to remember is that you should always slightly exaggerate the heroic qualities of your hero,

and attempt to ignore or omit any negative, or undramatic qualities" (46). Specifically, Lee and Buscema stress, for the men "a superhero simply has to look more impressive, more dramatic, more imposing than the average guy" (46). For the women, however, "we do not emphasize muscles on a female. Though we assume she's not a weakling, a woman is drawn to look smooth and soft as opposed to the muscular, angular rendition of a man" (45). In other words, the goal of most comic book art is not to depict realistic bodies but to model and define aspirational gender ideals.

Classically Perfect

In addition to *How to Draw Comics the Marvel Way*, other instructional guides like Burne Hogarth's *Dynamic Anatomy* (1958), Klaus Janson's *The DC Comics Guide to Pencilling Comics* (2002), and *Wizard* magazine's *How to Draw Heroic Anatomy* (2005) devote a significant amount of time to issues of anatomy, scale, and proportion. All three of these guides present an idealized version of the human body reflective of the three different time periods they represent. *Wizard*'s "how to" book is the most recent and contains instructions from many of the modern artists working within the contemporary Idealistic style. Though superhero comic books and classic paintings/statuary may seem antithetical as artistic endeavors (certainly at opposite ends on a scale of cultural value), they do share a concern with representing perfected bodies. Classical artists such as Polykleitos, Michelangelo, and da Vinci influentially premised their ideas of physical perfection on mathematical proportions. In his history of sexual allure, George L. Hersey notes: "Like so many of his contemporaries, Polykleitos believed that numbers ought to govern the human form because numbers and their rational sequences contain innate moral and perhaps magical powers" (1996, 44). The standardized figure in classical art was ideally seven heads tall, legs were three heads long, arms were three hands long, and so on. The most recognizable example of this mathematical approach to the perfect body can be seen in da Vinci's drawing "Vitruvian Man." The modern superhero, like da Vinci's sketch or Michelangelo's statue of David, is engaged in a similar project of depicting the ideal body. Not coincidentally, superhero versions of the "Vitruvian Man" image have been frequently used as comic book covers, with the likes of Superman and Spider-Man assuming the central position. Superman as Vitruvian Man can even be seen reproduced on the walls of artist Frank Quitley's Glasgow exhibition (Figure 2.5), lending an air of classicism to a comics display.

The "How to Draw" superhero guidebooks also recommend a mathematical equation to achieve an ideal figure, except the modern heroic body is now routinely nine heads tall and three heads wide at the shoulder for

3.2 How to draw Black Widow (2005), Kevin Maguire, artist.

men. Of course, with characters like the Hulk or The Thing, the proportions of the characters can increase exponentially. Some of the more monstrous heroes may be fourteen feet tall with shoulders as wide as a couch, but they remain proportionally to scale. For female characters, the measurements of the ideal body are clearly smaller than for the men, and with more of a focus on their curves than their muscles. As artist Kevin Maguire's example of female proportions from *Wizard*'s *How to Draw Heroic Anatomy* demonstrates, women's legs are now four and a half heads long and breasts are each equivalent to a head. Though Maguire's sketch of Black Widow is a simple standing pose, it still manages to emphasize her sexuality. Her legs are long and shapely without being too muscular, her waist is tiny, her hips and breasts stress her curves. Using a mathematical template ensures that the superhero is always ideally proportioned and symmetrical, and, as Polykleitos believed, "contains innate moral and perhaps magical powers." In the most common comic book form, the superhero is a modern image of a classically perfected body, even if the exact measurements of the ideally proportioned body have changed.

The mathematically derived symmetry and proportions in classical art are part of a larger tradition in Western philosophy that assumes a measurable aspect of beauty as an outward sign of virtue and divine design. In her wide-ranging analysis of the social construction of female beauty, Francette Pacteau summarizes the philosophical theme of "beauty" and "goodness" as a harmonious, balanced material state:

> For Plato, *measure* is the defining principle of the good and the beautiful. Measure is the determination of appropriate relationships through knowledge of proportion and of the mean; it forms the Ideal standard to which all creation that aspires to beauty must conform, and it is the rational ground on which all judgement of beauty must

> rest. For Aristotle, "the chief forms of beauty are order and *symmetry* and *definiteness*." For St. Augustine, beauty is a product of the unifying principle of *number*—"number" here meaning, at once, mathematical proportion, rhythmic organization and fittingness of parts . . . Ficino finds beauty in the agreement between matter and Idea, as in "the appearance and shape of a well-proportioned man." (1994, 23)

This ideological heritage that beauty equals goodness still holds considerable sway well into the twenty-first century. If anything, our global obsession with beauty and our mass-mediated worship of actors, models, singers, and the like has only compounded our belief that perfect-looking people are innately more honest and virtuous. As sociological studies have repeatedly demonstrated, attractive men and women are usually judged as better people, thus unconsciously benefiting in areas like employment, school, and legal issues. The grand heroic qualities of caped crusaders are readily apparent and culturally encoded for the men via their strong jawlines, well-defined pectoral muscles, visible abs, and perfectly shaped biceps. The beautiful superheroines are likewise ideally proportioned in a manner that indicates their goodness, but the additional suggestion of sexual fantasy adds a layer of gendered expectations about what a perfect female body implies.

Modern comic book superheroes remain one of the clearest examples of gendered ideals. Elsewhere (see Brown 2001, 2016), I have discussed at great length how the powerful super men and the eroticized wonder women model extreme cases of gender-specific bodies and attitudes. I do not want to simply rehash the argument that superheroes present masculine and feminine ideals, and influence consumers' beliefs about gender. It is important to recognize, however, that the impossibly perfect male and female bodies depicted in the style of Idealism are inextricably linked to the naturalization of social presumptions about muscled men and beautiful women as the pinnacle of humanity. The invincible male superhero is the epitome of what R. W. Connell famously refers to as hegemonic masculinity: "The configuration of gender practice which embodies the currently accepted answer to the problem of the legitimation of patriarchy, which guarantees (or is taken to guarantee) the dominant position of men and the subordination of women" (1987, 77). The male hero's perfectly muscled and super-powered body positions him as a symbol of hegemonic masculinity, able to defeat all challengers, defend weaker citizens, and win the hearts of the most desirable women.

The super-powered female body, however, does not signify dominance as much as it renders her beauty as a confirmation of women's primary value being their ability to conform to a standardized and impossible sexual ideal. In fact, Connell claims there is no female equivalent to

hegemonic masculinity in the sense of a privileged position of authority. Instead, Connell suggests the term "emphasized femininity" as an indication of women's ability to approximate the most acceptable version of compliant femininity, which is always Other to masculine dominance. As the art of Idealism demonstrates, the standard of femininity reproduced and celebrated through the superheroine emphasized her beauty above all else. The rejection of visible muscles in favor of long, thin legs, large breasts, and tiny waists, along with supermodel-looking faces and voluminous long hair, reinforces the superheroines' value as rooted in what Laura Mulvey famously referred to as women's "to-be-looked-at-ness" (1975). Where the ideal male body positions the men as hypermasculine fantasies (tough, powerful, infallible), the ideal female body presents her as hypersexual (fetishized, available, exhibitionistic).

The fetishistic overtones of superheroes are hard to miss, especially those rendered in the style of Idealism: all those fit and sexy bodies running around at night in their masks and tight leather costumes, strong figures grappling with each other, bodies literally erupting with various energies. Numerous critics, myself included, have dissected the various gender extremes signified within the genre, as well as alternative sexualities and barely concealed kinky implications (for a comprehensive overview, see Anna Peppard's edited collection *Supersex*, 2020). The conservative model of the male superhero as a noble rescuer of the beautiful damsel in distress at the root of the genre is erotically bent when the same men are captured or otherwise displayed for erotic contemplation. Similarly, the consistent image of sexy, powerful women in fetishistic costumes evokes the figure of a dominatrix, and suggests the underlying fear/desire of female sexuality as something that can lead even the strongest men to their doom. This specter of fetishism has been imbricated with the dominant style of superhero illustration from the very beginning. The previous chapter addressed how Joe Shuster's illustrations of the first superhero, Superman, became a stylistic standard for how characters should look. Thus, most of the other artists working with superheroes through the 1940s and 1950s adopted the Shuster style—which we can also see as the original form of Idealism. But even Shuster's superhero illustrations were easily transposed to more erotic forms. Indeed, as Craig Yoe documents in *Secret Identity* (2009), his collection of Shuster's erotic art that accompanied seedy pulp stories like the 1954 series *Nights of Horror*, there was always a very thin line between superheroes and fetishism. "In *Nights of Horror* there was little of the heroism and virtue of Superman, but all of the villainy and tension," Yoe notes. "There was spanking, flagellation, bloodletting, humiliation, teenage sex cults, torture devices, exhibitionism, and voyeurism (not to mention lesbianism and interracial sex)" (17). In Shuster's signature style, these illustrations looked very much like Superman and Lois Lane engaged in BDSM.

"Some of the characters look like dead-ringer, bizarre versions of Superman/Clark Kent, Lois Lane, Jimmy Olsen and Lex Luthor," Yoe goes on to argue. "Of course we know it is not them, but these drawings smack of the citizens of Metropolis gone wild" (21). The fact that Shuster's erotic art looks so much like his superheroic illustrations (Figure 2.1) suggests the fetishism that lies just underneath the surface. Shuster's dual career as the originator of superhero Idealism and as an erotic artist implies an overlapping tradition that has existed for nearly a century.

The superhero's unreasonably ideal proportions, symmetricality, muscularity (for the men), and curvaceousness (for the women) are particularly visible because the characters are essentially nudes. The colorful costumes are depicted as tight enough to show off every bulging muscle, striation, and throbbing vein for the men, while the tightness and skimpiness of the women's outfits clearly define their breasts and expose long legs and firm buttocks. As David Coughlan notes in his analysis of domesticity and superheroes: "The comic book hero, masked and costumed, clothed from head to toe, nevertheless remains, to intents and purposes, visually naked" (2009, 239–240). The costumes may conceal secret identities, but they do not hide much else (except for genitals, which we will come back to). The essentially nude superhero body at the center of Idealism adheres to classical dictates of nude art as an improvement on real bodies. Kenneth Clark's landmark art history text *The Nude*, first published in 1956 but still in circulation today, considers both male and female nudes from Greek antiquity to European modernism. Clark declares his influential opinion about the artistic function of the *nude* by contrasting it with the inferences of *naked*: "To be naked is to be deprived of our clothes, and the word implies some of the embarrassment most of us feel in that condition. The word "nude," however, carries, in educated usage, no uncomfortable overtone. The vague image it projects into the mind is not of a huddled and defenseless body, but of a balanced, prosperous, and confident body: the body re-formed" (1972 ed., 3). The nude in art, according to Clark, should be an improvement on the naked body, not "disturbed by wrinkles, pouches, and other small imperfections" (7). Moreover, Clark argues the "body is not one of those subjects which can be made into art by direct transcription" (5), because in our "search for physical beauty our instinctive desire is not to imitate but to perfect" (12). The modern comic book illustrators working in an Idealist style exemplify Clark's perspective. The ideal superhero is devoid of any physical flaws, imperfections, blemishes, or misshapen parts. The heroic body does not skirt issues of nakedness because he or she has a seemingly painted-on costume; rather they are "reformed" as nude, clothed in bodily perfection—"balanced, prosperous, and confident."

Idealism, as the basic superhero form, reproduces and embellishes the

aspirations of proportion, symmetry, and flawlessness that classical art pursued. Moreover, the modern crime-fighting figure taps into the same presumptions that link ideal bodies with beliefs about moral superiority and righteousness. "The usually sculpted, muscular bodies of the superheroes are exposed and explored not only to demonstrate their power," argues Julian Novitz, "but also as a way of signaling self-control and responsibility. The superhero's right to exercise judgement and authority over others" (2019, 97). Likewise, Michael Kobre notes, "superheroes have long been recognized as power fantasies, with dreams of strength and mastery inscribed in every cord and tendon of their bodies" (2019, 150). The ideal superhero form serves as visual evidence of not just physical strength, but also strength of character. Their flawless bodies imply self-control, discipline, achievement, confidence, prosperity, and mastery over others. Discussing the ideal body as a social sign in modern times, Susan Bordo claims: "The size and shape of the body have come to operate as a marker of personal, internal order (or disorder)—as a symbol for the emotional, moral, or spiritual state of the individual" (1993, 193). Furthermore, "the firm, developed body has become a symbol of correct *attitude*; it means that one 'cares' about oneself and how one appears to others, suggesting willpower, energy, control over infantile impulse, the ability to shape your life" (195). Visually, the heroes' idealized bodies signify complete mastery of oneself and, by extension, infallibility in their adventures. The illustration of these characters as incredibly perfect beings reinforces the heroic narrative wherein the superhero is an unquestioned champion of justice against any and all threats. And, conversely, the routine victory of the hero over obvious evils reaffirms the link between desirable qualities and physical attractiveness.

The ideal superhero is illustrated as a classical figure, an impossible and invincible embodiment of perfection. In her discussion of the political potential of bodies, Mary Russo summarizes: "The classical body is transcendent and monumental, closed, static, self-contained, symmetrical, and sleek; it is identified with the 'high' or official culture of the Renaissance and later, with the rationalism, individualism, and normalizing aspirations of the bourgeoisie" (1994, 8). Russo's central concern is with the female Grotesque (an artistic style and body type that will be explored in chapter 7), but her description of the classical body makes clear the association between ideal bodies and social status. It is also a near perfect description of the dominant superhero body: monumental, closed, static, self-contained, symmetrical, and sleek. I have argued elsewhere that a central concern of the superhero genre is the protection of borders: "good and evil, right and wrong, us and them. Intertwined with these abstract concepts are corporeal boundaries between male and female, mind and body,

self and other, that are just as obsessively and problematically policed by superheroes as the literal borders between nation states are" (Brown 2014). The classic superhero body often literalizes its monumental and impenetrable qualities through the cliché of bulletproof skin (Superman, Luke Cage, Power Girl), technologically advanced armor that looks like a muscular body (Iron-Man, Steel), or flesh that is actually made of metal (Colossus, Mettle, the Metal Men). Even characters whose bodies are not literally self-contained and impervious to assault still *look* like they are impenetrable. The depiction of flesh-and-blood heroes like Batman, Nightwing, Daredevil, Hawkeye, and Green Arrow as identical in physical appearance to the Supermans and Colossuses implies they are equally invulnerable. The appearance of the idealized super body becomes more than an aspirational physical ideal; it becomes a symbol of nobility and bourgeois values. Every superhero becomes an embodiment of "Truth, Justice, and the American Way," to generalize Superman's catchphrase. "First and foremost, the protean super-body signifies 'power,'" argues Jose Alaniz, "a unified, self-contained corpus/text, its meaning as clear and legible as the rippling muscles so often shrink-wrapped in bright primary colors, enacting an expansion of the narrative horizon beyond the human" (2014, 17). In the context of the typical superhero story, this "power" signified through ideal bodies is explicitly aligned with virtue.

The dream of being a "Man of Steel," impenetrable, self-contained, powerful but controlled, and impervious to pain, does reflect the larger superhero ethos of safeguarding borders both real and ideological. The iconic image of bullets harmlessly bouncing off the muscular chest of a superhero, for example in Jorge Jimenez's rendition for *Superman* #23 (2020) or Stuart Immonen's rendering of the mutant Colossus for *Ultimate X-Men* #56 (2005), literally solidifies their unassailable masculinity. Both Superman and Colossus appear angry and defiant, demonstrating their superior hegemonic masculinity against the threats of those trying to defeat him. The appeal of an ultimate "hardbody" super heroism (to borrow a phrase from Susan Jeffords's [1994] discussion of the seemingly impenetrable action heroes performed by the likes of Arnold Schwarzenegger and Sylvester Stallone) has been likened by several critics (Klein 1993, Bukatman 1994) to the Hitler-era German fantasy of a perfect, machine-like soldier. Historian Klaus Theweleit argued that a central tenet of this ideology was for soldiers to remain firm and self-contained against the threats of bodily dissolution: "The most urgent task of the man of steel is to pursue, to dam in and to subdue any force that threatens to transform him back into the horribly disorganized jumble of flesh, hair, skin, bones, intestines, and feelings that calls itself human" (1977, 160). The physical rigidity of the superhero reflects their hegemonic status as men and also offers a visual analogy for their unwavering bravery and pursuit of justice.

3.3 *Superman* #23 (2020), Jorge Jimenez, artist, DC Comics.

The impenetrability of superwomen, on the other hand, evokes a different ideal that both suggests sexuality and tempers it. Female characters Like Wonder Woman, Power Girl, Supergirl, Mary Marvel, Captain Marvel, and Emma Frost (in diamond form) can be just as bulletproof as the male heroes. But the heroines' combination of physical resilience with blatantly fetishized bodies (big hair, big breasts, flat stomachs, and low-rise pants) often comes across as flirty as much as it does defiant. For example,

She-Hulk rendered by Greg Land for *She-Hulk* #26 (2009) or America Chavez (aka Ms. America) as drawn by Nick Dragotta for *Vengeance* #4 (2011) are typical of the way even the strongest of heroines are still illustrated as beautiful and erotic, even while standing up to a barrage of bullets. The impermeable superheroine body of steel remains a higher-status classical body that is beautiful and suggestive of sexuality but also aloof and closed off. In contrasting the different ways female bodies have been presented in men's magazines (particularly in *Playboy* and *Hustler*), Laura Kipnis argues that a politicized class difference is mobilized. The higher-class female body depicted in *Playboy* is a closed illusion, while the grotesquely exposed body in *Hustler*, with its preoccupation with orifices and corporeal openings, is a lower-class and less ideal body. Like Russo, Kipnis draws on Bakhtin's terminology and describes this elite female form as a "classical body" characterized as "a refined, orifice-less, laminated surface—homologous to the forms of official high culture which legitimate their authority by reference to the values—the highness—inherent in this classical body" (1992, 137). The eroticized, but impenetrable, superheroine depicted in Idealism is the comic book equivalent of Kipnis's image of the upper-class woman's body as a "refined, orifice-less, laminated surface." The stylized heroine is all sexual fantasy and no corporeal reality. Her orifice-less body and perfectly laminated appearance confirms her desirability at the same time it denies access to her body (even to bullets). Moreover, her status as a refined, upper-class beauty reinforces the assumption of her merit and the solidity of her moral compass.

The dominant superhero themes of strength, power, control, and containment are concisely represented through the style of Idealism. The hero's harmonious and balanced form, embellished with excessive muscularity and a handsome face, reflects the philosophical alignment between ideal figures and admirable traits. From the very beginning of the genre, superheroes have demonstrated what Glover and Kaplan call "the perfectibility of the male body, which became an outward sign of a man's moral superiority and inner strength of character" (2009, 89). In addition to philosophical principles that link well-developed bodies with well-developed characters, religion has similarly associated male strength and build with virtue through concepts like "Muscular Christianity," which was popular as early as the mid-1800s and still exists in a variety of forms today. The idealized superhero also resonates with Judeo-Christian religious themes that reinforce an assumption of morality and righteousness. "From the very beginning Superman stories have contained potentially religious or scriptural references or echoes," observes Dan W. Clanton, "leading interpreters to suggest that there are religious/scriptural meanings or subtexts within *Superman*" (2017, 33). Superman, the archetypal superhero, has often been interpreted as a Christ figure: a god-like being,

the only son of a supreme otherworldly father, sent to Earth as an infant, and raised by poor but honest parents to defend the weak and to save the world (or at least America). Visually, superheroes are often illustrated as saviors descending like angels from the heavens to rescue the helpless. The cover image by Al Barrionuevo for *Superman* #659 (2007) overtly alludes to the Kryptonian's god-like status, as he floats down to a mass of people, his arms spread open, with a halo of sunlight and imagined wings behind him. The parallels are clear enough that, as Susie Paulik Babka claims, "popular culture has gleefully connected Superman and Jesus" (2008, 116). The subtext of altruistic superheroes as caped gods reinforces the link between their heroic-looking bodies and their divine moral righteousness. Interestingly, the overlap between superheroes and religion may also influence how figures like Jesus are portrayed. Comic book–looking depictions of a very buff version of Jesus have become common. Similarly, Jennifer L. Koosed and Darla Schumm note, "The dominant image of Jesus emerging in the late twentieth and early twenty-first centuries is that of the Super Jesus" (2009, 4). Focusing on the films *The Passion of the Christ* (2004) and *The Gospel of John* (2014), Koosed and Schumm argue these depictions build "on the hyper-masculinity of the American superhero," presenting Jesus as "strong, impervious to pain, ultimately triumphant" (4). The strength of the body and the divinity of the character are thoroughly intertwined.

Standardization and the Heroic Mold

The comic book convention of multiplicity is described by Henry Jenkins as a feature that allows for a range of simultaneously existing versions of a single character. As Jenkins observes: "readers may consume multiple versions of the same franchise, each with different conceptions of the character" (2009, 21). Thus, an inexperienced sixteen-year-old Spider-Man can appear in one series, while a married late-twenties Spider-Man is featured in another, and a middle-aged version of Spider-Man set in the future exists in another book. The type of multiplicity that Jenkins is concerned with is a narrative device which allows for a broad number of stories that feature a familiar character in different settings. As mentioned in chapter 1, we can also describe the artistic variations of a single hero drawn by different illustrators as a form of visual multiplicity. But the idea of "multiplicity" in superhero comics can also allude to the depiction of identical versions of a superhero, which is a relatively common narrative device. For some characters, the ability to create multiple copies of themselves is part of their power set. Triplicate Girl from *The Legion of Superheroes* can divide into three people; the mutant hero Jamie Madrox (aka Multiple Man) can create an almost infinite number of duplicates of himself, as can martial

arts hero Shang-Chi after he is exposed to radiation. Android replicants sophisticated enough to pass as the original character are a frequent device as well, with Superman's assembly line of robots, Dr. Doom's "Doombots," and Nick Fury's trademark "Life Model Decoys." And nearly every superhero has been perfectly (and often imperfectly) cloned. Dozens of Spider-Man clones existed for a while; at least two became ongoing characters in their own series. MVP of Marvel's *New Warriors* died early but is survived by three identical clones. The effective duplication of a character is made possible because the illustrator can simply draw exact copies. Though these coexisting identical copies are clearly a form of multiplication, it would be more accurate (artistically speaking) to understand them as a repeated "singularity." In other words, the standardization inherent in Idealism facilitates a replication of identical bodies and faces, a singular perfected type which is reproduced endlessly. The generic logic of clones, robots, and other replicants is a form of singularity—but in a broader sense, the visual repetition of a singular physical type across heroes establishes a belief in a narrow conception of ideal bodies.

The depiction of so many perfect bodies in the style of Idealism creates the impression that all costumed characters are equally classic in form, function, and motivation. In fact, the standardized nonpareil appearance of superheroes and superheroines whose measurements all conform to a singular concept of symmetry and proportion, coupled with each artist's signature style, often results in an almost disturbing similarity between characters. As Julian Novitz observes: "The superhero's right to exercise judgement and authority over others is conventionally associated with a more-or-less uniform body type" (2019, 97). What Novitz describes as a "uniform body type" can create an image of interchangeable super bodies, where every hero and heroine looks exactly the same except for the color of their costumes. In his analysis of the changing ideological relationship between Superman and Batman, Phillip Bevin argues that for much of their history the two heroes have been "twin nemeses of crime, with different abilities but a shared, even interchangeable, approach to criminal justice" (2015, 125–126). Even in modern stories, where Superman and Batman are often presented as thematic opposites, the characters remain identical in form. Recognizing the physical similarity of Superman and Batman's bodies, numerous stories have involved scenarios where they swap costumes to successfully fool villains or mislead nosy female reporters. Artists like Ed McGuinness or Ed Benes, as well as Michael Turner, Clay Mann, Jim Lee, and others, have such a distinct template for masculine super bodies that characters look like they emerged from matching molds. On a practical level the standardized figures help save an artist time when under deadline pressure, but the cumulative effect of all these identical bodies normalizes a very narrow image of ideal masculinity.

3.4 Green Arrow/Green Lantern from *Justice League* #7 (2006), Ed Benes, artist, DC Comics.

For the imposing-looking men, the rigidly structured indistinguishable bodies suggest an industrial, machine-like achievement of physical perfection; the body as a weapon, armored and forged from steel. The unrelentingly hypermasculine bodies, combined with the superhero's vigilant maintenance of the social order, is interpreted by some critics as verging on a romanticized expression of fascism. Indeed, the slippage between DC Comics's Superman and Friedrich Nietzsche's concept of a biologically superior "Ubermensch" shares more surface properties than we might care to admit, since one is an icon of America and the other is aligned with Nazi propaganda. In *Male Fantasies* (1987), Klaus Theweleit famously outlines the German fascist belief in masculinity as organized, mechanistic, hard, stern, and upright—defined in contrast to the soft, weak, flaccid body of the feminine and racial Other. The ideal masculinity of the Third Reich was identical and interchangeable, like steel parts in a larger nationalistic machine. In discussing the 1990s style of Jim Lee (one of the clearest examples of Idealism), Anna F. Peppard describes his artwork as "part of a long tradition of superheroic characters being inspired by and compared to weapons, machines, and other modern technologies," and illustrating "both the appeal and the risks of the partible, machine-like body" (2019, 326 and 328). The hypermasculine superhero is a symbol of individuality on his own, but as part of a genre, and as part of certain teams, the identical bodies function as both machine and machine part. Working as part of a super team is framed as each individual part contributing to the greater whole. As the rallying cries declare: "Avengers Assemble!" and "Titans Together!"

The ideological implication of such near-identical super bodies varies depending on the gender of the characters. For superheroines the "uniform body type" at the center of Idealism is more hypersexual, and thus evokes a cultural fantasy of interchangeable femininity that is critically different from the masculine machine-like principle. The identically sexy women are suggestive of the misogynistic dream of an endless line of

3.5 Psylocke and Rogue figure design, J. Scott Campbell, artist (2011).

women available for a male gaze. Of course, this implication is premised on assumptions of a heteronormative and adolescent male audience, the core demographic that superhero comic books have always catered to. As with male characters illustrated in Idealism, each artist seems to have one official female body type used repeatedly. Each artist famous for their sexy women has a distinct style, but that style is always sexual. J. Scott Campbell's heroines are very thin, with long legs, a tiny waist, and one hip always sticking out. Amanda Conner's women are busty and rounded, but with expressive eyes and little upturned noses. Adam Hughes's females look like airbrushed versions of centerfolds always caught by surprise in compromising positions. Terry Dodson's heroines all have high cheekbones, sultry eyes, and big hair, with very curvy bodies. The formulaic nature of these superheroines is a type of beauty pastiche, a constant reproduction of features that signify an ideal woman. Annette Kuhn famously argued that this tradition of structuring glamorous women from a list of valuable parts in an effort to standardize an image of female beauty can be found "from myth to fairytale to high art to pornography," and that the women "are stripped of will and autonomy" and "dehumanized by being represented as a kind of automaton, a 'living doll'" (1985, 14). The nearly identical superheroines—endlessly repeated—are a different format for a common theme of standardized beautiful women in popular culture; Victoria's Secret Angels, *Playboy* Playmates, cheerleaders, *Charlie's Angels*, the Kardashian sisters, Video Vixens, beauty pageants, pop star ingenues, and so on. The constantly reproduced beautiful woman implies interchangeability (which devalues women) and an easily achievable perfection (which is an impossible standard for women, and an impossible expectation for men).

The fetishized assembly line of superheroines that occurs in Idealism caters to a male fantasy of plentitude. In discussing the gendered nature of Orientalism in Hollywood movies, Ella Shohat describes this type of assembly-line beauty as the logic of a harem:

> *Harem structures*, in fact, permeate Western mass-mediated culture. Busby Berkeley's musical numbers, for example, project a harem-like structure reminiscent of Hollywood's mythical Orient. Like the harem, his musical numbers involve a multitude of women who . . . serve as signifiers of male power over infinitely substitutable females. The mise-en-scene of both harem scenes and musical numbers is structured around the scopic privilege of the master and his limitless pleasures in an exclusive place inaccessible to other men. Berkeley's panopticon-like camera links visual pleasure with a kind of surveillance of manipulated female movement. (1997, 51–52)

A similar "scopic privilege" is at work with the "infinitely substitutable females" in this style of comic book art. The near-identical women are often displayed in succession or as a group for the reader to gaze at for as long as he desires. Like the male gaze of cinema described by Laura Mulvey, the comics reader is an invisible voyeur presented with an unrestricted vision of beautiful women in tight clothes and invitingly sexual poses. The harem structure is sometimes blatantly obvious, like Greg Land's cover for *The Women of Marvel* #1 (2018), a book meant to celebrate the strength and power of the company's superheroines, where four major female characters pose sexually, waiting for the reader to buy their book. Or Jay Anacleto's variant cover for *Detective Comics* #1000 (2019) featuring Batman sitting on a throne surrounded by five provocatively posed costumed women from Gotham City. The infinitely substitutable superheroines suggest an unlimited supply of beauty for men to enjoy, a way to exercise control over female sexuality and to commodify it.

The "scopic privilege" that Shohat identifies as part of the harem structure designed to visually appeal to a male fantasy of sexual plentitude, a cornucopia of identically perfect women, is also a fundamental part of the Idealistic style of superhero illustration. The introductory chapter noted that superhero bodies are often described as "spectacular," noting that Anna F. Peppard claims "superhero comics center upon and make meaning out of the spectacle of the body, whether in exertion, pleasure, pain, or trauma" (2014, 565), and Charles Hatfield declares: "Superhero comic books have always been about the spectacle of bodies on the page" (2019, 217). When critics argue that the bodies of comic book superheroes are spectacular, an incredible sight to behold, they are referring to the characters as they are depicted in the default style of Idealism. In Idealism, the superhero is eminently visible. The body is always foregrounded, striking poses and framed for a privileged view. It may not be as bright and sunny as the Retro and the Cute styles, but it does shine a light on the details of the body. Conversely, the Grotesque style distorts and obfuscates the body, often displaying the deformities like in a freak show rather than as an ideal

to emulate or lust after. And the style of superhero Noir often hides the hero's body in shadows and subdued coloring.

The contrast between a super-masculine ideal and a super-feminine ideal is clarified through the drawings of their bodies. The influential presentation of ideal physicality is further reinforced by visual conventions of how the body is framed, how it is posed, and how it is often declared as ideal by observers within the story. Both male and female super bodies are framed within each panel as the central object, their forms taking up most of the space, with any other features (background details, motion, or explosion graphics) all directing the reader's gaze to the heroic figure frozen in a moment of action. In Idealism, more so than with any other artistic style, male bodies are framed to look strong and powerful—sometimes with a muscular arm swinging an enlarged fist almost straight out at the reader. Women, on the other hand, are often framed with close-ups on their breasts or buttocks, and are more likely to have a provocative hip thrust at readers than a fist. The men are often framed from slightly below, the viewer looking up at them as they confidently dominate the panel. Patrick Gleason's portrait of Superman and Superboy for the *Superman* Omnibus collection (2021) epitomizes the way men are illustrated as not just perfectly muscular, but also ideally inspiring and bold, almost divine in their appearance. It is Superman as a physical and moral ideal for Superboy to imitate, and for young readers to aspire to. Strong female characters may be framed from below as well, but they are still more often presented straight-on, or from an aerial viewpoint. The superheroine's body is not framed as a personification of power; rather it is offered seductively as an object for the presumably heterosexual male gaze to explore. Frank Cho's image of Spider-Woman from *The New Avengers* #14 (2005), for example, has the sultry heroine dominating the frame, but she looks directly at the reader, her arms spread wide so her breasts occupy the center of the panel. Spider-Woman may look fierce, but it as a fetishized fierceness, not one designed to strike fear in the hearts of villains, nor to inspire heroic admiration. Spider-Woman is framed as, *well* ... a spider woman; a seductress who lures victims into her literal web. Far more often than not, female characters are illustrated in a manner that amplifies the visual dichotomy established by Laura Mulvey (1975) in regard to film, wherein women are always depicted as objects of a male gaze and valued for their beauty above any other characteristics.

Similar to framing, how artists choose to pose male and female characters typically aligns with divergent gender stereotypes. Posing is an especially important factor in comic books because it is a static medium. The superhero story is always an action-packed adventure where characters are constantly on the move, flying through the air, swinging between

3.6 *Superman* Omnibus promo image (2021), Patrick Gleason, artist, DC Comics.

buildings, or running faster than the speed of light. "Speed is, of course, central to comics," argues Scott Bukatman in his discussion of the fantastic in Superman stories. "Since the days of Topffer, the medium itself has scanned quickly. The iconography of comics has a number of ways to represent rapid motion. And superheroes possess speed in abundance—the Flash is not alone. Vast speeds and scales, fundamentals of the sublime structure the superhero universe" (2016, 196). But, in its printed format, all this action is an illusion suggested by carefully posed images presented in a sequential order. While "posing" in most forms means to hold a position for a moment, comic book superheroes are in a constant state of posing from one panel to the next. Thus, the concept of a "pose" in comic books is twofold: both stationary and active. A stationary posture is a conventional pose; like holding still for a camera in real life, it is an intentional

IDEALISM AND COMIC BOOK HEROES | 79

way of freezing the body to signify something. A family in matching outfits smiling for a studio portrait at the mall signifies a happy nuclear family. Or a lingerie-clad supermodel arching her back seductively for a *Victoria's Secret* advertisement signifies sexual fantasies. The most conventional stationary superhero pose—hands on hips, chest thrust forward, jaw angled slightly upward, staring confidently off into the distance—has been a genre cliché since the 1930s. This iconic pose concisely signifies a range of cultural ideals associated with heroism: strength, confidence, innate power, symmetry, height, youth, and a classically beautiful face. In fact, this pose has become so ubiquitous in popular culture that it now transcends the specifically masculine traits that it initially associated with characters like Superman, Captain Marvel (Shazam), and Batman. This pose has become relatively gender-neutral, with the modern artist as likely to use the "power stance" with heroines such as Wonder Woman, Power Girl, and She-Hulk.

Active posing is an inherently contradictory term, but it is a crucial visual and narrative device in comic books. It is an image used by artists that pose characters in a moment signifying action. Violent battle scenes are the cornerstone of every superhero story, and successful artists manage to depict characters frozen at the moment of impact. How the bodies are illustrated throwing punches or avoiding laser blasts emphasizes the implied kinetic action, and these posed bodies glorify the heroism of the figures. Though many of the active poses used in comic books are available to both male and female characters, there are specifically gendered trends in posing that reinforce cultural perceptions about masculinity and femininity. The most obvious active pose is the perpetually flexing male hero. Whether recoiling in pain, preparing to leap into the battle, or delivering the final punch, the male hero is always illustrated as taut, his power and his righteousness barely contained by his muscular form. Aaron Taylor accurately links this superhero cliché to bodybuilding: "Their glistening musculature, their glorious, anguished contortions, their endless posing—these are preening bodybuilders in capes and spandex" (2007, 352). And, just as the competitive bodybuilder moves from one static pose to another, the superhero moves from frame to frame. In both cases, the bodybuilder and the comic book superhero present a series of poses meant to pantomime movement but also allow a lingering gaze.

Given the still-dominant logic in popular culture that only women are valued for their beauty, their "to-be-looked-at-ness" as Mulvey puts it, superhero comic books utilize many of the same devices as Hollywood films to counter perceptions of feminizing the male heroes as erotic objects. As Steve Neale (1983) has argued in relation to film (especially the Western and the iconic image of the cowboy hero), and Richard Dyer (1982) has detailed in his discussion of publicity photographs of Hollywood heartthrobs and male pinups, when men are the visual spectacle,

3.7 Batman and Ghost-Maker from *Batman* #105 (2020), Jorge Jimenez, artist, DC Comics.

they are framed and posed in certain ways to negate their passive objectification, and to bolster their status as strong, active subjects. In both moving and still images, Neale and Dyer observe, men are presented as active figures, too busy fighting, playing sports, being tortured, or undertaking other masculine activities to invite a fetishizing gaze. We will return to the limits of these attempts to disavow the spectacle of the male body as an erotic object, but the emphasis on physical conflicts within the superhero story and the industry's investment in valorizing hegemonic masculinity is reflected in the active posing that dominates how these ideal male bodies are intentionally displayed. These highly ritualized scenes, whether illustrated in comics or filmed in the movies, are described by Neale as essential because they offer visual evidence of masculinity, with "no trace of an acknowledgement or recognition of those bodies as displayed solely for the gaze of the spectator" (1983, 18). For example, when a shirtless Batman engages in a sword fight with his nemesis Ghost-Maker in *Batman* #105 (2020), illustrated by Jorge Jimenez, his muscular torso is clearly a spectacle, but the action and the violence of the scene presents the spectacle as motivated by his heroism rather than as merely a posed display of the male body.

In contrast to the way male heroes are actively posed as angry, flexing fighters, the costumed women are more explicitly posed as erotic spectacles. The women may be depicted undertaking incredible feats mid-battle, just as the men are, but they still must be illustrated as beautiful and fetishized. In his overview of costuming, Mike Madrid notes the similarity between superheroines and super models when it comes to posing. "A heroine will look like a supermodel if she possesses what is known as 'strike a pose and point' powers," argues Madrid, "for as mighty as the X-Men's Storm is, she strikes a pose, extends a hand, unleashes a lightning bolt, and looks great. Just like posing for a picture in *Vogue*" (2009,

292). The preference for long-distance powers for women allows the artists to "strike a pose" with the heroines apart from the struggles of a physical confrontation. Moreover, this device serves as a narrative rationale to keep the heroines' faces flawless and their hair flowing perfectly. The most egregious action stance is the infamous "broke back pose" where female characters are illustrated contorting their bodies in impossible ways to display both their chest and butt. Carolyn Cocca describes this common pose where the women are "unnaturally twisted and arched to display all of their curves in front and back simultaneously. One's back would have to be broken to contort in such a way" (2016, 12), Cocca does note that the heroines are often presented within the narratives as strong, heroic, and independent women, but that depicting women in poses like the "broke back" underscores their continued fetishization. "Given that there are fewer female than male characters," Cocca continues, "the repetition of their being posed in these ways makes it seem as if female superheroes are objects to be looked at rather than subjects to view the story through" (12). As an artistic style, Idealism is so focused on the illustration of perfect bodies (which, for women, means sexualized) presented within a limited range of posing styles that this dominant form of superhero art consistently and thoroughly normalizes and naturalizes a perception of male subjectivity and female objectification. Some of the art styles that will be addressed in later chapters, such as the Cute and Grotesque forms, break from the incessant fetishization of female bodies, but the dominant image of women in comics still provides the model of superheroines as hypersexual first and foremost.

The frequent depiction of heroines in the broke-back pose attests to comic book Idealism's obsession with exposing the female body and illustrating it for maximum visibility. The broke back may be anatomically impossible except for in comics, but it is merely the most exaggerated of the myriad fetishistic ways female characters are drawn for maximum visibility. In their skintight outfits, heroines are habitually posed bending over and either arching their buttocks or revealing cleavage; they spread their legs wide for the viewer as they leap into the air or kick at the bad guys, and they stretch and lunge in a variety of sexy yoga-like poses. DC's Huntress is a bloodthirsty fighter and an ally of Batman, but as illustrated by Ed Benes for *Birds of Prey* #57 (2005), her window-smashing, high-kick leap is more erotic than it is intimidating. Huntress's midriff and thigh-baring costume, complete with over-the-knee leather boots, further accentuates her ideal body as her minimally covered crotch becomes a central focus point for the image. In fact, a number of superheroine costumes are essentially designed with arrows, or material cut-outs, that point to their crotches (Spider-Woman, Star Sapphire, Dagger, Emma Frost, Starfire).

The consistent and insistent rendering of female characters with cartoonishly sexual figures flaunted in every panel for the leering male viewer confirms their role within the genre as first and foremost sexual objects. At times, the illustrations may border on the pornographic, but through Idealism, the sexualization remains rationalized by the genre ("the tight and revealing costumes are for ease in fighting," "of course the bodies are all fit, they are athletic," and "of course the bodies are going to be exposed if they are fighting in mid-air"). But with comics, more than any other visual medium, each and every image is carefully chosen, framed, angled, and posed by the artist. This overdetermination of women as ideals is similar to what Nadine Wills, in her discussion of classic musicals, calls a "'110 per cent woman,' a female body where sex and gender are so codependent, stereotyped and stylized that the final product is an excessively delineated femininity" (2001, 121). Wills argues that early musicals filmed and posed women to accentuate, exploit, and contain their gender/sexuality in a manner that disguised the artificial construction of the "110 per cent woman" through narrative and visual conventions.

3.8 Huntress from *Birds of Prey* #57 (2005), Ed Benes, artist, DC Comics.

Specifically, Wills focuses her analysis of femininity on the preponderance of "crotch shots" in musicals. The cinematic crotch shot, in a movie genre not explicitly about sex, is the equivalent of the superhero comic's fetishistic posing of women. Just as the broke-back and open legs poses in comics visually foreground eroticized parts of the female body, the filmic crotch shot is "any particular moment when attention is drawn to the female genital area, either diegetically (by movement, costume, set, and so on) or technically (through cutting, framing or camera movement)" (Wills 2001, 124). Wills divides this very specific filming practice into two categories that serve both to authenticate the femininity of the character and to titillate audiences:

IDEALISM AND COMIC BOOK HEROES | 83

> Essentially there are two types of crotch shot in the musical genre, the "posed" crotch shot most (in)famously used by Berkeley, and the "accidental" crotch shot which succeeded it between 1935 and 1957. The main difference between the "posed" and the "accidental" crotch shot is that the former is much more obvious than the latter, even though both are equally contrived. The "posed" crotch shot, blatantly explicit, derives its titillating power from the shame/shamelessness of the exposure ("I can't believe she's showing me her panties!"); while the apparently less contrived "accidental" crotch shot is structured around the suspense of concealment/revelation ("Do we get to see her panties? When do we get to see them?"). (125–127)

A similar dynamic is common in comic books where crotch shots (and other bodily parts that signify female sexuality/gender) can be the focal point for heroines either when striking a stationary pose or an active one. For example, Amanda Conner's drawing of Power Girl from *Power Girl* #1 (2009), as she strikes the classic "hands on hips" heroic pose with a sexy twist while telling fellow adventurer Dr. Midnight: "Look at me. Tell me what I am missing." Conner's illustration is a typical image in comics, a self-aware version of the "posed" musical crotch shot, with Power Girl's body on display from her barely covered pubic area to her mostly exposed breasts. Likewise, comics are full of heroines' "accidental" crotch shots as they are drawn leaping, fighting, and contorting their bodies in ways that frequently show off their crotches as well as breasts, legs, and butts. Tom Derenick's drawing of Black Canary from *JLA* #121 (2005) as she flips upside down, legs spread, crotch presented to the reader, demonstrates the type of action often used to justify foregrounding taboo body parts. Both Power Girl and Black Canary's costumes are drawn with a noticeable middle seam, which (not coincidentally) gives the impression that both heroines are exposing even more than they are—a common case of superheroine "camel toe." Of course, as mentioned earlier, there is nothing "accidental" about any image in comics. They are all posed by the artist (and facilitated by the skimpy costumes) to present the body of the characters in very specific and ideological ways. In the case of Power Girl, Black Canary, and Huntress, these "crotch shots" substantiate the heroines as Wills's "110 per cent woman." They are fetishized, exposed, and objectified so thoroughly and repetitively that hypersexuality seems synonymous with femininity within the style of Idealism.

Interestingly, for male superheroes who are likewise illustrated as essentially naked bodies with costumes that reveal every overdeveloped muscle, there is a genre-specific treatment of crotches, but it serves to deflect eroticism rather than to court it. The costume cliché of wearing underwear on the outside of their tights visually highlights the male hero's crotch area. The

3.9 Power Girl from *JSA: Classified* #1 (2005), Amanda Connor, artist, DC Comics.

long-standing costume design (based on the image of 1930s circus strongmen) has served to demarcate the groin from the rest of the body as well as to cover it up. While muscles are always visible through the costumes, crotch bulges are denied by this device, dubbed by fans as the "Underwear of Power." In her overview of superhero masculinity, Esther De Dauw argues: "The reader's eyes are consistently drawn toward the crotch, because the

IDEALISM AND COMIC BOOK HEROES | 85

skintight bodysuit of the hero tends to be one single color, except for the chevron and the underwear, the Underwear of Power consistently frames the crotch and the penis to make drawing an actual bulge unnecessary" (2021, 37). Where crotch shots of female superheroes (and boob shots, and butt shots) link their gender to sexual objectification, for male superheroes there is a visual elision of the penis in favor of the larger and more cultural phallic implications of the character's physique and incredible powers. As Aaron Taylor summarizes the dynamic: "Perhaps the absence of the literal phallus in the world of the male superhero accounts for the relentless struggles for domination of the *symbolic* one" (2007, 354). The issue of the elusive and mythical super-penis is a topic rife with gender concerns. Elsewhere I have discussed how the visibility of the phallus and the invisibility of the penis consecrates the superhero's hegemonic masculinity and mirrors the duality of public/private identities that are fundamental to the genre (Brown 2020). With the focus here on the artistic style of Idealism, however, it is worth noting that the different construction of male and female crotch shots in itself operates to reinforce the gender binary of men as heroic subjects and women as erotic spectacles for objectification. De Dauw goes on to conclude: "Drawing a penis would further reduce the superhero to a sex object and sabotage the super-body's purpose: to inspire subject desire in the reader. The male superhero is not drawn as a sexual object but as a powerful subject, even accounting for the eroticism present in voyeuristic close-ups" (2021, 37). In other words, while the incredible male bodies of Idealism are illustrated as spectacles, a range of artistic and genre conventions function to overtly keep the men as points of reader identification rather than as objects of the reader's privileged gaze.

The often-absurd illustration of both male and female superhero bodies in the dominant style of Idealism reflects a wide range of cultural conceptions about gender, sexuality, and power that are assumed to be natural and rooted in the body. As such, the fantasy world of comic book heroes can hegemonically reinforce systemic beliefs about masculinity and femininity, as well as conceptions about morality and justice. They also help us, as researchers, understand what these gendered beliefs are and how they have changed and adapted. Superhero comic books expose (no pun intended) the importance of bodies as bearers of cultural meanings in a manner far more direct than in most media forms. It would be a mistake, however, to focus on the superheroic figure in Idealism as merely unrealistic and unachievable bodies. In his discussion of masculine aspirations and classic superhero bodies, Richard Harrison reminds us that these illustrations are meant to be symbolic, not realistic: "All of this analysis and talk treats comic book art as if it's representational, as if the purpose of the artwork in a comic book is to draw characters as though they

were human beings dressed up to play their superheroic or supervillainous roles. Instead, comic art is a species of graphic art precisely because the drawings aren't drawings of how characters look but of what the artists are telling the readers about them through the pictures" (2020, 351). Harrison's important point is that superhero bodies are exaggerated to signify an extreme of heroism rather than implying these are realistic or even possible bodies. Focusing on the artistic variations can help us understand how the "sign" of the superhero changes across time, or even just across storylines. For example, Jim Lee's cover illustration for *All-Star Batman and Robin* #9 (2008) is an homage to Bob Kane's classic depiction of the characters for *Batman* #9 in 1941, but the far more muscular and angry ideals in Lee's drawing signify a development of artistic techniques and, more importantly, a more aggressive characterization of the caped crusader. Lee's portrait of Batman is not meant to be taken as a real body, but it is an image of how the artist would like readers to perceive this larger-than-life character.

I would also like to clarify that, despite the ridiculous lengths comic books go to obfuscate the male body as an *erotic* spectacle, there is always a sense of male sexual objectification that is hard to discount. The conventional dichotomy of male bodies as subjects versus female bodies as objects is a dynamic that superhero comics have long embraced and naturalized to appeal to an assumed masculine and heterosexual readership. The art of Idealism reflects these assumptions, but Idealism is so excessive in both hypermasculinization and hypersexualization that different avenues of desire are readily accessible, whether intentional or not. The excessive display of super-male bodies invites erotic objectification even as it strives to deny it. Moreover, the genre conventions of secret identities, intimate same-sex sidekicks, and flamboyant, colorful, and tight costumes all facilitate a range of other avenues of desires. The structure of the genre that creates an indelible concept of hegemonic and heteronormative masculinity has always implied other nonheteronormative possibilities. "At every moment in their cultural history," Darieck Scott and Rami Fawaz contend, "comic books have been linked to queerness or to broader questions of sexuality and sexual identity in US society" (2018, 198). Likewise, Easton and Harrison argue that it is impossible for "comics to keep the line between the homosocial and the homosexual straight when it is so precariously thin." In fact, Easton and Harrison continue, superheroes "create *a queer space*, where various forms of masculine identifications and desires are *simultaneously* available" (2010, 138, italics in original). In the most common style of Idealism, superheroes are such extreme symbols of men and women that they are easily adapted to nonheteronormative interpretations.

Ideal and Exaggerated

In his discussion of the conformities implied by the superhero genre, Jose Alaniz describes how the hero's body serves as a focal point for identification and normative beliefs: "Baroque, absurd, and overdetermined, the super-body has its origins in fantasies of physical mastery typical of male adolescents (the primary comics demographic since the 1960s), which intersect with American national, ideological, and sexual myths" (2014, 17). Alaniz rightly points out the ideological influence the superhero has in promoting and naturalizing dominant beliefs. Furthermore, Alaniz's description of the super body as "baroque, absurd, and overdetermined" stresses the potential of even the idealized superhero body to be too much—exaggerated to the point of ludicrousness. Idealism can easily cross over a line and become ridiculous or grotesque because physical ideals in Western culture are so grounded in gendered terms, with visible muscles necessary for masculinity and curviness for femininity. The artistic excesses of the 1990s, which resulted in preposterously massive superheroes and impossibly chesty and long-legged superheroines, have already been mentioned. Current comic book illustrations are nowhere near the excesses that dominated styles in the 1990s, particularly from artists associated with upstart Image Comics. Anna F. Peppard describes this style as "using ultra-detailed line work and dense, complicated page layouts to depict bodies so hyper-muscular and hyper-sexualised that they seem to lack internal organs or the capacity to move without tipping over or toppling like a precarious Jenga tower" (2019, 321–322). Superhero bodies may not be as routinely excessive in the current market, but post-1990s Idealism still runs the risk of pushing images of perfection into the realm of absurdity.

Artists who merge Idealism with more cartoonish styles may ignore rules of anatomy in favor of stressing an image of strength or sexuality. As celebrated artist Klaus Janson claims in his guide to illustration, "The basic proportions of the human body can be exaggerated and distorted in comic book art" (2002, 28). When male muscularity or female curves are embellished as a means to undeniably signify gendered identities, the physical ideal can become absurd. Humberto Ramos, for example, uses a traditional American comic book style heavily influenced by Japanese manga. Ramos's figures are simple but graphically exaggerated in some areas. Ramos's depiction of Wolverine in Figure 3.10 demonstrates how even a seemingly neutral body part, in this case his neck, can become too hyperbolic. In an effort to depict the ultimate masculine body, illustrators often extend the excessive muscularity seen in biceps and pectorals to thick and veiny necks. In Idealism, no heroes are subject to the ridicule of being a "pencil-neck" (in itself, a bizarrely desperate and specific insult to one's masculinity). In signifying Wolverine's exceptional toughness, even while just

having a quiet conversation, Ramos's manga-influenced drawing adds neck muscles, ligaments, and veins that do not exist in human anatomy. Wolverine's neck becomes too long and too wide, making his head look absurdly tiny in contrast. Similarly, in J. Scott Campbell's pinup-influenced style of depicting superheroines, like the various identical-looking X-Women in Figure 3.5, the disproportionately long legs and midsections and pronounced breasts, despite looking dangerously skinny, are so extreme they become somewhat freakish. Campbell women (as well as those illustrated by many other artists) tend to look stretched-out, with twig-like arms and legs, as if they would have trouble even moving in real life.

In keeping with the superhero genre's obsession with basic structural dichotomies (good/evil, American/Other, order/chaos), a narrative device often played out through the convention of evil doppelgängers (Superman/Bizarro, Justice League/Crime Syndicate, Spider-Man/Venom, Batman/Wrath, Flash/Reverse-Flash, Shazam/Black Adam, etc.), there is a related visual dichotomy between Ideal and Grotesque bodily representations. While the concepts of Ideal and Grotesque appear to be polar opposites, in terms of comic book art the Ideal is always at risk of tipping over into the Grotesque. In his discussion of transforming superhero bodies, Michael Kobre points out: "Marvel's heroes, like the Hulk, were often perceived as monsters, but in fact the exaggerated, unstable bodies of virtually all superheroes can also be understood as monstrous" (2019, 156). Both narratively and visually, the superhero is a figure full of contradictions, many of which are often played out through the body. We will return to the issue of Idealism slipping into the realm of the Grotesque in chapter 7. Here I just want to acknowledge the subjective nature of categorizing artistic styles in a medium rife with contradictions and illustrative variety. One reader's Ideal is another's Grotesque, and vice versa.

3.10 From *Wolverine Civil War* #46 (2004), Humberto Ramos, artist, Marvel Comics.

IDEALISM AND COMIC BOOK HEROES | 89

4 | RETRO ART AND NOSTALGIA

The 1939 New York World's Fair was built around the theme of futurism. Adopting "The World of Tomorrow" as its slogan, the fair showcased marvelous inventions, new technologies, and incredible architecture, exemplified by the iconic Trylon and Perisphere buildings. A number of *World's Fair Comics* that were sold on the grounds featured stories of the new sensation Superman, who had become a full-blown phenomenon quickly after his first appearance just a year earlier. The 1939 World's Fair even had a special Superman Day that included athletic contests, comic book giveaways, and performers dressed as Superman. Like the fair itself, Superman was a vision of a possible American future full of hope. And, similar to the fair, Superman would take on the moniker "Man of Tomorrow," a descriptor still used in comic books nearly a century later. History books treat the New York World's Fair as a shining art deco celebration of American industry and national spirit, a moment of optimism just prior to the attack at Pearl Harbor and America joining World War II. Looking back at this moment in the early development of the superhero from the vantage of the twenty-first century creates a strange mixture of nostalgia for a seemingly more innocent era and its untarnished dreams for an amazing future. A similar sense of nostalgia pervades modern superhero comic books illustrated in a "Retro" style. Contemporary artists such as Darwyn Cooke, Javier Pulido, Tim Sale, Michael Allred, Steve Rude, Chris Samnee, Ty Templeton, Nick Derington, Bruce Timm, Michael Cho, David Aja, and Marcos Martín present clean, simple lines, bright colors, and uncomplicated (usually smiling) faces. The Retro aesthetic intentionally evokes a simpler bygone era populated by stylish heroes eager to sock it to villains. The Retro superhero represents a longing for an indistinct,

4.1 *Teen Titans* #5 variant (2014), Darwyn Cooke, artist, DC Comics.

mythical earlier time when heroism was simple. However, this façade of nostalgia works on a number of levels in superhero stories and reveals an obsession with the genre's own romanticized past, and with cultural shifts in relation to marginalized groups (people of color, women, LGBTQ, disabled, etc.) and how they are represented in comics.

Retro superhero illustrations share a number of similarities with the aesthetic of Cute superheroes that will be addressed in chapter 6. Both the Retro and the Cute styles are defined by bold outlines, basic color-blocking, streamlined bodies, and cartoony faces. Andrei Molotiu defines cartooning as "the graphic simplification of figurative shapes for the purposes of communication, humor, and so on in comic strip and comic book rendering" (2020, 153). Both styles also suggest a nostalgic affect, but whereas the Cute superhero brings to mind childhood or childish pleasures, the Retro version suggests an imagined collective history and an ideal moment of the genre's conception. The clean, crisp line work, bright colors, and two-dimensional renderings of Retro artists, exemplified by the work of Darwyn Cooke, strip "superheroes to their essences, finding a way to capture their spirits . . . with a timeless flair" (Wallace 2018, 54). Cooke's artwork for *Teen Titans* #5 in 2014 showcases the conventions of the Retro style: happy young heroes, classic costumes, and a general aura of an earlier time period.

The popularity of Retro-style superheroes in modern comics was inspired by the incredible success of the television program *Batman: The Animated Series* (1992–1995). Created by Bruce Timm, Paul Dini, and Mitch Brian, *Batman: The Animated Series* took its visual cues from the Superman

cartoons produced by Fleischer Studios in the early 1940s. Bruce Timm's designs for the characters and the settings combined an art deco aesthetic with an angular, but still cartoonish, style. The standardized Retro look of the characters carried over into other television series, including *Superman: The Animated Series* (1996–2000), *Batman Beyond* (1999–2001), *Justice League* (2001–2004), and *Green Lantern: The Animated Series* (2011–2013), as well as several sequel Batman series and spin-off movies. This animated look created by Timm essentially became DC's official look during the 1990s and 2000s, reproduced on countless merchandising forms and spawning a number of successful comic book series. Timm's style was adapted by numerous artists for print, most notably Ty Templeton, across titles like *The Batman Adventures* (1992–1995), *Batman & Robin Adventures* (1995–1997), *Batman: Gotham Adventures* (1998–2001), *Superman Adventures* (1996–2002), and *Justice League Adventures* (2001–2004). This ambiguously nostalgic style appealed to old and young audiences alike, inspired a range of similarly streamlined artistic styles, and established Retro as a common alternative to the dominant extremes of Idealism.

In previous chapters I have mentioned the overlap between styles of superhero art. Though this project treats categories as somewhat distinct for the purposes of analysis, the borders between styles are often blurred. From cartoonish to photo-realistic, all of the styles addressed in this book need to be understood as a matter of degrees, as different points on a flexible scale. Retro art is prone to blend with other categories of illustration because it functions as a visual referent to the past, an evocation of a historical mood or tone, which itself may be varied. There are several prominent artists whose work is often classified as Retro that I will not focus on in this chapter because their "Retro-ness" is typically subsumed under other visual/narrative tropes. Alex Ross's incredible work, especially for the Kurt Busiek–written *Marvels* (1994), is a type of Retro illustration. But the defining trait of Ross's work is his lifelike depictions of characters, so his style will be addressed in the context of Realism in chapter 5. The nostalgic effect of Ross's art is a result of his realistic illustrations set in earlier time periods, or suggesting versions of characters as played by actors in old television programs, like George Reeves as Superman from the 1950s, Adam West as Batman in the 1960s, or Lynda Carter as Wonder Woman from the 1970s. A case could also be made that superhero art that falls under the category of Noir, which will be the focus of chapter 8, could also be classified as Retro because the Noir aesthetic is overwhelmingly identified with the classic 1930s/1940s cycle of Film Noir. Thus, the illustrations of creators like Matt Wagner and Howard Chaykin invoke a type of nostalgia through their visual allusions to the stylish femme fatales and the trench-coated private eyes of the past. I have opted to address both Wagner and Chaykin's work in the Noir chapter, rather than here as Retro,

because their artistic look is more generalizable across styles; both are less exclusively Retro.

There is a fine distinction to be made in relation to comic books, nostalgia, and different artistic styles. Several mini-series have explored historical moments in the superhero genre without employing Retro-style illustrations. Most notably, Alan Moore's landmark *Watchmen* (1985–1986), with art by Dave Gibbons, has been described as nostalgic in that the story slips between the past and present as it deconstructs the superhero fantasy across several generations. The complex *Watchmen* has been one of the most explored texts within comics studies, and nostalgia has been invoked primarily in a postmodern sense to address the story's engagement with history, as well as the use of other narrative forms and a variety of impactful graphic techniques. While a book like *Watchmen* may count as nostalgia in some senses of the word, it does not make use of Retro artwork to enhance the nostalgic effect of the series. The absence of Retro artwork denies the series a sense of nostalgia as the colloquial "fond remembrance." In fact, *Watchmen* does not look back fondly at the history of superheroes; instead it critiques and deconstructs the figure of the superhero as a vile and corrupt illusion. In other words, the use of Retro illustrations can be taken as the chief determinant of a nostalgic emotional sensibility; it can produce a fond sweetness and project an air of innocence. The art sets the tone for the stories and can frame a historical adventure as a naïve adventure or an ugly revelation.

Super-Nostalgia

In a very broad sense, nostalgia is often identified with superheroes. Comic books are associated with childhood and quaint memories of bygone days spent lovingly dreaming about becoming a superhero, or Saturday mornings watching *Spider-Man* or *Super Friends* cartoons. Nostalgia is pictured through rose-colored lenses, whether it is our personal past or a cultural history. America has invested a great deal of its identity in an image of the past that effaces conflicts and inequalities, instead promoting a hegemonic sense of the nation as pure and unsullied. In his landmark work on postmodernism, Fredric Jameson (1984) identified nostalgia as a distinctive feature of late capitalism. According to Jameson's theory of postmodernism, in a shift that developed after the high-modernist era of the 1950s and early 1960s, our consumer-based market and media-dominated environment has created a culture of pastiche. Styles and artforms have become blended, equally debased, and grounded in artifice. Jameson uses the example of movies to demonstrate how nostalgia circulates in postmodern times as a cluster of stylish signifiers without a direct referent to historical

reality. "The nostalgia film was never a matter of some old-fashioned 'representation' of historical content," Jameson argues, "but approached the 'past' through stylistic connotation, conveying 'pastness' by the glossy qualities of the image, and '1930s-ness' or '1950s-ness' by the attributes of fashion" (563). The fashions, props, hairstyles, music, even the actors' performances evoke an image of the past that is devoid of actual historicity. Ultimately, Jameson notes, the battery of signifiers that connote historical periods construct the past as a form of simulacrum, or an "identical copy for which no original has ever existed" (562). In other words, nostalgia is a fond evocation of a past that never really was: an imagined moment in time that is nothing more than a style of representation, scrubbed free of undesirable historical realities. Or, as Jean Baudrillard (1995) would add, in postmodern culture the representation replaces the real in a manner that discourages serious considerations of current realities.

Retro comic book art is the height of postmodern nostalgia. The Retro art is pure simulacrum, designed to convey an appearance of historicity, a "feel" or "mood" from a past moment in time, without really being of that earlier moment. As chapter 1 detailed, superhero art has changed over time, reflecting different aesthetic principles in different eras. But Retro art does not re-create the *actual* look of the past, only a generalized *suggestion* of it. Retro artists often simplify the figures, doing away with features that are no longer considered visually gratifying (i.e., barrel-chested bodies) or with lower-quality production standards (smudged ink lines or diluted colors). The stylized and romanticized image of the past created through Retro art captures an imagined historical aesthetic in a manner that may be more marketable than the actual artwork from the past. The most recent editions of the DC Comics archive collections featuring stories divided by historical periods, for example, have replaced cover art from the earlier decades with new art meant to evoke those times. The initial cover for *Superman in the Fifties* featured an image of the Man of Steel drawn by Wayne Boring in 1954, whereas the newest edition displays a Retro version of Superman illustrated by Michael Cho in 2018. Similarly, all of the books reprinting comic stories from the different decades and Ages (Golden, Silver, Bronze) have Retro-looking covers illustrated by current artists like Jenny Frison, Dave Bullock, and Nick Derington, as well as Michael Cho. As a popular commodity, the simulacrum of Retro superheroes has literally replaced the actual illustration of the characters from the past, at least on the covers. Within the stories themselves, the Retro style has been used primarily in three different ways, each of which relies on the art to evoke a nostalgic feel for a general time period. Moreover, the nostalgic mood imbues specific qualities of innocence and naïveté in the characters and the genre as a whole. Retro art typically appears in stories about the origins or past adventures of iconic superheroes, in tales about earlier time periods

that rewrite history to include an array of earlier versions of popular characters, and in adventures set in current times but with an intentional allusion to the past.

The general fascination with a sense of nostalgia that Jameson identifies as a component of postmodern culture is a distinctive feature of the current comic book industry and the consumption practices of fandom. The simultaneous presence of old and new versions of popular heroes invites an acute awareness of previous appearances and storylines on the part of both creators and fans. From back-issue bins in every comic book specialty store to the robust collectors' market for high-end reproductions of older comics in archive or anniversary editions, nostalgia typically sits in close proximity to the present day with superheroes. Previously, I touched on the fact that different artistic styles can function as a visual representation of Henry Jenkins's conception of "multiplicity" in superhero comics that identifies the various co-existing versions of characters. Retro comic book illustrations depict characters as "different" within the context of multiplicity with a particular reference to bygone eras. Jenkins does identify historically minded comics as a significant contribution to multiplicity. "If one factor contributing to the multiplicity of superhero comics is a growing consciousness of genre history, then it is hardly surprising that this historical reflection occurs often within the pages of the superhero comics themselves," Jenkins argues. "An important subgenre of superhero comics might be described as a curious hybrid of historical fiction (seeking to understand the past through the lens of superhero adventures) and fictional history (seeking to understand the development of the superhero genre by situating it against the backdrop of the times that shaped it)" (29). In other words, the stories either focus on historical moments with an inclusion of superhero characters to provide a different (and imaginary) perspective, or they explore earlier points in a hero's career to further define the character. When this "curious hybrid of historical fiction and fictional history" is illustrated in a Retro style, the nostalgic tone of the stories is visually signified (be it carefree and innocent, or melancholy and remorseful), despite being a mere simulacrum of the past.

The passage of time has always been fuzzy in superhero stories. Characters can time-travel or visit parallel universes frozen in different eras. Heroes are reimagined in "Elseworlds" and "What If?" tales of medieval knights, Elizabethan performers, seventeenth-century pirates, Industrial Age adventurers, 1930s hard-boiled detectives, and any number of other historically displaced scenarios. In comic book terms, all of these routine variations are rationalized under the premise of a multiverse. As Karin Kukkonen describes it, "This multiverse holds different versions of different characters from different epochs and different series, in comics written

by different authors" (2010, 46). And, we can add, illustrated by different artists in different styles. More practically, history is a vague concept because the heroes (many of whom have been in continuous action for over eighty years) need to remain perpetually young. Umberto Eco (1979) has famously referred to this as the superhero's "oneric cycle." The commercial imperative of selling the same story week after week means that comic books must balance the illusion of change with a return to the status quo for the beginning of each new adventure. Eco argued that Superman (and by extension all comic book superheroes) "develop in a kind of oneric climate—of which the reader is not aware at all—where what has happened before and what has happened after appear extremely hazy. The narrator picks up the strand of the event again and again, as if he had forgotten to say something and wanted to add details to what had already been said" (114). The "haziness" of exactly what has occurred in previous stories contributes to a timeless quality of the characters and the genre. Exactly how old the characters are and how long they have been dressing up to fight crime is ambiguous. This intentional blurring of time in comics allows the façade of Retro art to effectively represent an earlier (but still indistinct) period in a hero's career. For example, both Javier Pulido's illustrations for *Robin: Year One* (2000) and Marcos Martín's work on *Batgirl: Year One* (2003) are meant to indicate an earlier and more naïve time for each of the heroes, before they were jaded by the violence of crime fighting. The stories never say when they take place, nor how long ago the first year was. But the Retro style evokes a sense of nostalgia that reinforces the vague sense of "pastness" necessary to the adventures.

Artist Tim Sale's Retro style has become almost synonymous with nostalgic tales about superheroes' earliest—and character-defining—adventures through his frequent collaborations with writer Jeph Loeb. Sale and Loeb have explored some of the industry's most iconic figures, starting at DC Comics with *Batman: The Long Halloween* (1996), *Superman: For All Seasons* (1998), and *Catwoman: When in Rome* (2005); and at Marvel with *Daredevil: Yellow* (2001), *Hulk: Gray* (2003), *Spider-Man: Blue* (2011), and *Captain America: White* (2015). Except for the Captain America story, which is set during World War II, none of these stories are grounded in a clear time period. Sale's Retro style functions like rose-colored glasses, signifying a romanticized past and a sense of innocence for the young heroes. In fact, what these stories document are the moments when the heroes lost their sense of innocence, the events that helped turn them into the characters we see in current comic books. In his introduction to the prestige-format collection of all four Marvel stories, *Yellow, Blue, Gray & White* (2015), Sale notes that working on these heroes was nostalgic on a personal level. "I grew up, got into and was first really passionate about the medium of

4.2 From *Robin: Year One* #1 (2001), Javier Pulido, artist, DC Comics.

4.3 From *Batgirl: Year One* #6 (2003), Marcos Martín, artist, DC Comics.

comics when I discovered Marvel Comics," Sale writes. "So when Jeph and I had a chance, in 2001, to play in the Marvel world, and to do it in the way that we had established elsewhere—tales set in the early years of these iconic characters, emphasizing the heart and sentiment, as well as the dynamics and wonderful characters—it was, for me, a dream come true" (Loeb and Sale 2018, 10). Sale's Retro illustrations, the vague "pastness" of the tales, and the creators' fondness for the heroes they enjoyed in their own youth conveys a feeling of a wistful and melancholy memory.

Each of the books in the Marvel "colors" series by Loeb and Sale is structured around a love letter written by the hero to someone they have lost. In *Daredevil: Yellow* the titular hero writes a letter to his deceased love Karen Page reliving his father's murder at the hands of mobsters and several of his first costumed adventures, which coincided with Daredevil (and his alter ego Matt Murdock) falling in love with Karen. Told essentially as an extended flashback, the time period is never clarified. Daredevil made his comic book debut in 1964, but the illustrations depict a New York that looks more like the late 1940s or early 1950s. The hairstyles, poodle skirts, capri pants, suits, thin ties, and office décor all reinforce the general Retro look of Sale's art. *Yellow* retells moments that were originally depicted in several of the earliest issues of *Daredevil*. More to the point, through Sale's artwork, *Yellow* does not just re*tell* these adventures, it nostalgically reen*visions* them. For example, the full-page sequence of attorney Matt Murdock and his secretary/girlfriend visiting the mind-controlling villain Purple Man in prison that originally occurred in *Daredevil* #4 (1964) is reenvisioned in *Daredevil: Yellow* (2001), but the scene looks even older in the modern version than in the original

98 | SUPER BODIES

4.4 From *Superman: For All Seasons* #2 (1998), Tim Sale, artist, DC Comics.

from thirty-seven years ago. Literary critic Harold Bloom describes revisionism as "a re-aiming or a looking-over-again, leading to a re-esteeming or a re-estimating. The revisionist strives to see again, so as to *esteem* and *estimate* differently, so as to *aim* 'correctively'" (1975, 4, italics in original). Revisionism has been a common practice in superhero comics ever since Marv Wolfman and George Perez's *Crisis on Infinite Earths* mini-series (1985–1986) was used to clear away the confusing and contradictory history of too many coexisting versions of DC heroes. Following suit, a great deal of Comics Studies research has focused on revisionist texts like *Batman: The Dark Knight Returns* (1985) and *The Watchmen* (1987). In his discussion of revisionist superhero narratives, Geoff Klock argues, "revisionary realism is only another version of what comic books often accomplish in the narrative, a literal revising of the facts of the comic book character's history on the basis of recent interpretation" (2006, 119). Moreover, Klock claims revisionism is a conscious "process" that "actively strives to participate in comic book traditions, invoking various recognizable aspects in such a way as to recast readers' understandings of what they have seen before" (119). Tim Sale's Retro illustrations help create a text that is a nostalgic revisioning of the hero's history, not changing the actual events but altering them by adding a sentimental perspective. As Daredevil self-consciously narrates at the end of *Yellow*: "The rest of the story you know too well. It's been told a lot of ways, with many other people in my life, but this is the way I choose to remember it when I think of you."

Stories like *Robin: Year One* and *Batgirl: Year One* (as well as a slew of other Year One books for different DC heroes) and the various Tim Sale and Jeph Loeb mini-series at both Marvel and DC revisit a character's

RETRO ART AND NOSTALGIA | 99

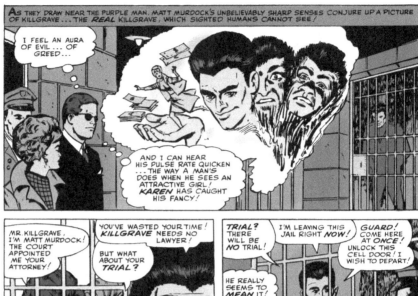
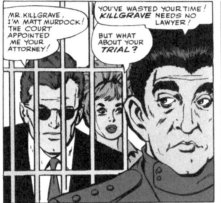
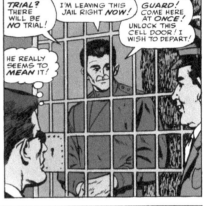
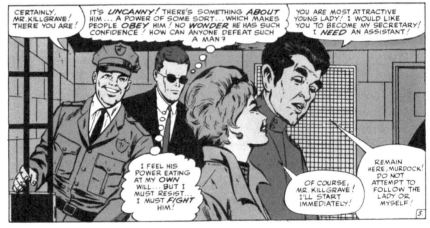

4.5 From *Daredevil* #4 (1964), Joe Orlando, artist, Marvel Comics.

past and revise how that past is understood through nostalgia. "Year One books—starting with Frank Miller's influential *Batman: Year One* in the mid-1980s—have a paradoxical mission," Henry Jenkins points out in his discussion of multiplicity. "On the one hand, they want to strip down encrusted continuity so that they can introduce the classic characters and plots to a new generation, but at the same time, these books are going to be avidly consumed and actively critiqued by the generation of comics readers who grew up with these figures. In many ways, the emotional impact of

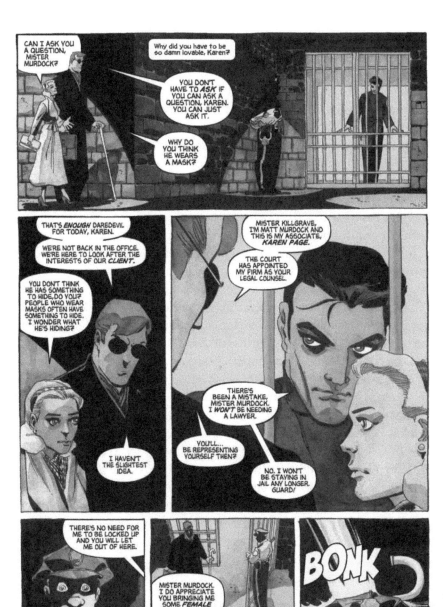

4.6 From *Daredevil Yellow* #2 (2001), Tim Sale, artist, Marvel Comics.

Year One stories depends on our knowledge of what is to follow (or more accurately, what has already happened in earlier books)" (2009, 31–32). Jenkins is correct about this double-bind faced by Year One-type comics, yet the common use of Retro art to create a vague aura of nostalgia in these books helps to position them as eternally "of the past" rather than as a new beginning (or in comic book terms, a relaunching or rebirth). David Mazzucchelli's art for *Batman: Year One* established a Retro style as an effective tool to create a timeless quality to these tales. Rather than committing

RETRO ART AND NOSTALGIA | 101

to an exact date, or a certain number of years ago, Miller's narrative for *Batman: Year One* remains vague, but even more strikingly ambiguous are Mazzuchelli's illustrations, which look like they would be at home anywhere from the 1950s to the 1980s.

As much as superhero stories set in the past serve to explore new perspectives on the characters' origins, there are certain formative moments the retellings *must* touch on. Martha and Thomas Wayne must always be murdered in an alley in front of young Bruce's eyes. Uncle Ben must die so Peter Parker learns that "With great power comes great responsibility." Jean Grey must pose a threat of losing control and becoming the Phoenix. Captain America must always be a man out of his own time. These iconic moments define the characters and are treated as sacrosanct events, as if they are true historical events not subject to any significant alteration. "Stories of past comics serve as an important basis for contemporary superhero storytelling: creators cannot simply invent something new with no regard to existing works, as this will lead to a disruption of continuity as well as outraged fans," Nao Tomabechi argues. "Because of the convention of the genre to always tie present works closely to the past, ground-breaking progressions are challenging to achieve, for there must always be a link between the new and the old" (2019, 39). As a genre, the superhero comic book is obsessed with its own past and traditions, never really breaking free of storylines that may have been conceived fifty to eighty years ago. But the stories can add elements or shift the focus of the pivotal moments to suit the expectations of current audiences. Furthermore, the use of a Retro artistic style encourages readers to understand these revised or retold events as grounded in history, or as if they are witness to the original moment, at the first time it occurred.

Redrawing the Past

The best-selling miniseries *DC: The New Frontier* (2004), written and illustrated by Darwyn Cooke, is considered the epitome of Retro art. Set between the end of World War II and the dawn of the Kennedy era in the early 1960s, *The New Frontier* charts a fictional history of the DC universe transitioning from the Eisenhower years to the youthfully optimistic Silver Age of comics. In his discussion of racial representations in *The New Frontier*, Sean Guynes describes the miniseries as "an unabashed, nostalgic paean to the vast history of DC's intellectual properties and narrative and artistic legacies" (2020, 174). Moreover, Guynes adds, "*New Frontier* meld's Cooke's signature style with the aesthetics of 1950s Populuxe design to render a nostalgic glimpse of early Cold War America and its superheroes" (175). The story manages to include nearly all the major (and many

minor) DC characters, beginning with the military- and scientific-themed teams of adventurers that were popular in the aftermath of World War II, and carries through to introduce, ostensibly for the first time, all of the colorfully clad superheroes at the heart of the DC universe. The plot is concerned with a malevolent otherworldly power known as The Center, which the heroes need to unite against in order to save the world, thus ushering in a new age of heroes. But the central conflict is relatively inconsequential; what the series revels in is the nostalgic introduction of the superheroes in their youth, and the image of a bright and shiny America full of hope for a wonderous future. What Cooke manages to do in *The New Frontier* is to construct an origin story for the entire genre of superhero comics at DC. Situating the heroes as all emerging in an idyllic national moment, the story reinforces the belief in superheroes as an embodiment of America as powerful, honest, and good. Contrary to all the grim-and-gritty revisionist takes on superheroes ever since *Batman: The Dark Knight Returns* changed the world of comics in 1985, *The New Frontier* successfully creates a colorful and unsullied imagining of the genre's past. It is an ideal, Norman Rockwell-esque vision of Americana, with capes and masks.

Of course, the world of *The New Frontier* never existed, not just because it is a fictional story dealing with aliens and super people, but because even in the comic books of the 1950s and 1960s, superheroes did not look as pure and untarnished as they do in Cooke's illustrations. Cooke's striking artwork dominates and defines *The New Frontier* as a nostalgic tour-de-force. From the various clean-cut and cartoonish superheroes in their original costumes to the stylish automobiles, planes, cocktail dresses, and nightclubs, Cooke visualizes a sanitized 1950s utopian America. Henry Jenkins describes Cooke's art in *The New Frontier* in postmodern terms as "lushly colored images—more interested in evoking a mood or a milieu than digging deeply into the characterizations. His artwork borrows little from actual postwar comics, tapping the popular futurism associated with magazine ads and the Technicolor images of Hollywood movies" (2009, 34). This is a 1950s simulacrum—a copy of a copy with no original—that presents a dream version of the past and links that dream to an imagined history of the superhero genre. Similarly, Matt Yockey describes what he calls Cooke's "hyper-nostalgic" depiction of the era as "a retrograde, nostalgic refurbishment of these characters that quixotically makes them more overtly *of* the early 1960s than the actual comic books of the 1960s themselves do" (2012, 365). *The New Frontier* may evoke an unblemished ideal of the superhero, of the way we imagine superheroes in that time period actually looked, or the way they are fondly remembered by individuals who read comics from this era in their childhood, but it is a wishful and romanticized chimera of the past.

The narrative strategy of using real figures and events as touchstones

in *The New Frontier* to ground the story in some sense of historical veracity is applied in a number of revisionist comics. In a Las Vegas prize fight, Ted Grant (aka Wildcat) defeats the real champ, Cassius Clay, all while Bruce Wayne, Selina Kyle, Lois Lane, and Oliver Queen cheer from the front rows. Or we see Frank Sinatra crooning, "Fly me to the moon" in a swanky nightclub as Hal Jordan (Green Lantern) and Kyle Morgan of the Challengers of the Unknown sip highballs with their dates. The inclusion of historical actors and environments mixed with superheroes and alien invaders levels the distinction between reality and fiction in a postmodern sense, granting them both equal importance. "The New Frontier touches lightly on the great dilemmas of its period as it moves from McCarthy to Kennedy, but each deft touch brings the story onto a very large stage with echoes of the challenges we faced," legendary comics creator Paul Levitz intones in his introduction to the collected edition of the story. "It is a very special gift of comics, with their ease at transcending space and time, to mix reality with fiction seamlessly, and Darwyn does it especially well." But, of course, there is nothing historically accurate about this nostalgic frame. The light touch of reality is, like the Retro art, merely another empty sign of "pastness" that preempts critical considerations. Even Levitz admits that these historical touches can encourage the reader to "fill in from his or her knowledge of the time . . . or merely move quickly past, if the knowledge isn't there" (ellipses in original). I do not mean to suggest that historically set superhero fiction should accurately reflect reality—the two are mutually exclusive—but this odd mixture of history and fiction delivered through a sanitizing filter of beautiful Retro art works together to confirm both a perception of mid-twentieth-century American promise and a belief in the wholesome All-Americanness of the superhero comic book.

The stylish mixture of history and fiction played out in *The New Frontier* is possible because it is a postmodern pastiche. Cooke's story and artwork mix real events and real historical figures with fantastic superheroes to imagine a better past. In his introduction to the 2019 collected edition, Paul Levitz notes: "*The New Frontier* is assertively set in America as the 1950s fade into the '60s, and it brings together the changes in our culture with the stories in our comics in a way that was impossible at the time." Levitz clarifies that the "impossibilities" he refers to range from the creative permission to utilize characters across different titles and genres in a single story and, more importantly, to incorporate unspoken real-world problems. Ultimately, Levitz claims, "Darwyn chose to revisit this world with the freedoms of the twenty-first century, and tell a tale that was fundamentally of the mid-20th." Though Cooke lovingly depicts a relatively utopian past, he does include several subplots which grapple with racism in a manner informed by twenty-first-century sensibilities more than the mid-twentieth century ever did. The shape-shifting Martian Manhunter

4.7 From *DC: The New Frontier* #2 (2004), Darwyn Cooke, artist, DC Comics.

finds himself stranded on Earth and chooses to assume the identity of a white male detective, John Jones, to avoid xenophobic panic and violence. John is horrified by the racist violence faced by Black Americans and rightly assumes that if the world knew what he was, and what his original Martian form looked like, he would be destroyed. Seeing how people cheer for Superman, who is open about his extraterrestrial origins, John Jones is hopeful, but Jones recognizes that Superman is accepted and celebrated

RETRO ART AND NOSTALGIA | 105

because he is the picture of ideal white masculinity. In fact, the only non-white superhero included in *The New Frontier* is John Henry Irons (aka Steel), and his few appearances are separated from the other heroes and play out a disturbing example of racist violence. John Henry's story is set in the rural South, where he is out to avenge the murder of his wife and children by the Klan. Dressed in a hangman's hood, with a broken noose around his neck, and wielding a sledgehammer, John Henry's tragic story ends in his death rather than in heroic redemption.

Despite the inclusion of subplots detailing the rampant and brutal racism of the mid-twentieth century, Darwyn Cooke's stunningly upbeat Retro art overshadows the critical themes and foregrounds a sense of optimism personified by the plucky superheroes. The sweepingly revisionist story and, more importantly, Cooke's beautiful illustrations ultimately reclaim history as the domain of stalwart white men of action. Indeed, Wonder Woman is the only costumed heroine to appear in the story, and she must endure being criticized by Superman for allowing a group of Vietnamese women who were being held in cages and treated as "sexual cattle" to slaughter their captors. And though she receives a medal from President Eisenhower, he then dismisses her progressive ideas and effectively forces her into retirement on Paradise Island. Jennifer Swartz-Levine notes: "Wonder Woman's plight is not immediately obvious, though, for it is obscured by the nostalgia that suggested that the 1950s was wholly idyllic" (2017, 173). The clean, happy Retro look of the superheroes tends to override many of the pessimistic aspects of the story. Similarly, Neta Gordon claims the stylish adulation of the young heroes in *The New Frontier* "reflects the text's idealization of retrograde masculinity, and transforms narratives about othering into celebrations of colonialism and American manifest destiny" (2019, 237–238). Gordon's trenchant point is that while the quaint, uplifting story effectively revises the origin of the superhero genre as set in an idyllic 1950s/1960s, the focus on white male heroes like Superman, Batman, Green Lantern, the Challengers of the Unknown, and Task Force X "recenters the white male adventurer/hero" as the solution to American problems. Indeed, part of the nostalgic celebration at the heart of both the story and the art in *The New Frontier* is a romanticized portrayal of the various pilots and explorers (Hal Jordan/Green Lantern chief among them) in the vein of the American mythologizing seen in Tom Wolfe's book *The Right Stuff* (1979) and the 1983 feature film adaptation. Moreover, Gordon argues that the escapist fantasy of the story combines with the figure of the dashing superhero to confirm a hegemonic view of both the past and the present: "Cooke's nostalgic return to these figures encourages a reading of masculine adventure that, like the exploits of the superhero, is both exciting and familiar and which is a reconfirmation of an historical status quo" (240). The traditionally white male superhero is

reified as the ultimate masculine ideal, even more so thanks to the rosy patina of nostalgia.

In a broad sense, Nao Tomabechi addresses the still-rampant Orientalism in comics (all those ninjas and Kung Fu masters) and claims that for all modern superhero stories set in the past, "the sentimental nostalgia allows the genre to ignore racism and Orientalism of past works" (2019, 40). The exclusionary practices of past superhero adventures are generally glossed over (or mentioned in passing as a minor subplot—as with John Henry in *The New Frontier*), thus repeating and reconfirming an older assumption of heroism as exclusively white. Dealing with racial issues in *The New Frontier* specifically, Sean Guynes argues that rather than simply reinforcing a white masculine norm for heroism, Darwyn Cooke's work forces a recognition of the genre's historical lack of diversity. "In telling his story of the JLA, Cooke does not retroactively include black superheroes," Guynes reasons. "He does not sanitize DC's legacy, but reinscribes the company's decision (and, indeed, the genre's tendency) to exclude black superheroes until the chorus of civil rights had grown so loud as to demand greater social realism in comic book representation" (2020, 175–176). A critical disjuncture, however, occurs between Cooke's story and his artwork. The narrative of *The New Frontier* does explicitly address the racism and xenophobia as the shameful underbelly of midcentury concepts about American heroism. But the Retro illustrations are so charmingly innocent, and the art eclipses the story so much, that the overall effect still creates a sense of idyllic nostalgia for the square-jawed, blue-eyed, white male adventurers that defined the era.

Though the simulacrum of pastness signified by Retro art is often vague or imprecise, the various renditions tend to suggest the later 1950s and early 1960s, otherwise known as the Silver Age of comics. This midcentury period seems to represent an ideal moment in superheroes, perhaps ironically, because in reality it was a relatively bland time for comics. Following the infamous accusations made by psychiatrist Fredric Wertham in his best-selling *Seduction of the Innocent* (1954) and the subsequent Senate hearings that explored comics and juvenile delinquency, the superhero became a two-dimensional do-gooder. The comics industry opted for self-regulation through the Comics Code Authority, which ruled out any suggestions of sexuality, violence, corruption, alcohol, drugs, gangs, or any number of other unseemly topics. This simplification of the superhero comic book resulted in silly, innocent adventures of the type that Retro art alludes to. The conservative and cautious superhero seems to be a perfectly vapid cypher of a long-lost past that is easily invoked as pure style. The nostalgia for the '50s/'60s reflects a general cultural nostalgia for the era; more specifically, it reflects a postmodern longing for the solidity of High Modernism. Fredric Jameson notes that the splintering, deconstructionism,

and artificiality of the postmodern turn began around the late 1960s and early 1970s, thus framing the Eisenhower era as a virtuous and unsullied moment before "America lost its way" with the assassination of Kennedy, the rise of psychedelic drug use, and the Vietnam War. Moreover, Jameson describes this Modernist moment as the ultimate object of cultural nostalgia, the "mesmerizing lost reality of the Eisenhower era; and one tends to feel that for Americans at least, the 1950s remain the privileged lost object of desire—not merely the stability and prosperity of a pax Americana, but also the naïve innocence of the countercultural impulses of early rock-and-roll and youth gangs" (1984, 563). The "lost object of desire"—a simpler and purer America—is perfectly expressed through the cartoonish Retro style of simpler and purer superheroes.

As mentioned at the outset, most of the Retro artists discussed so far are based in what Molotiu calls cartooning: "the graphic simplification of figurative shapes" (2020, 153). The relative simplicity of Retro cartooning, in contrast to the dominant style of Idealism, stands out in the current comic book marketplace as a signifier of hazy pastness. The cartoony Retro style is an effective way to create a past era for characters that did not actually exist in that past time frame. By inserting them retroactively into a historical continuity, the Retro style supplies a backstory that never existed. Nick Dragotta's Retro illustrations for *The Age of the Sentry* (2008–2009) helped construct a new elaborate past for a superhero, the Sentry, who only became popular when he was reintroduced during Brian Michael Bendis's run on *The Avengers*. Wilfredo Torres's work on the Mark Millar–written *Jupiter's Circle* (2015–2016) filled in a past for characters who had previously only been referenced as a first generation of superheroes. The association of a cartoony style as definitively Retro is intentionally bolstered by nostalgia-based series like *Batman '66* (2013–2018) and *Wonder Woman '77* (2015–2017), which explored the further adventures of Batman and Wonder Woman within the aesthetic and time frame of their classic television programs. *Batman '66* used a number of different artists, including Jonathan Case, Michael Alllred, Ty Templeton, Joe Quinones, and Sandy Jarrell, all of whom used a cartoony style to convey the campy adventures of a 1960s Batman. Likewise, *Wonder Woman '77* utilized several artists, including Richard Ortiz, to illustrate the stories of a 1970s Amazon princess in a cartoony style. Interestingly, all of the covers for *Wonder Woman '77* featured illustrations that were more photorealistic images of Lynda Carter as she appeared in the original television series. As will be discussed in the following chapter, Realism often carries heavy overtones of Nostalgia as well, but typically in a melancholy way. The cover images of Carter as Wonder Woman by Nicola Scott, however, are a bright and cheery type of nostalgic Realism.

4.8 From *Jupiter's Circle* #6 (2016), Wilfredo Torres, artist, Millarworld.

4.9 From *Batman '66* #1 (2013), Jonathan Case, artist, DC Comics.

RETRO ART AND NOSTALGIA | 109

Modern Retro

The cartoonish version of Retro illustrations has become so intertwined with nostalgia that it implies a sense of timelessness even when the story is set in the present. Examples include Michael Avon Oeming's art for *Powers* (2000–2020), David Aja's work on *Hawkeye* (2012–2015), Nick Derington's artwork on *Batman Universe* (2019), Michael Allred's drawings for *X-Statix* (2002–2006), or Chris Samnee's illustrations for *Captain America* (2017–2018). These simplified styles of illustration are rife with nostalgia aesthetically, even though the stories may not be. The Retro artwork conveys a simpler, less bombastic atmosphere than most comic book art and for many readers harkens back to an imagined earlier era of superheroes. There are other Retro aesthetic styles that evoke the past (even if the stories are not set in the past), but they often carry different intonations than the cheerful cartoonish style. Even the difference in tone between Tim Sale's illustrations and those of Darwyn Cooke is palpable. The muted colors and serious faces in Sale's work imply a bittersweet or melancholy remembrance, whereas the bright colors and smiling heroes depicted by Cooke insinuate an innocent optimism.

Illustrator Phil Noto, for example, has a uniquely Retro look to his artwork that avoids being cartoonish but still suggests a particularly "mod" aesthetic. Noto's art has always resembled the graphic figuralism of 1950s and 1960s magazine illustrations, pulpy paperback covers illustrated by artists such as Robert McGinnis, Mitchell Hooks, Tom Lovell, and Glen Orbik, and painted Hollywood movie posters—typified by the artwork for James Bond films, which were also drawn by Mitchell Hooks. Marvel recognized the appeal of Noto's Retro style after he garnered a lot of fan attention for posting a series of illustrations fashioned after candid 1960s "behind-the-scenes" casual photographs. In February of 2015 all of Marvel's comics featured variant historically themed covers by Noto that solidified his status as a different type of Retro artist. Noto's illustrations tapped into the fascination of mid-twentieth-century modernism made popular by the chic television series *Mad Men* (2007–2015). The critically acclaimed program was lauded for its historical detail relating to the fashionable clothing, home and office décor, makeup, and hair stylings of the early 1960s. Much of *Mad Men*'s appeal was credited to nostalgia and its depiction of a hyperstylized modernism. Discussing *Mad Men* in relation to postmodernism and neoliberalism, Deborah Tudor argues: "*Mad Men*, a contemporary media product situated in media-derived nostalgia[,] demonstrates how audiences read the past through the postmodern, neoliberal discourse of style" (2012, 333). The focus on the style or "look" of *Mad Men*, as both part of the program's appeal and as the primary signifier of its historical period, is similar to the way Noto's artwork evokes

4.10 From *Captain America* #695 (2017), Chris Samnee, artist, Marvel Comics.

nostalgia. Though Noto's Retro style is not cartoonish, his illustrations also do not strive for Realism. Like *Mad Men*, Noto's work signifies a midcentury look based on surface appearances. Moreover, because Noto's Retro style is consistent regardless of the time period he is illustrating, his work maintains an aura of nostalgia even in a modern context.

Aside from his stylish cover illustrations, Phil Noto is best known for his work with writer Nathan Edmondson on *Black Widow* (2014–2016). Natasha Romanoff, aka the Black Widow, made her debut in *Marvel's Tales of Suspense* #52 in 1964 as the ultimate Russian femme fatale. The Black Widow's role as a sexy Russian spy was inspired by the character of Tatiana Romanova in the 1963 James Bond film *From Russia with Love*. Like Tatiana, who eventually rejects Russia and embraces the West, the Black Widow quickly became a popular American superhero. Though the Black Widow has always been principally identified as an exotic sexual fantasy, drawn most often in the exaggeratedly curvy manner of Idealism discussed in chapter 2, many of her solo adventures are still linked to her Soviet background and the political intrigue of the Cold War. The structure of the Cold War is still serviceable for superheroes because, as Matthew Costello argues in relation to the history of patriotism in comics, Soviet and American characters "represented the moral certainties of the Cold War, with plot lines that defined the conflict in stark contrasts between good and evil" (Costello 2009, 63). Many of the Black Widow's most recent comic book adventures have been linked to her shady past in Russia, expressed through flashbacks or encounters with old comrades and enemies. Retro art styles help to contextualize the Black Widow as a product of the Cold

RETRO ART AND NOSTALGIA | 111

4.11 Fantastic Four promo image (2015), Phil Noto, artist, Marvel Comics.

4.12 *Kill Now, Pay Later* (1960), Robert McGinnis, artist.

War and to evoke the look of 1960s espionage. Thus Chris Samnee's minimalist, cartoonish style fits with the Mark Waid-penned series *Black Widow* (2016–2017), which sees Natasha remembering and confronting the Soviet "school" that trained her to be an assassin as a child, as does John Paul Leon's and Daniel Acuña's Retro Noirish styles for the past and present Cold War thrillers in, respectively, *Black Widow: Deadly Origin* (2009–2010) and *Black Widow: The Name of the Rose* (2011). Similarly, Phil Noto's style of illustration works well for the Black Widow because it conveys a sense of Cold War nostalgia, a theme that effectively haunts most of her exploits, even though the stories Noto illustrates are all set in the present. The more poignant tone of the Retro art utilized in recent Black Widow stories (whether it is cartoonish, pulpy, or noirish) is a grimmer type of nostalgia rooted in the threats of the Cold War rather than the optimism of Kennedy's "New Frontier" era.

Similar to Noto's midcentury, *Mad Men*-esque Retro look is Greg Smallwood's artwork, particularly his illustrations for *The Human Target* (2021–2022), written by Tom King. Though the story is set in the current DC universe, the suits, haircuts, furniture, and cars all appear culled from the early 1960s. Smallwood's illustrations of all the characters, especially the central hero, Christopher Chance, are all rendered in the stylings of

hard-boiled pulp paperback covers. King's story is also pure hard-boiled fiction, with Chance drowning his sorrows in whiskey, a world-weary narration, and a cast of dangerous dames and shadowy villains. The superheroine Ice, from the Justice League International, takes on the image of the distraught female client and potential femme fatale. In fact, the storyline is a version of the classic Noir film *D.O.A.* (1949), as Chance finds himself fatally poisoned, with only twelve days left to solve his own murder. The vague nostalgic affect of Smallwood's illustrations for *The Human Target* create a specific tone for the superhero-infused murder mystery. It is not about linking the tale to a historical setting, but about using the art as a means to convey an atmosphere of impending doom. Reviewers were quick to point out the story's shift away from typical superhero fare. Comicbookroundup.com referred to it as "a hard-boiled, gritty story in the vein of classic detective noirs." On *The Super Powered Fancast*, Deron Generally notes: "Smallwood brilliantly captures the noir quality of the story with art that is beautiful in its style and design. I love the classic feel to the panels" (November 2, 2021). In fact, to achieve the pulpy look that so many reviewers applauded, Smallwood claimed to have studied the pulp covers illustrated by Robert K. Abbett and Mitchell Hooks while penciling *The Human Target*. Andrew Firestone of *Screen Rant* also emphasized the retro beauty of the art "with a vibrant, Lichtenstein-esque pop art style from Smallwood that simply dazzles the reader. Fans of the late Darwyn Cooke should feel right at home with his muted Golden/Silver Age pastiche" (November 4, 2021, para. 3). Matt Meyer at Comicwatch.com argues that "Smallwood, always a talent of no small measure, rises to an entirely new level with *HT*. Rendering all aspects of the art himself, Smallwood brings an early '60s sensibility to the art, reminiscent of the late, great Darwyn Cooke's work on *The New Frontier*. It is, in a word, stunning. There's no two ways about it" (November 2, 2021, para. 4). That numerous reviewers compared the Retro look of Smallwood's art to the art of Darwyn Cooke implies a recognition of the

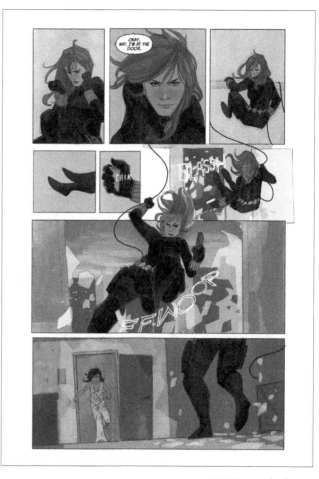

4.13 From *Black Widow* #13 (2014), Phil Noto, artist, Marvel Comics.

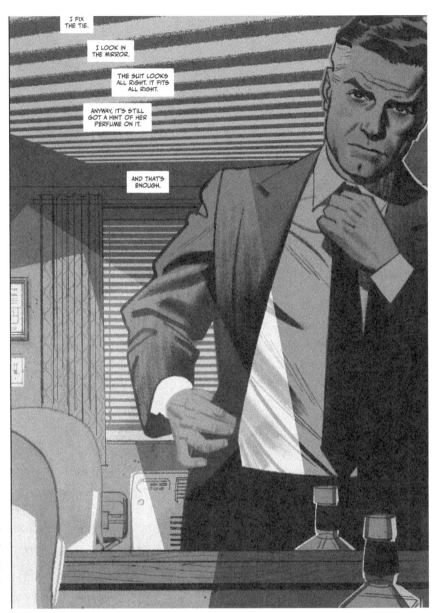

4.14 From *The Human Target* #1 (2021), Greg Smallwood artist, DC Comics.

illustrations as a means to suggest a bygone era as much as (or more than) to convey narrative themes. In other words, the Retro atmosphere Smallwood provides is more than just an invocation of Film Noir.

The next chapter will deal with the comic book version of Realism primarily as a means to convey a sense of somberness to a genre about men and women in tights, but Realism can also signify a type of nostalgia, albeit of a more maudlin tone. Alex Ross is a master of comic book Realism, and his work will be addressed in detail in the following chapter, but the nostalgic component of his artwork needs to be mentioned here in the framework of Retro as a distinct affective style. Alex Ross's incredibly realistic-looking artwork delighted fans and critics alike when he first gained notoriety for

the award-winning, Kurt Busiek–written series *Marvels* in 1994. *Marvels* retells the history of the Marvel universe from the perspective of Phil Sheldon, a photojournalist and average citizen of New York. All of the major moments in the Marvel universe are touched upon from an outsider's view and are humanized through Ross's painted art. The combination of the historical narrative and Ross's Realism linked his style to a nostalgic rendition of past events. Much of Alex Ross's work after *Marvels* was set in the present (e.g., Batman, Superman, Wonder Woman) but retained a nostalgic look. Ross's detailed and realistic portrayals of superheroes is at the opposite end of the spectrum from the cartoonish renderings utilized by Retro artists like Darwyn Cooke, Chris Samnee, Michael Cho, and Marcos Martín. But Ross's style is always intertwined with a sense of nostalgia because the costumes look like real cloth outfits worn by live-action film and television superheroes such as George Reeves as Superman in the '50s, Adam West as Batman in the '60s, Lynda Carter as Wonder Woman in the '70s, and Christopher Reeve as Superman in the '80s. Moreover, Ross depicts most of the characters (especially the male superheroes) with body types more associated with the heroes of the 1950s than with the current standard of Idealism. As discussed in chapter 1, the broad and barrel-chested physiques reflect a historical ideal of masculinity that has since become a more streamlined and excessively defined muscularity.

5 | REALISM IN AN UNREALISTIC GENRE

In the words of legendary comic book creator Stan Lee, heroes were not just super; they were "amazing," "fantastic," "mighty," "incredible," and "invincible." Though Lee was famous for his bombastic tones and hyperbole, his descriptions were not out of place. Superheroes exist in a world of the impossible. It is not just that superheroes are fictional characters, but that they can fly; blast lasers from their eyes or hands; change into water, ice, diamond, or fire; grow or shrink to inhuman sizes; and travel through time, across space, or between dimensional universes. Superhero stories are about impossible characters undertaking impossible adventures. At its core, the superhero genre is about fantasy, and the imaginativeness of the stories is typically reflected in the abstract, idealized, or exaggerated artistic styles most commonly employed. The colorful and extravagant ways superheroes are illustrated manifests the preposterousness of the genre. "Realism" would seem to have no place in comic books. Thomas Inge, the author of one of the first academic books about comics, claimed that "Realism is incompatible with comic art" (1990, 14). But, in recent years, a number of artists have become celebrated for their realistic depiction of superheroes and have expanded the notion of what comic book illustrations can look like. Realism in superhero art is most closely identified with the award-winning work of Alex Ross, but it is also apparent in the art produced by Lee Bermejo, Joshua Middleton, Francesco Mattina, Adi Granov, Mico Suayan, Mike Mayhew, Gabriele Dell'Otto, Rodolfo Migliari, Lucio Parrillo, Ian MacDonald, Ben Oliver, and Shannon Maer, among others. The use of Realism as a comic book style can have a powerful affect precisely because it is so different from the more typical illustrations used

for superheroes. Realism depicts characters as if they were actual people. They may still be earth-bound gods or aliens, but the realistic hero is more three-dimensional, costumes have substance and texture rather than merely being colored bodies, faces have wrinkles, necks have veins, and characters do not all look cut from the exact same template. Realism adds a level of gravitas and moral weight to the stories by presenting even the most impossible of characters as nearly possible.

The use of Realism in comic books raises a number of issues regarding the status of the medium (and the superhero genre) as either adolescent or mature entertainment and the relative "quality" of artwork associated with childish or mature content. Intertwined with these issues are important perceptions of Realism for how it straddles a conceptual divide between traditional illustration and photography. Moreover, Realism's more lifelike characters affect the audience's ability to identify with the heroes and creates a more serious tone for the adventures. The image of realistic superheroes has become a more acceptable aesthetic in recent years. The incredible popularity of live-action superhero movies and television programs has helped to reframe the perception of powered men and women in colorful suits as believable and authentic in a real-world setting. Advances in cinematography, makeup, costuming, computer-generated images, and digital special effects have made the fantastic world of superheroes—which could previously only be depicted through drawings—seem real. Just as live-action movies have come to look more like comics, the comics can also look more like live-action. In many cases, technology has also aided comic book artists striving for a sense of Realism. Digital technologies and a variety of computer graphics programs allow artists to quickly enhance the Realist appearance of their illustrations. Likewise, more powerful gaming systems and better programming technologies have resulted in some very lifelike superhero depictions in games like the *Arkham Asylum* series and *Marvel Avengers* for PlayStation 5. Though the various technological developments have made realistic-looking superheroes more common, they are still identified differently from comics illustrated in a style of Realism. According to literary critic Pascal Lefevre, comics readers are always aware of the artist's hand. "In contrast to the photorealistic images of live-action film that deliver a realistic impression," Lefevre reasons, "drawings in comics are static and strongly stylized, so the spectator becomes aware of their hand-made quality. Unlike in real life or in photographic images, lines are prominent in drawings" (2012, 72).

The reader's awareness of the "hand-made quality" of comic book art, which Lefevre mentions, is crucial for the appreciation of Realism as a unique style. Though every style of comic book illustration requires an enormous amount of skill, the detail needed for Realism to approach a lifelike impression reflects a different level of artistic proficiency and perseverance.

As outlined in chapter 1, historically the comics industry has been better suited to artists who could produce multiple pages in a short amount of time. The commercial imperative to crank out drawings as quickly and efficiently as possible to meet the ever-looming deadlines resulted in an often simplified and standardized approach to the art. Realism, on the other hand, is typically a painstakingly slow approach to rendering comic book superheroes. Because Realism requires significantly more time to produce, it is not the most practical style for the comics industry. Instead of appearing in regular monthly ongoing series, Realism is usually reserved for prestige-format limited series or as enticing and frameable variant covers for landmark issues or special events. Thus, while Realism may not be the most common of comic book styles, it is still a highly regarded and highly visible form that indicates how these same characters can be drawn (and painted) to create an entirely different perspective on the genre.

As a point of clarification, superhero Realism as a style of *illustration* is not the same as *narrative* Realism, though the two do often work in tandem. Realism, in terms of the artwork, refers to comic book illustrations that strive for a more accurate representation of reality. Realistic art eschews the exaggerated bodily proportions, colorful costumes, flashy sound effects, and other more cartoony, visual clichés in favor of creating images that appear to be closer to the real world. By definition, the superhero genre is science fiction, the stuff of pure fantasy, and every story is inherently unrealistic. Still, some writers have approached the figure of the superhero from a different perspective, seeking to create realistic stories within a quintessentially unrealistic formula. When realistic stories and realistic art are both present in a comic book, they can mutually reinforce the intended sense of Realism. Comics like the Kurt Busiek–written and Alex Ross–illustrated *Marvels* or Kami Garcia's *Joker/Harley Quinn: Criminal Sanity* featuring art by Mico Suayan, Jason Badower, and Mike Mayhew (each will be discussed in this chapter) combine a realistic story with realistic drawings, allowing the superhero genre to leave behind the absurdist sci-fi components and venture into the terrain of "serious" literature. But the two forms of Realism do not have to appear in lockstep. Sometimes Realist stories are drawn in exaggeratedly dark, noirish tones, such as Brian Michael Bendis's run of *Alias* illustrated by Michael Gaydos, or Ed Brubaker's take on *Daredevil* as drawn by Michael Lark. Likewise, author Matt Fraction's down-to-earth *Hawkeye* series was illustrated in a simple Retro style by David Aja, as was Mark Waid's revisionist version of *Black Widow* with Chris Samnee providing the Retro populuxe artwork. In fact, DC Comics has an entire line on "Earth One" comics that imagine what some of their superheroes would be like in a real setting (Earth 1 being DC's designation of our superhero-free world). None of the "Earth One" books are illustrated in the style of Realism.

Photo vs. Realism

Realism as a comic book art style is a relative term. Many of the artists working in this mode can achieve incredibly lifelike portrayals of even the most outlandish superheroes and villains. Others combine a realistic illustration with elements of Idealism. In either case, Realism must be considered in the larger context of comic book art. Realistic figures and faces can be a startling contrast to the usual cartoonish or hyperdesigned depictions commonly found in comics. At its most accomplished, Realism is more akin to photography than it is to traditional drawings. In his analysis of art traditions, Andrei Molotiu argues that some comic illustrations cannot be classified under the broad banner of "cartoons." Several artists, Molotiu notes, use "more naturalistic rendering styles, the most extreme of which have traditionally been dubbed 'photo-realism'" (2020, 153). But Molotiu is also quick to clarify that what he is referring to as "photo-realism" should "not to be confused with Photorealism in the fine-arts world" (2020, 153). This distinction between photo-realism in comics and Photorealism in fine art reflects the assumed hierarchical status of *real* art versus *comic* art, an important theme explored in detail in chapter 2. The distinction is also an important one because there is a degree of difference between Realism in superhero illustrations that retain some sense of fantasy and Photorealism that strives for a perfect mimesis of photography. For the sake of clarity, I have dropped the designation "photo" from the term, opting for "Realism" because even in its most realistic forms the comic book illustrations are always understood as stylized drawings representing an impossible reality *as if* it actually occurs in the real world. In other words, Realism is understood as a means to signify (rather than directly represent) certain attributes and values associated with the superhero genre, albeit in a far more realistic manner than the likes of Idealism, Cute, or Grotesque artwork.

The previous chapter touched on Alex Ross's style of Realism as a form of nostalgia that was established in his award-winning illustrations for Kurt Busiek's *Marvels* in 1994. Busiek's story shifted the focus of the Marvel universe to be seen through the eyes of Phil Sheldon, a normal man who is—not coincidentally—a photojournalist, who witnesses and struggles to relate to all of the major events in Marvel's history. But it was Ross's strikingly realistic paintings that literally provided a different "view" of the heroes across different historical periods. Through Ross's use of Realism we see Sheldon catching glimpses of the Human Torch and Namor battling in the sky over Manhattan, Giant-Man striding over people and between buildings, Captain America leaping into action in Times Square, or Spider-Man crawling up the windows of the *Daily Bugle* offices. In each case the characters look more lifelike than ever before. Gone are

the hypermasculine heroes and the impractically long legs of the heroines; instead, all of the figures look like they could be actual people on the street, in the office, or even flying through the skies. Because *Marvels* was a retelling of more than fifty years of comic history, and because Ross's paintings were so essential to defining the story, his type of Realism has become a common way to depict nostalgic moments from the genre's past. For example, Mike Mayhew's illustrations for *X-Men Origins: Jean Grey* (2015) and J. K. Woodward's work on *X-Men Origins: Beast* (2015) both opt for Realism in their depictions of the early days of these mutant characters to create a sense of historical authenticity and an environment not overrun by the artistic extremes of current comic books.

Realism tinged with nostalgia has been used to create an ambience of bygone eras and/or to convey the vigor and innocence of younger versions of characters. But Realism is also used in stories with contemporary settings in a manner that shifts the reader's overall impression from pure fantasy to possible reality. The impressive body of work produced by Alex Ross after the breakthrough success of *Marvels* has made him one of the most celebrated artists ever to work in comics. Ross has illustrated (and often written or cowritten) a number of landmark mini-series, including *Kingdom Come* (1996), *Earth X* (1999), and *Justice* (2005), and has also produced hundreds of variant covers for Marvel, DC, Image, and Dynamite Comics. Moreover, Ross's work has been instrumental in elevating the status of comic book illustrators as accomplished artists in their own right, an issue that will be taken up in chapter 8. Several high-quality artbooks have collected Ross's sketches and paintings, including one each devoted to his work at DC, Marvel, and Dynamite. Descriptions of Ross's illustrations emphasize his ability to make even the most fantastic superhero characters look real. In the collection *The Art of Painted Comics* (2016), Chris Lawrence describes Alex Ross as using "an incredibly detailed, photo-inspired painting style to bring comics' classic characters to three-dimensional life" (221). Likewise, author Brad Meltzer claims Alex Ross "makes it look not just real, but believable" (quoted in Lawrence 2016, 222). In his introduction to *Mythology: The DC Comics Art of Alex Ross* (2017), director M. Night Shyamalan writes that "Alex Ross always brings the mythical to reality for me." And, in *Marvelocity: The Marvel Comics Art of Alex Ross* (2017), filmmaker J. J. Abrams notes that with superheroes "we believe the impossible, in part, because it's a comic book." But, Abrams argues, "what Alex Ross does is different. He combines a remarkable, incomparable, classical artistry with the sheer fantasy of superheroes. In a style that owes as much to Norman Rockwell as it does to Jack Kirby, Ross makes the nearly impossible look easy: he brings our favorite characters to actual, familiar, relatable life . . . as if these characters were flesh and blood" (23). As these comments about Alex Ross's work emphasize, his style is insistently associated with

5.1 From *Marvels* #4 (1994), Alex Ross, artist, Marvel Comics.

a photographic-like standard of reality and a sense of bringing the characters to life.

The mutually reinforcing perceptions of "photographic" and "lifelike" qualities conveyed through comic book Realism, most recognizably by Alex Ross, invoke a long-standing and complicated debate regarding paintings and photographic renderings of reality. Painting has always been accepted as an artistic endeavor where artists visually interpret a subject

122 | SUPER BODIES

5.2 From *X-Men Origins: Jean Grey* (2008), Mike Mayhew, artist, Marvel Comics.

through their work, rendering it in a way that adds meaning. As mentioned in chapter 2, in relation to Idealism and the illustration of hyper masculine and feminine bodies, art historian Kenneth Clark famously declared that the purpose of art is a "search for physical beauty," and thus the artist's "instinctive desire is not to imitate but to perfect" (1953, 12). Photography, however, is often assumed to be purely objective, a mechanical capturing of real events. In his discussion of modern digital images, Martin Lister

REALISM IN AN UNREALISTIC GENRE | 123

recognizes that photographic images are often understood "as slavish imprints of physical reality, as mirrors held up to the world, or as open windows through which it can be directly seen" (2003, 219). Even in an era where photo manipulations have become standard practice for both professional and amateur photographers, there is still a stubborn belief that "seeing is believing," that photographs are trustworthy analogues of reality. Though Realism as a style of illustration is more akin to Kenneth Clark's conception of paintings than it is to photography (or even Photorealism in the fine art sense), there is still a visual thread that ideologically links the photograph with specific superhero art. The association of comic book Realism with photography implies a sense of actual moments captured by the artist and reproduced as evidence for the reader. Of course, readers know these are not really the same as photographs. But the evidentiary quality of photographs, which have long been regarded as unmediated and relatively indisputable depictions of reality, influences the overall impression the artwork can create.

The belief that photographs document reality is fundamental to the practice of photojournalism. The photographic image, in the context of news, offers visible evidence of an event having indisputably happened and is objectively presented as fact. As Sarah Kember notes in her discussion of the semantics of images, the faith that photography can capture reality unfiltered is particularly important "for photojournalists who have an ethical and professional stake in the truth status of the photograph and resort in some cases to semantic and logical gymnastics in order to defend it" (2003, 202). Every photograph involves editorial and/or artistic decisions that influence exactly how a moment is captured. Angles, composition, shutter speed, color, cropping, exposure, and other small variances all influence the truth presented in the photograph. Still, as Kember clarifies, photojournalists have worked to perpetuate a cultural assumption that photographs are unequivocally truthful and realistic. It is perhaps not surprising that the role of Phil Sheldon as the everyman observer of Marvel's history in *Marvels* is reinforced through his status as a photojournalist. Sheldon's fictional photographs document the major superhero events over several decades, providing evidence of their truth within the story. By extension, Alex Ross's realistic illustrations also carry a connotation of photographic "truth." Interestingly, photojournalists in comics (like Jimmy Olsen as a staff photographer for the *Daily Planet* and Peter Parker's freelance work for the *Daily Bugle*) have long predated Phil Sheldon. Within the story worlds, a photograph of a superhero like Superman or Spider-Man is a valuable commodity because it supposedly captures a truth about these fantastic characters. Extra-textually, the same logic holds true: photographic-like Realism as an artistic style in comics implies a similar sense of truthfulness even in an obviously impossible story. In

5.3 From *Marvels* #2 (1994), Alex Ross, artist, Marvel Comics.

his discussion of references to photographs in otherwise simple art styles, Roy T. Cook observes that overall, "the more realistic style of depiction is somehow linked to the objective purport of photography—that is, to the idea that photographs are somehow more objective, accurate, or authoritative than other modes of visual presentation" (2011, 129). Even in the fantastic world of comic book superheroes, Realism creates an aura of authenticity.

The association of Realism in comics with photographic qualities of "truthfulness" feels like an overstatement. Still, in contrast to more traditionally cartoonish styles, Realism *feels* like an accurate representation of a familiar reality, a merging together of the real and the unreal, the

REALISM IN AN UNREALISTIC GENRE | 125

fantastic and the mundane, the ordinary and the super. In his introduction to Alex Ross's Marvel art collection, J. J. Abrams writes that the illustrations look "as if these characters were flesh and blood, posing before the artist, whose preternatural gift with the brush allows him to depict what he's seen" (Kidd and Spear 2017, 10). In fact, Abrams's suggestion that the characters posed before the artist is not that far off the mark given Ross's penchant of using photo references as part of his process. Ross routinely takes pictures of live models, sometimes in full superhero costumes, and then draws detailed pencil sketches that enhance or subtract from the photo as necessary. The photographs allow Ross to accurately reproduce lights and shadows, as well as more realistic touches like skin creases or clothing wrinkles. The pictures serve as a visual reference to reality, but Ross does not merely copy them. As he remarks in *Marvelocity*: "There's so much transformation that goes on from the reference to the finish, the pictures are an imperfect match from what I want them to be. They need to be *interpreted* by the mind, not copied" (quoted in Kidd and Spear 2017, n.p., italics in original). Many comic book artists use photo references as part of their creative process, or utilize some form of lightbox photo tracing, photoshop painting, or digital photo manipulation, without achieving a photo-realistic depiction of characters. When artists like Mike Deodato Jr. or Greg Land use photo references of celebrities within their styles of Idealism, Norman Osborn may look like Tommy Lee Jones (Deodato) and Emma Frost may look like Pamela Anderson (Land), but they do not evoke the photographic qualities of truthfulness in the manner of artists working with Realism. Idealism perfects and exaggerates characters even when the images are based on photographs of real people—erasing flaws and force-fitting them into a singular heroic mold—whereas Realism strives for a uniqueness for each figure.

For all of Realism's association with photography (and thus, the photograph's claim of presenting an evidentiary truth), the artistic interpretation by the illustrator is a crucial factor to keep in mind. In every style the artist mediates between the reader and the story. "Realism" is no more real than any other artistic style used in comic books. Realism is a look that influences the tone, feel, and message of the story for a specific effect, in the same way that more obviously artificial styles, like Cute and Grotesque, do. Part of the perceptual dissonance that comes into play with Realism is because it *appears* to discard the genre's more fantastical look, replacing it with an accurate depiction of real (or at least, possibly real) people in costumes. Recall that chapter 2 mentioned Richard Harrison's observation in relation to arguments that superheroes present unrealistic gender ideals: "All of this analysis and talk treats comic book art as if it's representational, as if the purpose of the artwork in a comic book is

to draw characters as though they were human beings dressed up to play their superheroic or supervillainous roles" (2020, 351). Instead, Harrison continues, comic art is "a species of graphic art precisely because the drawings aren't drawings of how characters look but of what the artists are telling the readers about them through the pictures" (351). In other words, to criticize superhero bodies drawn in the most conventional form of Idealism is futile because the bodies are exaggerated to signify an extreme of heroism, not to represent what people would actually look like in capes and tights. While this is an insightful way to explain how different artistic styles allow illustrators to convey different impressions (muscular heroism, nostalgia, horror, etc.), Realism confuses the issue precisely because the style means "to draw characters as though they were human beings dressed up to play their superheroic or supervillainous roles," as Harrison argues (2020, 351). Alex Ross's Realistic homage to the cover of *Batman #9* is very different in tone than the original image by Bob Kane, and from all of the other tributes to the image that have been produced in different styles. In Realism, "what the artists are telling the readers about them through the pictures" is that this is *what superheroes would look like in real life*. Ross's image implies this is what a real man dressed as Batman and a real boy dressed as Robin would look like, unlike the overly muscular version presented by Jim Lee mentioned in chapter 2, or the streamlined Retro version by Bruce Timm discussed in chapter 4. Of course, it is not actually what superheroes would look like. Realism is just another graphic style, but one that implies a more truthful and realistic story is being told because it feigns a grounding in reality.

I do not mean to suggest that Realism completely forgoes perfected or idealized images of superheroes because it is associated with photography. In fact, many artists who use Realism combine it with principles of Idealism in a form that is all the more impossible because it looks both realistic and perfect. Like so many facets of superhero comics, the combination of Realism with Idealism is particularly noticeable when used to create extreme representations of gender ideals. In the discussion of Idealism in chapter 2, several of the artists who are identified with hypermasculine and hyperfeminine styles of illustration, such as Adam Hughes, Greg Horn, and Greg Land, could also be considered as bordering on Realism. Where Alex Ross's form of Realism made the bodies of male heroes appear bulkier and less defined, others have combined Realism with the body-builder look that is central to Idealism. For example, Adi Granov's portrait of Wolverine and Francesco Mattina's depiction of Batman both present detailed lifelike paintings far removed from any sense of cartoonishness. The characters are three-dimensional, well shadowed, and expressive, but they are also both extremely well built with bulging shoulders, veins popping from

5.4 Wolverine, by Adi Granov (2020), Marvel Comics.

5.5 Batman, by Francesco Mattina (2018), DC Comics.

the biceps, and muscle striations clearly visible through the costumes. Both portraits also reinforced the gendered expectations of hypermasculinity as tough, surly, and ever prepared to jump into battle. With claws and bat-rope at the ready, Granov's Wolverine and Mattina's Batman may look more credible than in most comic book renderings, but they are still exaggerated and impossible ideals embodying strength and control.

Similarly, many depictions of costumed women in the style of Realism present a believable image of the characters, but are also overdetermined by their sexualization. Idealism and Realism converge, for example, in portraits like Shannon Maer's Catwoman and Ian MacDonald's Psylocke. Both women are illustrated in incredibly lifelike ways, with carefully detailed facial expressions, naturalistic hair, and credible costume textures. Despite the Realism achieved by Maer and MacDonald, Catwoman and Psylocke are still illustrated as sexual fantasies. Catwoman leans forward in her leather outfit, which is unzipped daringly low to show off her cleavage, while her makeup is perfect and her lips are moist and plump. Psylocke has her katana and her psychic blade at the ready, but she is posed with her bare hip and buttock exposed to the viewer, her long purple hair blowing in the wind, a sultry look in her eyes. The seemingly permanent

gender dichotomy found in superhero comic books is only reinforced through this melding of Realism and Idealism. Male heroes like Wolverine and Batman remain rugged icons of hegemonic masculinity, while superheroines like Catwoman and Psylocke are still treated as sexy centerfolds, fully available for the gaze of male consumers.

5.6 Catwoman, by Shannon Maer (2020), DC Comics.

5.7 Psylocke, by Ian MacDonald (2019), Marvel Comics.

Image and Identification

The lifelike qualities associated with Realism often suggest a more achievable version of popular superheroes, even if they are actually unachievable ideals. For many fans, this façade of achievability may encourage identification ("I *could* look like that"); for others it may foreclose a sense of identification ("I *do not* look like that"). The assumption that comic book fans identify with superheroes is commonly understood as the central appeal of the genre: readers can imagine themselves as the all-powerful hero, able to leap tall buildings in a single bound, ready to defend truth, justice, and the American way. Umberto Eco famously noted that "through an obvious

REALISM IN AN UNREALISTIC GENRE | 129

process of self-identification, any accountant in any American city secretly feeds the hope that one day, from the slough of his actual personality, there can spring forth a superman who is capable of redeeming years of mediocre existence" (1979, 108). Nor has the importance of heroic identification subsided since Eco first described its crucial logic. More recently, Henry Jenkins declared that superhero comic books "tell larger-than-life stories that draw us into close identification with their characters and immerse us in their world" (2017, 68). Jenkins also argues that both the prose and the illustration in comics are designed to present the story as clearly and quickly as possible so we become wrapped up in the exciting fantasy. In this regard, Jenkins claims the "aesthetic goals" of superhero comics "are much like those of classical Hollywood cinema" (68). Indeed, comic books have adopted a number of cinematic techniques that, as film scholar Christian Metz (1986) describes, "suture" us into the narrative through assuming the heroes' point of view, being given a privileged access to the heroes' thoughts and opinions, and by sharing in the hero's victories. The masculine wish fulfillment played out vicariously in Hollywood movies has been a given in film and gender studies. Most influentially, Steve Neale, building on Laura Mulvey's (1975) landmark work regarding femininity and the male gaze, detailed how masculinity is prescribed by film through offering male viewers a form of "narcissistic identification" with the masculine fantasies of "power, omnipotence, mastery, and control" (1983, 11). Similarly, as a primarily masculine-defined genre, the superhero comic book directly suggests that readers can identify with the dream of magically transforming themselves (through the right radiation exposure, spider bite, magical word, or alien artifact) into a hypermasculine ideal.

As an aesthetic style, Realism is at the opposite end of the spectrum of representation that Scott McCloud describes as "amplification through simplification." According to McCloud, the more abstracted a figure is, the easier it is for readers to identify with the character and the events depicted. Conversely, the more realistic an illustration gets, the more difficult it is to imagine ourselves into the story. McCloud reasons abstracted figures allow cartoons to focus the attention of the reader, and the universality of the simpler face facilitates a reader's projection of their own perspective. "The cartoon is a vacuum into which our identity and awareness are pulled," argues McCloud, "an empty shell that we inhabit which enables us to travel in another realm. We don't just observe the cartoon, we become it!" (1993, 36). McCloud claims that the realistic figures, at the other end of the scale, present too much information and interfere with the comic's message and the ability to "become it." McCloud's point is that the more an image looks like an actual person, the more it is differentiated from the reader himself. Thus, according to McCloud's theory, Realism hinders identification rather than promotes it. Though his theory may

underestimate the capacity of audiences to identify with realistically illustrated characters, his concept does have a significant bearing on the effect of Realism when employed for superhero comics.

McCloud's notion that identification with characters is disrupted when the figures are depicted as realistic—as too much like an actual person with their own identity and subjectivity—is complicated by the longevity and diversity of superhero illustration. Comic book fans are accustomed to seeing familiar characters depicted in a wide range of styles, both concurrently and over time. For most readers, identification is far more complex than just the relative simplicity of the art style. Identification is premised on a number of variables, including familiarity with the character, narrative tone, self-image, personal values, identity politics, and style of illustration. Audiences are able to imaginatively identify with various superheroes across artistic styles and media formats. Every audience may have its own aesthetic preferences; readers may prefer Superman in a Retro style, or Spider-Man in a Cute style. Fans often have very specific favorites, like Alex Maleev's noirish version of Daredevil, or Amanda Conner's innocently sexual depiction of Harley Quinn. Likewise, as the popularity of Alex Ross's style of Realism implies, many fans have no problem getting past the realistic appearance of the heroes in order to identify with them. After all, as film theory demonstrates, identifying with fictional heroes like James Bond, John Wick, or Katniss Everdeen is not impeded because they look like Daniel Craig, Keanu Reeves, and Jennifer Lawrence. Any discomfort with familiar characters illustrated in Realism may have less to do with not being able to identify with them because they look too much like someone else, and more to do with the perception that they look different than we imagined they would in real life. The disjuncture that Realism can cause for some readers may be akin to the very public debates about which actors should play certain characters, or who played them best. Do we imagine Batman *really* looks like Adam West, Michael Keaton, George Clooney, Ben Affleck, or someone else? Does the Batman depicted in the realistic styles of Alex Ross, Mico Suavan, or Kaare Andrews just not look like some readers expected them to *really* look?

The perspective of critics and fans regarding most Realism illustrations is overwhelmingly positive. Comments typically focus on the lifelike images and the incredible artistic skill needed to render superheroes as realistic. More than most styles of comic book illustration, Realism is valorized as Fine Art rather than the traditional (and derogatory) assumption of cartooning. Many of the artists who work primarily in a style of Realism are associated with the cultural shift that now treats comic book illustrators as legitimate artists, a trend that we discussed in detail in chapter 2. The belief that incredibly lifelike paintings require a far greater level of skill from the artist, and much more time to produce, contributes to a

5.8 Huntress, by Irvin Rodriguez (2021), DC Comics.

5.9 Jessica Jones, by Jeff Dekal (2017), Marvel Comics.

perception that *these* realistic images are real art that just happens to feature imaginary superhero characters. Furthermore, most of the Realist artists have achieved a level of success outside the narrow and "juvenile" confines of comic books. Some, like Irvin Rodriguez, have established themselves as accomplished painters in the high-art circuit; others, like Jeff Dekal, have worked profitably in advertising, fashion, or portraiture. The elevated status of Realism within the comics industry is highlighted through its most common use as variant cover art. In fact, many of the artists associated with Realism *only* do covers, a professional standing usually reserved only for the most in-demand industry artists like Adam Hughes, Amanda Conner, and Skottie Young. Several Realist artists like Kaare Andrews, John Tyler Christopher, JH Stonehouse, Marko Djurdjevic, Joshua Middleton, and Tim Bradstreet exclusively produce cover art rather than interior, sequential illustrations. The Realist variant covers construct a general mood for the character rather than being directly linked to the narrative of a particular book, solidifying an image of, for example, Huntress as a disturbed avenger, Jessica Jones as a hard-boiled detective, Batgirl as a beautiful and vigilant protector of Gotham City, or The Punisher as a brutal killer of criminals who leaves a trail of dead bodies in his wake. When Realism is employed in this manner, exclusively on the cover, it may not directly affect the story between the pages, but it does mobilize a larger perception of the characters in a more accurately human form. Moreover, the "cover only" approach sets the Realism apart from the interior illustrations, clarifying its elevated status as exceptional artwork.

Despite Realism's vaunted artistic status, some critics and comic fans

5.10 Batgirl, by Joshua Middleton (2019), DC Comics.

5.11 The Punisher, by Tim Bradstreet (2004), Marvel Comics.

describe the characters as creepy and unsettling. The realistic faces in particular are often called unnerving because they are simultaneously lifelike and yet lifeless. Thus, superhero illustrations by artists like Lucio Parrillo and Adi Granov can simultaneously be lauded for their skill and disliked for the unnerving sensation of being caught between traditional comic book art and *not quite* a depiction of possibly real people. The discomfort some readers describe with Realism suggests a variation of the Uncanny Valley effect. The concept of the Uncanny Valley was introduced by roboticist Masahiro Mori in 1970 to describe the perceptual dissonance that occurs when we encounter a near-perfect simulation of a person. Though Mori was talking about the anxiety that results when confronted with almost human–like robots, the concept of the Uncanny Valley has been utilized since the end of the twentieth century primarily to address the limitations of computer-generated images (CGI) in Hollywood movies. Modern theorists have argued that the increasing use of CGI characters in blockbuster films can cause viewers to experience the Uncanny Valley because the figures register as close to reality, but still inhuman. Some critics reason that audiences are intuitively aware that synthetic actors (synthespians) are incapable of representing authentic emotions because, as Barbara Creed puts it, "In short, the synthespian does not have an Unconscious" (2002, 132). In metaphysical terms, the Uncanny Valley is a recognition that a simulation has no "soul," or an inner identity, though it appears human enough that it should convey an internal presence. In animation, a close cousin of comic book illustration, the linguistic implication is clear. The Latin root "animus" is a reference to the soul; thus to animate something like a cartoon is not just to put it in motion but to grant it a sense of internal

REALISM IN AN UNREALISTIC GENRE | 133

being. The uncanny or disturbing feeling evoked by some Realist artwork is because it resides at this odd juncture: human-looking in *almost* every way, except for that spark of life that we take as an indication of the inner person. Of course, readers are well aware that these are merely drawings on the same level as more simplistic Cute or Retro illustrations of the same characters. But viewers can be more forgiving of the abstract versions because they are more generalized; readers can then project a sense of humanism on the characters.

The sense of uncanniness sometimes invoked by Realism can be used effectively to reinforce an aura of anxiety and apprehension, or a feeling of impending doom. DC Comics's "Black Label" imprint publishes limited-edition series in a prestige format that explore primarily darker stories related to their superheroes. The Black Label imprint allows DC to explore stories that could not fit within the confines of mainstream continuity. Henry Jenkins observes: "There is much greater tolerance for works on the fringes of the continuity—such as an alternative 'what if?' or 'elseworlds' story, or works that are designated sites of auteurist experimentation. There is space for the moral inversion involved in telling the story from the point of view of the villain or a secondary character rather than the superhero" (2017, 67). As an example of this experimental terrain, Jenkins sites "the popularity of Brian Azzarello's graphic novels about The Joker and Lex Luthor" (67). For our purposes, it is worth noting that Lee Bermejo illustrated both *Joker* (2008) and *Luthor* (2010) in his signature style of Realism. Bermejo's distinctly gritty and detailed Realism contributed to the unique perspective of *Joker* and *Luthor* in equal parts to Brian Azzarello's narrative. Azzarello and Bermejo partnered again for the first Black Label mini-series *Batman: Damned* in 2018. Azzarello's brutally dark themes and Bermejo's grim artwork again resulted in a hauntingly Gothic and unsettling Batman tale. The adventure is more of a horror story than typical superhero fare. Batman struggles to remember if he killed the Joker while being led astray by various demons, ghosts, faulty memories of his childhood, and several of DC's anti-heroes who inhabit a world of black magic and necromancy. Bermejo depicts Batman as an actual person; eyes and facial expressions visible despite his rigid cowl, the material of his costume looks like actual fabric, complete with tears and clasps. In Bermejo's illustrations the caped crusader appears vulnerably human, but also dangerously similar to the ghostly and monstrous renderings of characters like Deadman, Etrigan the Demon, and a wraithlike enchantress who also populate the story. In *Batman: Damned*, the realistic artwork merges the uncanny and the grotesque.

Despite the otherworldly characters that confront the Caped Crusader in *Batman: Damned*, Bermejo's drawings serve to ground the story in a reality closer to our own. Bermejo's Batman is clearly just a guy in a suit. This

is not the Dark Knight with impossible muscles, intimidating white slits for eyes, fists the size of basketballs, and a twenty-foot-long cape that always flows majestically in the wind. Bermejo's Batman is human and vulnerable, which lends to the narrative tension of Azzarello's script. Because Batman looks realistic in *Damned*, his injuries seem more life-threatening; this is a body that can be hurt, unlike the hypermasculine and seemingly impenetrable body that Batman is most often illustrated with. Furthermore, because Bermejo's art humanizes Batman, it also gives him a sense of fallibility. Batman, even more so than most superheroes, is conventionally depicted as physically, mentally, and morally flawless. Yet, in *Damned*, it is implied that this realistic-looking Batman is physically vulnerable, possibly mentally unstable, and morally compromised: he is shown flatlining in an ambulance, seeing ghosts and phantoms, unable to remember events from just a few days before, doubting his own grasp on reality, and needing to correct his decision to let the Joker fall to his death. *Damned* is a story about human frailties and mistakes. For the tale to work, Batman must seem to be just a man, not an all-powerful and all-knowing superhero. Bermejo's artwork allows the story to effectively make the superhero vulnerable while still incorporating many of the genre's more fantastical elements.

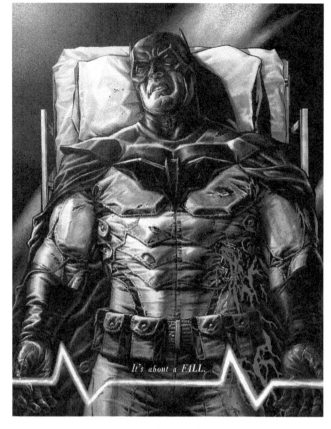

5.12 From *Batman Damned* #1 (2018), Brian Azzarello, artist, DC Comics.

Other Realist stories strive to excise any fantastic elements altogether. The ten-issue series *Joker/Harley: Criminal Sanity* (2020–2021), written by Kami Garcia and illustrated in Realism by Mico Suayan, Mike Mayhew (issues 1–2), and Jason Badower (issues 3–10), is set long before the Joker and Harley Quinn became the characters most comics fans recognize today. *Joker/Harley* focuses on Dr. Harleen Quinzel as a young criminal profiler working with the Gotham City Police to catch a brutal serial killer, the infamous Joker. The story is written and illustrated in the grim tones of a television police procedural, albeit one recast with characters from the world of Batman comic books. The blue-collar environment of the police station frames the story as authentic, and the realistic-looking characters ground the horrific events as actual possibilities. Harley's grief and anger

REALISM IN AN UNREALISTIC GENRE | 135

over the murder of her roommate five years ago looks realistic through Suayan's pencils and Badower's painting. In other comic book styles, extreme grimaces are meant to signify complex emotions without needing to capture any of the details of a real face. The visual code of comic styles like Idealism and Retro serves as a list of generic pantomimes for emotion. Realism strives to capture a richer emotional detail. The Joker is all the more menacing because he is not depicted as a caricature of a clown, but as a realistic psychopath with just a few smears of color on his face to disguise his identity. Interestingly, *Joker/Harley: Criminal Sanity* alternates between scenes set in the present that are illustrated by Suayan in black and white, and those set in the past by Mayhew or Badower in color. As mentioned in previous chapters, the technique of alternating between different illustrators in a single story is often used as a means to visually confirm flashbacks, different time periods, or different character perspectives. Typically, this device juxtaposes two very distinct styles, such as a noirish present and a Retro-looking past, or a Grotesque perspective clashing with a Cute interpretation. The slippage in *Joker/Harley: Criminal Sanity* between Suayan's gritty pen-and-ink Realism and Mayhew/Badower's airbrushed Realism with muted colors maintains a mood of dread despite subtle shifts. The past is not framed through illustration styles as a simpler or more idyllic time. None of the artists for *Joker/Harley* provide a respite from the horrors of a gruesome serial killer or the events that shaped him.

The gritty story and the Realistic art in *Joker/Harley* both benefit from the prestigious, adult-oriented Black Label format. This early version of the Joker is not a mischievous prankster; he is a serial killer who dismembers his victims and displays their body parts as gruesome tableaux. The mature intent of the story is an effort to take the Joker seriously as a villain by exploring the psychology behind the character. *Joker/Harley* incorporates a range of documents meant to authenticate the story as a serious psychological drama, including arrest records, actual photographs of crime scene evidence, psychiatric evaluation forms, official memos, internal GCPD emails, and coroner's reports. The use of these documents, glimpsed spread across desks or taped to walls, function in the same manner that Roy T. Cook describes with realistically illustrated photographs in comics: "rendering them in a manner that suggests a higher level of objectivity, accuracy, or authority as records of the fictional objects and the events they depict" (2011, 129). The authentic-looking documents add a patina of objective truth to the narrative. In general, the realistic artwork reinforces the story's solemn aspirations by setting the tale in the "real" world and alluding to the larger dramatic genre of Hollywood criminal profilers and serial killers. While discussing Mico Suayan's sketches in the collected edition of *Joker/Harley: Criminal Sanity*, author Kami Garcia describes how the appearance of the characters and the complexity of the

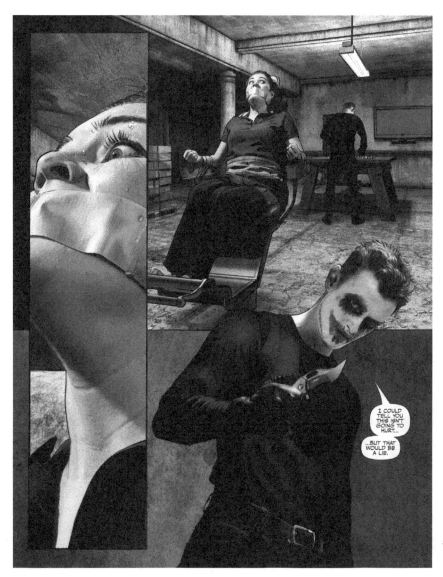

5.13 From *Joker/Harley: Criminal Sanity* #2 (2020), Jason Badower, artist, DC Comics.

story intertwine: "Our iteration of the Joker blends classic elements of the character with a hyperrealistic, forensically and psychologically accurate, portrait of a dangerous and highly intelligent psychopathic killer." Garcia explicitly links the "hyperrealistic" art with a more mature story that has aspirations of "forensically and psychologically accurate" characterizations of a psychotic clown prince of crime and a criminal profiler who will later become a Harlequin-themed ditzy henchwoman. Of course, there is no legitimacy to claiming a realistic portrayal of Joker and Harley Quinn; they are fictional villains who have drifted between very different, but always extreme, characterizations. But, in the case of *Joker/Harley*, the multiple levels of Realistic illustrations create an environment that seems true to life.

Realism can also be a powerful way to bring a sense of earnestness to

5.14 From *Fear Itself: Homefront* #3 (2011), Mike Mayhew, artist, Marvel Comics.

a genre usually defined by ridiculous extremes. One of the stories in Marvel's anthology series *Fear Itself: Homefront* (2011) addresses the culpability and need for redemption of Speedball, an irresponsible B-list superhero whose careless pursuit of a criminal resulted in a school explosion which killed 250 children in Stamford, Connecticut. Racked with guilt, Speedball has been volunteering in his civilian identity to help rebuild Stamford. When the other volunteers discover that their friend and coworker is actually Speedball incognito, the citizens of Stamford brutally attack him. Mike Mayhew's lifelike depictions of all the characters suggests a seriousness that matches the story and reflects the somber tones of a flawed superhero coming to terms with the life-altering consequences of his decisions. The silliness of a character like Speedball, emphasized by the juxtaposition of his colorful costume alongside the normal clothes of those around him, is granted a degree of gravitas through Mayhew's art. Speedball's need to atone for his tragic mistake is grounded in the realistic faces of the townsfolk and in his own heartfelt expressions. Mayhew's realistic illustrations express guilt and grief with a greater depth and sense of authenticity than more traditional comic book art styles can manage.

In a post-9/11 environment, superhero stories have grappled with the consumer's altered understanding of wide-scale violence and trauma. Certainly, the epic battles between heroes and would-be world conquerors remain a formulaic staple for the genre. But the casual disregard of civilian bystanders, innocent victims, and massive urban destruction has been tempered somewhat after the tragedies of 9/11 made these horrors more than routine entertainments. During the early 2000s, Hollywood action movies struggled to connect with audiences that suddenly viewed excessive violence as a reminder of tragedy rather than escapism. Interestingly, it was the superhero that saved Hollywood, as the film versions of

Spider-Man, the X-Men, Batman, Iron Man, Captain America, and dozens of other iconic comic book characters became billion-dollar tentpole franchises (see McSweeney 2020). At the cineplex, the superhero could rescue New York and Washington (and their fictional stand-ins) from terrorist attacks in ways that the Rambos and Commandos of earlier action movies never could. Over and over again, the cinematic superhero refought and won 9/11, providing a comfortable fantasy for a nation in mourning. Superhero comics, however, often responded to the post-9/11 anxieties by questioning the violence they had always purveyed. In his discussion of the comics industry's response to 9/11, Henry Jenkins notes that, unlike most of the superhero movies, comic books "urged caution as we entered a new war against terrorism" (2006, 72). Instead, "comic book artists and writers re-examined these familiar characters in the wake of September 11," Jenkins argues. "The characters became powerful vehicles for pondering America's place in the world" (79). Ultimately, Jenkins observes, many of the most significant comics that metaphorically touched on 9/11 influenced storylines that "rejected fisticuffs or vigilante justice in favor of depicting the superheroes as nurturers and healers" (79). The less-bombastic tones of several superhero comics sought to contextualize, limit, or otherwise come to terms with the genre's penchant for violence, often benefiting from the emotional sensitivity that realistic illustrations can evoke. The heartfelt emotions that Mike Mayhew's illustrations evoke in *Fear Itself: Homefront* add depth to the seriousness of trauma and its long-lasting effects. It is a far cry from the typical casual violence associated with superhero comic books.

6 | SUPER CUTE MANGA, KAWAII, AND INFANTILIZATION

The comic book boom of the early 1990s ended when speculators turned their attention and their disposable income to other pursuits. The consumer base of dedicated fans remained, of course, but most fans were no longer buying up multiple copies of poly-bagged "special" issues. By the latter half of the 1990s the industry was in dire trouble, many of the newly formed and creator-owned publishers went out of business, and even Marvel was on the verge of filing for bankruptcy. Eventually, changes in corporate ownership (Disney's purchase of Marvel in 2009) and the leveraging of licensed characters across media formats (the rise of superhero blockbuster movies) would stabilize the comics industry. But in the late 1990s and early 2000s the comics industry desperately needed to cultivate new audiences. "When all looked dark and foreboding, however, something unexpected happened to comic books in North America," Paul Lopes chronicles. "Suddenly, the fastest growing publishing market became Japanese comic books, *manga*, sweeping young female and male readers into a reading frenzy" (2009, 151). The popularity of Japanese animated television series (anime) like *Sailor Moon*, *Dragon Ball Z*, and *Pokemon* introduced mid-1990s North American audiences to the distinctive Japanese visual style that was shared with manga. Like anime, manga is characterized by a simple and cartoonish style of illustration, where characters are often abstracted into almost infantile, cute, and interchangeable figures. This Cute style was in direct contrast to the hypermasculine and hypersexualized illustrations popularized by Image Comics in the early 1990s. In their broad-ranging discussion of gender politics in superhero comics, Lee Easton and Richard Harrison argue that partially in response to the excesses of the Image body, a "countervailing pressure was also making

its presence known as Japanese manga became an important influence on superhero comics, especially in the artwork" (2010, 83). Indeed, in an effort to expand the North American market for comic books, many superhero artists were inspired by manga and embraced an aesthetic of cuteness and the bold, graphic, cartoonish lines identified with Japanese illustration.

The focus of this chapter is the influence of manga as an artistic style and the rather peculiar approach of infantilizing superhero characters. The melding of manga's cuteness with established American superheroes has become increasingly popular over the last twenty years and specifically targets very young consumers and female readers, but also maintains a substantial following among older male fans as well. Many artistic styles in contemporary superhero comic books can be subjectively deemed "cute"; however, I want to limit my focus to two specific forms that are crafted as objectively and intentionally "Cute." First is contemporary superhero artwork directly indebted to the stylings of manga and illustrations that explicitly reproduce Japanese styles, essentially turning American comic books into manga featuring iconic superheroes. Manga-influenced artists outside of Japan include such notable creators as Humberto Ramos, Dan Mora, Brian Ching, Chris Bachalo, Jae Lee, and Gleb Melnikov. Second is the excessively Cute style that infantilizes even the most un-kid-friendly of characters, turning them into cuddly little babies rather than heroic adventurers. The infantilized style is most associated with the work of Skottie Young, Art Baltazar, Dustin Nguyen, Eric Jones, and Chrissie Zullo.

Manga and the American Way

Manga is based on centuries-old Japanese narrative and visual aesthetics that favor simple but bold illustrations coupled with exaggerated facial expressions. The current shape of manga, which dominates the publishing industry in Japan and has become a massive cultural export globally, is commonly traced back to the post-World War II period. While Japan was under Allied occupation, a sudden influx of American popular culture (particularly animated films from Walt Disney and the Fleischer Brothers Studio) influenced Japanese artists to combine traditional styles with cartoonish effects and cinematic visual techniques. Legendary artist Osamu Tezuka is considered the pioneer of modern manga for his prolific work from the late 1940s to the 1970s, including such internationally recognized manga and anime as *New Treasure Island* and *Astro Boy*. Tezuka has often credited this early exposure to American animation as his primary influence. Manga has never been stigmatized in Japanese culture in the way comic books are in the West. In modern Japan, manga is enjoyed by

millions of readers, young and old, on a daily basis. For most, manga is a cheap disposable form of entertainment to be read casually during daily commutes or to relax after work. Some more dedicated Japanese fans are classified as *otaku*, described by manga historian Paul Gravett as "obsessive fans, who make manga a lifestyle" (2004, 14). Manga consumption is equally popular with male and female readers, and while categories are divided along gendered lines—*shonen* and *seinen* for men, *shojo* and *josie* for women—the graphic style is relatively consistent regardless of the age and/or gender of audiences.

As global media trade and systems of distribution developed near the end of the twentieth century, manga followed anime into Western markets and quickly attracted a large and devoted following. Throughout the 1990s, publishers such as Viz Communications, Dark Horse Comics, and Mixx Entertainment offered English translations of manga, flipped from their original right-to-left Japanese reading layout. Soon after, Tokyopop began reprinting a broad range of English manga in their original format, expanding the audience and eventually leading to manga sections in every major retail bookstore. "At the start of the twenty-first century," Jean-Paul Gabilliet notes, "Japanese comics constituted a publishing and commercial phenomenon that, because it offered a tremendous range of diversity, reached an extremely large readership in terms of gender and age groups" (2010, 101). While sales of mainstream superhero comics were falling off drastically, manga was emerging as a powerful international influence, particularly through its distinctive style of illustration. Many artists outside of Japan, and young fans who would become artists, were inspired to adapt the bold, cartoonish style of manga to their own work. In his overview of manga history, Frenchy Lunning argues that since the 1990s, "manga has had a tremendous influence on the styles and narrative being created in contemporary American and European comics" (2020, 77–78). And, while illustrators were inspired by the look of manga, publishers became interested in adapting manga aesthetics to their own superhero books in an attempt to attract some members of the newly emerged manga audience, especially the women and younger readers that constituted the bulk of Western fans.

The explosion of anime and manga in North America at the turn of the century was the vanguard of a broader embrace of an aesthetic of cuteness. Cute has become a defining feature of everything from humorous costumes for pets, to cartoon-inspired purses and high-top sneakers, to the Victoria's Secret "Pink" line of exercise clothes. As Anthony P. McIntyre argues: "Cuteness is a powerful affective register whose social proliferation since the turn of the millennium has been striking. Whether in the form of YouTube videos of kittens, the increasing prevalence of cupcakes, or the emoticons that terminate many text messages, the rise of the cute

has left few areas of life untouched by its ebullient reverberations" (2015, 422–423). The current widespread proliferation of a Cute aesthetic in the West originated with the spread of Japanese media and consumer products on the international market. Post-World War II Japanese youths, especially but not exclusively females, embraced Cute aesthetics in various subcultural styles as well as in merchandising and media forms. Lolita-inspired schoolgirl uniforms, Harajuku Girls, Speed Racer, and Hello Kitty are all emblematic of the dominant Cute aesthetic that has been adopted worldwide. In fact, exported forms of Cute popular culture are often regarded as Japan's most valuable international commodity. "Cuteness gives Japan 'cultural power' and is something Japanese are 'polishing' overseas," observes Allison in her analysis of Pokemon in a global economic context (2003, 383). Moreover, Allison argues, "cuteness may be Japan's key to working foreign capital in the twenty-first century" (383). McVeigh (2000) similarly argues that cuteness is at the root of Hello Kitty's domestic and international economic popularity, and Miller (2011) contends that Japanese government and business interests have calculatedly leveraged the concept of Cute as a means to secure Japan's financial strength internationally. The successful commodification of *kawaii* in the global market has resulted in cute as an increasingly important value worldwide. And, as Granot (2014) observes: "Within the last 30 years *cute* has evolved from a Japanese cultural phenomenon into the ubiquitous chant of almost every (female) teenager: 'that's cute'" (69). Manga is a fundamental example, and ambassador, of Cute cultural values.

In Japanese culture the distinctive visual style used in manga is part of the concept known as *kawaii*, which is commonly translated as "cute, adorable, lovable, and darling" with an underlying theme of "helplessness and vulnerability." The illustrations used for manga tend to share the qualities that visually define *kawaii*: rounded faces, pointed chins, big expressive eyes, elaborate hair, bright colors, a relatively androgynous look, and a generalized childlike appearance for most characters. According to Oana-Maria Birlea's overview of Cute studies, "Kawaii promotes the appreciation of small, stylized objects and of childish or atypical looking characters considered vulnerable for various reasons (size, looks, attitude, etc.)" (2021, 93). The use of this *kawaii* aesthetic with American superheroes ranges from a marginal influence to explicit inspiration or homage. This drastic stylistic influence that emerged at the turn of the century demonstrates the flexibility of the superheroes visually and shows how major changes in representation can shape alternative meanings despite long-established characterizations.

Some of the most popular artists currently working in mainstream American comics have a clear manga look to their illustrations. The more masculine-focused *seinen* form of manga is an easy fit with superhero

comics. The action/adventure narratives and the sleek graphic style of *seinen*, which still maintains the innocent oversized eyes and hyperanimated faces identified with Japanese illustrations in general, added an expressive and fun element to the look of American superhero comics in the new century. Prolific Mexican artist Humberto Ramos, most famous for his work on various Marvel titles including *Spider-Man*, *Wolverine*, *Venom*, *Champions*, and *Strange Academy*, is often credited with employing an energetic manga-*ish* style to invigorate characters. Ramos's figures have exaggerated forms, where legs are too long, hair is too big, and muscles are pure caricature. Like in Japanese manga, Ramos's heroes have cute facial expressions, and their bodies typically appear contorted, ready for action. In Figure 6.1 from *The Superior Spider-Man* #7 (2018), for example, the Avengers are poised to battle Spider-Man (it is really Doctor Octopus in Peter Parker's body) with every hero striking a dynamic pose, looking like fierce cartoons more than traditional superheroes.

Though the influence of manga on North American artists is visually apparent, it is perhaps best understood as indirect, part of a general stylistic shift that also reflects broader aesthetic changes and developments within the industry. Even Humberto Ramos, whose illustrations are frequently referred to as manga by critics and fans (and academics), has claimed that the manga trend was somewhat tangential to his evolving style. "Am I manga? That's what *Wizard* [a comics fanzine] labeled me," Ramos observes in the Marvel Monograph *The Art of Humberto Ramos* (2019). "I like anime and manga but I'm not really a follower of them. One of my biggest influences in my development, though, has been Art Adams, and he was really into manga. So, I never try to go against that label they put on me because I suppose in a way I was an American manga artist, simply based on the artists I was inspired by."

Canadian artist Chris Bachalo became a bankable fan favorite in the early 2000s for his very manga-like work on Marvel titles like *Uncanny X-Men* and *Doctor Strange*. On his blog, chrisbachalo.net, Bachalo describes how his style changed when he moved from illustrating more literary/fantasy comics to superheroes in the early 2000s: "Late in my run on *Gen X* I embraced a cartoony, manga-ish style. I was looking at a lot of that around that time." Indeed, Bachalo became famous for his expressive faces and boldly graphic bodies patterned after manga dynamics (see Figure 6.2). Similarly, in an interview with SYFY.com, artist Jonboy Meyers claimed: "In the '90s I really started getting serious about drawing, and that's when I discovered manga and anime . . . Any guy who had an anime flair to his work, I gravitated to. Michael Golden, Arthur Adams, Scott Campbell, Joe Madureria, and Jason Pearson all imprinted on me so much." Many of the industry's top artists who came into their own as illustrators in the 1990s and after credit the novelty and energy of Japanese manga as a foundational

6.1 From *The Superior Spider-Man* #7 (2013), Humberto Ramos, artist, Marvel Comics.

influence. By sheer osmosis from being around the comic book industry in the early 2000s, artists may have been indirectly influenced to alter or develop their work according to the newly emerging popular standards.

Superhero comics have increasingly tried to cultivate a larger share of female readers to enhance their traditional audience. The overwhelmingly male-dominated genre has seen a marked increase in female characters headlining their own series, including Silk, Spider-Woman, Captain Marvel, Squirrel Girl, Hellcat, Spider-Gwen, Superwoman, Batwoman, and so on. In addition to centering female characters, publishers have made a concerted effort to employ more women on the creative side of production. Moreover, the ongoing popularity of manga with female readers in the West has been an important factor in how mainstream superhero comics have courted female consumers. As Easton and Harrison point out regarding the importance of Japanese imports on the North American publishing market: "manga has gained a foothold with the elusive girl/young women market which comics companies continue to court" (2010, 83). Many of these twenty-first-century female-centric series avoided the standard hypersexualization of costumed heroines that may be alienating to female consumers, opting instead for artists whose manga-inspired work was perhaps more appealing to women. Marvel had a great deal of success with the manga illustration styles of artists like Robbie Rodriguez for *Spider-Gwen*, Erica Henderson with *The Unbeatable Squirrel Girl*, Brittney Williams with *Patsy Walker, A.K.A. Hellcat!*, and Stacey Lee or Veronica Fish on *Silk*. In the hands of these artists, the heroines are depicted as cute, sweet, and joyful rather than grim, violent, and voluptuous.

DC Comics followed a similar template of using manga-inspired artists to reinvigorate some of their most valuable female properties for a new audience of young women. For example, both *Batgirl* and *Supergirl* enjoyed their best sales figures in decades when they were illustrated, respectively, by Babs Tarr and Brian Ching. In 2014 DC Comics hired Tarr to take *Batgirl* in a new direction based primarily on her manga fan art. Tarr's partner, writer Cameron Stewart, described *Batgirl* as "part of this unofficial line called 'Young Gotham,' which was a deliberate decision to try to reach out to new audiences." Cameron clarified: "I thought Babs would be perfect. She is great. Her art is influenced by anime; it is stylish and fashionable, bright and fun" (Coogan, 2018, 615). Tarr and Cameron redesigned Batgirl's skintight costume into a far more practical fitted jacket and pants, replacing her high heels with yellow combat boots. Batgirl was also teamed up with several other female characters who supported each other as crime fighters and friends. Visually, Tarr's depiction of Batgirl and her allies was not about sex appeal, but rather offered a more expressive and playful tone to the characters. Similarly, in 2016, artist Brian Ching joined writer Steve Orlando in rebooting *Supergirl*, and Ching intentionally emphasized the

6.2 From *Supergirl* #1 (2017), Brian Ching, artist, DC Comics.

manga tendencies of his previous artwork to give the character a sense of naïve innocence rather than the conventional blonde bombshell male fantasy in a miniskirt. Ching's depiction of Supergirl did not try to appease the conventionally male consumer by offering a series of erotic pinups; instead it appealed to female readers as a realistic and endearingly cute version of an immensely powerful (but adolescent) character.

The rise of comic book specialty stores and direct marketing in the 1980s and 1990s removed comics from the traditional convenience store outlets where young consumers of generations past would first encounter monthly issues. The fact is that preadolescent comic book readers have been a dwindling market share since the 1980s. In the 2000s superhero comic books, activity books, and "learning-to-read" books for younger children began to flourish as a means to attract preadolescents. As a recent article for NPR observed, while "comics simply weren't for kids anymore" after the 1980s, lately "publishers of independent comics and children's book publishers are pumping out a huge and varied number of comics, manga and graphic novels for young readers" (Weldon, January

5, 2016, para. 11). After decades of fighting to be perceived as more than just a "childish medium," the comics industry is now fighting to bring the "child" back to the superhero genre for the sake of financial stability. To attract younger readers to comic books the two majors, DC and Marvel, have tried several strategies. Both DC and Marvel have rebooted their entire superhero universes to permit more accessible "jumping on points" uncluttered by decades of obscure backstories. And both have produced, or reintroduced, series focused on adolescent protagonists like *Teen Titans*, *Gotham Academy*, *Avengers Academy*, *Titans Academy*, *Strange Academy*, *The Runaways*, *Young Justice*, *Young X-Men*, *Young Allies*, *Young Avengers*, *Super Sons*, and *Champions*. Just as American comics have taken their cue from Japanese publishers in trying to appeal to women, manga aesthetics have been leveraged for younger-skewing superhero titles that publishers hope will attract a whole new generation of readers.

The younger-skewing team books are almost exclusively illustrated in a fun manga style. It is no coincidence that Humberto Ramos, the artist most closely identified with a North American style of manga, has been a primary illustrator for several of Marvel's youth titles. Ramos's portrayal of the teenage heroes in *Champions*, for example, captures a lighter side of the characters, where friendships and crushes matter as much as supervillains. Ramos's style reflects the gangly bodies and exuberant reactions of the *Champions*' young heroes. The cartoony look of the series fits perfectly with the stories, reflecting an innocence not available through other art styles. Similarly, a manga-influenced look has been important to the success of DC's various *Super Sons* series, which focus on Superman and Batman's biological sons, Jonathan Kent and Damian Wayne (aka Superboy and Robin). Despite the use of different illustrators on *Super Sons* storylines, the playful and more comedic tone of two preteen adventurers is conveyed through a heavily stylized appearance. Superboy and Robin are consistently depicted in this series as thin and lanky, with dramatically spikey hair and round faces—whether drawn by Jorge Jimenez, Max Raynor, or Carlo Barberi. The fun narrative tone of the Super Sons books (primarily written by Peter J. Tomasi) is reinforced by the adorable illustrations. Even on the occasions when things turn relatively serious in *Champions* and *Super Sons*, these manga-styled books manage to convey a sense of childish adventure above all else.

The link between preteen and teen superheroes and anime/manga stylings are, at times, explicitly made. The Japanese pop theme song for the *Teen Titans* cartoon (2003–2006) performed by "Puffy Ami Yumi" established the series as superhero anime from the start. This series is often credited with making anime style widely acceptable in North America and attracting a whole new generation of fans to Japanese cultural products. More

6.3 From *Super Sons* #1 (2017), Jorge Jimenez, artist, DC Comics.

recently, the comic book *Robin* (2021–ongoing) has been praised for injecting "the series with a primarily manga-influenced tone," both narratively and with a "manga influence in the art as well that looks stunning" (Jones 2021, para 8). Series artist Gleb Melnikov's work is inspired by manga aesthetics, a fact that is made explicit in the first storyline by incorporating panels of actual black-and-white manga drawn by Melnikov alongside the main panels. The story within the story (or perhaps the Japanese manga within the American manga) features two young painters comparing how

150 | SUPER BODIES

they approach their art. One follows his teacher's guidance and always has a plan in mind, while the other is spontaneous and allows her creativity to surprise her. The implication is that Damian Wayne (Robin) also needs to determine his own path as a hero, which may or may not mean strictly following the teachings of his father, Batman. Meta-textually, this version of Robin is not just artistically inspired by the look of manga; the story positions Damien as a fan of manga (like many real readers), as well as a product of it.

The influence of manga on the look of superhero comics over the last two decades has been significant. The manga-ish style of some artists is more obvious than others, but it has marked a distinct shift in tone. Additionally, in the broad efforts to attract manga fans to American-made superhero characters, several mini-series and crossover events have explicitly linked Cute manga aesthetics and characters with superheroes.

6.4 From Robin #1 (2021), Gleb Melnikov, artist, DC Comics.

From 2000 to 2002 Marvel published several one-shot *Mangaverse* versions of many of their most popular figures. Then in 2005 the five-issue series New Mangaverse was released with art by Tommy Ohtsuka, a noted manga artist from Japan. Ohtsuka's illustrations were done in a very traditional manga manner with an emphasis on the large eyes and smaller bodies found in most Japanese *seinen* books, and recasting some key characters (Iron Man and Captain America) as women. In 2012 DC launched the title *Ame-Comi Girls* based on the manga designs for a series of collectible statuettes of DC's heroines in sexy poses. Though the comics were illustrated by a number of different artists, they were all intentionally depicted according to *kawaii* standards. More recently, in 2021 Marvel's series of *Demon Days* one-shot books written and illustrated by Japanese creator Peach Momoko recasts numerous superheroes as feudal era warriors in a traditional manga style. For example, Figure 6.5 from *Demon Days: X-Men* portrays the purple haired Psylocke as a katana-wielding girl and her wolf companion, Logan (aka Wolverine), battling the evil witch, White Queen (Emma Frost), and her monstrous servant Jaga (Juggernaut). The historical Japanese setting, the robes, and the traditional straw headwear, *amigasa*, all work to confirm that this is a cultural as well as stylistic variation on the familiar X-Men characters.

Also in 2021, the DC mini-series *RWBY/Justice League* provided a crossover between DC's biggest characters and the Japanese gaming figures known as RWBY. The entire series is drawn by a variety of artists with traditional manga versions of Superman, Batman, Wonder Woman, and

SUPER CUTE MANGA, KAWAII, AND INFANTILIZATION | 151

6.5 From *Demon Days: X-Men* (2021), Peach Momoko, artist, Marvel Comics.

all the other heroes. Furthermore, traditional black-and-white manga versions of both DC and Marvel characters have been serialized in Japanese magazines, and then collected and republished in North America as manga novels. During the late 1960's Batman craze inspired by the campy 1966 television program *Batman* starring Adam West and Burt Ward, Jiro Kuwata published a Japanese version of the character that was collected and released in a three-volume set in 2014 titled *Batmanga*. Currently, the

Batman and the Justice League manga by Shiori Teshirogi is very popular in Japan as a complete cross-cultural reimagining that is, in turn, embraced as a unique take on familiar characters when repackaged for Western fans and sold at North American bookstores.

Adorable Baby Superheroes

The cuteness at the core of *kawaii* aesthetics is taken to an extreme with infantile depictions of characters. As primarily illustrated characters that already exist across numerous media platforms and through a range of different visual styles, superheroes are easy to depict according to the aesthetic conventions of cuteness. Cherub-like, cutesy versions of all the most recognizable superheroes from both DC and Marvel have become mainstays in the comics and in popular toy and collectible figures lines from merchandising partners like Funko, Cosbaby, Hallmark, Jada Toys, Mezco Toyz, Lego, Duplo, and Playskool. An incredible amount of Cute superhero merchandise designed to attract even preliterate fans is in current circulation. This aesthetic of the Cute superhero is reproduced and reinforced far beyond the comic books themselves in popular cartoons like *Teen Titans Go!* (2013–ongoing), *DC Super Hero Girls* (2015–ongoing), and *Marvel's Superhero Squad* (2009–2011), as well as through the successful merchandising of products like Funko Pop Style Bobbleheads, Li'l Bombshells and Dorbz rounded mini-figures, Quantum Mechanix Q-Pop figures, Disney's line of MXYZ and Tsum Tsum merchandise, Fisher Price's line of Little People and Imaginext superhero toys, and Cosbaby's collectible figures. By tapping into an aesthetic of cuteness at odds with the traditionally violent action of superhero stories, these products appeal to consumers ranging from toddlers to seniors. The juxtaposition of the Cute and the dramatic versions of superheroes exposes the affective means by which the characters are enjoyed by fans for various purposes and across different points of personal development. That even characters primarily defined by dark and violent motivations and actions like Batman, Wolverine, Deadpool, Lobo, and The Punisher have been turned into kid-friendly figures reveals not just effective marketing strategies, but an *affective* relationship between consumers and fictional characters.

Most of the Cute comic book series recast the superheroes as younger and more gleeful, and superheroing as a fun, playful activity rather than grim and gritty. The infantile superhero look is exemplified by Skottie Young's work on a range of *Little Marvel* books and as a variant cover artist for almost every Marvel title. Though Young has illustrated comics in a variety of styles, his most recognizable work is his Cute depiction of Marvel heroes. Young's popular variant covers are highly sought by collectors

6.6 From *Giant Size Little Marvel: AvX* #2 (2015), Skottie Young, artist, Marvel Comics.

6.7 From *Tiny Titans: Return to the Treehouse* #1 (2014), Art Baltazar, artist, DC Comics.

and have become the basis for numerous promotional products. His *Little Marvels* work is part parody, part tribute, and all a revision of superheroes through the lens of childhood. Thus, in a story like *Giant-Size Little Marvel: AvX* (2015), Young's reworking of the popular "Avengers vs. X-Men" universe-wide event of 2013, the pint-sized heroes align with their respective teams for a schoolyard dodgeball battle rather than a bloody slugfest. The characters are all recognizable and clad in their traditional costumes, but they are depicted as cartoonish children with stubby limbs, big round heads, and little button noses. Similarly, Art Baltazar's illustrations at DC Comics on *Tiny Titans* and with Dark Horse Publishing on *Itty-Bitty Hellboy* repositions iconic superheroes as cute and dynamic little children. The teenage heroes of the DC universe at the core of *Tiny Titans* are transformed in Baltazar's signature style into happy and playful cherub-like children who squabble over toys and costume choices while hearts and sweat lines float over their heads to express emotions as they do in manga.

Most of the Cute superhero books marketed to children forgo traditional adventures altogether in favor of unthreatening juvenile humor. For example, in *Tiny Titans* the Li'l heroes have tea parties, play with their pets, and try to find a perfect home for their tree house. Likewise, in the young readers book *Study Hall of Justice* (2015), illustrated by Dustin Nguyen, preadolescent Bruce Wayne, Clark Kent, and Diana Prince have to deal with hall monitors and Lex Luthor's campaign to be school president. In *Li'l Gotham*, also drawn by Nguyen, Batman and the other superheroes teach Robin how to trick-or-treat on Halloween and what other holidays are about. Eric Jones's art for *Supergirl: Cosmic Adventures in the 8th Grade* focuses more on the goofy things that happen to Supergirl in school than on grand adventures. And, while writer/artist Mike Kunkel's series *Billy*

Batson and the Magic of Shazam does take on lighthearted superhero missions, the emphasis is on Billy and his friends as children.

The innocence of the infantilized superhero character is an aesthetic representation of widely held beliefs regarding childhood as a time of purity. At least since the eighteenth century, when philosopher Henri Rousseau postulated that childhood is a natural, pure, perfect, and thus innocent state, childhood has been romanticized as a golden age of innocence that needs to be protected from the vile world of adults. "In contemporary Western societies," observes Affrica Taylor in her discussion of childhood sexualization, "the compulsion to essentialise, de-historicise and universalize childhood as a natural state of innocence is incredibly powerful" (Taylor 2010, 52). The superhero genre's cute and childish variations serve, in large part, as an acceptable entry point for young readers who may not be interested in the grittier themes found in other superhero forms. Likewise, protective parents may be comforted by the neutered and innocent version of these iconic characters. As Robinson and Davies argue, the Western belief in childhood innocence is intertwined with a perceived need to protect the very concept of childhood from volatile and serious topics:

6.8 From *Li'l Gotham* #1 (2014), Dustin Nguyen, artist, DC Comics.

> Within hegemonic discourses of childhood, innocence is viewed as natural, and moral panic is often associated with a perceived risk of the child's innocence being compromised. Within these discourses, stemming from philosophy and developmental psychology, childhood is perceived as a universal natural state of human development, epitomized by angelic purity and innocence. Adulthood and childhood become mutually exclusive polarized worlds, with the child becoming the powerless "other" in the world of adults, a world in which adults become the "gate-keepers" of knowledge and experience in an effort to preserve the perceived essence of childhood; that is, "innocence." Adults often have a nostalgic longing for childhood, reminiscing that it is a time of carefree fantasy that is too quickly lost. Within this constructed dichotomy, certain kinds of knowledge become the exclusive rights of adulthood. Politics, sex and death, for instance, become adult knowledge from which children are excluded. (Robinson and Davies 2008, 343)

The Cute aesthetics of these characters reinforce and signal the type of superhero adventure on offer: one free of any real violence, sex, politics, or other concerns deemed too mature for children.

Rather than the standard bulging muscularity of supermen and the eroticized curves of superwomen common to the dominant style of Idealism (see chapter 3), these Cute versions look more like toddlers or babies with oversized heads, rounded torsos, stubby limbs, and huge eyes. These infantile physical characteristics coincide with how Oana-Maria Birlea describes the origins of cuteness studies in Konrad Lorenz's 1943 theory of "Baby Schema." As Birlea summarizes: "the main features that arouse empathy and positive feelings are a round face, full cheeks, fleshy lips, large eyes, short and thick limbs" (2021, 84). Birlea notes that as researchers developed Lorenz's theory in different ways, evidence has remained consistent "that 'cute stimuli' capture the viewer's attention and arouse the protective instinct" (84). With big eyes and an impish smile, even the grimmest of superheroes now exist as cuddly plush dolls, friendly Lego characters, silly cartoons, and adornment on baby clothes. The "cuteness" of these variations reconfigures the violent and often traumatic side of superheroes and repositions them as figures in need of our love and support . . . deserving of cuddles. The radical shift that occurs with making a character like Batman an excessively kid-friendly do-gooder (rather than a Dark Knight avenger) also creates a narrative space where some of the more negative aspects of the genre and character can be deconstructed. The Cute superhero trend suggests an alternative understanding of the superhero's appeal in our society.

The general seriousness of modern superheroes is not undermined by the emergence of Cute versions of the characters. Instead, and even more so than other artistic variations, cuteness exploits and capitalizes on the representational variety within comic books and industrial shifts necessitated by multimedia convergence. The addition of Cute superheroes to the lexicon of representation is extreme, but not without precedent in the world of superheroes. This multiplicity can extend beyond character representations to incorporate entirely different narrative worlds. Jan-Noel Thon points out that this idea of multiple and varied fictional worlds is becoming increasingly common in modern franchises: "Every work that is part of the franchise represents a storyworld of its own but, at the same time, establishes a relation between that storyworld and the storyworlds represented by the other works that are part of the franchise" (2015, 31). Within the Marvel and DC Comic universes this idea of a franchise's multiple "storyworlds" has been literalized with a range of various "Earths" established to account for the coexistence of different characterizations of the heroes (see Kukkonen 2010 and/or Bainbridge 2007). The addition of Cute superheroes fits so neatly alongside the dynamic of multiplicity in the

comics that DC simply designated "Earth 42" as the home of the impish variety of their characters. The Cute version of superheroes does not disrupt the overall image of any particular character as much as it adds a new perspective, one that seeks to attract an underrepresented audience.

Likewise, the emergence of Cute superheroes, especially in media and product forms tangential to the comics themselves, reflects the current industrial use of multimedia "worlds" to support audience expansion. Instead of diluting the identity of characters, the abundance of Cute superhero cartoons, toys, shirts, and other collectibles boosts overall brand recognition. In this era of corporate synergy where Marvel is owned by Disney and DC Comics is owned by Time Warner, superheroes have been at the forefront of media convergence. Characters like Iron Man, Captain America, Superman, and Batman are easily adapted and marketed across comics, movies, television, video games, toys, novels, and any other media form imaginable. The development of the Marvel Cinematic Universe and the DC Extended Universe as shared narrative worlds that can be adapted and diversified across media platforms reveals how superheroes exemplify the entertainment industry's current pursuit of synergistic profitability. For example, in his analysis of Marvel's innovative approach to cinema, Derek Johnson describes the studio's strategy as "industrial convergence," wherein Marvel's shared narrative universe extended across multiple variations of characters and was derived "explicitly from contemporaneous patterns and practices of convergence whereby the firm sought to organize the production and consumption of its comics content across media platforms" (2012, 8). Likewise, using slightly different terminology, Aaron Taylor argues: "These contemporary blockbusters exemplify the new industrial logic of *transmedia* franchises—serially produced films with a shared diegetic universe that can extend within and beyond the cinematic medium into correlated media texts" (2014, 182). In other words, each variation of any given superhero character does not dilute or contradict some core identity, but rather promotes and reinforces the overall brand of that character and/or its parent corporation. Cute superhero merchandise simply extends the concept of those characters into a different representational realm and appeals to different market segments.

The current ubiquity of Cute superhero aesthetics across a range of media forms facilitates an affective response of endearment and protectionism in readers and consumers. My use of the term "affect" in this discussion is at once both literal and symbolic. Cuteness is a style that solicits a specific emotional response from observers related to the perceived innocence, helplessness, and childishness of the Cute object. Cute is a condition that affects those who experience it in an emotional and reactive manner. But the aesthetic of cuteness is also affective as a symbolic bridge to individual and cultural perceptions about abstract ideals such as nostalgia and

childhood innocence. While Affect Theory is a dynamic and growing area of research, it is sometimes a frustratingly obtuse and subjective theoretical tool. Affect is not a thing, not an object, nor a clear concept. Affect does not exist outside of personal responses; it is not directly observable. As Sara Ahmed points out, we should "not assume there is something called affect that stands apart or has autonomy, as if it corresponds to an object in the world, or even that there is something called affect that can be shared as an object of study" (2009, 30). But things do affect us: the mere look of something can inspire expressive responses linked to certain beliefs and values. Seigworth and Gregg argue: "Affect, at its most anthropomorphic, is the name we give to those forces—visceral forces beneath, alongside, or generally *other than* conscious knowing, vital forces insisting beyond emotion—that can serve to drive us toward movement, toward thought and extension" (2009, 1). The affect of Cute superheroes reveals not just an artistic appreciation, but a protective impulse linked to childhood innocence. Moreover, the Cute superhero represents a reclaiming of innocent, childish delight within a general framework of superhero narratives and fantasies.

Given the general pervasiveness of Cute in contemporary mass culture and the overlap of American comic fandom with a passion for Japanese anime and manga, it was perhaps inevitable that infantilization would eventually be applied to superheroes. In its most rudimentary form, the *kawaii* aesthetic adopted worldwide is characterized as simplistic and childish. In her discussion of cuteness in relation to avant-garde art and literature, Sianne Ngai argues: "cute objects have no edge to speak of, usually being soft, round, and deeply associated with the infantile and the feminine" (2005, 814). Ngai continues: "As an aestheticization of the small, vulnerable, and helpless, cuteness, not surprisingly, is a taste quality first and foremost aligned with products designed for children" (817). The explicitly Cute variation of superheroes devotedly conforms to this aesthetic of childlike softness, roundness, and overall smallness. The titles of the Cute comic book superheroes clarify their small status (*Li'l Gotham*, *Little Marvels*, *Tiny Titans*), as do the names of the toy lines (Little People, Cosbaby, Li'l Bombshells). As with Cute aesthetics in general, the Cute superheroes are depicted as baby or toddler versions of the more familiar adult or teen characters. The simplified visual depiction and infantile characterizations replace hard edges and mature features with soft curves and baby faces. The illustrations and the toys suggest a world of childhood innocence far removed from the realms of violence and intrigue common to most superhero stories.

This Cute toddler aesthetic that has found a foothold in superhero comics and merchandising is a version of the *chibi* form of anime and manga. *Chibi* is a type of stylized caricature popular in Japanese animation in which

figures are depicted as small and chubby, with oversized heads and large expressive eyes. This infantilized *chibi* appearance that emerges in the artwork of Skottie Young, Art Baltazar, Dustin Nguyen, Mike Kunkel, and others has become a signature look employed by both DC and Marvel to attract very young audiences. Not coincidentally, artist Derek Laufman has created distinct *chibi*-style templates for both DC and Marvel to use in a range of promotional forms. Though they differ slightly in appearance from each other, Laufman's line of *DC Super Friends* and *Marvel Superhero Adventures* are billed on his website as "toddler focused branding." These *chibi* variations of superheroes have become enormously popular with adults as well as toddlers, and they suggest the inherent flexibility of the character type and the range of acceptable artistic styles.

The qualities associated with cuteness (small, soft, rounded) imply not just an abstract artistic or aesthetic style, but specifically a sense of the object's infantile vulnerability. Cuteness signifies weakness, dependency, and helplessness. Critics of cuteness point out how important this perception of the Cute object as helpless is to the overall construction and affect of the aesthetic. For example, Daniel Harris outlines the relationship between being cute and being needy: "Something becomes cute not necessarily because of a quality it has but because of a quality it lacks, a certain neediness and inability to stand alone" (2000, 4). Likewise, Ngai observes how "the formal properties associated with cuteness—smallness, compactness, softness, simplicity and pliancy—call forth specific affects: helplessness, pitifulness, and even despondency" (2005, 816). It is this association between the appearance of cuteness and perception of helplessness that creates an affective and emotional response in consumers. The Cute object stimulates an affective protectionist impulse in consumers. Cuteness not only fosters aesthetic appreciation but also stirs a desire in consumers to cradle and protect. The possessive and protective response to the vulnerability implied by cuteness may be, as Wittkower (2012) notes, a biological, evolutionary imperative that has helped ensure the safety of helpless human infants, and/or it may be a culturally learned trait about social responsibilities toward weaker individuals. Whatever the biological or cultural reason for most people's reaction to cuteness, it is the perceived vulnerability, which is part-and-parcel of characterization, that produces a very specific emotional response.

Certainly, a key to the novelty of the Cute superheroes is their radical departure from the traditional depiction and characterization as big, powerful, self-reliant, and sexual. The Cute superhero inverts many of the core attributes of the standard superhero persona, literally reenvisioning superheroes as childlike and child-friendly characters. The Cute versions of superheroes clearly place the characters in the domain of children's entertainment, a relatively innocent world where heroic adventures are

pure play rather than dangerous adventures. The commercial success of Lego superhero sets featuring mini-figures of almost every Marvel and DC Comics character illustrates how systematically superheroes can be adapted to Cute aesthetics and innocent play. Lego sets are now routinely produced to coincide with every superhero feature film. The Lego versions reproduce key scenes from the movies such as the pivotal fight in *Batman v. Superman: Dawn of Justice* (2016) in which Batman tries to kill Superman, and the opening chase scene from *Captain America: Civil War* (2016) that culminates with the villain Crossbones activating a suicide bomb and killing hundreds. But where these scenes are violent in the movies, their reproduction in Lego form is presented as harmless play. None of the characters are scary or dangerous when they are all reduced to the standard Lego mini-figure form with tiny square bodies and round heads, and no harm can come to anyone in a fantasy world where bodies, buildings, and vehicles are designed to break apart and be reassembled endlessly. The Lego version of Cute superheroes has proved to be an extremely popular style beyond just the toys, as it is reproduced in comic books, early reader books, and a variety of merchandise ranging from shirts to key chains to Christmas ornaments. Moreover, several original direct-to-video animated movies featuring Lego superheroes such as *Marvel Super Heroes: Maximum Overload* (2013), *Marvel Super Heroes: Avengers Reassembled* (2015), *Justice League: Cosmic Clash* (2016), and *Justice League: Gotham City Breakout* (2016) depict fun stories where the heroes joke around, learn to be friends, and have fun catching merely mischievous bad guys. The crossover appeal of fun and cute Lego superheroes came to full fruition with the blockbuster feature film *The Lego Batman Movie* (2017).

The contrast between traditional comic book superheroes and the Cute superheroes was explicitly addressed in *Superman/Batman* issues #51 and 52 (2008), written by Michael Green and Mike Johnson and illustrated by Rafael Albuquerque. The "Li'l Leaguers" story features a team-up adventure between the conventional Superman and Batman and their Cute counterparts from a parallel dimension. Li'l Superman and Li'l Batman, as well as miniaturized versions of most of the Justice League characters, are brought into the primary DC Comics Universe by the magical interdimensional imps Mister Mxyzptlk and Bat-Mite to remind Superman and Batman not to be so grim. Li'l Superman and Batman are presented as earnest but ridiculous caricatures of the real heroes. Li'l Superman saves the president, catching Air Force One before it crashes, but witnesses are dumbfounded to see a tiny Superman. Likewise, Li'l Batman stops a mugging in Gotham, but the criminals are shocked to see a diminutive Dark Knight punching them with little fists and scowling at them with oversized anime eyes. When the adult Superman and Batman meet their tiny doppelgangers, Li'l Superman is a caricature of Superman's optimistic

persona, gleefully exclaiming: "That's awesome! I'm Superman too! It's *so cool!* We can team up and fight crime together! This is going to be so *great!*" Conversely, the Batmen scowl at each other, and Li'l Batman's expression of toughness is framed as ridiculous: "I'm *Batman!*" the knee-high Caped Crusader growls. When the adult Batman disagrees, his little counterpart screams: "*I'm the goshdarn Batman!*" The humorous use of "goshdarn" stresses the childish nature of Cute Batman as a direct reference to the excessively macho "I'm the god damned Batman!" catchphrase introduced by Frank Miller in *All-Star Batman & Robin* (2005) that has been used repeatedly in the adult-oriented comics and turned into a popular online meme.

The physical differences between the big and Li'l superheroes are stressed throughout the "Li'l Leaguers" story. Superman and Batman tower over their tiny counterparts, their sculpted physiques a stark contrast to the pudgy infant bodies of the small heroes. Likewise, when the rest of the Li'l League arrives, it becomes apparent the bodies of the female superheroes are coded as presexual compared to the curvy and revealingly costumed adult women. Teenage Supergirl has flowing blonde hair and a miniskirt, while Li'l Supergirl has a cute ponytail and her skirt goes down to her ankles; adult Wonder Woman has noticeable cleavage, but Li'l Wonder Woman has a round body; adult Black Canary has long, fishnet-clad legs and wears a corset, while Li'l Black Canary wears the same costume but has stubby legs and zips her jacket all the way up. The Li'l superheroines are desexualized narratively as well as visually. Li'l Black Canary sits on her grown counterpart's lap making a "yucky face" as she asks: "You mean you kissed Ollie Queen?! On the lips?!" Rather than the eroticized figure of the typical superheroine, any sexual implications of the Cute heroines are recast as innocent fascinations. When Li'l Wonder Woman, Supergirl, Black Canary, and Vixen first see the regular-size Robin in the Batcave, they flutter around him with big smiles, blushing cheeks, and floating heart symbols, exclaiming: "Robin, you're so, so . . . *tall!*" The cute little superheroines are physically and narratively a far cry from the erotically spectacular costumed women depicted in most comic books, the standard portrayal of superheroines referred to by Richard Gray as "vivacious vixens and superhotties" (2011, 75).

The strength and competence of the Li'l superheroes is also depicted as childish. While the Cute heroes ostensibly have the same powers as the adult ones, they are noticeably weaker and more vulnerable. The tiny Superman and Batman are confounded by their experience in this strange, big world: when they try to stop a supervillain from robbing a bank, Li'l Batman screams, "Oww! What is happening to my arm?" because he has never felt pain before, and when Li'l Superman is thrown against a wall he exclaims, "*I felt that!* Usually we just bounce off everything!" Rather than

the bloody and violent world depicted in most superhero narratives, the milieu of the Cute heroes is one devoid of any real danger—a cuter, softer, friendlier kid-safe fantasy world populated by cuddly costumed heroes (and villains). Bullets are replaced with suction cups, arrows are replaced with plungers, bombs are replaced with whoopee cushions, and lasers are replaced with silly string.

The exaggeratedly Cute aesthetics of the Li'l superheroes depiction in both the comics and countless merchandising forms, combined with their infantile adventures, suggests that the primary appeal of these superhero variations is different from the dream of empowerment at the core of the genre and so clearly expressed through the dominant style of Idealism. The visual qualities of cuteness signify an attitude of being weak and helpless, which is anathema to the fantasy of superheroes as fictional avatars of strength. One of the central tenets of the superhero genre is the assumption that the stories of average Joes who miraculously turn into super-powered beings is at the root of the genre's appeal for its mostly male audience. As Umberto Eco famously observed in his seminal 1972 essay "The Myth of Superman": "Clark Kent personifies fairly typically the average reader who is harassed by complexes and despised by his fellow men; through an obvious process of self-identification, any accountant in any American city secretly feeds the hope that one day, from the slough of his actual personality, there can spring forth a superman who is capable of redeeming years of mediocre existence" (1972, 108). Elsewhere (Brown 2001), I have argued that our culture's assumption of gender in binary terms typically defines masculinity as a cluster of desirable traits in opposition to undesirable, or "feminine," ones: hard *not* soft, strong *not* weak, reserved *not* emotional, and active *not* passive. Symbolically, these abstract traits of masculinity are literally embodied and exaggerated in the traditional figure of male superheroes. In the comic books male superheroes are routinely illustrated with bulging muscles, flexed and ready for action, their impossible abs, biceps, and chests highlighted by their skintight costumes. The superhero does not just eradicate any softness within himself to assume a hegemonically masculine position, he also thoroughly vanquishes other (lesser) men and proves his superior manliness. Where the ideal of hegemonic masculinity may be an illusion in real life, an impossible status for anyone to truly achieve, in fiction the superhero embodies and performs it. But, when superhero characters conform to an aesthetic of cuteness, they embody the exact opposite traits valorized in the original superhero style. Their cuteness exaggerates signs of softness, weakness, and helplessness. In gender terms the Cute superhero is repositioned as feminized and infantilized—as sweet and cuddly rather than tough and strong.

Overall, the Cute superheroes suggest a complete erasure of the darker elements fundamental to caped avengers in order to make the genre

appropriate for the extremely young target audiences. The "Li'L Leaguers" story reveals how different the Cute superheroes are by reworking the basic beginnings of the heroes. The Cute superheroes' origins are repositioned as a sanitized version of one of the most important conventions in the genre: personal tragedy. Li'l Superman cheerfully reveals that in his reality he is not the lone survivor of the doomed planet Krypton. Li'l Krypton is fine, Cute Superman sees his birth parents all the time . . . they just sent him to Earth to keep him dry when it got rainy on Krypton. Likewise, Li'l Batman's origin humorously rewrites one of the most famous and tragic scenes in popular culture. Rather than witnessing his parents being murdered in an alley, Li'l Batman dramatically explains that his parents were simply "pushed to the ground. Two shoves, and nothing was ever the same again. I swore that night that *no one* would ever be bullied in Gotham City." The adult Batman is incredulous and decides to preserve L'il Batman's innocence by not revealing the gruesome death of his own parents. As figures that are not shaped by the type of tragedies that provide the motivation for almost every mature version of the superhero, the Cute superheroes remain firmly ensconced in the realm of childhood. Having never lost their innocence through tragedy, the Cute superheroes are an effective means to rewrite the characters for preschool-aged audiences. These are versions of popular characters that little kids can identify with, without the frightening specter of parents being killed.

This alternate version of Li'l Batman's origin story, with Thomas and Martha Wayne simply being shoved rather than murdered, may be included for humor, but the absurdity of the change signifies just how far apart Cute superheroes are from their adult counterparts in general. The devastating murder of young Bruce Wayne's parents is one of the most sacrosanct and often-repeated moments in modern fiction. The scene is represented or alluded to in hundreds of Batman comic books and with every film version of the character. The Waynes' murder is so familiar that when it was depicted yet again in Zack Snyder's movie *Batman v. Superman: Dawn of Justice* (2016), numerous critics complained about it. A review in the *Atlantic* grumbled: "It presents us yet again with the robbery-murder

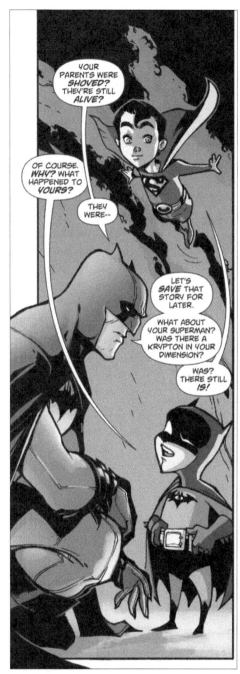

6.9 From *Superman/Batman* #51 (2008), Rafael Albuquerque, artist, DC Comics.

of young Bruce Wayne's parents, perhaps the scene in all popular cinema that least needed to be portrayed anew" (Orr, March 24, 2016). Likewise, Crystal Bell of *MTV News* asked: "Why did we have to watch poor Thomas and Martha Wayne die . . . again?" (Bell, April 4, 2016). The *Los Angeles Times* even ran a story ranking the top ten scenes of Bruce Wayne's parents in the movies, on television in *Gotham* (2014–ongoing), and in video games like *Batman: Arkham Asylum* (2009) and *Batman: Arkham Origins* (2013) (Fischer, April 1, 2016).

In their landmark essay "I'm Not Fooled By That Cheap Disguise," Uricchio and Pearson argue that the death of Bruce Wayne's parents is the most important and consistent element of the Batman mythos. Batman has been represented in a myriad of ways over his more than seventy-five-year history, but his core motivation of vengeance has remained steadfast since it was first told in *Detective Comics* #33 in 1939 and solidified in *Batman* #1 in 1940. Uricchio and Pearson note: "The constant repetition of the basic origin events has turned them into the central touchstone of the character, which can be and frequently are reduced to one sentence summaries" (1991, 196). Specifically, Uricchio and Pearson argue: "The fixed events of the origin serve two rather paradoxical functions: 1) they provide the motivation for the endless iterative events necessitated by the character's series nature and 2) they help to contain the character while also containing the traits/attributes that contribute to his elasticity" (194). In other words, the death of Bruce Wayne's parents is the unalterable foundation upon which everything Batman is built. This tragic event defines the character's motivations and actions no matter how much the depiction of Batman may be altered by individual creators, different eras, and different mediums. Batman can appear in "Elseworlds" and "What If?" stories as a medieval knight, as a vampire, or as a steampunk avenger, or he may be embodied by different actors, or look radically different in various media forms . . . but audiences know he is always Batman, a grim avenger, dedicating his life to fighting crime because he witnessed the murder of his parents. "The merest reference to the origin events," Uricchio and Pearson point out, "activates an intertextual frame which insists upon the Batman's motivation and key traits/attributes while permitting for variant elaboration" (196). Above all else, Batman *is* Batman because of the murder of his parents.

In reducing the tragic murder of the Waynes to the humorous "shoving" of the Waynes, the Li'l Leaguers storyline emphasizes how fundamentally different the implications of Cute superheroes are. The Cute superhero aesthetic leverages the familiar attributes of recognizable superheroes (costumes, powers, gadgets, etc.) but repositions them as signifiers of innocence and helplessness. Cute superheroes represent harmless superhero play for young consumers. The Li'l superheroes are still an imaginative path to empowerment, but without the risk of exposing children to

ideas of real violence. Defeating "bad guys" is just a simple game. Part of the appeal of cute and cuddly superheroes for preschool-aged children is relatively obvious: they are a safe and simple way to introduce children to a world of imaginative play where they learn the basic principles of right and wrong, good guys and bad guys, without any age-inappropriate content. The helpless and infantile qualities of the Cute superheroes allow children to not only identify with the characters but also feel a sense of possession or mastery over them. Children can revel in the harmless stories and funny aspects of the hero's powers, and also feel a sense of superiority as well as inclusion.

The appeal of Cute superheroes to older readers and consumers suggests a different, but interrelated, level of cultural or personal response than that of younger audiences. While most of the comic books and illustrated chapter books featuring Cute superheroes are intended primarily for very young children, the merchandising of Cute superheroes is equally targeted at consumers both young and old. Funko Pop Bobbleheads and Dorbz, Jada Toys's "Metal Die Cast," and Cosbaby's figures are heavily featured in adult stores like *Hot Topic* and *Spencer's*. Adult-sized T-shirts adorned with Cute superheroes are sold in the men's and women's departments of most major clothing retailers. And many of the collectible figures are priced for an adult market rather than as children's toys. The range of merchandise and marketing approaches implies that adult consumers are just as responsive to the Cute aesthetic of superheroes as children are. In his discussion of Hello Kitty commodities in Japan, Brian McVeigh (2000) argues that the character's cuteness appeals to different age groups for different reasons. Children respond to the simplistic innocence of Hello Kitty's cuteness; adolescents associate Hello Kitty with the values of being cool; and for adults there is a campy and nostalgic element to the products. The appeal of Cute superheroes may, in general, be similarly divided along these three axis points. But the clear demarcation between the three age groups and the primary appeal of the Cute characters suggested by McVeigh does not account for possible overlapping issues in relation to the pleasure many adults may derive from the Cute superhero aesthetic.

Like children, the affective response of adults to the overall helplessness and neediness suggested by Cute superheroes promotes a sense of protectionism, mastery, and ownership. For most adults, superheroes are a semiotic and nostalgic link to beliefs about childhood innocence. The Cute superhero forms (especially the kitschy merchandising) allow access to that belief in childish innocence through consumerism. The incredible popularity of Cute superhero merchandising literalizes the ownership of these characters. Cherub-like superhero collectible figures, shirts, buttons, mugs, keychains, phone cases, and so on all promote the direct possession of the superhero as a symbol of innocence. Where for children the

minimalist and infantilized Cute superhero facilitates identification and a sense of mastery, for adult consumers the Cute superhero signifies the simplistic fantasy of the genre and an affective response of control/possession. In other words, the Cute superhero possessed by adults suggests an erstwhile identification with the characters, an idealized vision of childhood pleasures, and a sense of maternal or paternal protective ownership over the characters. The affective sense of ownership and protectionism of Cute superheroes is intentionally motivated in consumers through the aesthetic style, but it is akin to the feelings of ownership over characters that many fans express toward superheroes in general. As fan studies scholars like Henry Jenkins (1992) and Matt Hills (2002) have demonstrated, devoted fans tend to identify with their objects of fascination to an extent that they feel proprietary about them. Comic book fans each have their own preferences for how characters should be defined and depicted. Fans will argue for hours about the "correct" version of a character, rebuking any perspectives that run counter to their own beliefs about characters they feel a kinship with and stewardship over. The eminent possessability of Cute superheroes in small merchandise form is an extension of the fans' general logic of mastery and ownership over favorite characters.

Moving beyond the commercialized Cute superhero aesthetic as it is presented in the comics and countless merchandising products, issues of cuteness and superheroes intersect in a broad range of cultural forms that also suggest an affective response of adult protectionism and an idealization of childhood innocence. Young children in superhero costumes; baby clothes, blankets, and bottles adorned with superhero symbols; even superhero costumes for pets; all function at the intersection of cute and super. The contrast between helplessness and superheroes registers as exceptionally cute for adult observers. That parents and pet owners want to dress up their infants and dogs in superhero costumes and post videos of them to YouTube illustrates that the merger of helpless and superhero is a self-conscious recognition of the ridiculous disparity between cute and powerful. As children age, but while their superhero play is still regarded as ridiculously cute, parental feelings of protectionism remain in the fore, protective of both individual children and the idea of childhood innocence as an ideal, all neatly symbolized by a child's identification with characters of unlimited power.

The Cute superhero is only one of many possible variations of costumed comic book characters, but it is notably divergent from the image of strength and virility that is most commonly associated with the genre. The ubiquity of superheroes and the range of media in which they appear has always facilitated a wide variety of ways that individual characters can be depicted in any given time period. However, since the start of the new millennium, superheroes have become increasingly defined as mature

and grim adventurers within their central comic books. Moreover, the incredible popularity currently enjoyed by superhero movies has helped to solidify an adult market and to set a general perception of the characters as primarily serious and violent. In effect (and in affect) the emergence of Cute superhero aesthetics in comic books, merchandising, and animated film invokes a "return of the repressed." In this case, the repressed features that are given expression through Cute superheroes are not about sexual or violent urges (as the phrase "return of the repressed" is usually applied). In fact, the repressed elements that reemerge via Cute aesthetics are just the opposite: a sense of innocence and childlike wonder, fun, imagination, and vulnerability are reintroduced to the world of superhero play and fandom.

Like all the other styles addressed in this book, the category of "Cute" is subjective. Works I have put into this category may be regarded by other observers as anything but adorable. In fact, there is a penchant by some artists to intentionally straddle the line between cute and creepy, melding the clichés of cuteness with an aura of the grotesque. Though this balance between cute and creepy is entirely idiosyncratic, the work of such artists as Joe Chiodo, Tara McPherson, Jae Lee, James Jean, and Chris Uminga challenges the concepts of cute and creepy and the points where they intersect. The following chapter concentrates on Grotesque art styles that are a response to, and are measured against, the dominant figural Idealism associated with superhero comic books. With Idealism as a central point, both Cute and Grotesque can be understood as opposite sides of a spectrum. Cute and Grotesque aesthetics may seem worlds apart, but because they are both contextualized in contrast to Idealism (Cute shifting the focus to innocent fun, Grotesque to abject horrors), they also overlap in unusual and unsettling ways.

7 | GROTESQUE BODIES AND MONSTROUS HEROES

A villain with a relatively unusual theme battles Batgirl in the 2018 story arc "Art of the Crime" written by Mairghread Scott and illustrated by Paul Pelletier. From *Batgirl* #25 to #29 the female caped crusader pursues "Grotesque," an art thief turned serial killer. Previously, Grotesque had only stolen exquisite paintings and sculptures, but now he was gruesomely murdering the wealthy collectors, as Batgirl narrates in issue #25, before "using their bodies to create his disgusting works of *art*." Grotesque arranges the maimed corpses of his victims into bloody tableaux that mimic scenes from classical art. When Batgirl confronts Grotesque in issue #27, he screams at her, "They deserved it!!!" Grotesque claims that his art reveals a greater truth about the human condition because the rich "can't see the pain all around them! I made them see the pain behind all those pretty things. I make them pay the price for those illusions!" Readers do not need to understand Grotesque as an allusion to a specific artistic and critical style to enjoy the adventure. In fact, despite Grotesque's pretensions to social commentary about Gotham City's wealthiest denizens, he turns out to be just another costumed crazy trying to steal his way to fame and fortune. The emergence of a comic book villain grounded in a highbrow artistic concept is an odd fit. Despite Grotesque's devilish-looking horned mask, the rest of the characters are illustrated in the standard format of Idealism. Batgirl herself is a carefully illustrated image of female beauty in a skintight outfit. The very idea of grotesque art seems anathema to the superhero genre.

Superheroes are supposed to be classically muscular, handsome, and proportionate; never grotesque. As discussed in chapter 3, superheroes are predominantly associated with Idealism, drawn as hypermasculine

or hyperfeminine in the comics and consequently performed by sculpted actors in the movies (with a little CGI help if needed). Modern caped crusaders are depicted with flawless bodies: bulging muscles for the square-jawed men, and sexy curves for the beautiful women. Indeed, the superhero has become synonymous with an exaggerated standard of physical perfection. The genre's emphasis on idealized characters constructs a dominant, but not exclusive, image of incredible-looking heroes fighting for "truth, justice, and the American way." But the work of several acclaimed comic book artists can best be understood as a form of Grotesque. The use of a Grotesque style of illustration presents a radically different appearance that exists in sharp contrast to the standard Idealism employed in most comic book depictions. The grotesque illustration of superheroes can be used for humor, but, more importantly, it also evokes a complicated critique of the assumed alignments between Idealism and heroism, beauty and virtue, and the contrast between humanity and monstrosity.

The Grotesque aesthetic is a much-debated artistic and literary style. It is often described as originating in the eighteenth century, though aspects of the style have existed throughout history. Grotesque works are not defined by a singular look or tone. Rather, they are somewhat subjectively classified by their ability to challenge and confound dominant perceptions of beauty, normality, and virtue. The visual standards of Grotesque high art tend to exaggerate and distend natural forms, present horrific tableaux, and address disturbing themes. The work of painters as diverse as Otto Rapp, Francis Bacon, Edvard Munch, Francisco Goya, Henry Fuseli, and Salvador Dali typify the uncanny and unsettling art associated with the Grotesque. The primary unifying feature of Grotesque artwork is its ability to ridicule, critique, and reveal a sense of the ugly barbarousness that lurks beneath the surface of personal and cultural façades. In his history of Grotesque art, Frances S. Connelly outlines the difficulty of delineating the style. "As visual forms," Connelly argues, "grotesques are images in flux: they can be aberrant, combinatory, and metaphoric. This visual flux is necessary but not sufficient itself to define the grotesque, because, at its core, the grotesque is culturally generated. Grotesques come into being by rupturing cultural boundaries, compromising and contradicting what is 'known' or what is 'proper' or 'normal'" (2012, 2). Grotesque art is radical for its unsettling images, but it is also unnerving because of the emotions it can stir in viewers: the critical affect it may invoke. Rather than inspiring an appreciation of beauty, Grotesque art questions the artificiality of aesthetics and morals.

Grotesque comic art has always been associated more with alternative or underground comix than with mainstream superhero comic books. Since the 1960s, the work of artists such as Robert Crumb, Gilbert Shelton,

Bryan Talbot, Spain Rodriguez, and Harvey Pekar has utilized Grotesque illustrations as part of a satiric or countercultural message (Sabin 1993). The scratchy lines and misshapen figures that visually defined underground comix was a melding of form and function into a unified critique of social values. More recently, alternative artists like Michael DeForge, Johnny Ryan, Jesse Moynihan, and Lisa Hanawalt continue the use of Grotesque imagery to establish the mood and the tone of their stories. In his analysis of DeForge's comic strips, Keith Friedlander notes that all the alternative comics creators "have traditionally used the grotesque to generate social commentary, exaggerating and distorting the human body and its functions in order to satirize mainstream sensibilities" (2020, 538). Like the underground comix before them, modern alternative cartoonists rely on hyperbolic forms and abstract bodies to reinforce their critical messages about such foundational social ideals as heteronormativity, consumerism, and religion. But superhero comics have rarely shared the subversive or countercultural objectives associated with alternative comics. In fact, as mentioned in earlier chapters, the superhero genre has traditionally been aligned with maintaining the status quo, not changing it. The conservative ideological focus on maintaining order, defending the nation, and protecting property rights is reinforced by the most typical superhero illustrations with strong, perfect bodies via strong, clear, bold lines and bright colors. Put simply, the abstract Grotesque style identified with underground comix reflects their challenge to artistic and social norms, while the figural Idealism conventionally employed with superhero comics reflects their valorization of classical aesthetics and dominant cultural ideas about morality and justice.

When used in superhero comics, the Grotesque is radically different than the clean and simple designs employed in the Cute and Retro styles, and it is in direct opposition to the perfect bodies at the heart of Idealism. The designation of "grotesque" does not mean the illustrations are without beauty, nor that the artists are less skilled. On the contrary, Grotesque art is visually beautiful in an unconventional manner, bringing expressiveness to a genre all too often defined by conventional art. Grotesque aesthetics in superhero stories are akin, in both appearance and affect, to the artists like Bacon and Goya mentioned previously. Like the beautiful but often unnerving paintings by these acclaimed artists, comic book superheroes rendered in a Grotesque style are overwrought with details, lines, and shading. Friedlander argues that modern Grotesquery "is most commonly associated with art that distorts the human form, emphasizing the unsightly features in order to disgust, discomfort, or disorient the viewer" (2020, 539). Even superheroes can be grotesque when bodies and faces are distorted and exaggerated, limbs are too long and too angular, or noses

and chins are too big or too sharp. Importantly, the obvious muscles so closely identified with caped crusaders do not just bulge; they are misshapen, awkwardly disproportionate, and ridiculously embellished. The costumes of characters like Batman are so distended as to be absurd. Capes billow and swoop for dozens of yards, cowls are pointed like beaks, and the ears become three-foot horns. Lithe figures like Spider-Man can become gaunt, gangly, and sharp; heroines like Wonder Woman may be drawn with inhumanly thick muscularity, or as disturbingly top-heavy with pencil-thin legs and boney hips. Backgrounds are indistinct, and the entire mis-en-scène is like something out of a nightmare. Among the most notable comic book artists to employ a Grotesque technique are Kelley Jones, Sam Kieth, Frank Quitely, Bill Sienkiewicz, Mike Mignola, Ted McKeever, Simon Bisley, John Bolton, Paul Pope, Sean Murphy, Rafael Grampá, Toby Cypress, and Dave McKean.

In Grotesque comic book art all characters, even the heroes, look more like monsters than super beings. This visual shift from ideal bodies to grotesque ones can change the tone of superhero stories from comforting and valiant fantasies to eerie and horrific dramas. Unlike the contained classical bodies usually associated with the genre, these Grotesque illustrations reveal an unsettling anxiety that lies beneath the image of caped crusaders. This chapter addresses the Grotesque as a significant component of superhero illustration. An important distinction exists between the stock grotesque characters that often round out the superhero landscape within traditional styles of comic book art and the aesthetic of Grotesque illustration utilized by some artists to recontextualize the entire superhero landscape. Grotesque characters typically function as a physical aberration in contrast to the idealized figure of the superhero. As Edwards and Graulund note in their overview of Grotesque expressions in a range of artistic forms: "the grotesque illustrates how the normal is defined in relation to the abnormal" (2013, 8). Where the conventional hero's beauty is emblematic of virtuousness and respectability, the grotesque character (most often physically deformed villains) aligns the misshapen form with degeneracy and wickedness. Grotesque art as a style, on the other hand, depicts all bodies as relatively abject, uncontainable, and destructive forces. When conjoined with the figure of the superhero, the Grotesque style moves beyond being merely carnivalesque reworkings of ideal bodies. Superhero grotesques emphasize the absurdities and the terror of ethical struggles normally obfuscated by colorful adventures and simple morality tales. Shifting the depiction of the superhero from an ideal form to a grotesque one can inspire an uncanny and unsettling affect for audiences; an affect which potentially undermines the genre's dominant themes of safeguarding cultural, moral, legal, and physical standards.

Grotesque Characters in a World of Beautiful Heroes

The focus of this chapter is the Grotesque as an artistic style. As a comprehensive aesthetic, "Grotesque" is related to, but should not be confused with, the long-standing practice in superhero comics of depicting numerous villains as grotesques. The tradition of illustrating specific figures as physically monstrous is grounded in the rudimentary logic that a character's appearance reflects their persona. In discussing the typical contrast between good guys and bad guys in Gotham City, Uricchio and Pearson argue: "In the universe of the Batman artists, phrenology and allied 'sciences' have never lost their explanatory power. The nameless thugs seem to be driven to crime by anatomy. To paraphrase Jessica Rabbit, these criminals aren't really bad, they're just drawn bad" (1991, 204). Influenced by the lurid pulps and newspaper adventure strips that preceded the comics, supervillains and lackeys alike were often portrayed with exaggerated features or obvious deformities in many of the original stories. "Early supervillains such as the Joker (1940) and Red Skull (1941)," note Smith and Alaniz in their discussion of differently abled bodies in comics, were "presented as disfigured, inhuman Others, their maleficence going hand in hand with their deviation from the superhero's physical ideal" (2019, 3). This spurious logic that equates misshapen bodies with loathsome personalities still runs rampant in modern comics: from the corporeal obesity of the mobster Kingpin, or the alien Mojo, or the massive Blob from the Brotherhood of Evil Mutants to the Penguin's long, sharp nose and Two-Face's acid scarred face, the shapeless mound of mud that is Clayface, or Doctor Octopus's fused mechanical arms, or Cheetah's human/animal hybridity. For these and countless other villains, physical deformities serve as an external sign of their moral corruption and their monstrous nature.

This alignment of exaggerated bodily characteristics and loathsome personalities serves to contrast physically and morally desirable figures with undesirable ones. In comics, this type of symbolic Othering is born from a history of racial stereotyping and demeaning caricatures. Charles Hatfield argues that the Grotesque figure in superhero stories is a direct result of "the genre's roots in overt and spectacular racism—more broadly, in xenophobic Othering, or the grotesque imaginative heightening of assumed difference. From monstrous Asiatic 'spooks,' to scientifically enhanced 'beast-men,' to subhuman dwarfs, these old stories testify to something awful at the heart of the genre. Difference, in superhero comics, has historically been loaded" (Hatfield 2019, 218). Hatfield is right that differences, especially visible differences, in comics have always been a problematic method for signifying aberrations from a presumed norm, a device that yokes loathsome looks with loathsome personalities. The

narrative shorthand of signifying evil characters as deformed, brutish, and unattractive was a common approach during the 1950s and 1960s that continues today. Matthew Costello, in his analysis of Cold War politics and midcentury comic books, argues that Soviet villains were typically illustrated as bloated thugs, which in contrast "reinforced the assertion of the moral superiority of America through racial stereotyping" (2009, 63). Unlike the communist figures, Costello continued, American superheroes were typified by "the blond, blue-eyed Steve Rogers (Captain America) or the urbane and sophisticated Tony Stark (Iron Man), handsome and, by association, virtuous" (64). Bad guys, whether they serve as representations of race, nationality, class, or politics, have routinely been illustrated as grotesque characters, loaded with misconceptions and stereotypes, prejudices and assumptions of being less than human.

The unabashedly racist implications of the grotesque villains that have historically populated comic books have been tempered somewhat in the modern era. But where the direct racial caricatures have lessened, the physical deformity of the supercriminals has become even more detailed and commonplace. Terrifying animal/human hybrids like Killer Croc, Man-Bat, and King Shark haunt the streets of Batman's Gotham City, and the likes of the Lizard, Rhino, Grizzly, and Vermin battle Spider-Man in New York. There are also creepy alien invaders like the Skrulls, the Brood, and the symbiotes Venom and Carnage, as well as the various para-demons from the hell planet Apocalypse. Even crime lords are almost always deformed in some way, such as Black Mask, whose face is a basically a black skull; the mobster Jigsaw, who has thousands of scars stitched all over his face; the pale and stone-like visage of Tombstone; or any of the obese, bald, and misshapen organized crime bosses: Kingpin, Tobias Whale, Slug, or Blockbuster. "Within comics," Jack Fennell argues in his discussion of symbolically evil appearances, "these criminals are often deformed *before* they become criminals, in ways that provide advance warning about the precise kind of villain they are. In these cases, it does not matter whether or not the deformity preceded the criminality; this preemptive, almost karmic punishment makes the precise nature of their criminality manifest" (2012, 322). In the world of superheroes, biology is often assumed to be destiny.

The symbolic importance of grotesque characters is doubled in superhero comic books because the genre so obsessively glorifies physically ideal heroes and heroines. For the most part, superhero illustrations celebrate images of exceptional men and women. As detailed in chapter 3, the dominant form of superhero illustration makes a spectacle of beauty, with physical perfection reflecting moral flawlessness. The overwhelming dominance of white, male, straight, able-bodied heroes throughout most of the genre's history means that anything outside of this very narrow norm risks

being framed as grotesque. More than just a statistical norm, superhero comic book illustrations tend to be *normalizing*. In other words, the preponderance of perfect-looking heroes (and nearly perfect-looking supporting characters as well) presents a world where differences are minimized, marginalized, and vilified. Grotesque characters stand out as monsters because they are so unusual and different from the heroes. As Jose Alaniz argues, the superhero comic "privileges the healthy, hyper-powered, and immortal body over the diseased, debilitated and defunct body. The superhero, by the very logic of the narrative, through his very presence, enacts an erasure of the normal, mortal flesh in favor of a quasi-fascist physical ideal" (2014, 6). The conventional spectacle of superheroes with identically perfect bodies and faces implies that all men and women should look like a super man or a wonder woman. Anyone who does not conform to this standardized ideal is a failure, at best a lovable comic relief, at worst a supervillain bent on world domination.

The routine bodily and aesthetic perfection offered up for readers through Idealism reinforces gendered expectations above all else. Culturally, men are valued for their strength and women for their beauty. Julian Novitz views the conflict between ideal heroic bodies and grotesque villain bodies as essential to producing heroic masculinity as unassailable: "The way in which the bodies of superheroes are frequently contrasted with those of their supervillain opponents is a component of this hypermasculine valorization. Supervillains are usually distinguished by strong visual markers in comic books, which typically take the form of deformities (e.g., scarring, facial disfigurement, etc.), non-standard body shapes (e.g., unusually slender or obese physiques), or outright monstrous characteristics" (2019, 97). The implication is that the disfigured villains are failed versions of masculinity. The villains are grotesque not just in appearance but also in the manner that their appearance visually reaffirms physical and moral failings. Too fat, too skinny, too ugly. In gendered terms, the villains may also be too feminine or too excessively masculine. "The bulging, monstrous, and bestial bodies of villains like Sabretooth from the *X-Men* comics and films, or Bane, Solomon Grundy, and Doomsday from DC Comics," Novitz continues, "represent the dangers of unchecked or undisciplined power in contrast to the typically sculpted and symmetrical superhero physiques" (98). Similarly, heroines and villainesses may both be illustrated in a hypersexual manner, but only the villainesses use the sexuality for monetary gain. The superheroes' bodies reinforce the boundaries of ideal masculinity and femininity, boundaries that are clarified through the examples of outlawed or freakish bodies that are coded as "too much" or "too little."

Rosemarie Garland Thomson's (1998) analysis of the similarities between beauty pageants and freak shows parallels the comic industry's insistent contrast of the superhero's ideal figure and the villain's deformed

7.1 Bruce Wayne from *Batman/Catwoman* #1 (2021), Clay Mann, artist, DC Comics.

7.2 Oswald Cobblepot from *Heroes in Crisis* (2018), Clay Mann, artist, DC Comics.

appearance. "Although one traffics in the ideal and the other in the anomalous," Garland Thomson argues, "both the beauty pageant and the freak show produce figures—the beauty and the freak—whose contrasting visual presence gives shape and definition to the figure of the normative citizen" (1998, 459). Like the superhero and the villain, beauty pageants and freak shows make a spectacle of their subjects, putting them on display for paying customers, emphasizing their physical appearance with standardized costumes, stock poses, and narratives provided by pageant hosts or carnival barkers (or comic book writers). In most artistic styles the superhero (male or female) is a personification of beauty, whereas a significant number of villains are akin to freaks. Chapter 3 detailed the excessive image of physical and moral perfection presented through costumed heroes, but it is important to note that even out of costume the good guys are idealized and the bad guys illustrated as horrific. For example, Clay Mann's rendering of Bruce Wayne having tea and Oswald Cobblepot, aka the Penguin, eating dinner succinctly captures their oppositional characters. Bathed in the warm glow of a fireplace, Bruce has a handsome, chiseled face; the perfectly symmetrical and well-developed muscles of his chest, shoulders, and biceps can be seen through his sweater. In contrast, Oswald is framed by a cold, blue light; the girth of his stomach is thrust forward, his skin is a sickly gray tone, his teeth are too sharp and blackened, his misshapen head is bald except for a few wiry and greasy hairs that hang down his neck and frame his jowls, and his nose is too long and pointy. And even though villainesses are less often depicted as grotesque (they tend to be dangerously seductive beauties), Joëlle Jones's drawings of Selina Kyle, aka Catwoman, and her nemesis Raina Creel, a ruthless crime boss, demonstrate the contrast between beautiful heroines and grotesque villainesses. Selina is a picture of elegant glamour out of her costume; her hair is stylish, her features delicate, with plump lips and captivating green eyes. When Creel discards her wig and makeup, however, she is drawn as hideous; her face is gaunt and emaciated, she is bald and heavily wrinkled, several teeth are missing, and most of her nose has been removed through botched cosmetic surgeries. The

7.3 Selina Kyle from *Catwoman* #1 (2018), Joëlle Jones, artist, DC Comics.

7.4 Raina Creel from *Catwoman* #1 (2018), Joëlle Jones, artist, DC Comics.

desirable qualities of Bruce and Selina are written on their attractive faces, just as surely as the contemptibility of Cobblepot and Creel is conveyed through their repulsive appearances.

Garland Thomson also deconstructs how both the beauty and the freak are structurally presented as extremes (as aspiration or revulsion) in relation to an objectifying and privileged audience. "The three constituent elements of the beauty pageant and the freak show—viewer, viewed, and mediator—are not equally visible," Garland Thomson notes. "The viewed object is overwhelmingly conspicuous while the viewer and the intermediaries remain obscured" (463–464). In other words, the beauty and the freak are put on stage, under a spotlight, often in revealing clothing or costumes that emphasize specific physical features, and they are made to perform under the direction of the emcee or the barker. The audience is able to anonymously gaze at the beauty and the freak; to freely inspect their bodies from every angle, and for as long as they want. A similar dynamic exists between the comic book superheroes and their readers. The costumed crusaders are drawn for maximum visibility, frozen mid-action, allowing readers to dwell on the images. Moreover, just as Garland Thomson clarifies that despite the beauty and the freak's demonstration of nominal talents, "the spectacle is the body itself rather than what it does" (464). The foregrounding of the heroes' forms overshadows even their incredible powers. The superheroes' skintight costumes that reveal every muscle (or ample bosom), the seemingly endless flexing and assertive posing, constantly reaffirms for readers that these figures are masculine and feminine ideals. Conversely, the grotesque characters, or the freaks, who occupy the same world as these super beauties are framed as undesirables, in every sense of the word. The grotesque character has often occupied the role of villain almost by default.

The alignment of physical deformities with villainy still persists in

GROTESQUE BODIES AND MONSTROUS HEROES | 177

modern comics. Yet, since the 1960s, monstrous-looking heroes have become an acceptable (but still minor) variant on the heroic form. Marvel broke new ground when they introduced grotesque but still heroic characters to the superhero genre. The debut of The Thing (Ben Grimm) in the pages of *The Fantastic Four* #1 in 1961 and the incredible Hulk (Bruce Banner) in his own 1962 solo series bridged the chasm between heroes and monstrosities. The handsome and charismatic Ben Grimm is exposed to mysterious rays while on a space mission with his best friend Reed Richards, Richards's fiancée Sue Storm, and her brother Johnny Storm. The rays grant all four of the adventurers fantastic powers, but only Ben becomes disfigured. Ben gains super strength and impenetrability, but he is also transformed into a brutish orange figure with rock-like skin. Reconstituted as a seemingly inhuman "Thing," Ben struggles with the revulsion and condemnation that his monstrous appearance evokes from everyone who sees him, even the people he rescues from supervillain attacks. As The Thing, Ben Grimm became an enormously popular tragic hero, a persona that would help define Marvel's reinvigoration of the comic book industry in the 1960s. "The hideously disfigured Ben Grimm was, in numerous ways, a detonator who would set off a constellation of changes," argues Matthew J. Costello, "changes that would expand and complexify the notion of comic book heroes fundamentally and forever" (2009, 29). Under Stan Lee's direction, Marvel's Silver Age heroes became outsiders and flawed characters, as likely to be feared as admired. Spider-Man is branded a criminal by the NYPD and J. Jonah Jameson of the *Daily Bugle*; Dr. Strange is a weirdly psychedelic shaman camped out in Greenwich Village; Luke Cage is an ex-con "hero for hire" who hustles on the streets of Harlem; and the X-Men are genetic mutants who are reviled and discriminated against as the perfect metaphorical outsiders.

Similar to The Thing, Marvel's Hulk blurred the line between hero and Grotesque. When meek scientist Dr. Bruce Banner is exposed to mysterious gamma radiation, he is cursed to transform into a gigantic green beast, the mindless Hulk, whenever he becomes angry. The Hulk is a tragic beast and an incidental hero, one inspired as much by Frankenstein as by Superman. The groundbreaking success of The Thing and the Hulk as Grotesque heroes can be directly linked to Marvel's earlier emphasis on monsters in horror comics. Christopher McGunnigle traces the historical trajectory from Marvel's 1950s and early 1960s horror titles to the development of their outsider superheroes. "Built upon the rhetorics of the monster era, the silver age Marvel superhero adopted many of the characteristics of the Marvel monster," argues McGunnigle. "The heroic monster and its transformation from human form to something else inspired many of Marvel's anti-heroes and outsiders who assumed monstrous names and epithets to reinforce their uncanniness and incredible-ness. The appearance and

identity of many Marvel silver age superheroes was likewise influenced by visual rhetorics and archetypes of the monster era, particularly in color and shape designs inherent to graphic narrative" (2018, 113). The Thing and the Hulk straddled the horror and the superhero genres, transposing the man-turned-monster from a danger to a tragic hero, a man who looks monstrous but may still be good. Classic monsters like Dracula, Frankenstein, and the Werewolf have always played out as a warning parable for young audiences, particularly in relation to controlling sexual urges, less one turn into a monster. As numerous film scholars have pointed out, the convention of masculine duality in monster movies (the man turned werewolf or vampire, or the stalwart hero fighting the beast for the love of a woman) enacts a simple analogy for the physical and emotional changes of puberty, and the need to control these impulses. Superhero stories are, in many ways, the inverse of the monster's tale. The superheroes' clichéd masculine duality (secret identities, mild-mannered teenager developing incredible powers after an accident) is likewise a clear analogy for puberty. But where the monster story is a warning, the superhero is aspirational. The monstrous superhero introduced by The Thing and the Hulk reveals the overlapping logic behind both genres and hints at the possibility that even costumed crusaders may be figures to be feared as well as desired.

The Thing and the Hulk challenged the idea that only square-jawed handsome men could be superheroes, even if the narrative emphasis on their revolting freakishness and their ostracization from humanity continued to reinforce the expected ideal of heroic beauty. Though modern comic book heroes are still overwhelmingly illustrated as physical ideals, the concept of Grotesque heroes as lovable but tragic figures is used increasingly to explore the disjuncture between an ugly appearance and a beautiful soul. Marvel's ever-expanding roster of mutant characters in particular has embraced nontraditional-looking superheroes. Two of the most intentionally grotesque characters, Beak and Glob, have become fan favorites appearing in various *X-Men* comics. Beak and Glob both debuted in *New X-Men* #117 (2001) during writer Grant Morrison and artist Frank Quitely's acclaimed run on the series. Morrison is recognized for his unusual and revisionist stories that often explore the complicated psychological themes typically glossed over in superhero comics. Beak's genetic mutation gives him bird-like powers that also transform him into a hideous figure with a beak for a mouth, bulbous eyes, chicken feet for hands, and an overall emaciated look of a plucked turkey. Glob is super-strong and durable, but his body is a transparent pink gelatinous mass through which his skeleton, brain, intestines, and other organs are visible. Despite their unconventional appearances, and their limitations as heroes, both Beak and Glob became popular mutant characters. Marvel's heavily populated X-Men books have always embraced melodramatic subplots between team members that give

the series an air of the soap opera. Beak and Glob's heartbreaking insecurities about their looks, and the growing friendships (and even romances) that develop between them and other mutants, fit well with the emotional dynamics of the stories. These characters and others are now used to teach readers not to discriminate based on appearances, or to judge a mutant by his cover. Modern costumed characters who skew toward a more grotesque countenance are a progressive presentation of heroism as a possibility even in alternative bodies. Unfortunately, the visual landscape that X-Men like Beak and Glob inhabit is still defined primarily by the handsome images of characters like Captain America and Thor.

Grotesque Worlds and Superheroes

The overwhelming emphasis on heroes as physical ideals—and by implication as models of morality—is consistent across most styles of illustration. Grotesque artwork is the only style that inverts the traditional aesthetics of superhero representation. Some of the alternative artistic styles that have been analyzed throughout this book may alter or shift the dominant mode of Idealism without inverting its core implication of the hero's superiority. For example, the Cute aesthetics discussed in chapter 6 soften and infantilize the characters, and the Retro style detailed in chapter 4 streamlines the hero and eschews excessive muscularity or sexual detailing, but both the Cute and Retro styles maintain a general emphasis on the caped crusaders as ideals. The Grotesque style, however, implies something monstrous about the entire genre. The radically different illustration of the hero, from the clean, smooth lines and perfectly proportioned figures of other styles to the exaggerated, distended, lumpy, and uneven forms of the Grotesque, is a remarkable diversion from traditional superhero illustrations. The balanced, sleek, and symmetrical depiction of a character like Batman drawn in Bruce Timm's signature Retro style is incongruous with Sam Kieth's illustration of the same character. Edwards and Graulund argue: "The grotesque lies in juxtaposition to the common conceptions of classical aesthetics, which focus on symmetrical representations of bodies and figures that are unified, harmonious and well-proportioned" (2013, 37). A figure like Batman is understood as grotesque in Kieth's drawing because it is so radically different from the typical depiction provided in Timm's portrait. The grotesque Batman with his ridiculously elongated neck, protruding triceps, and bulbous thighs is incongruous with the impossibly symmetrical and square-jawed Batman who is drawn in perfect Vitruvian proportions.

The awkward juxtaposition of ideal and freakish figures serves to define and delineate the Grotesque as the antithesis of most dictates about the

7.5 From *Batman: Ghosts* (2006), Sam Kieth, artist, DC Comics.

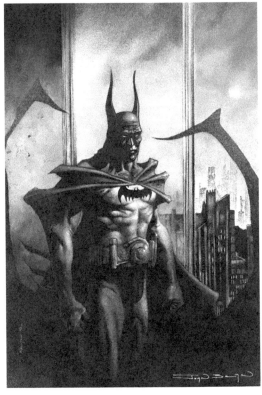

7.6 Kelley Jones's Batman from *Batman & Dracula: Red Rain*, DC Comics (1997).

7.7 Batman, by John Bolton (1997), DC Comics.

purpose of art as a means to represent beauty. Instead, the Grotesque intentionally invokes a sense of dread and a feeling of unease. The mise-en-scène of Grotesque art tends to be dark and indistinct, a threatening, otherworldly landscape. Ordinary settings become foreboding nightmares, with danger lurking in every shadow. In particular, the sharp contrast between the classical hero's form and the grotesque rendering of the same characters speaks to a different understanding of the human body. The superhero body is usually self-contained perfection, armored against the outside world, but the Grotesque body is less assured. The Grotesque superhero's body becomes too much or too little, it is uneven, it is stretched and twisted. In short, the Grotesque superhero body registers as abject. As Julia Kristeva defines the concept, "abjection" is that which refuses to "respect borders, rules" and "disturbs identity, system and order" (1982, 4). Superheroes usually safeguard against abjection in any form. In her discussion of Grotesque aesthetics in relation to gender, Mary Russo argues: "The images of the grotesque body are precisely those which are abjected from the bodily canons of classical aesthetics." Moreover, Russo continues, "the grotesque body is open, protruding, irregular, secreting, multiple, and changing; it is identified with non-official 'low' culture or the carnivalesque, and with social transformation" (1994, 8). Like the bodies from high art paintings and historical carnivals that Russo describes, the

Grotesque rendering of superheroes challenges cultural assumptions by foregrounding the abject features that are typically hidden from view.

It is more than just a superficial aesthetic difference when grotesque illustrations are employed for comic book superheroes. It is not merely the bodies that are different: the style makes an affective change to the stories and alters the genre's core message. Grotesque superheroes undermine the themes of heroic empowerment and ensured moral victories. Instead, the superhero story becomes an existential horror, with the lines between the hero and the monster obscured. Grotesque superhero art can vary a great deal in appearance. Defined in contrast to norms, in opposition to conventional rules, Grotesque illustrations can look radically different from one artist to another. As Sam Kieth's drawing from *Batman: Ghosts* demonstrates, Grotesque artwork can extend bodies to impossible extremes. Likewise, the work of artists such as Kelley Jones, Simon Bisley, and John Bolton is Grotesque because they amplify figures to an absurdist level. The hero's body may still be muscular, but those muscles bulge at weird angles and protrude from elongated limbs. In fact, these exaggerated bodies seem to ridicule the hypermasculine muscularity of more conventional superhero illustrations. Anatomies are swollen and overwrought with definition, and muscles that do not exist in reality are randomly added as bulges to arms and legs. Abdominal muscles become 22-packs rather than 6-packs, quadricep leg muscles become massive (octocep?) thighs. These grotesquely muscular bodies become surreal, threatening to burst through the skin, or to collapse under their own bizarre proportions. The overextended figures are a caricature of conventional superhero figures. The aesthetic requires readers to reevaluate the absurdity of a genre about muscle-bound men leaping around in skintight costumes.

Other comic book artwork is Grotesque not because it embellishes bizarre muscularity and physical proportions, but because it is too inhumanly angular or lopsided and disproportionate. Acclaimed comic book

7.8 Liam Sharp's Batman, from *Batman: Reptilian* #2, DC Comics (2022).

GROTESQUE BODIES AND MONSTROUS HEROES | 183

7.9 From *Ultimate Marvel Team-Up* #13 (2002), Toby Cypress, artist, Marvel Comics.

7.10 Daredevil, by Rafael Grampá, artist (2009), Marvel Comics.

artist Mike Mignola, the creator of Dark Horse's flagship character Hellboy, is widely recognized for his sharp, even lumpy, figures. Mignola's signature style involves dark, flat colors and unusually barrel-chested bodies. Utilizing a similar aesthetic, artists such as Ted McKeever, Mike McMahon, Denys Cowan, and Toby Cypress render characters with sharp angles and uneven bodies. Arms may extend to the ground or be as square as bricks, legs often look like stilts or bend at impossible angles. Other illustrators, like Paul Pope, Sean Murphy, and Rafael Grampá, rely on an excess of dark lines to detail their figures, giving the impression of creased and ill-fitting costumes on asymmetrical bodies, as well as deeply wrinkled, craggy, and even saggy skin. These Grotesque styles of illustration make bodies look more like freaks than physical ideals. None of these bodies are the sleek and beautiful forms that imply they are godlike, able to soar across the heavens, deflect bullets, or strike an inspiring pose. These Grotesque figures suggest bodies that are burdened with physicality, weighed down by gravity and the limitations of corporeality.

Because the comic industry is so invested in female characters as erotic objects, superheroines are not as frequently depicted in a Grotesque style as the men are. The Idealism of men and women in the comics is framed by different cultural standards. Men embody hegemonic masculinity primarily through their strength and power, which is reflected in their muscles. Male sexual attractiveness is secondary, or is seen as an incidental result of their rugged manliness. Superwomen, however, are principally valued for their beauty and hypersexual figures. The women's conventional

attractiveness is their defining attribute. The unequal beauty expectations for men and women mean that the Grotesque depiction of masculinity is less radical than the Grotesque version of femininity. In blunt terms, a grotesque woman is less culturally acceptable than a grotesque man. The social disruption posed by grotesque women has been recouped by feminist approaches that focus on the rebellious political possibilities of unconventional women. Drawing on Mikhail Bakhtin's theory of the carnivalesque, the idea of the female Grotesque as a politically and ideologically powerful figure of subversion has become an important concept in feminist studies. The opposite of the classical body in both appearance and ideology, the "grotesque body is open," writes Mary Russo, "protruding, irregular, secreting, multiple, and changing; it is identified with non-official 'low' culture or the carnivalesque, and with social transformation" (1994, 8). In other words, where the classical body is the dominant normative model representing ideal beliefs and values, the Grotesque body is emblematic of all things socially unacceptable and thus abject. As Rowe compares these two cultural body types: "The 'grotesque body' exaggerates its processes, bulges, and orifices, whereas the static, monumental 'classical (or bourgeois) body' conceals them. The grotesque body breaks down the boundaries between itself and the world outside it, while the classical body, consistent with the ideology of the bourgeois individual, shores them up" (1995, 33). The modern female Grotesque, those women who either fail or refuse to conform to the dominant physical ideal, can become an agent of "social transformation," as Russo put it. As a liminal character standing outside the borders of proper cultural behavior, the female Grotesque can examine, criticize, parody, and ideally force people to question the supposed naturalness of social expectations, both physical and behavioral. Numerous studies of plus-size female comedians, from Mae West to Roseanne to Melissa McCarthy, have documented the ability for unconventional female bodies to confront social norms.

The critical effectiveness of real-life women whose nonconformist appearance allows them a greater voice—an ability to dissent through humor, to mock the artifice of social standards—is difficult to replicate in superhero comics. The physical strength and the threatening sexuality of most female costumed characters is already an inherent threat to patriarchal standards. The standard superheroines' exceptional beauty serves as compensation for the threats she otherwise activates. As with the men, the grotesque exaggerations of women in superhero comic books do question the classical bodily ideals and the assumptions of moral and ethical superiority that go along with perfectly symmetrical and proportioned bodies. The Grotesque superheroine also undermines the masque of beauty that usually camouflages her physical and sexual dangers. Ted McKeever's version of Wonder Woman in the one-shot special "The Blue Amazon"

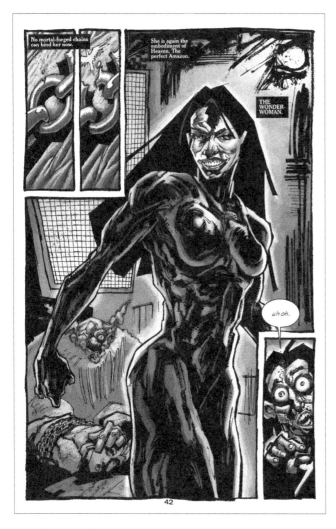

7.11 From *Wonder Woman: The Blue Amazon* (2003), Ted McKeever, artist, DC Comics.

depicts the Amazon Princess as heavily and excessively muscled rather than voluptuous and curvy. Likewise, her face, which is usually the epitome of feminine attractiveness ("As beautiful as Aphrodite"), is now harsh and angular. McKeever's type of grotesque Wonder Woman threatens to be too powerful, too masculine. Conversely, Simon Bisley's illustration of Catwoman (a character already predetermined by her sexuality) threatens with a body overflowing with sexuality, her breasts and hips barely contained by the tight costume. Unlike the feminist Grotesque that can serve as an agent of political change, the image of the superheroine Grotesque emphasizes the threats (too powerful, too sexual) that are disguised in other illustration styles.

All of these different Grotesque forms, both male and female, challenge the dominance of the classical superheroic body as an impossible ideal. Instead, the grotesquely drawn superhero offers a figure that questions traditional aesthetics and, thus, the assumption of righteousness ascribed to the characters. Frances S. Connelly reasons that the defining ideological attribute of the Grotesque, regardless of where it appears, is its ability to disturb or breach borders: "Grotesques come into being by rupturing cultural boundaries, compromising and contradicting what is 'known' or what is 'proper' or 'normal'" (2012, 2). This "rupturing" places the Grotesque at odds with the conventional superhero because, at its core, the superhero genre is all about boundaries. As discussed earlier, despite the superheroes' powers, these characters always maintain the status quo. As Uricchio and Pearson (1991) argue, superheroes serve as de facto "agents of hegemony" through their perpetual defense of law, order, and a naturalized standard of morality. The heroes always save the day, capture the criminal, defeat the alien invaders, and rescue endangered innocents. Elsewhere I have argued the importance of borders to the central structure of the stories: "Specific plots are almost irrelevant, what the superheroes repeatedly enact for readers is a symbolic policing of the borders between

key cultural concepts: good and evil, right and wrong, us and them. Intertwined with these abstract concepts are corporeal boundaries between male and female, mind and body, self and other, that are just as obsessively and problematically policed by superheroes as the literal borders between nation states are" (Brown 2015, 137). The cliché of bulletproof heroes, often encased in iron suits or with skin of steel, glorify the impervious body. The super body is often literally impenetrable, and even if some of those bodies can be wounded, they always rise up. The manner in which superheroes are typically illustrated signifies their physical integrity and their rigidity. These are usually characters who can be described as sculpted and chiseled, and their appearance implies being made of stone.

The perfect bodies, beautiful faces, and clear, bold lines used to render superheroes in the most conventional forms begins to dissolve in Grotesque renderings. Likewise, the ideology of unassailable categorical distinctions between right and wrong, hero and monster, morality and immorality that are typically embodied by the heroes also begins to dissolve. In Grotesque styles the once perfectly proportioned and symmetrical anatomy of the heroes can extend beyond even the most radical of real-world models, capes and hair can trail on endlessly, and bodies can twist, turn, and pose at impossible angles. Many of the artists that work in a Grotesque style use less-conventional techniques (watercolor, pastels, and photomontages) that compromise or fade distinct edges. Dave McKean's illustrations for the landmark graphic novel *Arkham Asylum* (1986) depict a blurry nightmare world where Batman's form seems in danger of dissolving. In other words, the bodily boundaries of the hero may blend with the backgrounds, or dissolve into vertiginous collages. Rather than the classical, statuesque, and self-contained body, these Grotesque renderings present bodies that appear compromised, indistinct, flawed, or swollen to the point of absurdity. The depiction of superheroes as grotesque introduces the possibility that these usually ideal figures are also inherently abject.

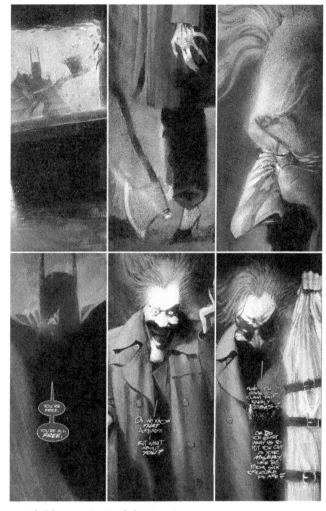

7.12 From *Batman: Arkham Asylum* (1986), Dave McKean, artist, DC Comics.

In *Powers of Horror: An Essay on Abjection* (1982), Julia Kristeva argues that depictions of the abject are crucial for solidifying the cultural norms that define and delineate the borders between order and that which lies beyond acceptability. According to Kristeva, the abject is "subject to a range of taboos designed to control the culturally marginal" (Doane 1991, 26). Through various cultural rituals and personal lessons, societies demarcate a symbolic line between the acceptable and the abject. Elements of abjection are coded as taboo because they violate borders, from sexual prohibitions against incest and bestiality to disgust with corpses and bodily waste. Of course, abject elements can never be fully expunged, and indeed are needed to validate acceptable elements by contrast. As Barbara Creed (1986) has demonstrated, horror is a genre that routinely exercises and reinforces our fear of the abject by transgressing boundaries between features such as life and death (ghosts, zombies), human and animal (werewolves, vampires), and bodily integrity versus vulnerability (all those stabbed, chopped, and mutilated victims). Where the horror genre works to enforce rules against abjection through explicit fear, the superhero genre does so by marking the rejection of the abject as a heroic act. Both genres contain bodies that at times erupt and explode beyond their own borders, but where horror eradicates those bodies, superheroes seek to contain them. Classical, Idealistic superhero art is one of the many ways that our society seeks to expunge the abject from view—erasing it in an attempt to control it. The genre is by and large successful in bracketing out the abject through perfectly proportioned bodies made of steel and relatively bloodless violence. But the grotesquely rendered superhero reasserts the presence of the abject and suggests that it must still be guarded against because it lurks just below the surface of superheroes. The fact that Grotesque artwork shifts the superhero adventure into the terrain of the horror story means the excising of abjection occurs through both fears of crossing boundaries and the valorization of reinforcing borders.

The ability of Grotesque art to undermine the dominant message of superheroes as a fantasy of personal empowerment and a hegemonic maintenance of the status quo affectively shifts the stories from the realm of straight adventure into the genre of horror. This shift from adventure to horror is made explicit in that many of the stories that use Grotesque illustrations are concerned with traditional monsters rather than supervillains. These stories, and the Grotesque art, are often presented as removed from primary continuities via "What If?" and "Elseworlds" imprints. This type of editorial segregation of Grotesque art is marked as atypical in the official description printed with each Elseworlds book: "heroes are taken from their usual settings and put into strange times and places—some that have existed, or might have existed, and others that can't, couldn't or shouldn't exist." For example, a single character like Batman is repositioned as both

a vampire-fighter and a vampire in *Batman: Nosferatu* (1999), illustrated by Ted McKeever, and *Crimson Mist* (1998), drawn by Kelley Jones (who also illustrated the series *Haunted Gotham* in the same year). The Dark Knight also becomes possessed by a demon in *Batman/Demon: A Tragedy* (2000). He fights a Lovecraft-inspired monster in the 1920s in *The Doom that Came to Gotham* (2000) by Mike Mignola, and Batman battles a demonic cult in *The Order of the Beasts* (2004), with art by Eddie Campbell. Likewise, though it is not coded specifically as horror, in *Batman: Year 100* (2006), Paul Pope depicts the Dark Knight fighting against evil mind-controlling villains in a dystopic and totalitarian future. In all these stories, the Grotesque artwork compliments the horror-infused plots and develops a sense of dread. The art suggests an impending doom rather than the superhero's typically hopeful narrative arc.

The shift to abject or uncanny horror implied by the Grotesque artwork allows the superhero to function in ideological opposition to the more traditional depictions usually found in the comics. Of course, even in these stories the hero usually saves the day. But he is not presented as an aspirational ideal, as someone readers want to be like and look like. Nor are superheroines illustrated as beautiful and innocent women to admire or lust after. The Grotesque superhero in many ways becomes monstrous rather than heroic, unnerving rather than comforting, and morally compromised rather than morally perfect. The Grotesque superhero is better suited to the fringe margin of the genre, sequestered primarily in the realm of "Elseworlds" and "What Ifs?" Rather than a heroic model, the Grotesque hero becomes a warning or a potential threat. The inherent violence and inhumanity glossed over in most comic books bubbles to the surface via the Grotesque. Heroes can become monsters doing what they do. It is perhaps no coincidence that many of the stories that employ Grotesque illustrations are told from an alternative perspective. Readers see the hero through the eyes of the mentally unstable bad guys or as interpreted by naïve and terrified bystanders.

This alternate view of comic book heroes implied by Grotesque illustrations can be a very effective tool for stories that explore the hero's alienation and his differences from mere humans. Riley Rossmo's artwork is typically crooked and uneven, with bodies that are too twisted and lumpy, faces that are warped, and an excess of scraggly lines meant to delineate muscles that merely mock the incredible definition found in most comic books. Rossmo's work on DC characters like the Flash, Batman, and Deadman playfully mocks them as ideals, implicitly questioning their appeal as heroes if they do not look like bodybuilders in tights. Rossmo's unusual style is an anomaly in most superhero series, often best suited to depict monsters and macabre ghosts, as he did in the supernatural *Constantine*. In a miniseries reboot, *Martian Manhunter* (2018–2019), written by Steve Orlando,

7.13 From *Martian Manhunter* #2 (2018), Riley Rossmo, artist, DC Comics.

Rossmo's illustrations help capture the titular Martian (aka J'onn J'onzz) perceived as a monster and an ostracized outsider. As a literal alien, and a shapeshifter, the Martian Manhunter is often depicted as amorphous and unstable, the exact opposite of the firm, impenetrable body we associate with superheroes. Rossmo's Grotesque artwork reinforces the frequent question posed by J'onn's police partner: "What are you?" In his alien form, even when he tries to mimic human bodies, the Martian Manhunter is unrecognizable as a hero. Interestingly, Rossmo's pencils also shape the humans as monstrous, working with Orlando's narrative that Earthlings are just as frightening to the Martian as he is to us (Figure 7.13). In the end, the story becomes a classic buddy-cop tale where both Jon and his partner, Diane Meade, learn to value each other despite their appearances and their mistakes.

Grotesque superhero art comes in a range of different looks depending on the personal style and intent of the artist. The fact that grotesque versions of superheroes even exist, let alone are popular, means that the genre requires a broader range of analysis. Superheroes are not always mere defenders of the status quo and ridiculous masculine fantasies. Grotesque heroes create a drastic shift in the meaning of the characters and the narrow alignment between ideal-looking caped crusaders and assumptions of virtue and justice. Like the Grotesque paintings of Goya, Bacon, or Dali, these superheroes force viewers to question not just aesthetic standards, but also assumptions regarding abstract cultural ideas like justice, terror, innocence, and righteousness.

8 | SUPERHERO NOIR, MORE THAN JUST BLACK AND WHITE

When Jerry Siegel and Joe Shuster's Superman made his spectacular debut in 1938, the figure of the superhero seemed to emerge fully formed. Superman has been described as the dream of young Siegel and Shuster, two impoverished adolescents from Cleveland experiencing the inequalities and corruption in America brought on by the Great Depression, and observing the rise of Hitler, the Third Reich, and the impending war in Europe. In addition to these influences, numerous histories have detailed the wide range of precursors to the superhero, including classical mythology, religious parables, circus strongmen, science-fiction serials, and earlier heroic models like Robin Hood, the Scarlet Pimpernel, Zorro, and Sherlock Holmes. Another important presage to comic book heroes were the racy pulp magazines that dominated newsstands with their tales of crime and intrigue, and featuring such superhero*ish* characters as Nick Carter, Doc Savage, the Spider, and the Shadow. The Pulps would also connect with the literary genre of crime fiction, helping to establish the hard-boiled detective made famous in the writings of Raymond Chandler, Dashiell Hammett, James M. Cain, Jim Thompson, and Mickey Spillane. The development of the superhero comic book, particularly the darker characters like Batman, Dr. Midnight, and the Sandman, was influenced in large part by the narrative and visual tropes established in the Pulps and hard-boiled detective stories. Indeed, crime comic book series like *Crime Does Not Pay* (1942–1955), *True Crime* (1947–1952), and *Crime Suspenstories* (1950–1955) rivaled superheroes in the early years of the medium. As James Lyons notes in his review of early crime comics: "Noir films and comics share common forerunners in the shape of the pulp magazines and dime

novels popular in the first decades of the twentieth century, typified by sensational content and enticingly lurid covers" (2013, 460). With the establishment of the Comics Code in the mid-1950s, the crime comic was essentially eliminated as a comic book genre. But the contemporary comic book industry has witnessed a resurgence in popularity of crime-focused graphic novels, which has reintroduced distinct narrative themes and visual styles that both harken back to the Pulps and hard-boiled detectives and establish conventions for new Noir comics.

One of the most distinctive styles in superhero comic books, "Comic Noir" is typically aligned with specific writers rather than artists. Prolific modern writers like Brian Michael Bendis, Ed Brubaker, Greg Rucka, Brian Azzarello, and Jeff Lemire have bridged the gap between crime comics and superhero stories. While all of these writers have been studied for the way they have updated crime comics and/or managed to blend current story-telling techniques with classic hard-boiled detective fictions (see Wandtke 2015), less attention has been given to the manner in which specific artists working alongside these authors have established a subtle visual code for superhero Noir comics. Crime comics have a long history of mimicking the appearance of lurid Pulp covers and the style of Film Noir through sharp angles, the distinctive image of trench coat- and fedora-wearing protagonists, sultry femme fatales, dangerous cityscapes, and the effective use of shadows. While the writers have been credited with reinvigorating Noir tales, the artists who have worked with them, including Alex Maleev, Lee Weeks, Dan Panosian, Michael Gaydos, Tomm Coker, Eduardo Risso, John Paul Leon, Michael Lark, Mike Perkins, and Andrea Sorrentino, have created illustrations that resituate the superhero from flashy, over-the-top adventures to somber mysteries. The Noir style is used primarily (but not exclusively) with superheroes like Batman, Daredevil, Jessica Jones, The Question, and Moon Knight, who inhabit the dangerous back alleys of decaying cities, rather than the all-powerful interstellar heroes. Superhero Noir is a unique mixture of crime writers, dark anti-heroes, and artists skilled in creating a subdued and gloomy atmosphere. This chapter is concerned with Superhero Noir as an artistic style premised primarily on the aesthetic conventions of classic Film Noir and how these illustrators literally redraw the superhero as a tragic figure fighting villains, systemic corruption, crimes of passion, and fate itself.

The mood and meaning of a modern comic book scene can become more serious, melancholy, and tragic through the use of Noir illustrations. Noir aesthetics have become so ingrained in our visual landscape that readers do not need to be familiar with Film Noir or the history of crime comics to perceive the fatalistic tones concisely suggested by some artists' styles. For example, Lee Weeks's artwork in Figure 8.1, from *Batman Annual #2*

(2018) written by Tom King, utilizes shadows and extreme close-ups to create a moody, hard-boiled flashback moment between Batman and Catwoman, the detective and the feline fatale. The alternating and increasingly tighter framing of their faces becomes claustrophobic, just as the dialogue about Batman's and Catwoman's similarly tragic pasts gets uncomfortably personal. As this scene suggests, the figure of the superhero depicted through a Noir lens can radically change the impression of characters and their overall ethos. The stereotypical idea of muscle-bound heroes slugging it out while spouting puns is a long way from the serious, hushed tones of existential angst played out in the shadows. Rather than the decisive victories we have come to expect from superhero comic books, where the hero can save the innocent with a powerful right hook to the villain's jaw, Superhero Noir denies the simplicity of an easy conclusion. Most superhero tales are a series of world-saving adventures no matter how many small setbacks the hero faces along the way to his or her ultimate triumph. In contrast, Superhero Noir implies a futile Sisyphean task of fighting against the darkness of the world without ever really changing anything. For the most part, the superhero genre is in favor of nothing changing. Superheroes are about supporting the status quo; they are champions of law and order, not cultural change. Umberto Eco argued in his 1979 essay about Superman that heroes are narratively required to maintain the status quo, to return everything to normal after each adventure, so the stories can continue indefinitely. As Richard Reynolds notes in one of the first serious book-length considerations of the genre: "the villains are concerned with change and the heroes with the maintenance of the status quo" (1992, 51). And, in Jason Dittmer's discussion of nationalistic heroes, he claims that superheroes are "a literary genre that is almost universally about the conservation of the status quo; superheroes are about the protection of life and property and almost never seek to fundamentally

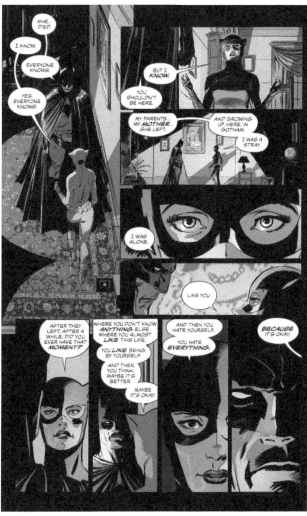

8.1 From *Batman Annual* #2 (2018), Lee Weeks, artist, DC Comics.

revolutionize the system" (2005, 642). Reframing the superhero's world as Noir shifts this dominant theme by stressing the futility of trying to maintain the status quo.

Crime comics in the 1940s were a logical development, moving from the themes of popular pulp magazines like *Black Mask*, *Private Detective*, and *Spicy Mystery* that helped introduce the gritty style of writers like Dashiell Hammett and Raymond Chandler. As a more visually based medium, early crime comics also looked to Film Noir and mimicked the aesthetic of the films through strong angles, heavy shadows, and distinctively stylized character designs for trench coat-wearing detectives and fashionable femme fatales. The themes of Noir in all its various forms (pulp, dime novel, film, and comic book) expressed an American zeitgeist of disillusionment that emerged following years of economic depression, failing urban infrastructures, and the inevitability of World War II. While some of these early crime comics incorporated elements associated with superheroes—for example, Will Eisner's classic The Spirit, which featured a stalwart masked detective—most of the crime-focused titles often revolved around murder and extreme violence. The content of crime comics came under intense scrutiny in Fredric Wertham's infamous bestselling book *Seduction of the Innocent* (1954), in which he argued that comic books were corrupting the youth of the nation. Wertham accused crime comics (a category in which he included horror and superheroes alongside true crime, gangster, and detective stories) of implicitly and explicitly including scenes of gruesome violence as well as extramarital sex, drug use, bondage, and homosexuality. Following Wertham's accusations and a general moral panic in America about juvenile delinquency, a special Senate subcommittee was convened to address the corrupting influence of comics. Much like the McCarthy-era investigation of supposed communist propaganda in Hollywood resulted in the self-censoring Hays Code, comic book publishers created the "Comics Magazine Association of America" in 1955 and established their own highly restrictive code of approval.

The code focused on moral expectations which targeted the crime and horror comic books that had been held out as the most offensive during the Senate hearings. In fact, words like "horror" and "terror" were no longer allowed in the title of any comics. The code dictated: "policemen, judges, government officials and respected institutions shall never be presented in such a way as to create disrespect for established authority, and in every instance good shall triumph over evil and the criminal punished for his misdeeds." After 1955, crime comics were essentially outlawed on the grounds of glorifying criminals and violence. As a result of the strict code prohibitions, even superheroes avoided tackling anything that looked like real crime, instead dealing with silly aliens and interdimensional tricksters while also trying to avoid romantic entanglements. In her definitive

historical account of the code, Amy Nyberg notes: "gradually the type of comic book that had caused so much trouble for the industry disappeared, and what remained were romance, teen, and funny animal comics" (1998, 127). The shifting regulation of the comic book industry may have reduced the explicit violence that could be illustrated, but the larger stylistic influence of crime comics remained useful for a number of comic stories. Superhero tales that ventured closer to detective fiction than science fiction were often rendered in tones closer to Film Noir than the bright colors usually found in the genre.

Film Noir emerged from Hollywood during the late 1930s and early 1940s (the same era that saw the birth of the superhero) and became a genre defined as much, or more, by its style than any central narrative pattern. First identified retroactively by French film critics after the war, Film Noir was described as a mood, a tone, a bleak aesthetic that reflected a dark view of American urban corruption. Stylistically, Film Noir was marked by its use of chiaroscuro lighting, unusual camera angles, heavy shadows, and claustrophobic framing of characters. The emphasis on darkness and shadows in particular became Film Noir's defining feature. As Janey Place and Lowell Peterson note in their seminal 1974 analysis of Film Noir: "the low-key *noir* style opposes light and dark, hiding faces, rooms, urban landscapes—and, by extension, motivations and true character—in shadow and darkness which carry connotations of the mysterious and the unknown" (66). Common iconography also contributed to the look of Film Noir with the repetition of rain-soaked streets, neon lights, seedy bars, even seedier hotels, and late-night offices illuminated only by the streaks of light allowed through the window blinds. Similarly, familiar characters like the devious femme fatale and the washed-up detective with a tragic past, and narrative techniques such as jaded voice-overs and multiple flashbacks all leading to a doomed conclusion, contributed to the overall look and mood of Noir. The importance of signature visual conventions is stressed in the opening paragraph of James Naremore's definitive 2008 study of Film Noir:

> The term *film noir* conjures up a series of generic, stylistic, or fashionable traits from certain Hollywood pictures of the 1940s and 1950s. There are, for example, noir characters and stories (drifters attracted to beautiful women, private eyes hired by femme fatales, criminal gangs attempting to pull off heists); noir plot structures (flashbacks, subjective narration); noir sets (urban diners, shabby offices, swank nightclubs); noir decorations (venetian blinds, neon lights, "modern" art); noir costumes (snap-brim hats, trenchcoats, shoulder pads); and noir accessories (cigarettes, cocktails, snub-nosed revolvers). (2008, 1)

The distinctive visual features that quickly came to define Film Noir, and that have persisted long after the original phases of the genre disappeared, risk overdetermining the genre as nothing but a cluster of familiar signs, easy to mimic but devoid of an underlying worldview.

In fact, Ian Brookes argues that it is the "confluence of visual style, iconography, and narrative themes, that is often held to define noir" (2017, 35). Comic books, a visually centered medium on par with film, have copied and adapted these symbols of Film Noir as a simple means to evoke the aura of Noir. The mood and tone of Film Noir is easily echoed in the comics, largely due to the artwork—even if caped crusaders in masks have replaced detectives in fedoras. Superhero Noir both literally and figuratively mutes the usually colorful adventures of superheroes and shifts the implicit morality of the stories. Focusing specifically on the link between American detective fiction and crime comics, Terrence Wandtke describes the Noir hero in terms that fit many current superheroes: "Hard-boiled detective fiction represents the cynical fears of a post-Depression era through a private investigator who had no faith in the American dream. While mysteries might be solved, the hard-boiled detective merely keeps the chaos at bay, a loner in the mass of humankind longing for power to change things in the face of an oppressive world" (2018, 231). Moreover, Wandtke notes that the link between street-level costumed adventurers and Noir heroes was obvious very early in the development of comic books: "This pulp sensibility can clearly be seen in superhero comics with Batman, debuting in *Detective Comics*, a non-powered superhero fighting against a corrupt world of both gangsters and supernatural threats" (231). Though modern Superhero Noir representations are not restricted to the nonpowered heroes, there remains a strong link between the more street-level characters and the disillusioned, cynical anti-heroes of classic Noir. Since Noir is so overdetermined by its visual style, the artwork in Noir comics becomes a definitive component. Noir themes occur in superhero comics in a variety of ways; the most common versions are as Retro Noir and Neo-Noir. The primary distinction between these two categories is that Retro Noir is set in the same 1930s–1940s time frame as classic Film Noir, while Neo Noir occurs in a modern setting but with many of the same thematic and stylistic elements established in traditional Noir.

Retro Noir Comics

The superhero and Noir genres often overlap in modern comic books, sometimes very explicitly reenacting classic Noir. Both *Batman: Gotham Noir* (2001), penned by Ed Brubaker with art by Sean Phillips, and *The Batman: Nine Lives* (2002), illustrated by Michael Lark and written by Dean

Motter, presented reimaginings of traditional Batman characters as classic Noir figures. *Gotham Noir* and *Nine Lives* were stand-alone graphic novels published under DC Comics's Elseworlds imprint. The Elseworlds line allowed creators to explore DC's iconic characters outside of continuity, often displacing them across historical periods and/or genres. Most of the Elseworlds books (and the "What If?" books at Marvel) epitomize the pleasures of *multiplicity* that Henry Jenkins describes, wherein different versions of superheroes can exist simultaneously. Thus, Batman can be a grim avenger, a silly cartoon, a lone knight, a father to an extended Bat-family of protégés, an old man, and a 1940s masked hero all at the same time. "The Elseworlds books," Jenkins observes, "read the superheroes as archetypes who would assert themselves in many different historical and generic contexts; they invite a search for the core or the essence of the character even as they encourage us to take pleasure in their many permutations" (Jenkins, 2009, 24). This pleasure of seeing familiar characters in radically different settings seems, at first glance, purely whimsical, a marketing ploy to sell more comics to fans of specific characters. But placing familiar heroes in different historical contexts, or as formulaic figures in non-superhero genres, also allows the creators to develop new themes and/or to highlight elements that have always lurked just below the surface of the mainstream superhero stories—such as the futility of street-level superheroes constantly confronted with the tragedies of a city overrun with crime, violence, corruption, and poverty.

In *Gotham Noir*, alcoholic ex-cop James Gordon assumes the role of a down-and-out detective framed for the murder of a young woman who had dirt on both the corrupt mayor and the mob. Batman only appears as an indistinct figure, while Selina Kyle (Catwoman) is a femme fatale and the Joker is a disfigured mob underling. Sean Phillips's art replicates the aura of Film Noir and captures the desperation of Gordon as he scrambles to find the killer and keep his ex-wife and daughter safe. Rather than just including historically accurate clothing, hairstyles, and furniture, Phillips's drawings bring a sense of the sharp angles and claustrophobia associated with the tone of Noir. Similarly, *Nine Lives* depicts a 1940s version of Batman, while Gotham City is shown as a stylish but crime-ridden city populated by morally suspect socialites, gangsters, burned-out detectives, corrupt cops, showgirls, and wise-cracking secretaries. Bruce Wayne is still a playboy millionaire with a private life as the Caped Crusader, and James Gordon is the no-nonsense police commissioner. Dick Grayson (Robin) is recast as a low-rent private eye, while Barbara Gordon (Batgirl) is Grayson's spitfire assistant. Michael Lark's illustrations raise *Nine Lives* to more than just the novelty of reframing Catwoman as the owner of a speakeasy, or the Penguin as a mobster. Like Phillips's illustrations, Lark's artwork not only reproduces the look of classic Film Noir characters and

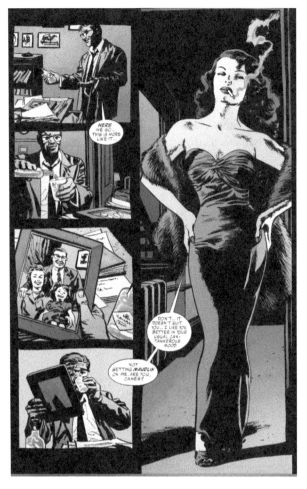

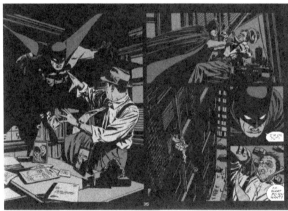

8.2 From *Batman: Gotham Noir* (2001), Sean Phillips, artist, DC Comics.

8.3 From *Batman: Nine Lives* (2002), Michael Lark, artist, DC Comics.

environments but also captures the tone of despair and moral corruption that underlines the traditional Noir narrative, and frames the comic panels in the style of Noir cinematography. The characters look realistic in size and dress, and the settings appear authentic but oppressive. Lark does use the visual clichés of Noir (shadows, window blinds, neon lights, etc.), but the simplicity and the grittiness of his illustrations suggest the violence and corruption at the heart of Gotham City, and at the core of Noir. Both Sean Phillips's and Michael Lark's ability to create an ambience of Noir goes beyond simply mimicking the appearance of 1940s detective films. Both artists would go on to solidify their association with a Noir style in contemporary and superhero settings: Phillips through his frequent collaborations with Ed Brubaker on crime comics like *Criminal* (2006–2019), *The Fade Out* (2015), and *Kill or Be Killed* (2016–2018), and Lark via his subsequent work on mainstream, in-continuity superhero adventures set in modern eras with characters like Daredevil, Captain America, and Black Widow (storylines which we will return to below).

Similar to the way *Gotham Noir* and *Nine Lives* explicitly linked Batman to classic Noir, Marvel released several mini-series in 2009 that presented their superheroes as hard-boiled 1940s private eyes and vigilantes. Daredevil, Wolverine, Luke Cage, the X-Men, Iron Man, Spider-Man, and the Punisher each received their own Noir reimaginings. The artwork varies across the different series, but generally the *Marvel Noir* books strived to replicate the feel and tone of Film Noir through dark tones and angles as well as images of rain-swept streets and dimly lit low-rent offices. In his discussion of *Marvel Noir* as a postmodern depthlessness, Martin Lund describes the look of the series:

198 | SUPER BODIES

> Visually, *Marvel Noir* uses some traits particularly associated with "classic" noir style. While the artwork generally stays close to the style of Marvel's overall output, one big difference between *Marvel Noir* and standard-continuity stories can be seen in their treatment of lighting and shadows. Almost across the board, colors are subdued, muted and grainy—this last aspect most notably in *Daredevil*. Most noteworthy of all in respect to *Marvel Noir*'s artwork is the different comics' unsparing use of chiaroscuro shading, unsurprising since this is one of the things with which film noir is most widely associated. (Lund 2015, 9–10)

Marvel Noir used the historical settings and the stock characters of Film Noir as a starting point for a broad intertextual experiment in shifting the central dynamics of a superhero story. Several of the stories fail to move beyond the cliché signifiers of Noir style and end up presenting superhero tales with a negligible patina of Noir. Ultimately, Lund concludes, "Much of *Marvel Noir*'s relation to the historical past is similarly stylized and generally superficial." However, some of the *Marvel Noir* tales (most notably Daredevil, Luke Cage, and Wolverine) become more than just a postmodern pastiche, primarily because the art reinforces a sense of authenticity to the hard-boiled stories. As Lund notes, Tomm Coker's illustrations for *Daredevil Noir* represent an effective use of Noir style to create an important tone for the slower-paced stories. When the 1940s Daredevil faces the Kingpin in his pitch-black office, the hero is obscured in shadows, and the tight frames of the villain drinking whiskey in the dark are reminiscent of the tough Film Noir hero confronting the embodiment of corruption. It is the comic book equivalent of Sam Spade encountering Kasper Gutman in *The Maltese Falcon* (1941). Moreover, this scene sets up the entire story as a long flashback as the Kingpin fills in the missing parts of the puzzle for Daredevil, a narrative device often used in Film Noir. *Daredevil Noir* also benefits from the character's long-standing association with street-level noirish tales about urban decay and moral corruption, themes that are also easier to explore with more working-class characters like Wolverine and Luke Cage, rather than the likes of Iron Man or the X-Men.

With some comics, the promotional links between superheroes and Noir can be understood as primarily a marketing tool. Perhaps the most reductionist example of this is DC Comics's hardcover collector editions of popular Batman books repackaged explicitly as Noir. In the late 2010s, DC reprinted landmark storylines in oversized coffee-table book formats under the banner of *Batman Noir*. Certainly, Batman's original conception by Bob Kane and Bill Finger was inspired by 1930s Film Noir and hard-boiled detective fiction. Following the silliness of the post-World

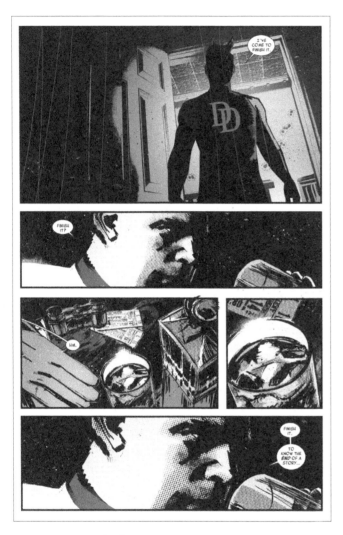

8.4 From *Daredevil Noir* (2009), Tomm Coker, artist, Marvel Comics.

War II era, the restrictions of the Comics Code in the 1950s, and the campiness of the Pop Art television series in the 1960s, editors at DC sought to return Batman to his dark avenger roots. Since the mid-1980s, Batman has been successfully overwritten as *grim and gritty*, making his adventures the most logical choice to evoke Noir themes and aesthetics. The *Batman Noir* line includes such landmark stories as Frank Miller's *The Dark Knight Returns* (originally 1986), Alan Moore and Brian Bolland's *The Killing Joke* (originally 1988), Jeph Loeb and Tim Sale's *The Long Halloween* (originally 1996), Loeb and Jim Lee's *Hush* (originally 2003), and Scott Snyder and Greg Capullo's *The Court of Owls* (originally 2011). While all of these stories, like many modern Batman comics, employ recognizable Noir elements, the organizing principle of the *Batman Noir* titles is that the stories are presented exclusively in black-and-white, pen-and-ink illustrations. These Noir editions are meant to highlight the work of the artists and inkers, providing a unique peek into a stage of the artistic process of making comic books. Indeed, the simple act of removing the color in the stories emphasizes a noirish feel to the books. This noirish feel results from a combination of the particularly hard-boiled Batman stories selected for the series and the strong association of black-and-white, or chiaroscuro, artwork with a Noir sensibility. Even Capullo's illustrations for *The Court of Owls* appear more Noir in tone when they are black and white rather than in his more traditional style of Idealism. Capullo's heroes are always ideal figures, perfectly muscled and handsome men and beautiful, wide-eyed heroines. Moreover, Capullo's pages are usually structured in a very conventional superhero style, with splash pages, quick pacing, explosive fights, and visuals that serve to make the narrative as clear as possible.

Super Neo-Noir

Terrence Wandtke traces the current combination of Noir sensibilities and superheroes to writer/artist Frank Miller's influential early work at Marvel from 1979 to 1983. "Daredevil was a good starting point for Miller in the superhero industry considering Marvel's devotion to the real-world city of New York and Daredevil's limited powers as a superhero," Wandtke argues. "These factors gave Miller the opportunity to explore the nature of city life and make the superhero story more into the crime story that Wertham feared it was" (2015, 68). Miller's critical and commercial success refashioning Daredevil into a tragic hero struggling to fight for a concept of justice that seems to have no place on the streets of Hell's Kitchen helped pave the way for more nihilistic superheroes and darker themes. Miller's status as a Noir-inspired comics creator was solidified with his monumental mini-series *Batman: The Dark Knight Returns* in 1986, and *Batman: Year One* in 1987 with David Mazzucchelli providing the artwork. Miller's take on Batman confirmed the Caped Crusader as primarily a grim Noir character, a trajectory that began in the 1970s as DC Comics sought to "reheterosexualize" Batman, as Andy Medhurst (1991) puts it, after the campy intonations of the 1966 television series starring Adam West. Comics historian Roger Sabin identifies Miller's *Dark Knight Returns* as a significant turning point for the entire industry: "This was the revisionist story to top them all . . . Miller took the myth back to its macabre 1930s origins, while at the same time giving it a cynical 1980s sensibility. Thus, Batman was portrayed not as the square-jawed law-enforcer of earlier comics, nor as the camp, pop-art figure of the classic 1960s TV series, but as a brooding psychopath, 50 years old and still traumatized by the death of his parents" (1993, 87). Frank Miller very vocally moved away from both Marvel and DC Comics in the early 1990s over disputes regarding royalties and creator rights. Miller's status as a comics auteur allowed him to experiment with even more hard-boiled Noir stories through his series *Sin City* (1991–2000) at Dark Horse Comics. The black-and-white *Sin City* tales were unapologetically Noir in nature, with sexy femme fatales and crusty anti-heroes fighting the mob, serial killers, and corrupt cops.

Following the recognition that comics creators like Frank Miller and Alan Moore received in the 1980s and their subsequent success with independent work, the range of genre possibilities broadened in the 1990s, facilitating a recognition of some creators as distinctive auteurs with a commercial value that superseded specific characters. For the first time since the 1950s, the relative monopoly shared by DC Comics and Marvel was challenged as new and creator-owned publishers redefined the comic book industry. Companies like Dark Horse, Image, and Milestone expanded

the market, introducing new superhero universes and developing popular series outside the narrow confines of the superhero genre. Moody crime stories reintroduced Noir themes to comics through popular and acclaimed independent works like *Mister X* (1983–1990) by Dean Motter from Vortex Comics, *From Hell* (1989–1998) by Alan Moore at Top-Shelf Productions, Howard Chaykin's *Black Kiss* (1992–1993) through Dynamite Entertainment, John Wagner's *A History of Violence* (1997) at Paradox Press, and Ed Brubaker's *The Fall* (1998) from Dark Horse Comics. Recognizing the expanding market for crime comics, DC introduced their "Vertigo" imprint, which showcased more mature-themed and stylishly violent mysteries, including series like *Sandman: Mystery Theater* (1993–1999) by Matt Wagner and Steven T. Seagle, *100 Bullets* (1999–2009) by Brian Azzarello and Eduardo Risso, and *Scalped* (2007–2012) by Jason Aaron. Though crime comics have made a comeback, most of these writers/artists and numerous others have also expanded into mainstream superhero comics and brought their Noir inclinations with them. "The superhero genre absorbs, reworks, accommodates elements of other genres, or perhaps we might frame this the other way around," reasons Henry Jenkins. "Writers interested in telling stories set in these other genres must operate within the almighty superhero genre in order to gain access to the marketplace" (2017, 18). The dominance of superheroes in the comic book market, particularly those published by the Big Two (Marvel and DC), is so established that the most iconic caped characters transcend any number of different genres, from romance to comedy to Noir.

Marvel hired comics creator Brian Michael Bendis to help bring a different perspective to their superhero characters. Bendis had established a reputation as a Noir writer from his independent graphic novels about petty criminals in over their heads, like *Fire* (1993), *A.K.A. Goldfish* (1994), and *Jinx* (1996). Bendis began writing the very conventional superhero series *Ultimate Spider-Man* in 2000, with Mark Bagley providing cheery and cartoony depictions of a teenage Peter Parker/Spider-Man and his typical roster of allies and villains. The popularity of *Ultimate Spider-Man* allowed Bendis the creative freedom to incorporate his passion for crime comics in 2001 when he took over *Daredevil* with artist Alex Maleev and created *Alias* with illustrator Michael Gaydos. Much like Frank Miller's Noir take on Daredevil in the late 1970s, Bendis used the character between 2001 and 2006 to anchor stories about organized crime, police corruption, the Yakuza, the Hand, and a few low-level supervillains—and blind Matt Murdock's efforts to protect Hell's Kitchen as a lawyer by day and the Man Without Fear by night. Maleev, who would become a frequent collaborator with Bendis, illustrated *Daredevil* in a distinctly graphic style that updated traditional Noir with a harshly modern expression. In Maleev's grainy renderings, Daredevil's world is seemingly devoid of light; shadows dominate

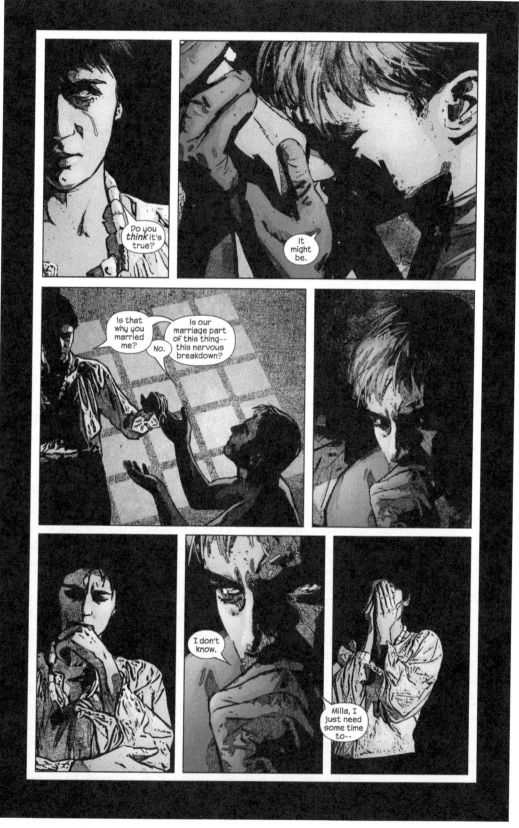

8.5 From *Daredevil* #60 (2004), Alex Maleev, artist, Marvel Comics.

almost every frame, obscuring faces and making every moment potentially dangerous. Maleev's scratchy line work and angular figures create an ominous mood whether the scene is Daredevil confronting the Kingpin, or Matt Murdock speaking with a client in his office. The artwork conveys a sense of doom and paranoia that surrounds heroes, criminals, and innocents alike. For example, when a sleazy FBI agent sells Daredevil's secret identity to the tabloids, Daredevil becomes a haunting presence lurking behind every shadow. Likewise, when Daredevil's wife, Milla, asks if he is having a nervous breakdown, Maleev's illustrations make the moment emotionally torturous; the characters' angst is written on their dark faces.

Brian Michael Bendis and Alex Maleev have also collaborated for stories with DC Comics characters, most notably for the *Event Leviathan* miniseries in 2019. Again, Maleev's artwork reinforces the hard-boiled story crafted by Bendis. The example of Maleev's art in Figure 8.6, from *Event Leviathan* #1, utilizes his heavily shadowed Noir style to obscure Batman from investigative reporter Lois Lane, and from readers. The shadows cast by Batman's flashlight amid the rubble of the building create an effective chiaroscuro frame, as does the tight blocking of their bodies within the panels. The art of this sequence contextualizes Batman and Lois Lane in Noir terms as a taciturn detective and a dangerous, gun-toting femme fatale. The Superhero Noir style of Maleev's art visually extends the themes of the miniseries, where the best detectives in the DC Universe join together to discover who is behind the covert agency brutally wiping out all of the various spy organizations. The mood of paranoia, suspicion, despair, and regret is magnified by the art and visually conveyed to readers. As the *Event Leviathan* series moves toward a spectacular climax, the story slowly becomes more conventionally heroic as the central characters shift from unpowered street-level detectives to magic-wielding heroes, and finally to the archetypal Superman himself. Despite the escalating stakes of the story, Maleev's illustrations remain dark, diffused, and sullen. In Maleev's work even the all-mighty Superman appears vulnerably human. For example, in issue #5, Superman recuperates in the Batcave after being beaten by the mysterious supervillain Leviathan. Rather than the typical depiction of Superman as majestic, larger-than-life, broad-shouldered, and square-jawed, Maleev's Man of Steel looks to be more average—the same size as the other characters, and diminished by his seated position as the other heroes hover around him. This scene, and Maleev's rendering of it, is important to clarify the stakes in this particular adventure, but it also reveals how the Noir tone of the images can reposition superhero masculinity from perpetually strong and triumphant to potentially demoralized and inadequate.

Maleev's illustrations epitomize a neo-Noir approach to superheroes that is particularly obvious when he is drawing Daredevil or Batman, but

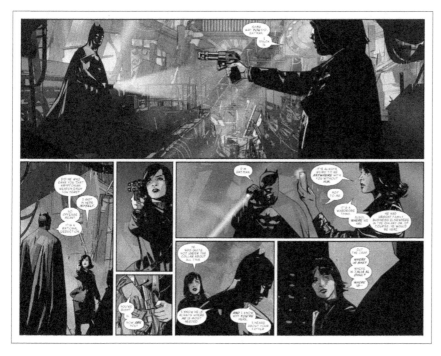

8.6 From *Event Leviathan* #1 (2019), Alex Maleev, artist, DC Comics.

which also carries over to his work on Iron Man, Captain America, Green Arrow, Moon Knight, Spider-Woman, and even Superman. Similarly, other artists like Michael Lark, Lee Weeks, Clay Mann, and Jock are mostly recognized for their Noir illustrations of Daredevil and Batman. The urban focus of both characters, their grim nighttime adventures, and their lack of powers in a world full of super-powered villains makes Daredevil and Batman easy to depict as hard-boiled heroes. Noir is so overdetermined by narrative and visual clichés that the distance between authenticity and satire is easily blurred. A character who is explicitly aligned with Noir conventions can lead to a superficial gloss of Noir signifiers for their own sake. Not every moonlit meeting between Batman and the trench-coated Commissioner Gordon against the Gotham City skyline is necessarily Noir.

The Noir implications of specific clichés and specific artists can be combined to bizarre and humorous extremes. Lee Weeks's art conveys such a strong sense of Noir, for example, that his illustrations helped writer Tom King present even Elmer Fudd as a tough guy. When DC Comics and Looney Tunes cartoons did a series of crossover issues in 2017, Lee and Weeks reimagined Elmer Fudd as a sullen hired gun who holds his own alongside Batman on the mean streets and in a barroom brawl. In *Batman/Elmer Fudd Special* #1 the tough-talking Elmer is out for revenge on the underworld when his gal Silver St. Cloud (or, as Elmer pronounces it, "Siwlver St. Cwoud") is murdered. When Elmer corners the low-life thug "Bugs" in Porky's seedy bar, Bugs claims it was Silver's former lover Bruce Wayne who gave the order. After an initial fight between Elmer and Batman, the two team up. As Elmer narrates: "We agwee to put ouwr diffewences to the

SUPERHERO NOIR, MORE THAN JUST BLACK AND WHITE | 205

side and find the twuth. This is a hawd pwace for hawd men. They won't take kindwy to youwr pwesence." Lee Weeks's style of illustration for this story is conventionally Noir in appearance—all dark shadows, rain-swept alleys, and neon signs. The framing within panels and the close-ups and fragmentations reposition Elmer and other Looney Tunes characters as Noir icons. Porky is a pig-nosed and portly bartender with a stutter; "Bugs" is a skinny, buck-toothed prankster; Yosemite Sam is a bearded lumberjack, and "Tweety" is a diminutive card shark who sleazily keeps telling people about a showgirl, saying, "I think I saw her Putty Tat." In the end it turns out that Silver St. Cloud is really just a femme fatale who faked her own death to pit her two lovers against each other. As unusual and caricatured as this team-up was, the combination of Weeks's straight Noir art and King's tongue-in-cheek dialogue effectively worked as both parody and revisionism, and even earned a coveted Eisner Award.

As an innovation to the superhero genre, crime-inspired writers like Brian Michael Bendis, Ed Brubaker, and Greg Rucka, teamed with Noir-style illustrators including Michael Lark, Alex Maleev, Michael Gaydos, and Mike Perkins, have also developed Superhero Noir comic series that sideline the superheroes almost entirely. Shifting from the private eye as an overlooked Noir protagonist on the fringes of a city full of superheroes, Brubaker and Rucka's police procedural *Gotham Central* (2002–2006), illustrated primarily by Michael Lark and Greg Scott, focused on the Gotham officers who have to investigate crimes despite the interference of caped crusaders. The most successful of the superhero-adjacent crime comics is *Alias*, featuring Jessica Jones, written by Bendis and illustrated by Michael Gaydos from 2001 to 2004, and then again in 2016–2018. The award-winning live-action adaptation of the character in Netflix's streaming series *Jessica Jones* introduced a much wider audience to Jones, a grumpy, alcoholic, ex-costumed hero turned private eye who regards her own superpowers as a curse. *Alias* was essentially Bendis's updated take on the working-class detective story, with a surly female lead and just enough mention of fringe superheroes to still count as a Marvel title. In his analysis of *Alias* as a modern crime comic, Terrence Wandtke describes the foul-mouthed heroine as "a hard-boiled mix of morality and resentment for the powers that be" and adds, "Jones fulfills the expectations placed on the detective who regularly inspires contemporary superhero and crime comics" (2018, 232). Michael Gaydos's artwork articulated the bleak environment of the series by self-consciously incorporating some of the visual signifiers of Film Noir and depicting Jessica Jones as dowdy and disheartened. As a cynical detective constantly uncovering the horrid things people do to each other, while struggling with her own trauma as an abuse survivor, Jessica is tonally far removed from the flashy adventures of the Avengers. Similarly, Gaydos's thick lines, heavy shadows, and frequent

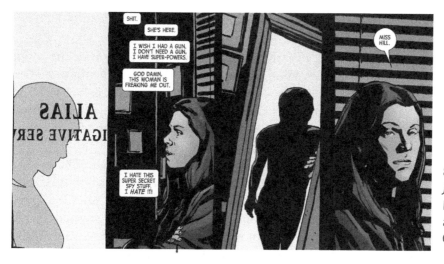

8.7 From *Jessica Jones* #10 (2016), Michael Gaydos, artist, Marvel Comics.

close-ups of sullen, unglamorous faces is a visual style in direct contrast to the typically heroic-looking figures and beautiful faces of Idealism. Moreover, the dark, muddy, and flat tones employed by Gaydos and colorist Matt Hollingsworth convey a sense of gloom cast over nearly every panel.

The Daily Planet's ace reporter Lois Lane is one of the longest-running characters in comics, having first appeared alongside Superman in *Action Comics* #1 (1938), the origin point for the entire superhero genre. For most of her history, she has been best-known as a perpetual damsel in distress for Superman to rescue, and as part of the unusual love triangle involving her, Superman, and Clark Kent. Lois has also starred in her own comic book series, but as the title *Superman's Girlfriend Lois Lane* (1958–1974) makes clear, she was only valuable because she was partnered with Superman. As Michael Goodrum notes in his analysis of the series as a means to contain threatening women in the mid-twentieth century: "Concerns about marriage and Lois' ability to enter into it routinely provide the sole narrative dynamic for stories and Superman engages in different methods of avoiding the matrimonial schemes devised by Lois or her main romantic rival, Lana Lang" (2018, 442). Though sexism is still an issue in many superhero comics, there has been a more recent directive to present Lois Lane as a worthy and interesting character in her own right. No longer just a girl reporter pining away for Superman, Lois is now a Pulitzer-winning investigative journalist married to the Man of Steel but still dedicated to her independence and her job. Most recently, Lois has been depicted as a hard-boiled reporter who does not need Superman's help in *Lois Lane: Enemy of the People* (2019–2020), written by Greg Rucka and illustrated by Mike Perkins. Rucka's tale of international intrigue and government cover-ups recasts Lois as a dogged investigator, and Perkins's dark and moody artwork presents her as a modern obsessive Noir hero out to discover the truth, even if she has to look in every back alley or dive bar. This modern Lois Lane as a tenacious journalist willing to risk her life to uncover the truth is established through Perkins's art on the first few

pages. For example, an early two-page spread features Lois on the phone with her editor, Perry White, discussing how dangerous her investigation is. The snappy conversation and alternating tight panels, as well as Lois's unglamorous appearance, liken her to a classic detective, the seedy hotel room she is hiding in replacing a low-rent office, her laptop as her weapon, and a bottle of whiskey helping her get through the day.

The combination of Noir aesthetics with the adventures of heroes like Batman and Daredevil is logical given both characters' association with gritty urban crimefighting, detective work, personal tragedies, and physical limitations as ordinary humans in a world of super-powered figures. Similarly, the narrative logic of using superhero-adjacent characters like Gotham City police detectives, Jessica Jones, or Lois Lane as the primary protagonists in Noir tales makes sense. Noir is about failure and hopelessness, or at best a relatively futile resistance to overwhelming forces. The more powerful and colorful superheroes offer a dream of always saving the day, while the Noir hero acknowledges that not everyone can be (or should be) saved. The spectacular assurance of the most traditional superhero comics is at odds with the essential fatalism of Noir. When conventionally super-powered heroes are rendered in Noir styles, the comics imply a sense of futility that may undermine the entire superhero fantasy of omnipotence.

Even a character as classically superheroic as Captain America can be retooled through Noir to represent a nation mired in corruption and paranoia rather than the embodiment of American exceptionalism. When writer Ed Brubaker began his acclaimed run on *Captain America* in 2004, he re-created the star-spangled super-soldier as a bleak special operative working for the government's spy agency, SHIELD. Brubaker's take on Captain America was enhanced by several Noir-proficient artists who illustrated different issues, including Michael Lark, Steve Epting, John Paul Leon, and Mike Perkins. Each of these artists created a sense of impending doom for the story, with every scene clouded in shadows and grime. The ominous tone established by the art and the pessimistic storylines created a sense of America itself morally and ethically adrift in a modern world of ruthless government intrigue and corruption. Fittingly, the story leads to the assassination of a handcuffed Captain America on the steps of a courthouse.

When writer Jeff Lemire began his run on *Green Arrow* in 2013, he chose to avoid the sillier characteristics that had defined the Emerald Archer (Oliver Queen) for decades as a self-indulgent, philandering millionaire who comically complains about the political status quo. Instead, from issue #17 to #34 (collected together as the "DC Essential Edition" graphic novel *Green Arrow: War of the Clans*), Lemire depicted the archer as an angry and pessimistic young hero confronting a range of mystical

8.8 From *Green Arrow* #19 (2013), Andrea Sorrentino, artist, DC Comics.

warriors from around the globe, fighting corruption and gang violence on the streets of Seattle and discovering the truth behind his own family legacy. Lemire's story is both epic and personal; it is Andrea Sorrentino's innovative artwork that creates a Noir feel for the book without directly replicating the appearance of Film Noir. Sorrentino's illustrations use a variety of techniques to convey the angst and emotional despair of the characters, and the inevitable tragedy they are each destined for. With Sorrentino's detailed line work, Seattle becomes an uncaring concrete-and-steel backdrop for Green Arrow's life-and-death struggles. At times the hero is an almost insignificant silhouette against the enormity of the city; in other moments he nearly fades into the back streets that share his muted hues—aided by the flat pallet of colorist Marcelo Maiolo—with everyone and everything diffused by the incessant rain. During action scenes, Sorrentino balances a sense of hurried motion with snippets of impact frozen in overlaying frames, emphasizing the danger and pain experienced by the characters. Moreover, one of the most effective enhancements of Sorrentino's illustrations is the innovative use of chiaroscuro images, without merely mimicking the sharp black-and-white shadows of traditional Noir. For example, the moment when Komodo reveals that he was the one to kill Green Arrow's father occurs in a single, full-page image, the hero and villain both drained of color but with the half-constructed building behind them in red. Sorrentino's striking artwork resonates as both gritty superhero tale and urban Noir with a modern, graphic edge.

Andrea Sorrentino collaborated with Jeff Lemire again for Marvel's *Old Man Logan* (2016–2018) and DC's *Joker: Killer Smile* (2019–2020) and *Batman: The Smile Killer* (2020). In these series, Sorrentino's artwork again matches the grim sorrow of Lemire's take on, respectively, an elderly Wolverine displaced from a dystopian future and a psychiatrist driven insane through his encounters with an incarcerated Joker. Sorrentino's illustrations continue to push the boundaries of a Superhero Noir tone and style without relying on a direct reference to classical Noir. His use of sharp contrasts between characters and backgrounds can make the hero seem insignificant against vast cityscapes or snow-covered mountains. Sorrentino also crosses over traditional frame boundaries to emphasize moments of physical pain, or to indicate movement. Even a scene as functional as Logan's motorcycle trip from the southern states to the far fringes of the Northwest Territories in *Old Man Logan* visually establishes an impression of the hero's world-weariness. The seemingly simple sequence in Figure 8.9 concisely conveys the length and the loneliness of Logan's journey as he passes through shifting terrains, moving from a cityscape to a barren, snowy mountain range. Silhouetted as a small figure against a vast and unforgiving environment in the final panel implies a Noir sensibility that transcends the clichés of asphalt jungles and urban decay. This older version

8.9 From *Old Man Logan* #5 (2016), Andrea Sorrentino, artist, Marvel Comics.

of Wolverine is alienated and guilt-ridden, his emotional state reflected through Sorrentino's unique graphic style. The art lets readers know that this Wolverine is a different type of hero: he is a disillusioned man who has seen too much of evil and has accepted his fate, tying up loose ends before he finally dies at the end of the series. The ominous and fatalistic formula of Noir works well in *Old Man Logan* because the series displaces the story from Marvel's primary Wolverine onto an older version of the same character from a possible future in the multiverse. This narrative feint is similar to the strategy employed with Retro Noir stories set in the past where it is not the "real" Batman or Daredevil playing out the role of a hard-boiled avenger confronting thugs in speakeasies. An older Wolverine from a parallel universe allows the creators to question facets of heroic masculinity without undermining the central image of Wolverine as a violent avenger and a profitable corporate property.

The existential themes of Noir present a different version of masculinity than is usually found in superhero comic books. The *Old Man Logan* series ingeniously wove together a meditation on failed hegemonic masculinity, redemption, old age, and fatalism often depicted in moody, Noir-ish tones that reinforced an elegiac quality to the story. Taken as a whole, *Old Man Logan* is easier to classify as a Noir Western than a superhero story. Writer Mark Miller and artist Steve McNiven first reimagined Wolverine as "Old Man Logan" in *Wolverine* #66–72 (2008). Fifty years in the future, Wolverine is a grizzled old man in a post-apocalyptic wasteland where most of the heroes are dead and the villains have destroyed the world. Logan's healing power is failing him, which leaves him looking and feeling very

old. He refuses to use his claws or engage in violence of any kind because the last time he did, evil psychics manipulated him into killing all of the X-Men, his closest friends. The violence that always defined Wolverine was used against him and helped to eradicate heroes from the world. Instead, Logan struggles to make a living as a farmer alongside his wife and two children. In the original storyline, Logan is desperate for money to keep the farm, so he joins an old and blind Hawkeye on a cross-country quest. When Logan returns, he finds the Hulk gang (the inbred grandchildren of Bruce Banner) have killed his family; Logan slaughters all of the Hulks and returns to his life of violence.

This alternate-future version of Wolverine quickly became a fan favorite, and Marvel paired writer Brian Michael Bendis with Andrea Sorrentino to create a story that would allow old Logan to relocate to the central Marvel universe. Their five-issue series, *Old Man Logan* (2015) focused on a distraught, angry, self-destructive Logan wandering across the forbidden borders of the wasteland and encountering ever-bleaker realities. By the time he finds his way to the main Marvel continuity, Logan is a thoroughly tragic figure, very much in line with the fallen man central to Film Noir. Sorrentino's unique style of illustration is a perfect match for the anguish and hopelessness of the tale. A heartbreaking backstory is, of course, one of the most common of superhero clichés, used to justify the hero's violence and confirm his moral code. Through Sorrentino's drawings, however, the burden of being a nearly unkillable mutant is not romanticized in the image of a muscle-bound vengeful hero screaming in rage. Instead, Logan is haunted and broken by his past, as Sorrentino's vulnerable portraits of Wolverine repeatedly suggest throughout the series. Despite embodying a very different take on the standard superhero story, old Wolverine remained a popular variation and garnered his own monthly series, also titled *Old Man Logan*, as well as being a leading member of the team books *Extraordinary X-Men* (2015–2017), *Astonishing X-Men* (2017–2018), *X-Men Gold* (2017–2018), and *Weapon-X* (2017–2018).

When Jeff Lemire and Andrea Sorrentino assumed control of the character in 2016 with a new *Old Man Logan* #1, they continued to explore the themes Bendis had developed: Logan's despair and his guilt over failing to save his friends and his family. Sorrentino's style carried the atmosphere of despair into the new series. In her discussion of Neo-Noirs, Phillippa Gates argues that "the legacy of film noir has been a shift in focus from the investigation of a crime to an investigation of the hero's masculinity" (2006, 93). Indeed, as the somber colors and the bleak tones of Sorrentino's artwork portray Logan as a man mired in despair, Lemire's story has Logan on a redemptive quest, trying to protect the woman who would become his future wife, even though she is just a child now, and attempting to save many of his friends from harm while warning them about the

consequences of violence. In short, despite the character's glorification of violence, Lemire and Sorrentino make it clear that Logan failed to enact the masculine ideal of protector, a role at the core of the superhero genre. And while Logan tries to shore up a patriarchal ideal of masculinity by returning to violence as a form of self-sacrificing atonement, Sorrentino's melancholy style serves as a constant reminder that he is doomed to fail, and in fact already has failed. Sorrentino's art, like that of all Noir-inflected artists working in modern comics, creates a more contemplative perspective on masculinity and heroism, suggesting, like Film Noir before it, that the differences between good and evil, right and wrong, are not as distinct as the color of a costume.

9 | DRAWING CONCLUSIONS

The six styles of comic book illustration discussed in this book (Idealism, Retro, Realism, Cute, Grotesque, and Noir) are by no means an exhaustive list, nor are these styles easily separable. Comic art is always developing, adapting, exploring new techniques, being influenced by other visual mediums, and attracting new artists with their own unique way of illustration. What I hope has become clear is that comic book art deserves more attention from comics scholars than it typically receives. The art is a crucial and defining part of the medium; it is an element that shapes the mood and tone of the stories, attracts and influences audiences, and reveals cultural beliefs and concerns. The shifts in artistic styles allow something as seemingly innocuous as a superhero comic book to activate different themes, appeal to different values, and change the message of the genre. As new styles emerge, new artists make their mark, and new formats take shape, the illustrations will continue to define the industry and the morals and ideologies conveyed. The realm of comic book art is a potentially rich field for Comics Studies to explore from a range of perspectives. Historical differences in aesthetic standards, collaborations between certain artists and inkers and/or colorists, the use of unconventional techniques such as watercolors or pastiche, cross-cultural influences, fan-produced artwork, and the intersections of art and commerce might all reconfigure how we think about comics and media consumption. While all these stylistic differences will invariably influence the development of comic book art, it is the potential of technological changes, namely digital comics, that may have the greatest impact on what comic book art can become.

Currently, the comics industry is at a turning point with the growing

influence of digital technologies in the creation, distribution, and consumption of comic books. In their overview of the current state of the industry, Matthew McAllister and Brian MacAuley note that "digital comics are widely assumed to be a key part of the future of the form and a key to attracting new readers" (2020, 105). As with most modern media forms, the advancements made in computer technologies and online systems are redefining how the comics industry operates, and ultimately will alter some of the most basic conceptions of what a comic is. In an overview of early digital comics, Wershler, Sinervo, and Tien argue that "digitization involves shifts in all these levels, affecting how comics are produced, circulated, and consumed" (2020, 256). While comics are increasingly propagated in entirely digital formats—illustrated on computers, colored on tablets, distributed online, read on smartphones, and catalogued in the cloud—how this change from the material to the immaterial will impact the look and the role of superhero artwork is unclear. By way of a conclusion, I want to touch briefly on how the digital turn in comics has begun to affect the production of illustrations and the consumption of the artwork.

Digital techniques have been used to varying degrees since the 1980s by many illustrators. In terms of technological advances, computers have become a common tool in the production of comic book images without any drastic differences immediately visible in the finished artwork. Some of the earliest efforts at digital illustrations were innovative experiments marketed as computer-generated firsts. Mike Saenz and Peter B. Gillis's short-lived series *Shatter* (1985–1987) was promoted as the "First Computerized Comic," then Saenz's stand-alone story *Iron Man: Crash* (1987) was declared "The First Computer Generated Graphic Novel," and Pepe Moreno's *Batman: Digital Justice* (1990) was described as DC Comics's "first computer-made adventure." All of these comics, as well as other early endeavors, incorporated cyberpunk-influenced storylines and were rendered in stiff, flat lines. As computers have evolved, most comic book illustrators have adapted to the available technologies, using them as tools to enhance traditional hand-drawing techniques rather than as a substitute for them. For the most part, modern comic book artists still hand-draw their initial sketches on paper before scanning the images to a computer so they can then be embellished through various programs like Photoshop or Adobe Illustrator. Similarly, as computer tablets, touchscreens, and digital pens have improved, many artists draw (or redraw) directly on screens. Moreover, inkers and colorists now add their contributions to the artwork almost exclusively through digital tools. The result has been crisp artwork that can be produced efficiently and makes use of a variety of different techniques. Top superhero artists like Todd McFarlane, Tony Daniel, Brian Bolland, and Jorge Jimenez have created online video demonstrations of how they incorporate tablets and computers into their artistic process.

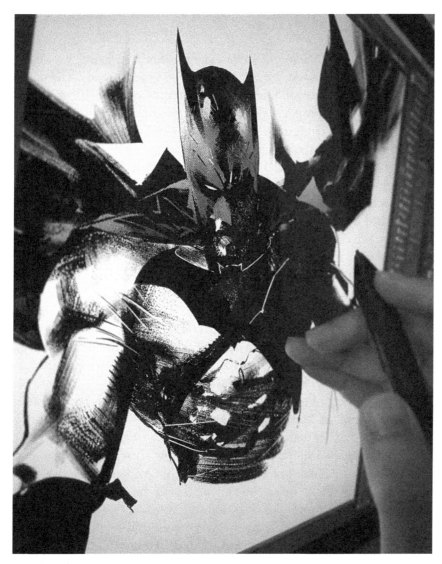

9.1 Digital Batman rendering by Jorge Jimenez (2019).

In essence, most comic book art is still hand-drawn and then enhanced through digital technologies. Once the comic book is published, there is effectively little (or no) difference that consumers can perceive between illustrations that underwent an extensive process of digitization and those that had none. The impact of digital comics on the artistic merits of the form may, however, become more important once the comic *book* itself is no longer the primary format of consumption.

Earlier we addressed the distinctiveness of comic books as a medium defined by a combination of printed words and serial illustrations. Comic books, especially the dominant genre of superheroes, are also unique in the persistent and preferred materiality of the form. Since the emergence of organized fandom in the 1960s and the rise of direct market distribution in the late 1970s, the comic book industry has increasingly relied on the desire of a passionate consumer base to collect physical books. In his

analysis of shifting market principles, Gregory Steirer argues: "For almost half a century, the imperatives of collecting have substantially determined both the culture surrounding American comic book consumption and the books' formal properties" (2014, 455). Moreover, Steirer continues, the core of comic fandom is "a culture organized around ownership and exchange." The actual comic *book*, whether cheap newsprint or glossy and library-bound, is the material focus of most consumers. Possessing a physical copy of a comic remains one of the primary pleasures of the medium's consumption. Readers collect comics, display them, catalogue and curate them. They appraise rare comics; bag, board, and seal new ones; reread favorites; sell or trade them; and pursue complete collections. More than any other form of mass-produced popular entertainment, comic books are linked to materiality and ownership. Bart Beaty (2012) correctly notes how comic books can serve as a nostalgic bridge reminding collectors of childhood and simple pleasures. But the "magic" of comic books as a physical object also evokes the pleasures of a private fantasy, an imaginative world that one can in a way possess, an object that can be cherished and invested in (both financially and in terms of one's identity), and an artform that can be viewed and appreciated at the consumer's leisure.

The physicality of most traditional media platforms has been replaced by digital versions. Movies on DVD and music on CD have been almost entirely displaced by digital downloads. Likewise, brick-and-mortar bookstores are quickly disappearing as e-books now outsell hard copies at an incredible rate. Comic book consumers have largely resisted this move to an all-digital world because the material artifact is still prized above all else. The physical comic book does not weigh more than a few ounces, and it is typically flimsy and delicate; however, even this light materiality can feel imminently more authentic and substantial than an intangible digital version of the same content. As of 2018, the majority of consumers who regularly purchased comics continued to buy hard copies from comic book specialty stores. In their detailed profile of the contemporary comic book market, Jerry Hionis and YoungHa Ki note that, despite technological developments, "comic book specialty stores are the leading sales channel, beating non-specialty bookstores, digital sales and subscription" (2018, 3). Ultimately, Hionis and Ki argue, "comic consumers seem to still prefer print comics to digital" (13). However, changes within the industry, including a general push by publishers for the more cost-effective digital distribution and the comfort level of younger audiences with technology, are quickly altering the way comic books are consumed. As Steirer observes, "the very recent development of the digital-comic marketplace, however, has introduced considerable complication into the collecting-based underpinnings of the medium" (2014, 455). Indeed, the potential for the physical comic book to be completely displaced by digital comics signals

a change in the consumption and collecting practices that have influenced the understanding of superhero illustration as a distinct artform.

Following several failed attempts with Motion Comics, a digital format that added a small amount of animation to the figures, in the early 2000s (see Wershler and Sinervo 2017), the concept of digital comics defaulted to a simpler reproduction of the standard comic book that can be read on electronic devices. As essentially just reproductions of the same materials in print, the mode of delivery changed, but very little else did. This conservative conception of digital comics also allowed a simple way for publishers to profit from decades of older stories by offering classic issues as downloadable content. To encourage digital consumption, publishers have utilized a number of promotional strategies, including digital first releases, digital exclusives, and free digital coupons. All of these strategies have helped to increase digital sales, but the lack of an easily accessible user system offering the range of comics that could be found in specialty stores initially hampered digital sales. Though both DC Comics and Marvel offer subscriptions to the bulk of their digital catalogues via "DC Universe Infinite" and "Marvel Unlimited," the online retailer Comixology has emerged as the leading source for digital comic sales. Comixology managed to outmaneuver several early competitors to become the primary one-stop online retailer of comics.

Launched in 2007 primarily as a program to help fans catalogue their collections, by 2010 Comixology had established partnerships with the big two, DC and Marvel, as well as most smaller publishers to sell digital versions of comics on the same day of release, in addition to vast amounts of every publisher's back catalogue. Comixology was acquired by online retail giant Amazon in 2014, which increased sales significantly through a direct link to its marketplace for Kindle and iPad readers. Considering the future of comics, Aaron Kashtan argues: "Comixology's success was due largely to its partnerships with almost all major comics publishers, but the secret weapon in its arsenal was its proprietary Guided View technology" (2018, 115–116). Given the size difference between the normal comic page at 6½ inches wide and 10¼ inches tall, and the average tablet screen at 5¾ inches by 9 inches, comics are not easily adaptable in their original dimensions. Comixology's Guided View program, however, automatically leads the reader from panel to panel in closeup. This software allows digital comics to be readable on handheld devices and laptop computers, but it does alter how the basic unit of the comic book page is consumed. "What makes Guided View unique and effective," Kashtan observes, "is that it preserves but also radically changes the experience of reading comics" (116). Readers are taken through the comic in a strictly linear pattern designed to privilege the line of the narrative rather than one guided by the impact and context of the images. While this Guided View does preserve

the story and maintain the legibility of the comic, it still struggles with some of the artistic properties unique to comics, such as the splash page, two-page spreads, massive battle scenes, montages, and unconventional panel designs. More than just reproducing a comic book to be read on a screen, digital comics alter what the art can do, and how the viewer can relate to the illustrated page.

Change is not new to the comics industry, but this digital turn may require a different perception of the visual aspects of the medium. Publishers are eager to embrace digital comics because they are far more cost-effective. As McAllister and MacAuley point out: "free downloads, subscription models, and 'digital-only' or 'digital-first' releases have all been used to revitalize a medium that once seemed on the verge of significant decline, especially with the shift of large-scale publishers to cross-media licensing" (2020, 105). The impending digital-only format for comics is just the latest, but perhaps the most extreme, structural change undergone by the medium. The properties, values, and significance of comic books have a long history of shifting in relation to industrial and cultural developments. Henry Jenkins reasons that the increased status afforded to comics changes their cultural value in a number of ways, including their physical form:

> Transitions in the status of comics impact their physical form (from floppy monthlies to bound books), their narrative structures (from comics to graphic novels), their cultural status (from "rubbish" to durable), their readership and distribution (from specialty shops to bookstores and libraries), and their underlying genres (a diversification from the superhero saga to a wider array of different kinds of stories, including many more stories focused on everyday life). (2020, 41)

Intertwined with the fluctuations Jenkins describes is the appreciation, quality, variety, and importance of comic book art. And, as we discussed in chapter 2, changes to the physical format or method of display can alter the purpose and the understanding of the illustrations. High-quality unfinished illustrations reproduced in hardcover *Artisan* (Marvel) or *Unwrapped* (DC) editions stress the originality of the unadorned work and directly link the images to the hand of a unique master artist. Likewise, museum and art gallery exhibitions of original comic book art change the context of how the art is experienced by viewers, both removing it from the context of an individual narrative and repositioning it alongside more traditional artforms and curatorial practices.

In point of fact, Daniel Stein argues that the emergence of expensive artist editions, gallery showings, and other physical forms of comic

book collectibles is a direct response to the impending digitization of the medium. Stein reasons, "It is the conservative and backward-oriented practices such as canonization and musealisation that have shaped at least part of the reaction of the superhero genre to the challenges of digitization" (2016, 285). In other words, at a time when the comic is becoming increasingly immaterial through digitization, the traditionalist factors within the comics industry and consumers themselves have prioritized the value and unique properties of physical artifacts. In particular, Stein focuses on the "museum in a box" type of collectibles that include gallery-quality reproductions of original art as well as faux artifacts like 1940s newspaper strips, 1950s membership badges, 1960s advertisements, and so on. For Stein, it is at this moment, when the "initial carrier medium, the printed comic book, may be becoming obsolete" (285), that the materiality of the comic book becomes over-valued as a form of compensation to potential displacement. An emphasis is placed on the tangibility of the comic as a prized form of material culture; the comic *book* can be singularly owned, preserved, and displayed. The book itself is vaulted as a work of art, as a physical artifact. "Indeed, the struggle to 'save' the superhero comic book and secure its survival as a print-based form of popular serial storytelling," Stein concludes, "centers to a substantial degree on practices of collecting, displaying, and re-enchanting allegedly ephemeral or rare memorabilia from decades past" (285). The importance of "displaying," both to the maintenance of the physical form of the comic book as well as to practices of fandom, implies a germane method of artistic appreciation.

Reading and collecting are still the primary features of comics fandom, but displaying favorite comics or collectible artwork is an important factor as well. Gregory Steirer notes an inherent difference between the private act of reading and the public act of displaying: "Display, by contrast, typically produces pleasure through either the social assertion of identity via ownership or the opportunity for regular aesthetic contemplation" (2014, 461). The public (and the private) act of display as an expression of personal identification within comics fandom can occur in a variety of material ways: hardbound collector's editions prominently displayed on bookshelves; statues, toys, and Lego dioramas in glass display cabinets; even T-shirts, watches, and baseball hats as sartorial displays of fandom. Fans post pictures of how they display their collections, often with an emphasis on the size of the collection or the beauty of the display design. More to the point of the art itself, the common practice of framing and displaying actual comic books demonstrates the ideological link between materiality and artistic appreciation. As fandoms of all types have emerged from the shadows of "legitimate" culture over the last few decades, there has been an increase in products specifically designed to display otherwise ephemeral artifacts. Specialized comic book frames of varying quality and

price are now available wherever picture frames are sold. The point is that the material object of a comic book serves as a site/sight of artistic value to be both gazed upon and possessed. Steirer describes comics as "aesthetic objects" on par with other arts: "Just as paintings and films are commonly seen as aesthetic objects in essence, scholars, fans and presumably most comics consumers tend to view comics as aesthetic objects as well" (2014, 458). The fact that a comic book is an *object*, both material and aesthetic, links the validation of superhero illustration as an artform to the materiality and possessability of the medium.

However, as much as many comic book readers cling to the materiality of the medium, there will come a time when comics are no longer available as physical books. Most bibliophiles finally embraced Kindles, iPads, and other reading tablets, just as music fans welcomed digitally downloaded music files. It is hard to ignore the convenience of simply downloading a book, album, or comic from the comfort of your own home, and having your entire collection available on your phone or laptop any time you want it. Moreover, in the current market, digital comics are priced lower than print versions, do not increase in price over time due to scarcity/collectability, and issues never sell out. Digital comics may allow the medium to reach a larger audience than ever before (bearing in mind the distinct gap between groups with an abundant access to technology and those with limited access). At a larger conceptual level, fully digitizing comic books opens up a world of creative possibilities that may be best explored through new artistic approaches. Thon and Wilde optimistically argue: "Digital production and distribution technology allows for a fundamental broadening of how comics can be conceptualized that goes considerably beyond the still comparatively 'conservative' forms" (2016, 236). Their description of the comic book as a "conservative" form is in reference to the narrative and industrial dynamics of the medium, but comics can also be considered relatively conservative in terms of the artwork. Despite minor changes in formatting and an increase in different styles, comic book art has fairly consistently relied on a sequencing of panels and dramatically drawn, but always recognizable, characters. New technologies may facilitate the artwork developing in unforeseen ways.

Scott McCloud proposed the concept of an "Infinite Canvas" in 2000, reflecting a utopian sense of possibility for comics that might be enabled by digital technology. According to McCloud, while the physical canvas used for traditional comic books is finite, with most comics standardized at 6½ by 10¼ inches, digital canvases are potentially limitless. "In a digital environment there's no reason a 500 panel story can't be told vertically," McCloud observes, "or horizontally like a graphic skyline. We could indulge our left-to-right and up-to-down habits from beginning to end in a giant descending staircase, or pack it all into a revolving cube" (2020,

12). In other words, in a digital presentation the progression of a story can branch off in different directions rather than be merely linear. Readers conceivably could go deeper, *through* one panel to another, or be led tangentially to side stories, other narratives, or different time periods. If digital comics were to go the multidimensional way of McCloud's Infinite Canvas, the change would be primarily structural, but the artwork will need to adapt to the new dimensions and the possibilities they imply. An Infinite Canvas also suggests an exponential increase in the possible narratives and the staggering amount of illustration that would be required to extend the comic in so many diverse ways.

It is also conceivable that as comics and other media formats, like animation and computer games, overlap and merge even further in the coming years, superhero art may occupy a different type of canvas altogether. Though the early experiments with fully digitally rendered illustrations (*Shattered*, *Iron Man: Crash*, *Batman: Digital Justice*) did not inspire a major change of artistic style for comic book art, digitally rendered superheroes have come to full fruition in modern animated movies and video games. As comics become less grounded in a physical format and potentially begin to explore innovative approaches such as motion, three-dimensional characters and environments, and/or virtual reality technology, comic art may begin to join together with the digitally rendered aesthetic of other mediums. The visual aspects of video games have come a long way since the pixelated days of early superhero games. Modern games like the *Batman: Arkham* series, *Spider-Man: Miles Morales*, *Marvel's Avengers*, and *Injustice: Gods Among Us* are all visually stunning. Characters look relatively lifelike, move fluidly, and reproduce the environments and characteristics of the superhero fantasy in incredible detail. In many ways, superhero video games have become more visually cinematic, and the movies have become more like games. But no matter how amazing the visual features of modern games are, they have rarely been considered an artform, nor identified with specific artists. Indeed, it is difficult to conceive of an artist behind the images for games. A specific look or style of illustration may be set for different games, but games are not rendered in the same individualistic manner as comic book illustrations are. Rather, we credit games and their artistic appearance to companies and teams of programmers.

My purpose in stressing the development of digital technologies within the superhero comic book industry is to note that this shift will inevitably influence the artwork. Digital comics will also shape how the artwork will be received by readers in unforeseen ways. But the advent of digital comics is also only one of the many ways that industrial and artistic changes can alter the status, quality, and perception of the artwork. The legal and contractual relationship between artists and publishers could alter the work with different deadline schedules or shared trademark rights. The

inclusion of a wider range of artistic techniques might also change how a comic book looks. Pastels, 3-D renderings, mosaics, or screen printing might become new standards that take the art in a different direction. Likewise, the global confluence of artists allows a greater influence of different national or regional styles. Just as Japanese anime and manga influenced the Cute style of American comic books, the harsh and abstract look of many Spanish artists might significantly alter the look of mainstream superhero books. The breadth of artistic diversity that already exists within superhero comic books is bound to develop in unpredictable ways and will continue to allow fans, critics, and scholars to consider the shifting meanings of comics.

As a remarkably underdeveloped field of study, comic art is wide open for analysis. One of the most frustrating things about writing this book was not being able to include more of the thousands of incredible artists who have worked, and continue to work, within the genre of superheroes. In choosing specific artists as representatives of the six different styles addressed in this book, I unfortunately have merely mentioned many others in passing or excluded them altogether. It was never my intent to ignore or marginalize any of the artists, but the nature of this type of study means that some fascinating creators remain unexplored. Future studies focused on individual artists as *dessinateurs* (rather than the vaulted auteurist who is both writer and artist) remain to be written, as do serious considerations of the collaborative work between certain illustrators, writers, inkers, colorists, and letterers, or the stylistic influences that emerge from bullpens, studios, schools, and/or mentors.

The subject matter of this book was limited to superhero illustration as a matter of practicality on a number of levels. First, the popularity and cultural awareness of superheroes makes them a valuable subject of analysis. Second, their consistency as a visual media form over the last century means a wealth of primary texts are readily available. Third, and most importantly, the distinct visual iconography of superhero characters provides a consistent anchoring point for comparisons across styles. In other words, by restricting the examples to superhero comic book art, I hope that the differences between the look, tone, and affect of each style are more clearly delineated. Even more narrowly, a study of diverse artistic representations of a single character could highlight other concerns and developments. In fact, at an early research stage for this book I contemplated focusing on a single character (perhaps Superman, Batman, or Spider-Man) who has been rendered in a surprisingly wide range of styles. Ultimately, I felt that extending the subject matter to include popular superheroes as a genre would allow for a broader spectrum of art styles and demonstrate that the visual changes were inherent to the medium and not

just a single character. However, concentrating on superhero artwork also limited the types of comic illustrations that are associated with other formats, but are just as deserving of serious study. Other comic book genres, for example, utilize artistic styles that are sometimes similar to those found in superhero books and sometimes unique to their own story format. The genres of Romance, Western, Horror, and Fantasy each embrace alternate styles and/or shift the context and meaning of a style that may be otherwise identical to one used in superhero books. Likewise, other comic formats evidence different artistic techniques and styles; the four-panel or single-panel newspaper comic, editorial cartoons, caricatures, children's books, and even narrative graffiti can all reveal distinct cultural and aesthetic meanings.

It is interesting that an artform as apparently straightforward as political cartoons is dominated by a distinctive style of severe caricature not commonly used in other formats. The basic purpose of a political cartoon is to mock the absurdity of current events. As one-panel comics, the political cartoon strives to make light of current events in a succinct and symbolic manner. Yet, whether left or right wing, contemporary or historical, in newsprint or on a website, political cartoons are often rendered via scratchy lines, exaggerated physical forms, and dark cross-hatched shading. Even the lettering used for text and speech balloons is distinctly thin and jagged—unlike the bolder type of font used in superhero comic books. The overall effect is often somewhere between grotesque caricature and exasperated absurdity. That this artistic style would come to dominate political cartooning is an intriguing combination of aesthetics and ideological commentary. Even when the political cartoons draw on the symbolism of another comic form, such as the superhero, the harsher and more angular style is often still utilized to mark out the scene as political humor. For example, recent political cartoons have incorporated the figure of Superman as an iconic American hero to illustrate the hypocrisy of right-wing ideas of patriotism. Mike Luckovich's 2021 drawing, for example, criticizes the turn away from foundational American beliefs within the modern Republican Party. Political cartoons use the image of Superman as emblematic of traditional American values that have become twisted and contentious in current political discourse. Moreover, this type of cartoon is marked as political commentary by the style of illustration, which affects how viewers understand the image even before they have read the content. It is a depiction of Superman according to the stylistic language of political cartoons rather than any of the comic book styles discussed in this book. But, like the different styles used in superhero comic books, the aesthetic of these cartoons carries a specific contextual meaning and ideological tone.

9.2 Political cartoon featuring Superman (2021), Mike Luckovich, artist.

Much like the character of the superhero itself, superhero art is a dynamic form always on the move, always developing new attributes, and always evolving in relation to the world around us. Attending to the artistic side of the medium permits not just a better understanding of the stories and how they construct meanings for consumers, but also how different aesthetics can influence cultural concepts in general. As the discipline of Comics Studies develops, the artistic side of the medium needs to become a more prominent subject. While some research has considered the structural components of the comic book's unique visual conventions (panels, thought bubbles, sound effects, etc.), and numerous coffee-table art books celebrate the distinct illustrative work of seminal artists, the broader influence of the medium's various aesthetics has been relatively ignored. The artwork is crucial to the stories, the characters, sales and fan popularity, the meanings conveyed, and the influence of the entire medium. The tendency in Comics Studies to overlook the inseparable contribution of the artwork means literally missing half the story.

The role of the artist, as we now understand it, may be in jeopardy once the paper-and-ink comic book is replaced as the primary format for superhero adventures. Though artists will still be required, the immateriality of the medium could undermine the skill of the illustrator. Most artists incorporate some digital assistance into their creative process already, but when the medium becomes entirely digital, the perceived degree of artistic skill may be questioned. How much was hand-drawn by an individual? How much was formatted by a computer program? The comic book artist's status may revert from that of a *dessinateur* to merely a technician or a programmer. Or worse, the art may be the result of a team of programmers. Of course, there is a great deal of artistic skill that can be expressed through programming, but our die-hard romantic conception of a real artist as a creative soul who can render beautiful illustrations by hand remains a dominant idea. However the medium changes in this increasingly digital age, it will be a long time before the artistic value of superhero comics is irrevocably altered.

In any case, my intention for this book is not to pigeonhole artists or styles into definitive and limiting boxes. Rather, my goal is to bring a more critical attention to the variety of aesthetics utilized in comic books and some of the ways they affect the stories, the readers, and the ideologies the

characters represent. For Comics Studies to continue to ignore the aesthetics of comic book art is to miss a major part of the medium. Style categories are just one possible starting point for taking superhero artwork seriously. I have no doubt that many comic book fans, and many comics scholars, will disagree with the way I have categorized certain artists. But that is part of the instigation for a project like this one. Why should that artist be in a different section? What does the overlap of an artist between two or more categories imply ideologically? The sheer amount of comic book art that exists, and that deserves critical attention, is staggering. Each week sees the release of new comic books featuring more and more work by incredible artists. Styles change, even if just a little, with every new book. In fact, one of the hardest parts of writing this book was having to exclude so much. New artists keep adding variety, and older artwork is constantly being made available again. I feel that I have just touched the tip of an artistic iceberg that needs to be explored. It is a daunting task, but, I hope, an illuminating one.

WORKS CITED

Ahmed, Sara (2009). "Happy Objects." *The Affect Theory Reader*, edited by Gregory J. Seigworth and Melissa Gregg, Duke University Press, 29–51.

Alaniz, Jose (2014). *Death, Disability, and the Superhero: The Silver Age and Beyond*. University Press of Mississippi.

Allison, Anne (2003). "Portable Monsters and Commodity Cuteness: *Pokemon* as Japan's New Global Power." *Postcolonial Studies* 6, no. 3: 381–398.

Babka, Susie Paulik (2008). "Arius, Superman, and the *Tetium Quid*: When Popular Culture Meets Christology." *Irish Theological Quarterly* 73, no. 1–2: 113–132.

Baetens, Jan (2001). "Revealing Traces: A New Theory of Graphic Enunciation." *The Language of Comics: Word and Image*, edited by Robin Varnum and Christina T. Gibbons, University Press of Mississippi, 145–155.

——— (2020). "Words and Images." *Comics Studies: A Guidebook*, edited by Charles Hatfield and Bart Beaty, Rutgers University Press, 193–209.

Bainbridge, Jason (2007). "'This Is the *Authority*. This Planet Is Under Our Protection': An Exegesis of Superheroes' Interrogations of Law." *Law, Culture and the Humanities* 3, no. 3: 455–476.

Ball, David (2020). "Comics as Art." *The Oxford Handbook of Comic Book Studies*, edited by Frederick Luis Aldama, Oxford University Press.

Baudrillard, Jean (1995). *Simulacra and Simulation*. University of Michigan Press.

Beaty, Bart (2012). *Comics versus Art*. University of Toronto Press.

Bell, Crystal (2016). "7 Crucial Batman v. Superman Questions, Answered." MTV.com, April 4.

Benton, Mike (1989). *The Comic Book in America: An Illustrated History*. Taylor Press.

Bevin, Phillip (2015). "Batman versus Superman: A Conversation." *Many More Lives of the Batman*, edited by Roberta Pearson, William Uricchio, and Will Brooker, BFI-Palgrave.

Birlea, Oana-Maria (2021). "Cute Studies, Kawaii ('Cuteness')—A New Research Field." *Philobiblon* 26, no. 1: 83–100.

Bloom, Harold (1975). *A Map of Misreading*. Oxford University Press.

Bordo, Susan (1993). *Unbearable Weight: Feminism, Western Culture and the Body*. University of California Press.

——— (2000). *The Male Body: A New Look at Men in Public and Private*. Farrar, Straus and Giroux.

Bourdieu, Pierre (1984). *Distinction: A Social Critique of the Judgement of Taste*. Harvard University Press.

Brookes, Ian (2017). *Film Noir: A Critical Introduction*. Bloomsbury Academic.

Brown, Jeffrey A. (2001). *Black Superheroes: Milestone Comics and Their Fans*. University of Mississippi Press.

——— (2015). *Beyond Bombshells: The New Action Heroines in Popular Culture*. University Press of Mississippi.

——— (2016). *Superhero Movies: Popular Genre and American Values*. Routledge Press.

Bukatman, Scott (1994). "X-Bodies (the Torment of the Mutant Superhero)." *Uncontrollable Bodies*, edited by Rodney Sappington and Tyler, Bay Press, 92–129.

——— (2016). *Hellboy's World: Comics and Monsters on the Margins*. University of California Press.

Camden, Vera J. (2020). "The Thought Bubble and Its Vicissitudes in Contemporary Comics." *American Imago* 77, no. 3: 603–638.

Clanton, Dan W. (2017). "The Origin(s) of Superman: Reimagining Religion in the Man of Steel." *Religion and Popular Culture in America*, edited by B. D. Forbes and J. H. Mahan, California Scholarship Press, 33–50.

Clark, Kenneth (1953). *The Nude: A Study in Ideal Form*. Princeton University Press.

Clarke, M. J. (2014). "The Production of the *Marvel Graphic Novel* Series: The Business and Culture of the Early Direct Market." *Journal of Graphic Novels and Comics* 5, no. 2: 192–210.

Clover, Carol (1992). *Men, Women and Chainsaws:*

Cocca, Carolyn (2016). *Superwomen: Gender, Power, and Representation*. Bloomsbury Academic.

Connell, R. W. (1987). *Gender and Power: Society, the Person, and Sexual Politics*. Allen and Unwin Press.

Connelly, Frances (2012). *The Grotesque in Western Art and Culture: The Image at Play*. Cambridge University Press.

Coogan, Peter (2006). *Superhero: The Secret Origin of a Genre*. Monkeybrain Press.

——— (2018). "The Redressing of Female Heroes: A Conversation with Cameron Stewart." *Journal of Graphic Novels and Comics* 9, no. 6: 612–620.

Cook, Roy T. (2011). "Do Comics Require Pictures? Or Why *Batman* #663 Is a Comic." *Journal of Aesthetics and Art Criticism* 69, no. 3: 285–296.

Cortsen, Rikke Platz (2012). "Full Page Insight: The Apocalyptic Moment in Comics Written by Alan Moore." *Journal of Graphic Novels and Comics* 5, no. 4: 397–410.

Costello, Brannon (2017). *Neon Visions: The Comics of Howard Chaykin*. Louisiana State University Press.

Costello, Matthew (2009). *Secret Identity Crisis: Comic Books and the Unmasking of Cold War America*. Continuum Press.

Coughlan, David (2009). "The Naked Hero and Model Man: Costumed Identity in Comic Book Narratives." *Heroes of Film, Comics and American Culture: Essay on Real and Fictional Defenders of Home*, edited by Lisa M. DeTora, McFarland Press, 234–252.

Creed, Barbara (1986). "Horror and the Monstrous-Feminine: An Imaginary Abjection." *Screen* 27, no. 1: 44–71.

——— (2002). "The Cyberstar: Digital Pleasures and the End of the Unconscious." *The Film Cultures Reader*, edited by Graeme Turner, Routledge, 129–132.

De Dauw, Esther (2021). *Hot Pants and Spandex Suits: Gender Representation in American Superhero Comic Books*. Rutgers University Press.

Dittmer, Jason (2005). "Captain America's Empire: Reflections on Identity, Popular Culture, and Post-9/11 Geopolitics." *Annals of the Association of American Geographers* 95, no. 3: 626–643.

——— (2012). *Captain America and the Nationalist Superhero: Metaphors, Narratives, and Geopolitics*. Temple University Press.

Doane, Mary Ann (1991). *Femme Fatales, Film Theory, Psychoanalysis*. Routledge.

Duin, Steve, and Mike Richardson (1998). *Comics: Between the Panels*. Dark Horse Books.

Dyer, Richard (1982). "Don't Look Now." *Screen* 23, no. 3–4: 61–73.

Easton, Lee, and Richard Harrison (2010). *Secret Identity Reader: Essays on Sex, Death and the Superhero*. Wolsak and Wynn Publishers.

Eco, Umberto (1979). *The Role of the Reader: Explorations in the Semiotics of Texts*. Indiana University Press.

Edwards, Justin, and Rune Graulund (2103). *Grotesque: The New Critical Idiom*. Routledge Press.

Fawaz, Ramzi (2016). *The New Mutants: Superheroes and the Radical Imagination of American Comics*. NYU Press.

Fennell, Jack (2012). "The Aesthetics of Supervillainy." *Law Text Culture* 16, no. 1: 305–328.

Firestone, Andrew (2021). "The Human Target #1 Review." Screenrant.com, November 4.

Fischer, Russ (2016). "The Many Deaths of Bruce Wayne's Parents, Ranked." latimes.com, April 1.

Frank, Kathryn M. (2017). "Who Makes the World? Before *Watchmen*, Nostalgia, and Franchising." *Cinema Journal* 56, no. 2: 138–144.

Friedlander, Keith (2020). "Beyond Alternative: Michael DeForge and the New Grotesque." *Journal of Graphic Novels and Comics* 11, no. 5–6: 538–553.

Gabilliet, Jean-Paul (2010). *Of Comics and Men: A Cultural History of American Comic Books*. University Press of Mississippi.

——— (2016). "Reading Facsimile Reproductions of Original Artwork: The Comics Fan as Connoisseur." *Image & Narrative* 17, no. 4: 16–25.

Gardner, Jared (2011). "Serial Killers: The Crime Comics of Ed Brubaker and Sean Phillips." *ZAA* 59, no. 1: 55–70.

Garland Thomson, Rosemarie (1998). "The Beauty and the Freak." *Michigan Quarterly Review* 37, no. 3: 459–474.

Gates, Phillippa (2006). *Detecting Men: Masculinity and the Hollywood Detective Film*. SUNY Press.

Gilmore, James N., and Matthias Stork (2014). *Superhero Synergies: Comic Book Characters Go Digital*. Rowman and Littlefield.

Glover, David, and Cora Kaplan (2009). *Genders*. Routledge Press.

Goffman, Erving (1963). *Stigma: Notes on the Management of Spoiled Identity*. Prentice-Hall.

Goodrum, Michael (2018). "'Superman Believes a Wife's Place Is in the Home': Superman's Girlfriend, Lois Lane and the Representation of Women." *Gender & History* 30, no. 2: 442–464.

Gordon, Ian (2017). *Superman: The Persistence of an American Icon*. Rutgers University Press.

Gordon, Neta (2019). "'The Enemy Is the Centre': The Dilemma of Normative Masculinity in Darwyn Cooke's *DC: The New Frontier*." *Men and Masculinities* 22: 236–253.

Granot, Elad, et al. (2014). "A Socio-Marketing Analysis of the Concept of Cute and Its Consumer Implications." *Journal of Consumer Culture* 14, no. 1: 66–87.

Gravett, Paul (2004). *Manga: Sixty Years of Japanese Comics*. Harper Design Books.

Gray, Richard J. (2011). "Vivacious Vixens and Scintillating Superhotties: Deconstructing the Superheroine." *The 21st Century Superhero: Essays on Gender, Genre and Globalization in Film*, edited by Richard J. Gray and Betty Kaklamanidou, McFarland Publishers, 75–92.

Gregov, R. J. (2008). "The Re-Illustration of Comic Book Heroes." *International Journal of Comic Art* 10, no. 1: 471–481.

Guynes, Sean (2020). "White Plasticity and Black Possibility in Darwyn Cooke's DC: The New Frontier." *Unstable Masks: Whiteness and American Superhero Comics*, edited by Sean Guynes and Martin Lund, Ohio State University Press, 174–190.

Harris, Daniel (2000). *Cute, Quaint, Hungry and Romantic: The Aesthetics of Consumerism*. Basic Books.

Harrison, Richard (2020). "Epilogue: The Matter with Size." *Supersex: Sexuality, Fantasy and the Superhero*, edited by Anna F. Peppard, University of Texas Press, 341–362.

Harvey, Robert C. (1994). *The Art of the Funnies: An Aesthetic History*. University Press of Mississippi.

——— (1996). *The Art of the Comic Book: An Aesthetic History*. University Press of Mississippi.

Hatfield, Charles (2012). *Hand of Fire: The Comics Art of Jack Kirby*. University Press of Mississippi.

——— (2019). "Fearsome Possibilities: An Afterword." *Uncanny Bodies: Superhero Comics and Disability*, edited by Scott T. Smith and José Alaniz, Penn State University Press, 217–224.

Hatfield, Charles, and Bart Beaty (2020). *Comics Studies: A Guidebook*. Rutgers University Press.

Helfand, Michael Todd (1992). "When Mickey Mouse Is as Strong as Superman: The Convergence of Intellectual Property Laws to Protect Fictional Literary and Pictorial Characters." *Stanford Law Review* 44, no. 3: 623–674.

Hersey, George L. (1996). *The Evolution of Allure: Sexual Selection from the Medici Venus to the Incredible Hulk*. MIT Press.

Hills, Matt (2002). *Fan Cultures*. Routledge Press.

Hionis, Jerry, and YoungHa Ki (2018). "The Economics of the Modern American Comic Book Market." *Journal of Cultural Economics* 43, no. 4: 545–578.

Inge, Thomas (1990). *Comics as Culture*. University Press of Mississippi.

Jameson, Fredric (1984). *Postmodernism, or, The Cultural Logic of Late Capitalism*. Duke University Press.

Janson, Klaus (2002). *The DC Comics Guide to Pencilling Comics*. Watson-Guptill Publications.

Jeffords, Susan (1994). *Hard Bodies: Hollywood Masculinity in the Reagan Era*. Rutgers University Press.

Jenkins, Henry (1992). *Textual Poachers: Television Fans and Participatory Culture*. Routledge Press.

——— (2006). "Captain America Sheds His Mighty Tears: Comics and September 11." *Terror, Culture, Politics: Rethinking 9/11*, edited by Daniel J. Sherman and Terry Nardin, Indiana University Press.

——— (2009). "Just Men in Tights: Rewriting Silver Age Comics in an Era of Multiplicity." *The Shifting Definitions of Genre: Essays on Labeling Films, Television Shows and Media*, edited by Lincoln Geraghty and Mark Jancovich, McFarland Publishing.

——— (2017). "Man without Fear: David Mack, Daredevil and 'The Bounds of Difference' in Superhero Comics." *Make Ours Marvel: Media Convergence and a Comics Universe*, edited by Matt Yockey, University of Texas Press, 66–104.

——— (2020). *Comics and Stuff*. New York University Press.

Johnson, Derek (2012). "Cinematic Destiny: Marvel Studios and the Trade Stories of Industrial Convergence." *Cinema Journal* 52, no. 1: 1–24.

Jones, Alexander (2021). "Don't Miss This: Robin by Joshua Williamson and Gleb Melnikov." Multiversitycomics.com, June 23.

Jones, Gerard (2004). *Men of Tomorrow: Geeks, Gangsters, and the Birth of the Comic Book*. Basic Books.

Kashtan, Aaron (2018). *Between Pen and Pixel: Comics, Materiality, and the Book of the Future*. Ohio State University Press.

Kember, Sarah (2003). "The Shadow of the Object: Photography and Realism." *The Photography Reader*, edited by Liz Wells, Routledge Press, 202–217.

Kennedy, Martha H. (2008). "Drawing (Cartoons) from Artistic Traditions." *American Art* 22, no. 1: 10–15.

Kidd, Chip, and Geoff Spear (2003). *Mythology: The DC Comics Art of Alex Ross*. Pantheon Books.

——— (2017). *Marvelocity: The Marvel Comics Art of Alex Ross*. Pantheon Books.

Kipnis, Laura (1992). "(Male) Desire and (Female) Disgust: Reading *Hustler*." *Cultural Studies*, edited by Larry Grossberg and Paula Treichler, Routledge Press.

Klein, Alan M. (1993). *Little Big Men: Bodybuilding Subculture and Gender Construction*. Suny Press.

Klock, Geoff (2006). *How to Read Superhero Comics and Why*. Continuum.

Kobre, Michael (2019). "Only Transform: The Monstrous Bodies of Superheroes." In *Superhero Bodies: Identity, Materiality, Transformation*, edited by Wendy Haslem, Elizabeth MacFarlane, and Sarah Richardson, Routledge, 149–160.

Koosed, Jennifer L., and Darla Schumm (2009). "From Superman to Super Jesus: Constructions of Masculinity and Disability on the Silver Screen." *Disability Studies Quarterly* 29, no. 2.

Kort-Butler, Lisa A. (2012). "Rotten, Vile, and Depraved! Depictions of Criminality in Superhero Cartoons." *Deviant Behavior* 33, no. 7: 566–581.

Kristeva, Julia (1982). *Powers of Horror: An Essay on Abjection*. Columbia University Press.

Kuhlman, Martha (2020). "Design in Comics." *Comics Studies: A Guidebook*, edited by Charles Hatfield and Bart Beaty, Rutgers University Press, 172–192.

Kuhn, Annette (1985). *The Power of the Image: Essays on Representation and Sexuality*. Routledge Press.

Kukkonen, Karin (2010). "Navigating Infinite Earths: Readers, Mental Models, and the Multiverse of Superhero Comics." *Storyworlds* 2: 39–58.

Later, Naja (2019). "The Deaf Issue: Hawkeye #19 and Deaf Accessibility in the Comics Medium." *Uncanny Bodies: Superhero Comics and Disability*, edited by Scott T. Smith and José Alaniz, Penn State University Press, 141–156.

Lefevre, Pascal (2011). "Some Medium-Specific Qualities of Graphic Sequences." *Substance* 40, no. 1: 14–33.

Lister, Martin (2003). "Extracts from Introduction to the Photographic image in Digital Culture." *The Photography Reader*, edited by Liz Wells, Routledge Press, 218–227.

Loeb, Jeph, and Tim Sale (2018). *Yellow, Blue, Gray and White Omnibus*. Marvel Publishing.

Lopes, Paul (2006). "Culture and Stigma: Popular Culture and the Case of Comic Books." *Sociological Forum* 21, no. 3: 387–414.

——— (2009). *Demanding Respect: The Evolution of the American Comic Book*. Temple University Press.

Lund, Martin (2015). "The Roaring '30s: Style, Intertextuality, Space and History in Marvel Noir." *Studies in Comics* 6, no. 1: 5–23.

Lunning, Frenchy (2020). "Manga." *Comics Studies: A Guidebook*, edited by Charles Hatfield and Bart Beaty, Rutgers University Press, 66–81.

Lyons, James (2013). "'It Rhymes with Lust': The Twisted History of Noir Comics." *A Companion to Film Noir*, edited by A. Spicer and H. Hanson, Wiley and Sons Press, 458–476.

Madrid, Mike (2009). *The Supergirls: Fashion, Feminism, Fantasy, and the History of the Comic Book Heroines*. Exterminating Angel Press.

Maltby, Richard (1995). *Hollywood Cinema: An Introduction*. Blackwell Press.

Marion, Philippe (1993). *Traces en cases*. Academia.

McAllister, Matthew, and Brian MacAuley (2020). "Comics Industries." *Comics Studies: A Guidebook*, edited by Charles Hatfield and Bart Beaty, Rutgers University Press, 97–112.

McCloud, Scott (1993). *Understanding Comics: The Invisible Art*. Kitchen Sink Press.

——— (2020). *Reinventing Comics: The Evolution of an Art Form*. Kitchen Sink Press.

McGunnigle, Christopher (2018). "The Difference between Heroes and Monsters: Marvel Monsters and Their Transition into the Superhero Genre." *University of Toronto Quarterly* 87, no. 1: 110–135.

McIntyre, Anthony P. (2015). "Isn't She Adorable! Cuteness as Political Neutralization in the Star Text of Zoey Deschanel." *Television & New Media* 16, no. 5: 422–438.

McSweeney, Terence (2020). *The Contemporary Superhero Film: Projections of Power and Identity*. Wallflower Press.

McVeigh, Brian J. (2000). "How Hello Kitty Commodifies the Cute, Cool and Camp: 'Consumutopia' versus 'Control' in Japan." *Journal of Material Culture* 5, no. 2: 291–312.

Medhurst, Andy (1991). "Batman, Deviance and Camp." *The Many Lives of the Batman: Critical Approaches to a Superhero and His Media*, edited by Roberta E. Pearson and William Uricchio, Routledge.

Metz, Christian (1986). *The Imaginary Signifier: Psychoanalysis and the Cinema*. Indiana University Press.

Meyer, Matt (2021). "The Human Target #1: Everybody Wins." Comicwatch.com, November 2.

Miller, Laura (2011). "Cute Masquerade and the Pimping of Japan." *International Journal of Japanese Sociology* 20, no. 1: 18–29.

Molotiu, Andrei (2007). "Permanent Ink: Comic Book and Comic Strip Original Art as Aesthetic Object." *International Journal of Comic Art* 9, no. 2: 24–42.

——— (2020). "Cartooning." *Comics Studies: A Guidebook*, edited by Charles Hatfield and Bart Beaty, Rutgers University Press, 153–171.

Mulvey, Laura (1975). "Visual Pleasure and the Narrative Cinema." *Screen* 16, no. 3: 6–18.

Munson, Kim A. (2020). *Comic Art in Museums*. University Press of Mississippi.

Naremore, James (2008). *More than Night: Film Noir in Its Contexts*. University of California Press.

Neale, Steve (1983). "Masculinity as Spectacle: Reflections on Men and Mainstream Cinema." *Screen* 24, no. 6: 2–16.

Ngai, Sianne (2005). "The Cuteness of the Avant-Garde." *Critical Inquiry* 31, no. 2: 811–847.

Novitz, Julian (2019). "Against Impossible Odds: Supervillain Bodies in Grossman's 'Soon I Will Be Invincible' and Matt Carter's 'Almost Infamous.'" *Superhero Bodies: Identity, Materiality, Transformation*, edited by Wendy Haslem, Elizabeth MacFarlane, and Sarah Richardson, Routledge, 96–116.

Nyberg, Amy Kiste (1998). *Seal of Approval: The History of the Comics Code*. University Press of Mississippi.

Orr, Christopher (2016). "Batman vs. Superman: The Dawn of Rubbish." theatlantic.com, March 24.

Pacteau, Francette (1994). *The Symptom of Beauty*. Harvard University Press.

Pearson, Roberta E., and William Uricchio (1991). "'I'm Not Fooled by That Cheap Disguise.'" *The Many Lives of the Batman: Critical Approaches to a Superhero and His Media*, edited by Roberta E. Pearson and William Uricchio, Routledge, 182–213.

Pederson, Kaitlin, and Neil Cohn (2016). "The Changing Pages of Comics: Page Layouts across Eight Decades of American Superhero Comics." *Studies in Comics* 7, no. 1: 7–28.

Pedri, Nancy (2015). "Thinking about Photography in Comics." *Image & Narrative* 16, no. 2: 1–13.

Peppard, Anna F. (2014). "Big Fun on Monster Island: Reading the Sexy Superbody in the Marvel Swimsuit Issue." *International Journal of Comic Art* 16, no. 2: 565–581.

——— (2019). "The Power of the Marvel(ous) Image: Reading Excess in the Styles of Todd McFarlane, Jim Lee, and Rob Liefeld." *Journal of Graphic Novels and Comics* 10, no. 3: 320–341.

Peppard, Anna F., ed. (2020). *Supersex: Sexuality, Fantasy, and the Superhero*. University of Texas Press.

Place, Janey, and Lowell Peterson (1974). "Some Visual Motifs of Film Noir." *Film Comment* 10, no. 1: 30–35.

Poharec, Lauranne (2018). "Focalized Split Panels: Bridging the Borders in Comics Form." *Studies in Comics* 9, no. 2: 315–331.

Potts, Carl (2013). *The DC Comics Guide to Creating Comics: Inside the Art of Visual Storytelling*. Watson-Guptill.

Pustz, Matthew J. (1999). *Comic Book Culture: Fanboys and True Believers*. University Press of Mississippi.

Reynolds, Richard (1992). *Super Heroes: A Modern Mythology*. B. T. Batsford Ltd.

Robinson, Kerry H., and Cristyn Davies (2008). "'She's Kickin' Ass, That's What She's Doing!': Deconstructing Childhood 'Innocence' in Media Representations." *Australian Feminist Studies* 23, no. 57: 343–358.

Roeder, Katherine (2008). "Looking High and Low at Comic Art." *American Art* 22, no. 1: 2–9.

Rowe, Kathleen (1995). *The Unruly Woman: Gender and the Genres of Laughter*. University of Texas Press.

Russo, Mary (1994). *The Female Grotesque: Risk, Excess, and Modernity*. Routledge.

Sabin, Roger (1993). *Adult Comics: An Introduction*. Routledge Press.

Sarris, Andrew (1968). *The American Cinema: Directors and Directions 1929–1968*. De Capo Press.

Scott, Darieck, and Rami Fawaz (2018). "Introduction: Queer about Comics." *American Literature* 90, no. 1: 197–219.

Seigworth, Gregory J., and Melissa Gregg (2009). "An Inventory of Shimmers." *The Affect Theory Reader*, edited by Gregory J. Seigworth and Melissa Gregg, Duke University Press, 1–25.

Shohat, Ella (1997). "Gender and Culture of Empire: Toward a Feminist Ethnography of the Cinema." *Visions of the East: Orientalism in Film*, edited by Matthew Bernstein and Gaylyn Studlar, Rutgers University Press.

Short, Sue (2019). *Darkness Calls: A Critical Investigation of Neo-Noir*. Palgrave-Macmillan.

Smith, Matthew J., and Randy Duncan (2009). *The Power of Comics: History, Form and Culture*. Continuum.

Smith, Scott T., and José Alaniz (2019). *Uncanny Bodies: Superhero Comics and Disability*. Penn State University Press.

Stein, Daniel (2016). "Mummified Objects: Superhero Comics in the Digital Age." *Journal of Graphic Novels and Comics* 7, no. 3: 283–292.

——— (2021). *Authorizing Superhero Comics: On the Evolution of a Popular Serial Genre*. Ohio State University Press.

Steirer, Gregory (2014). "No More Bags and Boards: Collecting Culture and the Digital Comics Marketplace." *Journal of Graphic Novels and Comics* 5, no. 4: 455–469.

Swartz-Levine, Jennifer (2017). "Madwomen: Sexism as Nostalgia or Feminism in The New Frontier." *The Ages of the Justice League: Essays on America's Greatest Superheroes in Changing Times*, edited by Joseph J. Darwoski, McFarland and Company, 172–185.

Tasker, Yvonne (2013). "Women in Film Noir." *A Companion to Film Noir*, edited by Andrew Spicer and Helen Hanson, Blackwell Press, 353–368.

Taylor, Aaron (2007). "He's Gotta Be Strong, and He's Gotta Be Fast, and He's Gotta Be Larger than Life: Investigating the Engendered Superhero Body." *Journal of Popular Culture* 40, no. 2: 344–360.

——— (2014). "Avengers Disassemble! Transmedia Superhero Franchises and Cultic Management." *Journal of Adaptation in Film and Performance* 7, no. 2: 181–194.

Taylor, Affrica (2010). "Troubling Childhood Innocence: Reframing the Debate over the Media Sexualisation of Children." *Australasian Journal of Early Childhood* 35, no. 1: 48–57.

Theweleit, Klaus (1977). *Male Fantasies*. 2 vols. Translated by Stephen Conway, University of Minnesota Press.

Thomas, John Rhett (2021). *Marvel Comics: The Variant Covers*. Insight Comics Press.

Thon, Jan-Noel (2015). "Converging Worlds: From Transmedial Storyworlds to Transmedial Universes." *Storyworlds* 7, no. 2: 21–53.

Thon, Jan-Noel, and Lukas R. A. Wilde (2016). "Mediality and Materiality of Contemporary Comics." *Journal of Graphic Novels and Comics* 7, no. 3: 233–241.

Tomabechi, Nao (2019). "Recycling the Other: The Role of Nostalgia in Superhero Comics' Orientalism." *Panic at the Discourse: An Interdisciplinary Journal* 1, no. 1: 37–46.

Tudor, Deborah (2012). "Selling Nostalgia: Mad Men, Postmodernism and Neoliberalism." *Society* 49, no. 4: 333–338.

Uricchio, William, and Roberta Pearson, eds. (1991). *The Many Lives of the Batman: Critical Approaches to a Superhero and His Media*. BFI Publishing.

Vale, Catherine M. (2015). "The Loyal Heart: Homosocial Bonding and Homoerotic Subtext between Batman and Robin, 1939–1943." *Dick Grayson, Boy Wonder: Scholars and Creators on 75 Years of Robin, Nightwing and Batman*, edited by Kristen L. Geaman, McFarland and Company, 94–110.

Wallace, Daniel (2018). *DC Variant Covers: The Complete Visual History*. Insight Comics Press.

Wandtke, Terrence R. (2015). *The Dark Knight Returns: The Contemporary Resurgence of Crime Comics*. RIT Press.

——— (2018). "The Working Class PI (aka Jessica Jones) Alias as a Narrative of Quiet Desperation." *Working Class Comic Book Heroes: Class Conflict and Populist Politics in Comics*, edited by Marc DiPaolo, University Press of Mississippi, 226–245.

Waugh, Coulton (1991). *The Comics*. University Press of Mississippi.

Weldon, G. (2016). "The War over Comics for Kids Is Nearly Over, and Kids Are Winning." npr.org, January 5.

Wershler, Darren, and Kalervo Sinervo (2017). "Marvel and the Form of Motion Comics." *Make Ours Marvel: Media Convergence and a*

Comics Universe, edited by Matt Yockey, University of Texas Press, 187–206.

Wershler, Darren, Kalervo Sinervo, and Shannon Tien (2020). "Digital Comics." *Comics Studies: A Guidebook*, edited by Charles Hatfield and Bart Beaty, Rutgers University Press, 253–266.

Wertham, Fredric (1954). *Seduction of the Innocent: The Influence of Comic Books on Today's Youth*. Rinehart.

Wills, Nadine (2001). "110 Per Cent Woman: The Crotch Shot in the Hollywood Musical." *Screen* 42, no. 2: 121–141.

Wittkower, D. E. (2012). "On the Origins of the Cute as a Dominant Aesthetic Category in Digital Culture." *Putting Knowledge to Work and Letting Information Play*, edited by T. W. Luke and J. Hunsinger, Sense Publishers, 167–175.

Wright, Bradford W. (2001). *Comic Book Nation: The Transformation of Youth Culture in America*. Johns Hopkins University Press.

Yockey, Matt (2012). "Retopia: The Dialectics of the Superhero Comic Book." *Studies in Comics* 3, no. 2: 349–370.

Yockey, Matt, ed. (2017). *Make Ours Marvel: Media Convergence and a Comics Universe*. University of Texas Press.

Yoe, Craig (2009). *Secret Identity: The Fetish Art of Superman's Co-Creator Joe Shuster*. Abrams Comic Arts.

Young, Paul (2016). *Frank Miller's Daredevil and the Ends of Heroism*. Rutgers University Press.

Zaglewski, Tomasz (2020). "The Unwrapped Editions: Searching for the 'Ultimate' Format of Graphic Novels and Its Limitations." *ImageTexT: Interdisciplinary Comics Studies* 11, no. 3: 1–12.

INDEX

Aaron, Jason, 202
Abbett, Robert K., 113
Action Comics, 20, 33, 34, 35, 207
Acuña, Daniel, 112
Adams, Arthur, 145
Adams, Neal, 38, 45, 47, 53
Ahmed, Sara, 158
Aja, David, 8, 9, 91, 110, 119
Alaniz, Jose, 70, 88, 173, 175
Albuquerque, Rafael, 160, 163
Allison, Anne, 144
Allred, Michael, 91, 110
All-Star Batman and Robin, 87, 161
Amazing Spider-Man, 19, 47, 58
Anacleto, Jay, 77
Andrews, Kaare, 131–132
anime, 24, 141–145, 147, 149, 158, 160, 224
Aparo, Jim, 38, 53
art galleries, 18, 22, 30, 46, 49, 54–58, 60, 220
Artisan editions, 57, 60, 220
auteurism, 2, 14, 15, 17, 22, 134, 201, 224
Azzarello, Brian, 134, 135, 192, 202

Babka, Susie Paulik, 73
Bachalo, Chris, 20, 24, 54, 142, 145
Bacon, Francis, 170, 171, 190
Badower, Jason, 20, 119, 135–137
Baetens, Jan, 10, 11, 13, 58
Bagley, Mark, 21, 202
Bails, Jerry, 45
Bainbridge, Jason, 156
Ball, David, 31
Baltazar, Art, 142, 154, 159
Barberi, Carlo, 149

Barrionuevo, Al, 73
Batgirl, 97, 98, 99, 132, 133, 147, 169, 197
Batman (character), 2, 4, 7, 8, 23, 25, 36, 37, 40, 42, 47, 50, 62–64, 70, 74, 77, 80–82, 93, 106, 115, 127–135, 149, 151–157, 160–164, 172–176, 180, 182, 187–193, 196–205, 208, 211, 217, 224
Batman (comic), 8, 10, 50, 81, 87, 127, 164, 192
Batman (television series), 93, 115, 152
Batman '66, 108, 109
Batman: Arkham Asylum, 164, 187
Batman: Damned, 134–135
Batman: Digital Justice, 216, 223
Batman: Ghosts, 181, 183
Batman: Gotham Noir, 196–198
Batman: Nine Lives, 196–198
Batman: The Animated Series, 38, 92, 93
Batman: The Dark Knight Returns, 47, 48, 50, 99, 103, 200, 201
Batman: The Long Halloween, 97, 200
Batman: Year One, 100–102, 108, 201
Baudrillard, Jean, 95
Beaty, Bart, 11, 15, 16, 32, 44, 45, 54, 218
beauty (physical), 17, 18, 66–68, 76–80, 123, 169, 171, 175, 176, 184, 185; as moral good, 22, 35, 63, 65, 66, 72, 170–177
Bechdel, Alison, 2
Beck, C. C., 33, 36, 37
Bell, Crystal, 164

Bendis, Brian Michael, 15, 108, 119, 202, 204, 206, 212
Benes, Ed, 63, 74, 75, 82–83
Bermejo, Lee, 51, 117, 134, 135
Bevin, Phillip, 74
Birlea, Oana-Maria, 144, 156
Bisley, Simon, 172, 183, 186
Black Canary, 84, 161
Black Widow, 65, 111–113, 119, 198
Bloom, Harold, 99
Bolland, Brian, 200, 216
Bolton, John, 172, 182, 183
Bordo, Susan, 69
Boring, Wayne, 38, 95
Bourdieu, Pierre, 46
Bradstreet, Tim, 132, 133
Breyfogle, Norm, 53
Brian, Mitch, 92
Brookes, Ian, 196
Brooks, Mark, 63
Brown, Jeffrey A., 46, 66, 70, 86, 162, 187
Brubaker, Ed, 15, 119, 192, 196, 198, 202, 206–208
Buccellato, Brian, 58
Bukatman, Scott, 2, 70, 79
Bullock, Dave, 95
Burgos, Carl, 36
Buscema, John, 4, 53, 63, 64
Busiek, Kurt, 15, 24, 93, 115, 119, 120
Byrne, John, 15, 53, 63

Camden, Vera, 13
Campbell, Eddie, 189
Campbell, J. Scott, 50, 63, 76, 89, 145
Caniff, Milton, 2, 34, 36

Captain America, 2, 29, 36, 43, 97, 102, 110, 111, 120, 139, 151, 157, 160, 174, 180, 198, 205, 208
Captain Marvel (Fawcett Publications), 36–38, 80
Captain Marvel (Marvel Comics), 71, 147
Capullo, Greg, 63, 200
Carter, Lynda, 93, 108, 115
Case, Jonathan, 108, 109
Catwoman, 50, 62, 63, 97, 128, 129, 176, 177, 186, 193, 197
Chaykin, Howard, 2, 15, 53, 93, 202
Chibi, 25, 158, 159
Ching, Brian, 142, 147, 148
Chiodo, Joe, 167
Cho, Frank, 63, 78
Cho, Michael, 91, 95, 115
Christopher, John Tyler, 132
Clanton, Dan, 72
Clark, Kenneth, 68, 123, 124
Clarke, M. J., 48, 51
Clover, Carol, 17
Cocca, Carolyn, 82
Cohn, Neil, 13
Coker, Tomm, 192, 199, 200
Cold War, 29, 102, 111, 112, 174
collectors, 22, 41, 47, 49, 54, 96, 153, 218
Colossus, 70
comic conventions, 13, 45, 60
Comics Code Authority (CCA), 41, 42, 107
Comixology, 219
Connell, R. W., 66, 67
Connelly, Frances S., 170, 186
Conner, Amanda, 20, 51, 54, 63, 76, 84, 131, 132
Coogan, Peter, 29, 147
Cook, Roy T., 8
Cooke, Darwyn, 23, 50, 55, 91, 92, 102–107, 110, 113, 115
Cortsen, Rikke Platz, 13
Costello, Brannon, 2
Costello, Matthew, 111, 174, 178
Coughlan, David, 68
Cowan, Denys, 184
Creed, Barbara, 133, 188
Crumb, Robert, 2, 170
curated, 46, 55, 218, 220
curator, 18, 45
Curtis, Maggie, 45
Cute (artistic style), 3, 16, 21, 24–26, 78, 82, 92, 120, 126, 131, 134, 136, 141–167, 171, 180, 215, 224
Cypress, Toby, 172, 184

Dali, Salvador, 26, 170, 190
Daniel, Tony, 216
Daredevil (character), 2, 20, 23, 25, 27, 28, 40, 70, 98–101, 119, 131, 184, 192, 198–205, 208, 211
Daredevil (comic series), 20, 28, 98, 100, 119, 199, 202, 203
Daredevil: Born Again, 58
Daredevil: Noir, 198–200
Daredevil: Yellow, 97–99, 101
Dark Horse Comics, 143, 154, 184, 201, 202
Davies, Cristyn, 155, 156
da Vinci, Leonardo, 23, 57, 64
DC: The New Frontier, 23, 102–107, 112, 113
Deadpool, 11, 153
De Dauw, Esther, 63, 86
DeForge, Michael, 171
Dekal, Jeff, 132
Dell'Otto, Gabriele, 50, 51, 117
Deodato, Mike, Jr., 126
Derington, Nick, 95, 110
dessinateur, 15, 22, 29–58, 226
Detective Comics, 20, 77, 164, 196
digital art, 46, 118, 123, 126, 215–226
Dini, Paul, 92
Ditko, Steve, 19, 45, 53, 57
Dittmer, Jason, 29, 193
Djurdjević, Marko, 132
Doane, Mary Ann, 188
Dodson, Terry, 63, 76
Dragotta, Nick, 72
Duchamp, Marcel, 26
Duin, Steve, 37
Duncan, Randy, 7
Dyer, Richard, 80–81

Easton, Lee, 87, 141, 147
Eco, Umberto, 97, 129, 162, 193
Edmondson, Nathan, 111
Edwards, Justin, 172, 180
Eisner, Will, 2, 11, 15, 36, 39, 45, 194, 206
Ellis, Warren, 15
Epting, Steve, 208
Everett, William Blake "Bill," 36
fandom, 22, 30, 44–49, 96, 158, 167, 217, 218, 221

Fawaz, Ramzi, 29, 87
Fawcett Publications, 36, 37
Fennell, Jack, 174
Finch, David, 63
Fine, Lou, 45
Firestone, Andrew, 113
Fischer, Russ, 164
Fish, Veronica, 147
Flash Gordon, 34, 35
Fleischer Studios, 93, 142
Foster, Harold "Hal," 34, 35, 36
Fraction, Matt, 8, 119
Frank, Kathryn M., 43
Friedlander, Keith, 171
Frison, Jenny, 95
Fuseli, Henry, 170

Gabilliet, Jean-Paul, 54, 56, 58, 143
Gaiman, Neil, 15
Garcia, Kami, 119, 135, 136, 137
García-López, José Luis, 38
Gardner, Jared, 15, 57, 58
Garland Thomson, Rosemarie, 175–177
Gates, Phillippa, 212
Gaydos, Michael, 21, 119, 192, 202, 206, 207
Gibbons, Dave, 48, 94
Gillis, Peter B., 216
Gilmore, James N., 29
Giordano, Dick, 38
Gleason, Patrick, 20, 78, 79
Glover, David, 72
Goffman, Erving, 30
Golden, Michael, 145
Goodrum, Michael, 207
Gordon, Ian, 42, 43
Gordon, Neta, 106
Goya, Francisco, 170, 171, 190
Grampá, Rafael, 172, 184
Granot, Elad, 144
Granov, Adi, 117, 127, 128
Grassetti, Rafael, 51, 52
Graulund, Rune, 172, 180
Gravett, Paul, 143
Gray, Richard J., 161
Green Arrow, 4, 70, 75, 208, 209, 210
Green Lantern, 36, 37, 75, 93, 104, 106
Green, Michael, 160
Gregg, Melissa, 158
Gregov, R. J., 19
Grell, Mike, 38

INDEX | 237

Grotesque (artistic style), 3, 9, 16, 17, 21, 25, 26, 41, 69, 72, 78, 82, 88, 89, 120, 126, 134, 136, 167, 169–190, 215, 225
Guynes, Sean, 102, 107

Hampton, Scott, 20
Hanawalt, Lisa, 171
harem structure, 23, 77
Harley Quinn, 20, 119, 131, 135–138
Harris, Daniel, 159
Harrison, Richard, 6, 33, 86, 87, 126, 127, 141, 147
Harvey, Robert C., 7, 11, 39
Hatfield, Charles, 2, 5, 35, 36, 44, 77, 173
Hawkeye (character), 8, 70, 212
Hawkeye (comic), 8, 9, 110, 119
hegemonic masculinity, 22, 66, 67, 70, 81, 86, 87, 128, 162, 184, 211
hegemony, 86, 94, 106, 155, 186, 188
Hellcat, 147
Henderson, Erica, 147
Hersey, George L., 64
heteronormative, 76, 87
heterosexual, 61, 78, 87
Hills, Matt, 166
Hionis, Jerry, 218
Hogarth, Burne, 36, 64
Hollingsworth, Matt, 21, 207
Hooks, Mitchell, 110, 113
Horn, Greg, 63, 127
Hughes, Adam, 51, 63, 76, 127, 132
Hulk, The, 25, 43, 65, 89, 97, 178, 179
Human Target, The, 112–114
Huntress, 82, 83, 84, 132
hypersexual, 20, 22, 42, 67, 76, 82, 84, 87, 88, 141, 147, 175, 184

Idealism (artistic style), 3, 11, 21–23, 28, 41, 50, 61–89, 93, 108, 111, 115, 120, 123, 126–129, 136, 156, 162, 167, 169–171, 175, 180, 184, 200, 207, 223
IDW Publishing, 57
Image Comics, 47, 48, 88, 141
Immonen, Stuart, 70
Infantino, Carmine, 4, 38, 45
Inge, Thomas, 117

Iron Man, 43, 70, 139, 151, 157, 174, 198, 199, 205, 216, 223
Irving, Frazer, 28

Jameson, Fredric, 94, 95, 96, 107, 108
Janson, Klaus, 6, 64, 88
Jarrell, Sandy, 108
Jean, James, 167
Jeffords, Susan, 70
Jenkins, Henry, 18, 19, 40, 73, 96, 100, 101, 103, 130, 134, 139, 166, 197, 202, 220
Jessica Jones, 20, 25, 132, 192, 206, 207, 208
Jimenez, Jorge, 70, 71, 81, 149, 150, 216, 217
Jock (artist), 54, 205
Johns, Geoff, 58
Johnson, Derek, 157
Johnson, Mike, 160
Joker, The, 9, 119, 134–137, 173, 197, 210
Jones, Eric, 142, 154
Jones, Gerard, 30, 34
Jones, Joëlle, 54, 176, 177
Jones, Kelley, 172, 182, 189

Kane, Bob, 36, 39, 45, 87, 127, 199
Kane, Gil, 45
Kaplan, Cora, 72
Kashtan, Aaron, 219
Kawaii, 24, 141–167
Kember, Sarah, 124
Kidd, Chip, 126
Kieth, Sam, 172, 180, 181, 183
King, Frank, 32
Kingpin, The, 173, 174, 199, 204
King, Tom, 112, 193, 205
Kipnis, Laura, 72
Kirby, Jack, 2, 15, 36, 43–45, 53, 55, 121
Kirkman, Robert, 15
Klein, Alan M., 70
Klock, Geoff, 99
Kobre, Michael, 69, 89
Koh, Irene, 20
Koosed, Jennifer L., 73
Kristeva, Julia, 182, 188
Kubert, Andy, 58, 63
Kubert, Joe, 45
Kuhlman, Martha, 13, 14
Kuhn, Annette, 76
Kukkonen, Karin, 96, 156
Kunkel, Mike, 154, 159

Land, Greg, 18, 63, 72, 77, 126, 127
Lark, Michael, 15, 119, 192, 196–198, 205, 206, 208
Larsen, Erik, 48
Later, Naja, 8
Latorre, Diego, 28
Lau, Stanley "Artgerm," 63
Laufman, Derek, 159
Lee, Cheol, 51
Lee, Jae, 142, 167
Lee, Jim, 47, 50, 55, 58, 59, 63, 74, 75, 87, 127, 200
Lee, Stacey, 147
Lee, Stan, 4, 15, 43, 58, 63, 117, 178
Lefevre, Pascal, 1, 13, 16, 40, 118
Lemire, Jeff, 192, 208, 210, 212, 213
Leon, John Paul, 112, 192, 208
Lex Luthor, 68, 134, 154
Liefeld, Rob, 18, 47
Linsner, Joseph, 63
Lister, Martin, 123
Loeb, Jeph, 15, 23, 97, 98, 99, 200
Lois Lane, 11, 67, 68, 104, 204, 207, 208
Lopes, Paul, 30, 31, 41, 42, 48, 141
Lotay, Tula, 28
Lovell, Tom, 110
Luckovich, Mike, 225
Luke Cage, 21, 25, 70, 178, 198, 199
Lund, Martin, 198, 199
Lunning, Frenchy, 143
Lupoff, Dick and Pat, 45
Lyons, James, 191

MacAuley, Brian, 216, 220
MacDonald, Ian, 51, 117, 128, 129
Mack, David, 27, 28
Mad Men, 110, 111, 112
Madrid, Mike, 81, 82
Maer, Shannon, 51, 117, 128, 129
Maiolo, Marcelo, 210
Maleev, Alex, 15, 20, 131, 192, 202–205, 206
Maltby, Richard, 12
Manapul, Francis, 58
manga, 19, 20, 24, 25, 40, 88, 89, 141–167, 224
Mann, Clay, 62, 63, 74, 176, 205
Marion, Philippe, 58
Martín, Marcos, 91, 97, 98, 115

Marvel Noir, 198, 199
Marvels, 24, 93, 115, 119–125
Mattina, Francesco, 20, 51, 117, 127, 128
Mayhew, Mike, 117, 119, 121, 123, 135, 136, 138, 139
Mazzucchelli, David, 58, 101, 201
McAllister, Matthew, 216, 220
McCay, Winsor, 31
McCloud, Scott, 8, 130, 131, 222, 223
McFarlane, Todd, 47, 216
McGinnis, Robert, 110, 112
McGuinness, Ed, 54, 63, 74
McGunnigle, Christopher, 178
McIntyre, Anthony P., 143
McKean, Dave, 172, 187
McKeever, Ted, 172, 184, 185, 186, 189
McMahon, Mike, 184
McManus, George, 32
McPherson, Tara, 167
McSweeney, Terence, 139
McVeigh, Brian J., 144, 165
Medhurst, Andy, 201
Melnikov, Gleb, 142, 150, 151
Metz, Christian, 130
Meyer, Matt, 113
Meyers, Jonboy, 24, 145
Middleton, Joshua, 117, 132, 133
Migliari, Rodolfo, 117
Mignola, Mike, 2, 15, 53, 172, 184, 189
Millar, Mark, 108
Miller, Frank, 2, 15, 28, 47, 48, 50, 53, 55, 58, 100, 161, 200, 201, 202
Miller, Laura, 144
Mixx Entertainment, 143
Molotiu, Andrei, 33, 40, 55, 56, 60, 92, 108, 120
Momoko, Peach, 151, 152
Moore, Alan, 14, 15, 48, 94, 200, 201, 202
Mora, Dan, 142
Moreno, Pepe, 216
Morrison, Grant, 8, 14, 15, 58, 179
Motter, Dean, 197, 202
movies, 12, 17, 29, 31, 33, 49, 77, 81, 93, 94, 103, 130, 133, 138, 157, 179, 218; Superhero Movies, 49, 118, 139, 141, 160, 167, 170, 223
Moynihan, Jesse, 171

multiplicity, 18, 19, 73, 96, 100, 156, 197
Mulvey, Laura, 67, 77, 78, 80, 130
Munch, Edvard, 170
Murphy, Sean, 172, 184
museums, 22, 30, 46, 54–56, 58, 220, 221

Naremore, James, 195
Neale, Steve, 80–81, 130
Ngai, Sianne, 158, 159
Nguyen, Dustin, 142, 154, 155, 159
Nightwing, 70
Nodell, Mart, 36
Noir (artistic style), 25, 93, 114, 192, 194–197, 198, 199, 206, 210, 212, 213
nostalgia, 3, 18, 23, 91–115, 120, 121, 127, 157
Noto, Phil, 110–113
Novitz, Julian, 69, 74, 175
Nyberg, Amy Kiste, 29, 195

Oeming, Michael Avon, 110
Old Man Logan, 210–213
Oliver, Ben, 117
Orbik, Glen, 110
Orientalism, 77, 107
original artwork, 4, 22, 33, 44, 45, 47, 49, 54–60, 220, 221
Orlando, Steve, 147, 189, 190
Ortiz, Richard, 108
Outcault, Richard, 31

Pacteau, Francette, 65
Panosian, Dan, 192
Parrillo, Lucio, 117, 133
Pearson, Jason, 145
Pearson, Roberta E., 164, 173, 186
Pederson, Kaitlin, 13
Pekar, Harvey, 171
Pelletier, Paul, 169
Penguin, The, 25, 173, 176, 197
Peppard, Anna F., 5, 14, 67, 75, 77, 88
Perkins, Mike, 192, 206, 207, 208
Peterson, Lowell, 195
Phillips, Sean, 196, 197, 198
Photorealism, 120–124
Pichelli, Sara, 54
Place, Janey, 195
Poharec, Lauranne, 13
Pollock, Jackson, 26

Pop Art, 113, 200, 201
Pope, Paul, 172, 184, 189
Populuxe, 102, 119
pornography, 17, 76, 83
Portacio, Whilce, 48
Potts, Carl, 13, 40
Power Girl, 70, 71, 80, 84, 85
Pulido, Javier, 91, 97, 98
pulp magazines, 25, 33, 34, 35, 36, 48, 67, 112, 113, 173, 191–196
Punisher, The, 132, 133, 153, 198
Pustz, Matthew J., 29, 45
Putri, Yasmine, 51

Quesada, Joe, 28
Quinones, Joe, 108
Quitely, Frank, 55, 172, 179

Ramos, Humberto, 20, 24, 54, 88, 89, 142, 145, 146, 149
Rapp, Otto, 170
Raymond, Alex, 34, 35, 36
Raynor, Max, 149
Realism (artistic style), 3, 21, 24, 36, 93, 99, 108, 111, 114, 115, 117–139, 215
Reeve, Christopher, 115
Reeves, George, 93, 115
Retro (artistic style), 3, 21, 23, 78, 91–115, 119, 127, 131, 134, 136, 171, 180, 196, 211, 215
Reynolds, Richard, 35, 193
Richardson, Mike, 37
Risso, Eduardo, 192, 202
Robin, 87, 93, 97–99, 127, 149–151, 154, 161, 197
Robinson, Kerry H., 155
Rodriguez, Irvin, 132
Rodriguez, Robbie, 147
Rodriguez, Spain, 171
Roeder, Katherine, 14, 42
Rogers, Marshall, 38, 53
Romita, John, Sr., 19, 47, 58
Ross, Alex, 18, 24, 51, 55, 93, 114–127, 131
Rossmo, Riley, 189, 190
Rothko, Mark, 26
Rowe, Kathleen, 185
Rucka, Greg, 192, 206, 207
Rude, Steve, 91
Russo, Mary, 69, 72, 182, 185
Ryan, Johnny, 171

Sabin, Roger, 171, 201
Saenz, Mike, 216

Sale, Tim, 15, 23, 91, 97, 99, 101, 110, 200
Samnee, Chris, 91, 110, 111, 112, 115, 119
Sarris, Andrew, 14
Schiff, Jack, 37
Schulz, Charles, 2
Schumm, Darla, 73
Scott, Darieck, 87
Scott, Mairghread, 169
Scott, Nicola, 108
Seagle, Steven T., 202
Seigworth, Gregory, 158
Seuling, Phil, 49
sexuality, 42, 60–67, 71, 72, 77, 80, 82–88, 107, 111, 128, 131, 155, 159, 161, 167, 175, 179, 180, 185–188, 194
She-Hulk, 72, 80
Shelton, Gilbert, 170
Sherman, Cindy, 26
Shohat, Ella, 76–77
Shuster, Joe, 33–36, 38, 39, 41, 43, 44, 45, 67–68, 191
Siegel, Jerry, 33, 34, 43, 44, 45, 191
Sienkiewicz, Bill, 28, 50, 172
Silvestri, Marc, 48
Simone, Gail, 15
Simonson, Walt, 53
Sinervo, Kalervo, 216, 219
Smallwood, Greg, 112–114
Smith, Matthew J., 7
Smith, Scott T., 173
Snyder, Scott, 200
Sorrentino, Andrea, 192, 209–213
Spider-Man, 2, 7, 8, 19, 23, 47, 64, 73, 74, 94, 97, 120, 124, 131, 139, 145, 146, 172, 174, 178, 198, 202, 223, 224
Spiegelman, Art, 2, 52
Sprang, Dick, 38, 45
Stein, Daniel, 53, 220, 221
Steirer, Gregory, 218, 221, 222
Steranko, Jim, 55
Stewart, Cameron, 147

Stonehouse, JH, 132
Stork, Matthias, 29
Suayan, Mico, 117, 119, 135, 136
Superboy, 78, 149
Supergirl, 63, 71, 147, 148, 154, 161
Superman, 2–7, 11, 18, 20–23, 32–45, 51, 52, 55, 58–68, 70–75, 78–80, 91–99, 105, 106, 115, 124, 131, 149, 151, 157, 160–163, 178, 191, 193, 204, 205, 207, 225, 226
Swan, Curt, 4, 5
Swartz-Levine, Jennifer, 106

Talbot, Bryan, 171
Tarr, Babs, 147
Tarzan, 34, 35
Taylor, Aaron, 80, 86, 157
Taylor, Affrica, 155
Teen Titans, 92, 149, 153
Templeton, Ty, 91, 93, 108
Tezuka, Osamu, 142
Theweleit, Klaus, 70, 75
Thing, The, 25, 65, 178, 179, 212
Thomas, John Rhett, 51
Thomas, Roy, 45
Thompson, Don, 45
Thon, Jan-Noel, 156, 222
Timm, Bruce, 38, 91, 92, 93, 127, 180
Tokyopop, 143
Tomabechi, Nao, 102, 107
Tomasi, Peter J., 149
Torres, Wilfredo, 108, 109
Tudor, Deborah, 110
Turner, Michael, 63, 74

Uminga, Chris, 167
underground comix, 11, 170, 171
Unwrapped Editions, 57, 58, 59, 60, 220

Valentino, Jim, 48
VanFleet, John, 8, 9, 10
variant covers, 26, 47, 49–51, 53, 77, 92, 119, 121, 132, 153

Viz Communications, 143

Wagner, John, 202
Wagner, Matt, 93, 202
Waid, Mark, 112, 119
Wallace, Danielle, 51, 92
Wandtke, Terrence R., 21, 192, 196, 201, 206
Ware, Chris, 2
Watchmen, 48, 94, 99
Waugh, Coulton, 7
Weeks, Lee, 192, 193, 205, 206
Weldon, G., 148
Wershler, Darren, 216, 219
Wertham, Fredric, 41, 107, 194, 201
West, Adam, 93, 115, 131, 152, 201
Williams, Brittney, 147
Wills, Nadine, 83, 84
Wittkower, D. E., 159
Wolverine (character), 20, 88, 89, 127–129, 151, 153, 198, 199, 210–213
Wolverine (comic), 145, 211
Wonder Woman (character), 2, 20, 37, 63, 71, 80, 93, 106, 108, 115, 151, 161, 172, 185, 186
Wonder Woman '77 (comic), 108
Wood, Wally, 39, 45
Woodward, J. K., 121
World War II, 29, 41, 43, 91, 97, 102, 103, 142, 144, 194, 199
Wright, Bradford W., 29, 30, 36, 39, 41

X-Men, The, 20, 43, 47, 50, 70, 82, 121, 123, 139, 145, 149, 151, 152, 175, 178–180, 198, 199, 212

Yockey, Matt, 103
Yoe, Craig, 67, 68
Young, Paul, 2
Young, Skottie, 132, 142, 153, 154, 159

Zaglewski, Tomasz, 54, 57
Zullo, Chrissie, 142